ILLUSTRATED
DICTIONARY *of*
PHOTOGRAPHY

Barbara A. Lynch-Johnt
Michelle Perkins

AMHERST MEDIA, INC. ■ BUFFALO, NY

ACKNOWLEDGMENTS

The authors wish to thank the photographers who contributed images to this project: Bill Hurter, Jeff Smith, Jeff and Kathleen Hawkins, Tim Schooler, and Jeffrey and Julia Woods. Without them, this book would not have been possible.

We would also like to thank WDVX (www.wdvx.com) for the countless hours of great entertainment we enjoyed while writing this book. We appreciate their commitment to Americana music and public radio.

FROM BARBARA LYNCH-JOHNT

To Madeleine, who has been fascinated by cameras for as long as I can remember, and whose vision always inspires me.

FROM MICHELLE PERKINS

Thank you to Ron, whose fearlessness and creativity are both (happily) quite contagious.

Published by:
Amherst Media, Inc.
P.O. Box 586
Buffalo, N.Y. 14226
Fax: 716-874-4508
www.AmherstMedia.com
Publisher: Craig Alesse

Editorial Assistance: Carey Maines, John S. Loder

ISBN-13: 978-1-58428-222-8
Library of Congress Control Number: 2007926857

Printed in Korea.
10 9 8 7 6 5 4 3 2 1

CONTENTS

1-bit. A pixel with a bit depth of 1 (2^1) and, therefore, 2 possible values.

2-bit. A pixel with a bit depth of 2 (2^2) and, therefore, 4 possible values.

A 2-BIT IMAGE (4 POSSIBLE COLOR VALUES).

2-D. *See* two-dimensional.

3-bit. A pixel with a bit depth of 3 (2^3) and, therefore, 8 possible values. Many early home computers with television displays offered 8-bit color.

3-D. *See* three-dimensional.

4/3 sensor. A standard proposed by Olympus and Kodak for a universal digital SLR system with a CCD image sensor having a 4:3 aspect ratio.

4-bit. A pixel with a bit depth of 4 (2^4) and, therefore, 16 possible values.

5-bit. A pixel with a bit depth of 5 (2^5) and, therefore, 32 possible values.

6-bit. A pixel with a bit depth of 6 (2^6) and, therefore, 64 possible values.

8-bit. A pixel with a bit depth of 8 (2^8) and, therefore, 256 possible values. Most Lab, RGB, grayscale, and CMYK images contain 8 bits of data per color channel.

AN 8-BIT IMAGE (256 POSSIBLE COLOR VALUES).

12-bit. (1) A pixel with a bit depth of 12 (2^{12}) and, therefore, 4,096 possible values. (2) An image that has three 4-bit channels. Sometimes used in small devices with color displays.

15-bit. An image that has three 5-bit channels combined to create 32,768 possible values. Also called high color.

16-bit. An image that has one 6-bit and two 5-bit channels combined to create 65,536 possible values. Also called high color or, on Macintosh systems, "thousands of colors."

18-bit. An image that has three 6-bit channels combined to create 262,144 possible values. Used on some LCD monitors to achieve faster transition times with minimal color sacrifice.

18 percent gray. *See* middle gray.

24-bit. An image that has three 8-bit channels combined to create 16,777,216 possible values. Also called true color or, on Macintosh systems, "millions of colors."

A 24-BIT IMAGE (MILLIONS OF POSSIBLE COLOR VALUES).

32-bit. A 24-bit image with an additional 8 bits of data added either as empty padding space or to represent an alpha channel. Used in Photoshop for HDR imaging.

35mm equivalent focal length. On digital cameras, a standardized format for describing the effective focal length of a lens. This eliminates the need to account for the widely differing sizes of digital-camera image sensors when determining the field of view a lens will provide. This is sometimes referred to simply as the "equivalent" focal length or the "effective" focal length. *See also* focal length.

35mm film. The roll film format most commonly used in still photography. The photographic film is cut into strips that are 35 millimeters wide with six perforations per inch (4.23mm per perforation) along both edges. Also called 135 film.

45-degree lighting. *See* Rembrandt lighting.

85-series filter. *See* Wratten numbers.

110 film. (1) An early 4x5-inch roll film discontinued in the late 1920s. (2) A 13x17mm cartridge film introduced in 1972 for Kodak's Pocket Instamatic series.

120 film. A format of roll film used by many medium-format cameras. Introduced by Kodak for their Brownie No. 2 in 1901, it remains popular with professional and advanced amateur photographers. The film is 72cm long and bears frame number markings for the three standard image for-

35MM FILM.

120 FILM.

mats (*see* medium format) on the backing paper. Because it is supplied on a thicker spool than the similar 620 film it has been referred to as "large hole." *See also* 220 film *and* 620 film.

135 film. *See* 35mm film.

220 film. Introduced in 1965, 220 film is the same width as 120 film but double the length (144cm), yielding twice the number of possible exposures per roll. Because there is no backing paper behind the film itself, just a leader and a trailer, 220 film cannot be used with red-window frame indicators. Also, since the film is thinner than a film with a backing paper, a special pressure plate or different film back may be required.

240 film. Cartridge film used in APS cameras.

620 film. A roll film introduced by Kodak in 1931 as an alternative to 120 format. It is essentially the same film on a thinner spool with a narrower flange. For this reason, it is sometimes called small hole film.

645 format. A type of camera that uses 120 film to shoot images with frames that measure 6x4.5cm.

802.11b wireless networking. *See* Wi-Fi.

1951 USAF resolution test chart. *See* USAF 1951 resolution test chart.

A. *See* aperture priority mode.

Å. *See* Angstrom.

Aarons, Slim. *See* appendix 1.

A/B. Alternately viewing two photographs to determine which is best.

Abbe number. In optics, a measure of a material's dispersive quality (the variation of refractive index with wavelength). Synonymous with V-number and constringence.

Abbott, Berenice. *See* appendix 1.

aberration. An optical defect in a lens that results in a photograph that is unsharp or otherwise distorted. *See also* barrel distortion, chromatic aberration, coma, field curvature, pincushion distortion, *and* spherical aberration.

abrading tool. A needle used in traditional retouching to remove pinholes and other opaque spots on a negative.

absolute colorimetric rendering intent. Converts out-of-gamut source colors to the closest in-gamut colors of the destination color space. Changes the white value in the destination color space to the white value in the source color space.

absorption. The assimilation of some or all wavelengths of light by the surface it strikes. This is a key factor in our percep-

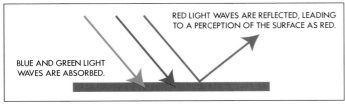

RED LIGHT WAVES ARE REFLECTED, LEADING TO A PERCEPTION OF THE SURFACE AS RED.

BLUE AND GREEN LIGHT WAVES ARE ABSORBED.

ABSORPTION.

tion of color. Many photographic filters also function on this principle by allowing only select wavelengths of light to pass through them to the film or image sensor.

abstract color space. *See* color space, device independent.

Abstract Expressionism. *See* appendix 2.

abstract photography. Capturing images with little or no attempt at pictorial representation (e.g., to depict a person or scene). Instead, lines, colors, and textures are emphasized.

accelerator. An alkaline chemical component of certain developers that hastens the action of the developer.

accent light. Any light that supplements the main and fill light(s) and is used for special effect (e.g., a hair light, which is used to highlight the hair and create separation between the subject and background).

acceptance angle. The measurement of the maximum spread of light that is read by an exposure meter.

accessory lens. A simple lens that can be attached to a camera lens to change its focal length, making it either more wide-angle or more telephoto. These are most commonly used to extend the limited zoom range on point-and-shoot cameras.

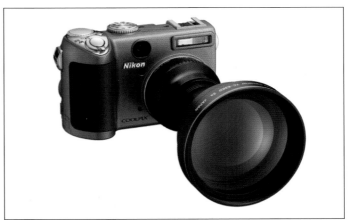

CAMERA WITH ACCESSORY LENS ATTACHED. PHOTO COURTESY OF NIKON.

accessory shoe. Metal or plastic fitting found on the top of a camera that supports a flash unit or other accessory. Synonymous with hot shoe.

accreditation. Professional certification achieved by meeting the standards set by a professional photographic organization (*see* appendix 3).

AC/DC. A designation that signifies an electrical device can be operated on an alternating or direct current.

ACE. *See* Adobe Color Engine.

acetate base. *See* acetate film.

acetate decay. The degradation of an acetate film base. This can result in distortion, shrinkage, and brittleness, as well as a vinegar-like odor.

acetate film. A type of photographic film featuring a fire-resistant, slow-burning base. Also called safety film. *Contrast with* celluloid.

acetic acid. A colorless, pungent liquid acid that is used in some developers in lieu of hydroquinone, which can be toxic to the operator and environmentally harmful.

acetylene. An explosive gas used in magic lanterns and early enlargers as a source of illumination.

achromatic. A tone devoid of hue, such as black, white, or gray. *Contrast with* chromatic.

achromatic lens. A lens comprised of a variety of glasses, each with differing focal powers, used to ensure an image free from the effects of chromatic aberration.

acid. A substance with a pH below 7. In the darkroom, a stop bath (acid) neutralizes the developer to halt the processing of the image. *Contrast with* alkali.

acid fixing bath. A fixer containing sodium thiosulfate and citric or tartaric acid popularly used for processing silver gelatin bromide plates and papers.

acid-free paper. Paper that contains no acidity or acid-producing chemicals, so that it resists deterioration from age. Synonymous with alkaline paper, archival paper, neutral pH paper, and permanent paper.

acquire. To download or retrieve a file from another device (e.g., a memory card, scanner).

Acrobat. *See* Adobe Acrobat.

acrylic diffuser. Semiopaque sheet of white acrylic placed between the light source and subject to evenly and softly diffuse the light.

acrylic resin. Filters that, unlike gelatin and polyester filters, do not need to be one solid color; they can be manufactured with clear areas graduating to color, or one color graduating into another. Acrylic resin filters are also very durable and lightweight for their size.

actinic. Electromagnetic radiation capable of initiating photochemical reactions or the fading of pigments. Because ultraviolet radiation strongly affects the photochemical processes, the term has come to be almost synonymous with ultraviolet, as in "actinic rays."

actinic focus. The point at which a lens brings actinic rays into focus. On a modern, fully corrected lens, actinic and visual focus coincide. Also called chemical focus.

actinometer. A light-measuring device used when making prints via gum or carbon methods, where visual analysis of the progress of the print during exposure was impossible.

action. In Photoshop, a series of automated commands used to process one or more image files. *See also* droplet.

action finder. An eye-level viewfinder that allows for a full-field view from a distance of 2–3 inches. Useful in sports photography and copy work.

action mode. *See* sports mode.

action photography. The photographic capture of moving objects. *See also* sports mode.

activator. A chemical agent used to trigger or enhance the action of the developer.

active autofocus. A system employed by digital cameras to determine the focus target and achieve sharp focus. When the shutter button is lightly pressed, a beam is emitted from the front of the camera. This is reflected back to the camera once it bounces off of a solid object, and the camera determines the angle from which the beam was reflected to calculate the distance of the subject and select the proper focus setting. *Contrast with* passive autofocus.

acuity. A measure of the visual perception of detail.

acutance. The density gradient across an area separating light and dark tones. A sharp gradient gives viewers the impression of a sharper image and more detail, while lack of focus is perceived in an image with a wider, softer gradient.

Adams, Ansel. *See* appendix 1.

Adams, Edward T. (Eddie). *See* appendix 1.

adapter. An accessory that allows normally incompatible elements to work together.

adaptive color. A method by which the file size of a digital image is reduced by limiting the number of colors in the image to those in a table comprised only of the most commonly occurring colors.

adaptive color balance. *See* automatic white balance.

ADC. *See* analog-to-digital converter.

AD converter. *See* analog-to-digital converter.

additive colors. *See* primary colors.

additive primary colors. *See* primary colors.

addressable resolution. The highest possible resolution signal a device can display.

ADF. *See* automatic document feeder.

adhesive. Natural gums, animal glues, starches, and natural rubber used to affix photos to matboards.

adjustable-focus lens. A lens that can be set to achieve sharp focus at a variety of camera-to-subject distances.

adjustment layer. In Photoshop, a function that applies color and tonal adjustments to the image without permanently changing pixel values. These adjustments are stored in the adjustment layer and apply to all the layers below it.

Adobe Acrobat. A software series that allows users to create portable document format (PDF) files and then view and print them using Adobe Reader.

Adobe Bridge. A program bundled with Photoshop offering various image-viewing and organizational tools.

ADOBE BRIDGE.

Adobe Camera Raw. Program bundled with Photoshop that allows you to import raw files from a wide variety of cameras, apply adjustments to the files, and open them in Photoshop.

ADOBE CAMERA RAW.

Adobe Color Engine (ACE). The color engine designed for Adobe's Creative Suite of applications.

Adobe DNG (Adobe Digital Negative). An archival file format for the raw image data from a digital camera. Designed by Adobe as a way to increase file compatibility, decrease the variety of proprietary camera raw file formats, and ensure that photographers can access their files despite changing technologies. Commonly denoted by the extension *.dng.

Adobe Illustrator. A vector-based drawing program developed and marketed by Adobe Systems and used for creating and designing artwork such as logos, illustrations, etc.

Adobe Photoshop. The industry's leading image-editing program, typically used by photographers to refine the technical aspects of a digital image and introduce creative effects.

Adobe Photoshop Elements. A "little brother" of Photoshop, this program offers most of the functionality of Photoshop at a lower price point, making it a perfect choice for serious amateur photographers.

Adobe RGB (1998). A color space designed to encompass most of the colors available on CMYK printers, allowing for the printing of a wide range of colors that cannot be reproduced in other color spaces.

advance. Tendency of a tone or color to gain visual prominence in a composition.

Advanced Photo System (APS). A film technology that offers photographers three format options—classic (C), high definition (H), or panoramic (P), depending on the photofinishing.

C format: 25.1x16.7mm; aspect ratio 3:2 (equivalent to a 35mm film image); 4x6-inch print
H format: 30.2x16.7mm; aspect ratio 16:9; 4x7-inch print
P format: 30.2x9.5mm; aspect ratio 3:1; 4x12-inch print

advertising photography. *See* commercial photography.
AE. *See* automatic exposure mode.
AE lock. *See* automatic exposure lock.
aerial fog. Non-image-forming density on photographic media that results when developer is oxidized by air. This can re-sult if an image is repeatedly taken out of the developer during processing.

aerial perspective. A phenomenon characterized by a loss in the intensity of color, tone, and outline of objects due to the dispersion of light by atmospheric particles.

aerial photography. The practice of capturing images from an aircraft for artistic or scientific purposes.

AF. *See* automatic focus.
AF assist lamp. *See* automatic focus assist lamp.
AF lock. *See* automatic focus lock.
afocal lens. An attachment that alters the focal length of the lens without disturbing the distance between the lens and the film plane.
AF servo. *See* automatic focus servo.
Agfa. A company that develops, manufactures, and distributes analog and digital products and systems used for creating, processing, and reproducing photographs.

agitation. A darkroom term that refers to the movement of a processing liquid over the material that is being processed (e.g., the inversion of the developing tank or the movement of the tray to ensure constant movement of the fluids) so that fresh chemicals come in contact with the negative, film, or print.

AI. The native file format of Adobe Illustrator.

air bells. Tiny bubbles caught in the binder of photographic plates or papers. Usually removed with a brush or toothpick.

air brush. (1) A pneumatic device that sprays a fine mist of liquid pigments or dyes. Used in overpainting and retouching. (2) In Photoshop, a brush setting that applies gradual tones to an image, simulating traditional airbrush effects.

AI servo. The predictive autofocus system developed by Canon. The name stems from the use of artificial intelligence to predict the speed and distance of a moving subject. The feature greatly increases the likelihood of getting a sharp image of the moving target. *Contrast with* one-shot.

alabasterine process. An improvement over the wet collodion process that used plates bleached with bichloride of mercury, making the positive image easier to see.

albertype. A photomechanical collotype process developed by Josef Albert.

album. A bound volume or book of photographs. Some feature pages onto which photographs are fixed. In other albums, images are printed onto blank pages that are then collected and bound. Still other albums feature open mats into which prints are inserted.

ALBUMS. PHOTO COURTESY OF KODAK.

albumen. A slightly yellow, transparent fluid made from animal or vegetable proteins (often egg whites) historically used as a binder for silver halide emulsions, for making lantern slides and stereo transparencies, and as a coating for photographic papers.

albumen paper. A printing paper developed in the mid-19th century that was brushed with albumen prior to sensitization. The process resulted in a whiter base and improved highlights. *See also* dilute albumen print.

alcohol. Organic liquid used in the preparation of photographic emulsions and developers. Also used for cleaning and drying photographic materials. *Synonymous with* aqua vitae.

algorithm. A procedure that allows for a step-by-step solution to a problem.

aliasing. Jagged diagonal lines sometimes apparent between two colors in a digital image, caused by the square shape of the pixels. Aliasing can often be prevented by shooting at a higher resolution or by applying anti-aliasing software settings.

ALIASING.

alkali. A substance with a pH greater than 7. A developer is an alkali substance. In the darkroom, development of film or paper is halted using a stop bath (acid).

alkali paper. *See* acid-free paper.

alpha channel. A grayscale version of an image that can be used to store selections and masks. *See also* channels.

alternative processes. Non-silver-based photographic processes not commonly used by contemporary photographers. Often, these are based on early methods of exposing and printing images.

aluminum chloride. A yellowish-white powder sometimes used in gold and platinum toning.

aluminum potassium sulfate. *See* alum, potassium.

alum, potassium. White crystal used to harden gelatin emulsions and as a clearing bath to remove developer stains from negatives. Also known as aluminum potassium sulfate.

Alvarez Bravo, Manuel. *See* appendix 1.

ambient light. Light present in the environment that is not subject to direct control by the photographer. Synonymous with available light and existing light.

ambrotype. A photographic process most popular from about 1851 to 1880 in which a photograph was made by exposing a glass plate treated with light-sensitive wet collodion. The image produced was whitish in tone but when placed over a black opaque surface (paper or paint) appeared as a positive. Portraits of this type were often handcolored.

American National Standards Institute (ANSI). Group responsible for setting standards for film dimension, chemical purity, processing methods, etc. Formerly called the American Standards Association (ASA). *See also* ISO *and* ASA system.

amidol. A reducing agent that works at low pH values.

ammonium bromide. Colorless crystals soluble in ether, alcohol, and water and used as a restrainer in alkaline developers.

ammonium chloride. Crystals used as a halide in albumen paper, gelatin emulsion, and other processes.

ammonium dichromate. An alternate and more sensitive chemistry, used in place of potassium dichromate, for sensitizing gelatin, albumen, gums, and other colloids used for pigment processes.

ammonium iodide. A water- and alcohol-soluble chemistry frequently used as a halide in collodion formulas, especially when it was needed immediately.

ammonium nitrate. Crystals soluble in water, alcohol, and alkalines used as a substitute for potassium nitrate in making flashlight mixtures.

ammonium thiocyanate. An ingredient in gold toning formulas. Also used in a 5 percent solution for dissolving gelatin in overexposed carbon prints.

amp. Short for ampere.

ampere (A). A unit used to measure an electrical current or the flow of electrical current.

amphitype. A unique printing process used to produce rich prints that can be viewed from both sides of the paper or as a transparency.

amplitude. (1) The size dimension of a waveform, normally shown on the vertical plane of a graph. The size represents the strength of the unit being measured. (2) The strength of an analog signal. In digital imaging, this is the voltage level that represents a brightness of a particular image point.

anaglyph. A picture consisting of two images of the same subject, captured from two slightly different angles, in two complementary colors. Viewed through colored spectacles, the images appear to merge, producing a three-dimensional sensation.

analog. Continuous, nondiscrete data. *Contrast with* digital.

analog-to-digital-converter (ADC). An electronic device that samples a source signal at regular intervals and converts the analog voltage (a continuously varying signal) to discreet digital values, represented in binary code.

analyzer. A device used in color printing to determine proper color filtration.

anamorphic lens. *See* cylindrical lens.

Andreev, Nicolai. *See* appendix 1.

angle of acceptance. The number of degrees within which a reflected light meter effectively receives and responds to light.

angle of convergence. The angle formed by the lines of sight of a viewer's eyes when gazing at a close object.

angle of incidence. The angle that is formed between a ray of light striking a surface and the normal (a line perpendicular to the surface). This equals the angle of reflection.

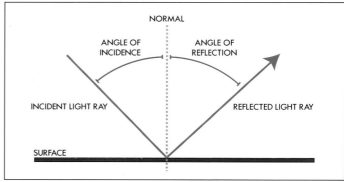

ANGLE OF INCIDENCE AND ANGLE OF REFLECTION.

angle of reflection. The angle formed between a reflected ray of light and the normal (a line perpendicular to the reflecting surface). This equals the angle of incidence. Also called the glare angle.

angle of refraction. The angle formed between a refracted light ray (one that has been bent at the bounding surface) and the normal to this surface (a line perpendicular to the surface).

angle of view. The area of the scene as observed through the lens or viewfinder, or as measured by a light meter.

angle viewfinder. *See* right-angle viewfinder.

Angstrom (Å). A unit of measure equal to .1 nanometer.

anhydrous. A term used to indicate that a substance does not contain water, helping photographers distinguish chemistries in a crystalline versus hydrated form.

aniline. An oil that serves as a base for many dyes used to increase the sensitivity of emulsions.

Ansco. An early manufacturer of photographic films that was Kodak's only domestic competitor until 1981.

ANSI. *See* American National Standards Institute.

anthotype. An alternative photographic process developed by Sir John Hershel in the 1840s. The "emulsion" is made of the pigments of berries, leaves, and flowers, combined with denatured alcohol and strained through cheesecloth. Paper is coated with the emulsion, contact printed with a transparent positive image, and exposed in sunlight for two to three weeks.

anti-aliasing. Software used to reduce the jagged lines (aliasing) that appear where two colors in an image meet. In graphics programs, this is often a text setting.

LEFT—WITHOUT ANTI-ALIASING. **RIGHT**—WITH ANTI-ALIASING.

anti-fog coating. A covering on optical devices used to discourage condensation.

anti-halation layer. In photographic film, a light-absorbing layer added to the back of the medium, between the emulsion and base, or integral to the base to prevent light from reflecting back into the photosensitive layer.

anti-reflection coating. A thin, transparent material applied to a lens surface to reduce reflection and flare and improve contrast and lens speed.

antiseptic. An additive (often oil of clove, cinnamon, or wintergreen) used to prevent decay in gelatins and starch-based pastes used to mount prints.

anti-shake. An image stabilization technology in which the CCD is mounted on a platform that moves in the opposite way as the movement of the camera. This facilitates photographing moving subjects in low light conditions by panning and/or when using long focal lengths.

anti-static brush. A tool used to remove dust particles from negatives and slides prior to scanning.

anti-static coating. A coating applied to image sensor surfaces that prevents dust particles from clinging to the sensor.

antivirus. Software used to detect and rid the computer of harmful programs that may damage software or data. *See also* virus *and* worm.

AP-70 process. *See* C-41 process.

aperture. An opening (diaphragm) in a light-blocking plate that allows light to strike the film or image sensor. The term also refers to the diameter of the opening, which is measured in f-stops. *See also* f-stop *and* diaphragm.

aperture priority mode. An exposure mode in which the photographer selects the desired aperture and the camera automatically selects a shutter speed that will produce a proper exposure. Typically designated by the letter A or the letters Av.

aperture ring. A ring on the the lens that is mechanically linked to the diaphragm to control the size of the aperture. F-stops engraved on the ring allow the desired aperture to be set.

aperture value (Av). (1) An f-number setting. (2) On some cameras, Av indicates the aperture-priority mode setting.

apochromatic (APO) lens. Lens designed to eliminate chromatic aberration when shooting with a long focal length. Some lenses are designed to correct aberration for red and blue, while other higher-quality lenses are designed to correct for red, blue, and green, bringing all colors to a common focus and eliminating color fringing at all but the longest focal lengths. These lenses are made of glass with special dispersion properties.

Apple. A company known for its Macintosh line of computers, software, and consumer electronic devices.

Apple ColorSync. The color management system built into Apple's Macintosh operating system, which is supported in all major graphic arts programs.

Apple RGB. An early RGB working space designed to reflect the characteristics of the Apple standard 13-inch monitor. Apple RGB was widely used before the introduction of standard working spaces like Adobe RGB (1998).

applet. A small program, often written in Java, that allows for the viewing of simple animation on a web page.

application. Software designed to allow the user to perform a specific task, such as image editing. Synonymous with program.

APS. *See* Advanced Photo System.

aqua fortis. A weak nitric acid.

aqua regia. A one-part nitric acid, two-part hydrochloric acid chemistry used in the preparation of gold chloride.

aquatint. *See* gum bichromate.

aqua vitae. *See* alcohol.

Arbus, Diane. *See* appendix 1.

Archer, Frederick Scott. *See* appendix 1.

architectural photography. The art and science of photographing buildings, typically using special equipment that allows for perspective correction.

archival paper. *See* acid-free paper.

archival stability. Term that refers to the span of time that a negative or print can be expected to remain free from the effects of degradation by chemicals or of the environment in which it is stored or displayed.

archival washer. A multi-slot device that holds fixed prints and circulates fresh, clean water around them to thoroughly clean the photographs. The contaminated water is diverted to a drain.

archive. Long-term, stable storage of digital image files, prints, negatives, or transparencies.

arc lamp. A photographic lamp in which electrical current arcs across two electrodes, providing an intense light source commonly used when creating photographic copies of negatives, transparencies, and prints.

area coverage. The angle of view and magnification of a lens. The larger the area coverage, the lower the magnification and the smaller the subject is recorded in the scene. The area coverage for any given lens is directly proportional to the subject's distance from it (i.e., doubling the distance to the subject doubles the area coverage). Area coverage may also be an inherent consequence of the lens design; wide-angle lenses have greater area coverage than telephoto lenses, for example.

argentometer. A device used to measure the strength of silver baths. Essentially, a hydrometer calibrated to measure the silver grains in a solution of silver nitrate.

aristotype. (1) A collodion-chloride printing-out paper manufactured by the Aristotype Company. (2) Name given to gelatin chloride printing-out paper.

array. The configuration of photoreceptors in an image sensor. These may be of two types: (1) arranged side by side in a grid pattern (called mosaic, matrix, grid, or wide array) or (2) a single row or set of three rows of sensors (called a linear array).

arrowtype. A fine white powder soluble in water and used for sizing hand-coated papers and as a binder for various halides.

Art Deco. *See* appendix 2.

art history brush tool. In Photoshop, a tool used to paint with stylized strokes, using the source data from a specified history state or snapshot. *See also* history brush tool.

ART HISTORY BRUSH TOOL. BEFORE (LEFT) AND AFTER (RIGHT).

artifact. An undesirable distortion or flaw that appears in a digital image as a result of inaccurate information introduced during capture or compression. Artifacts may take the form of new, unwanted data or the degradation of existing content. Typ-

ically, these changes are caused by the digital camera or the way the digital camera encodes the picture.

ENLARGEMENT OF GRID-PATTERNED ARTIFACTS RESULTING FROM EXCESSIVE JPEG COMPRESSION.

artificial daylight. A man-made light source that approximates the color temperature of daylight.

artificial light. Light that comes from a source other than the sun. Generally refers to the illumination provided by light units set up by the photographer.

artigue process. An improvement over the carbon process, used to produce prints with a velvety matte surface, full tonal range, and shadows with full detail.

artist's statement. A written description of the photographer's intention/motivation in producing a body of photographic work. This often accompanies fine-art portfolios and images displayed in galleries.

art photography. *See* fine art photography.

ASA. *See* American National Standards Institute.

ASA system. Created by the American Standards Association (now called the American National Standards Institute), a rating system describing the sensitivity of film to light. Now superceded by the ISO system.

ASCII (American Standard Code for Information Interchange). The standard character-coding scheme used in data transmission and to display letters, numbers, and characters.

aspect ratio. The ratio of height to width in a photograph, monitor screen, or page.

asphalt. Derived from decomposed vegetable matter, a brownish-black, somewhat light-sensitive substance used in the heliograph process and to produce acid-etched copper and pewter plates. Also known as bitumen or bitumen of Judea.

aspheric lens. A lens with one or more nonspherical surfaces. Such lenses have better optics and correct common aberrations but are more difficult to produce and are often higher priced.

astigmatism. A lens defect that causes vertical and horizontal lines in an image to be pictured at different focal positions.

astrophotography. The photographic capture of extraterrestrial objects such as the sun, moon, stars, planets, etc.

asymmetrical lens. A lens with different focal lengths at the entrance and exit pupils.

asymmetry. A subject or composition having elements that are arranged differently on each side of an imaginary midline.

Atget, Jean-Eugène-Auguste. *See* appendix 1.

atmospheric haze. A condition characterized by the scattering of the sun's light by particles suspended in the envelope of gasses surrounding the earth. Results in a low-contrast rendition of distant objects and a bluish cast. *See also* haze filter.

atomic weight. The standard method for weighing different elements. Useful when substituting one halide for another.

attachment. A digital image file, often at a low resolution, sent with an e-mail. Opening the file generally requires software other than the web browser or mail program.

audiovisual. An image presentation comprised of both sound and visual components. Often used in slide shows.

audiovisual (AV) cables. A trio of color-coded cables that connect two devices (e.g., a camcorder and a television). The cables plug into three sockets; one carries the picture and two are for stereo sound.

aurin. A nonactinic, red coloring medium used to treat fabrics for use on windows and doors in darkrooms. Also used as an antihalation layer on the backs of collodion and silver bromide gelatin plates.

autochrome lumière. An additive color screen plate process. This was the predominant color photography process until Kodachrome was introduced in 1935.

autofocus (AF). *See* automatic focus.

automatic backlight control. A camera technology that detects backlit subjects and automatically increases exposure to produce an acceptable image of the subject. This may result in overexposure of the background.

automatic bracketing. A feature available in some cameras that allows for the automatic capture of three or five images with the exposure varied up or down for each photograph. This helps ensure that at least one image will be well exposed.

AUTOMATIC BRACKETING.

automatic document feeder (ADF). A component of some scanners that allows for the automatic feeding of pages, one at a time, allowing for the scanning of multiple pages.

automatic exposure. *See* automatic exposure mode.

automatic exposure (AE) lock. A feature that allows the photographer to lock the aperture and shutter speed settings over a series of images. This is particularly helpful when creating images to be combined into a panorama using image-stitching software.

automatic exposure (AE) mode. A camera setting that allows the camera to automatically adjust the aperture, shutter speed, or both to produce an accurate exposure.

automatic flash. A mode in which the camera measures the light falling on the scene and automatically fires the flash in low light. Typically employed by point-and-shoot cameras.

automatic focus (AF). A feature of some camera systems that allows them to achieve and maintain sharp focus on a target by activating sensors and a motor. The system produces accurate results more quickly than the manual focus option. *Compare with* manual focus, continuous autofocus, *and* single autofocus.

automatic focus (AF) assist lamp. A small, limited-range lamp located beside or above the lens barrel on some cameras that illuminates the subject you are focusing on when shooting in low light.

automatic focus (AF) lock. A feature that allows the photographer to focus on a subject by pointing the camera directly at it, then maintain that focus while recomposing the image as desired.

automatic focus (AF) sensor. A camera component that collects data used to control an electromechanical system that adjusts the focus of the lens. Many systems utilize multiple sensors. Most modern SLRs feature through-the-lens (TTL) sensors that double as light meters. *See also* electronic rangefinder.

automatic focus (AF) servo. On SLRs, a feature that allows the photographer to continuously focus on a moving subject. This is a handy feature in sports and wildlife photography.

automatic thyristor. *See* thyristor.

automatic white balance (AWB). A digital camera setting that automatically adjusts the white balance in order to neutralize color casts and record color as it is seen by the human eye. Synonymous with adaptive color balance.

auto-portrait. *See* self-portrait.

autostereogram. *See* stereogram.

auto trace. A feature found in Adobe Illustrator and other similar programs used to trace a scanned image and convert it to an outline or vector format.

AWB

AUTOMATIC WHITE-BALANCE ICON FOUND ON MANY CAMERAS.

auxiliary exposure. A controlled amount of light allowed to fall upon photosensitive material before or after it is exposed to the main image-forming light. Used to affect the contrast or density in the image.

Av. (1) *See* aperture priority mode. (2) *See* aperture value.

available light. *See* ambient light.

AV cables. *See* audiovisual cables.

Avedon, Richard. *See* appendix 1.

average scene brightness. *See* middle gray.

averaging. *See* matrix metering.

AWB. *See* automatic white balance.

axis lighting. In portraiture, a lighting setup in which the main light is placed in line with the subject's nose (which forms the "axis" of the face) so that it strikes both sides of the face equally. This is also called on-axis lighting. *Contrast with* off-axis lighting.

azo dye. Stable chemical compounds with strong and pure colors—red, orange, and yellow—used as dyes and often employed in camera filters and integral tripack dye-bleach materials.

B. (1) *See* bulb mode. (2) *See* blue.

baby holder. A chair or device used to securely prop up or pose a baby for portraiture, allowing the infant to be photographed alone.

baby spot. A 500- to 1000-watt Fresnel light.

backdrop. The material against which a subject is photographed. Sometimes used synonymously with background.

back focal length. The distance from the rear surface of the lens to its focal point for a subject at infinity.

background. The area that falls behind the main subject, relative to the camera position. *See also* backdrop.

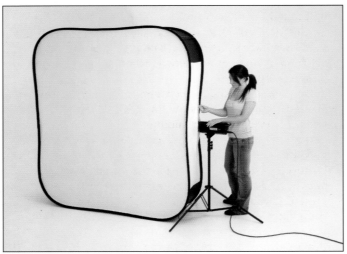

AN ILLUMINATED WHITE BACKGROUND FOR HIGH KEY PHOTOGRAPHY.
PHOTO COURTESY OF LASTOLITE.

background color. In Photoshop, the color used to make gradient fills and to fill in erased portions of an image. The default color is white, but photographers can select and apply a custom background color.

background eraser tool. In Photoshop, a tool that allows you to erase pixels to transparency, eliminating the background while maintaining the edges of foreground objects. Sampling and tolerance settings can be changed to control the effects. *See also* eraser tool *and* magic eraser tool.

background light. A light source used to illuminate the area behind the subject. This often helps to visually separate the subject from the background.

background paper. Large rolls of paper, available in a wide variety of colors, suspended from the ceiling or using freestanding poles and used as a backdrop. Also called seamless paper.

background stand. A system of poles and crossbars used to support a studio backdrop.

backing. (1) A chemical layer applied to film that absorbs light that passes through the emulsion. *See also* anti-halation layer. (2) A supportive component of film used to discourage curling. (3) Paper attached to roll film to protect against light fogging the film during loading and exposure.

backlight. Light source that illuminates the far side of the subject and points toward the camera. This causes the front of the subject to appear in shadow, and may result in underexposure or silhouetting. Also called contra jour. *See also* rim lighting.

BACKLIGHTING.

backlight compensation. An exposure adjustment made to prevent the underexposure of a subject that is illuminated from behind. This may result in the background being overexposed.

backscatter. In underwater photography, a phenomenon that occurs when particulate matter is illuminated by flash.

back up. To make one or more copies of a digital image file, folder, disc, etc., to protect against damage or loss.

baffle. A wall, block, or deflector placed to dissipate energy.

bag bellows. A wide, nonpleated bellows used on large-format cameras when working with wide-angle lenses.

bain marie. A heated water bath used to develop albumen plates and in the carbon printing process. Two trays are set up like a double boiler so that the upper tray of water never boils.

Bakker's saddle. A compositional guideline named for Gerhard Bakker. Similar to the golden mean, Bakker's saddle is based on a diagonal line from the top-left corner of the image to the bottom-right corner. A second line, perpendicular to the first, extends to the top-right corner. This creates a "saddle" where the subject is ideally placed.

balancing elements. Components in the scene that are included to create a sense of visual equilibrium in the composition.

ball head. A mounting device used on tripods or monopods that allows the camera to be pointed or tilted in any direction.

balsam. A sticky fluid from trees and plants historically used in adhesives to cement lens ele-

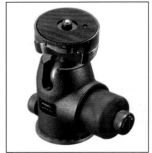

BALL HEAD.
PHOTO COURTESY OF MANFROTTO.

ments. Also used in asphalt varnishes and applied to salted paper and albumen prints to make them translucent for crystoleums and ivorytypes.

banding. A phenomenon in which continuous tones or gradients are broken into discrete colors or shades because an image or output device does not contain or support a full range of tonal levels. In capture, the problem can be solved by shooting at a higher resolution. *See also* posterization.

LEFT—BANDING IN THE SKY. RIGHT—IMAGE WITHOUT EVIDENT BANDING.

bandpass filter. An accessory that allows high transmission of a portion of the light spectrum and high absorption of the wavelengths on either side of that band.

B+W. Manufacturer of photographic filters.

bandwidth. (1) The measure of the range of wavelengths that a filter transmits. (2) The data-transmission capacity of a system.

bank light. A cluster of lights used as a single large light source.

Barbizon School. *See* appendix 2.

barebulb. A light source used without a reflector or other light modifier. The quality of light produced by a barebulb source is characterized by harsh shadows and high contrast.

barium glass. A type of glass with a high refractive index and fairly low dispersion.

barium sulphate. A powder used as a preliminary coating for raw photographic papers, producing a smooth white surface and acting as a barrier between the paper and emulsion.

Barlow lens. A diverging lens located between the prime lens and camera that works with other optics in the system to effectively increase focal length. *See also* teleconverter.

Barnack, Oskar. *See* appendix 1.

barn doors. An adjustable light modifier used on spotlights and flood lamps to control the direction and width of the beam.

barrel. The metal or plastic housing that contains the optical components of a lens.

barrel distortion. A lens aberration that causes straight lines at the edge of a frame to bow toward the center of the image, producing a barrel shape. *Contrast with* pincushion distortion.

barrier filter. An accessory used in fluorescence photography to absorb all excitation light and transmit only fluorescence from the subject. *See also* excitation light.

baryta. Barium sulfate, a component of the coating used to create the white surface of light-sensitive printing papers.

base. A sheet of material that supports photosensitive layers in photographic film, paper, and plates. Synonymous with support.

baseboard camera. A medium- or large-format camera featuring a foldout component that serves as a base and supports the lens board and bellows.

bas relief. A term used to describe an image with raised areas, commonly seen in carbon and gum printing processes, especially before prints have thoroughly dried.

batch. A quantity of film produced at one time. Selecting films with a single batch number can help reduce color, contrast, and speed variations. Synonymous with emulsion number.

batch process. In image-editing programs, an automated process that allows an action to be applied to a group of images.

bath. A general term used to refer to film processing and printing chemistries.

battery. Device that stores and provides electrical power to cameras and other devices. *See also* lithium ion battery, nickel cadmium battery, *and* nickel metal hydride battery.

BATTERY CHECK.
TOP—FULL BATTERY.
BOTTOM—EMPTY BATTERY.

battery check. An icon on a digital camera's display screen that indicates the amount of battery power remaining.

battery grip. On some DSLR cameras, an accessory that increases the available power by adding batteries to the camera. Also provides a grip for shooting in the portrait orientation.

battery packs. A set of batteries or battery cells configured in a series, parallel position, or both to deliver power to a device.

baud rate. The speed at which data is transmitted. Usually equivalent to bits per second.

Bayer pattern. A mosaic of square filters in green, red, and blue placed upon a grid of photoreceptors in CCDs or CMOSs. The pattern modulates the light that reaches each photoreceptor to provide luminance values that are translated into color information. *See also* demosaicing *and* color filter array.

BAYER PATTERN.

bayonet mount. A tab-and-notch coupling for attaching a lens (or, in some cases, a filter) to a camera. This allows for quick and easy lens changes but is not as secure as a screw mount. *Contrast with* breech mount *and* screw mount.

BCPS. *See* beam candlepower/seconds.

beach mode. A scene mode in which the camera helps achieve the correct exposure when photographing very brightly lit scenes or subjects. Similar to the snow mode on some cameras.

beam. A concentrated group of light rays.

beam candlepower/seconds (BCPS). Measurement of a light's effective intensity, for a period of 1 second, when focused into a beam by a lens or reflector.

beam splitter. Device used to divide a beam of light into one or more smaller beams. Used in autofocus technologies.

beeswax. A natural wax combined with solvents and oils for use as a coating to improve tones in salted prints and other processes. Also used as an atmospheric barrier.

Bellocq, E. J. *See* appendix 1.

bellows. An accordion-like, flexible accessory that connects a camera and lens. This tool allows photographers to move the lens farther from the image plane for close-up photography. In many large-format cameras and some medium-format cameras, bellows are employed for focusing or shift and tilt control. *See also* bag bellows.

bellows extension. The measure of the lens-to-film/sensor plane for a specific photographic scenario.

bellows factor. The exposure compensation required due to the reduction in image illuminance when the camera is focused on closer subjects and the lens-to-film/sensor distance is increased. This is determined by dividing the square of the image distance by the square of the focal length.

benzene. A group of volatile liquid hydrocarbon mixtures used mainly as solvents in film-cleaning products. Also known as petroleum ether. Benzene is carcinogenic, limiting its use.

Bernhard, Ruth. *See* appendix 1.

between-the-lens shutter. A shutter positioned between two lens elements. Popular in the 1920s–1960s, before reflex cameras with focal-plane shutters and cameras with interchangeable lenses dominated the market. These shutters are still used in some medium-format cameras. *See also* leaf shutter.

Bézier curve. A curve that is shaped by anchor points placed along its arc. In vector graphics, Bézier curves outline graphic forms and the characters in typefaces. In Photoshop, a Bézier curve acts as the interface in the curves command, providing an adjustable line that represents the tones in an image and allows them to be modified.

BEZIER CURVE.

bichromated colloid. A viscous substance (e.g., gelatin or albumen) made light-sensitive by the addition of a bichromate (usually potassium bichromate). Bichromated colloids harden during exposure and become insoluble in water; this is the principle behind many of the non-silver-based photographic processes, such as carbon prints, gum bichromate prints, and an array of photomechanical processes.

bichromate process. *See* gum bichromate.

bicolor print. *See* split tone.

bicubic interpolation. Calculation of output pixel values from a weighted average of the nearest sixteen pixels in a rectangular grid (a 4x4 array).

big data. In Photoshop, any portion of a layer that exceeds the physical dimensions of the document.

bi-level image. *See* binary image.

binary image. A digital image that has only two possible values for each pixel, black or white. In Photoshop, a binary image is the same as an image in bitmap mode. Also called a bi-level or two-level image.

binder. A substance (e.g., gelatin) that contains the silver image particles in light-sensitive materials.

binder degradation. The breakdown of the layer of light-sensitive media containing silver image particles.

biological decay. Degradation of photographic materials caused by molds, microscopic organisms, insects, etc.

bit. Short for binary digit, the smallest unit of information handled by a computer. Eight bits make up a byte.

bit depth. A measurement of how much color information is available in each pixel of an image. Greater bit depth means more available colors and more accurate color representation. Also called bits per channel, color depth, or pixel depth.

bitmap file format (BMP). A standard image format on Windows computers. The BMP format supports RGB, indexed color, grayscale, and bitmap color.

bitmap image. Image made of dots, each containing specific information as to its size, color, and position within the image. Also called a raster image. *Contrast with* vector image.

bitmap mode. In Photoshop, an image comprised of only pure black and pure white pixels.

bitmapped font. A set of dot patterns that represent the letters, characters, and digits in a particular font at a particular size.

bits per channel. *See* bit depth.

bitumen. *See* asphalt.

bitumen of Judea. *See* asphalt.

black (K). (1) In printing, an ink color used alone or in combination with other inks. Abbreviated as K to avoid confusion with blue (B). *See also* CMYK. (2) An achromatic color that absorbs almost all incident light.

black & white. Photographs containing only gray tones. May be made using a specialized film emulsion or a specific digital camera mode. Color images can also be converted to black & white using any one of a variety of features in an image-editing program. *See also* black & white mode, grayscale, *and* monotone.

black & white conversion. Creating a black & white image from a color original, often using image-editing software.

LEFT—ORIGINAL COLOR IMAGE. **RIGHT**—IMAGE CONVERTED TO BLACK & WHITE.

black & white mode. A shooting mode found on some digital cameras that allows photographers to capture an image in black & white rather than in color.

blackbody radiator. A theoretical object that absorbs all wavelengths with no reflection and emits energy only as a function of its temperature. A blackbody can be simulated by lining a cavity with carbon, which absorbs light.

black card. Device used to block light from hitting the set or subject.

Black Foil. *See* Cinefoil.

black light. Light from the ultraviolet spectrum used in darkrooms to allow some degree of visibility. Also, a light source used in fluorescence photography.

black mirror. Highly polished black onyx or glass sheet used to previsualize a landscape in black & white, without the distraction of color.

black noise. *See* dark current.

blackout. A loss of electrical power that can lead to the loss of data in a dynamic memory device (e.g., RAM).

blackout cloth/plastic. A lightproof material used to cover windows or doors to create darkness for projecting images or processing and printing film.

black point. The density and color of the darkest black that is reproducible by a device.

black-point compensation. In color management, a software setting that maps the black point of the source profile to the black point of the destination profile.

black spots. Specks on negatives caused by airborne dust particles or foreign material in processing baths. Metallic particles or pinholes in negatives can cause spots on prints.

black varnish. A dark-colored backing used for ambrotypes.

blackwrap. *See* Cinefoil.

Blanquart-Evrard, Louis-Désiré. *See* appendix 1.

bleach. A chemical bath used to convert the black metallic silver that forms a photographic image into a compound such as a silver halide, which can then be dissolved or dyed. Used in many reducing, toning, and color processes.

bleach-back process. Submersing a photographic print in a bleach (reducing) solution to dissolve image silvers and reduce image density. Synonymous with reduction.

bleach fix. A darkroom chemistry that combines bleach and fixer. Used in many color processes.

bleach out. A technique used to produce line drawings from photographic images. The photograph is processed normally, then its outlines are sketched and the black metallic silver image is bleached away to leave a drawn outline.

bleed. A page in a book or album in which the photograph extends to the edges of the page.

blend. To smooth the transition between the boundaries of different areas in a composited image.

LEFT—UNBLENDED EDGES. **RIGHT**—BLENDED EDGES.

blending mode. In Photoshop, a feature used to alter the way pixels on that layer interact with underlying pixels in the image. Synonymous with layer mode.

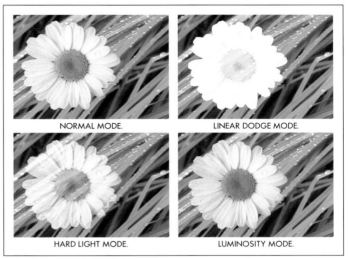

NORMAL MODE. LINEAR DODGE MODE.

HARD LIGHT MODE. LUMINOSITY MODE.

BLENDING MODE.

B light. Short for background light or backlight.

blind. *See* hide.

blister. The expanding and detaching of gelatin or albumen binders from the support material, usually due to overwashing.

blocked up. Shadow areas that lack detail and texture due to underexposure. Also called crushed.

blog. An online journal kept by many photographers to share personal insights, studio events, etc. Short for "web log."

BLOCKED UP SHADOWS.

blonde. A tungsten light rated at 2000 watts.

bloom. (1) In image sensors, the spillover of charge from an overly excited pixel to neighboring pixels. This can produce a loss of detail, inaccurate color, and inaccurate density readings. (2) A defect in a lens coating characterized by an inconsistency in color on the lens surface.

Blossfeldt, Karl. *See* appendix 1.

blotters. Photo-safe absorbent papers between which wet photographic prints are placed to dry after processing.

blown out. Highlight areas that lack detail and texture due to overexposure.

BLOWN OUT HIGHLIGHTS.

blue (B). Light with wavelengths of around 475nm. Blue, with red and green, is one of the three additive primary colors. *See also* RGB *and* primary colors.

blue print. *See* cyanotype.

blue sensitive. All 19th-century silver processes. These were sensitive only to ultraviolet, violet, and blue wavelengths until dye sensitizers were adopted.

blue screen. *See* chromakey photography.

blue toning. (1) A one- or two-bath toning process that, depending on the product used, the paper type, and toning duration, can produce pale tones or deep, saturated colors. The

process has a darkening effect on prints; therefore, prints that will be toned should be made slightly lighter than is generally desirable. (2) In image-editing programs, adding a bluish color cast to a monotone image.

Bluetooth. A radio technology that allows for the wireless transfer of data. Cameras using this technology can transmit images to any Bluetooth-enabled PC, printer, PDA, or cell phone.

blur. (1) Unsharpness that results from poor focus. Considered a technical flaw. (2) Unsharpness from camera/subject movement. Often used to convey a sense of movement. *See also* pan *and* shutter speed. (3) Unsharpness on subjects that fall beyond the depth of field provided by the lens/aperture setting. (4) Loss of definition and a bluish haze that can appear on distant subjects when high amounts of ultraviolet (UV) light are present. (5) An undesirable lack of sharpness caused by resampling. (6) Intentional softening of edges and reduction of detail created using the blur filters in an image-editing program.

BLUR CAUSED BY SUBJECT MOTION.

blur tool. In Photoshop, a tool used to soften hard edges or reduce detail in an image.

BMP. *See* bitmap file format.

body cap. A protective plastic, rubber, or metal cover used to protect the camera's lens mount when no lens is attached.

Bogen. Manufacturer of cameras, lenses, tripods, and more.

boiling. The heating of water to 212°F. Boiling the water surrounding an emulsion kettle increases the particle size and sensitivity in silver bromide gelatin emulsions.

boke. Japanese term used to describe the out-of-focus quality of lenses. For portraits, a soft-edged, rounded blur with the brighter area toward the center is desired. *See also* mirror lens.

bokeh. *See* boke.

bone gelatin. A component of 19th-century emulsions made from animal bones or hides and skins.

boom. An adjustable pole-like arm used to hold lights or lighting accessories.

BOOM ON LIGHT STAND.
PHOTO COURTESY
OF MANFROTTO.

borderless easel. Darkroom accessory used when printing frameless images.

borderless printing. Feature of some printers that allows images to be printed across the paper without a frame, allowing for increased image area.

boudoir photography. A portrait genre in which the subject is shown in a private setting (such as a bedroom) and in an alluring manner. The subject is often seminude (i.e., showing undergarments) or in a pose and composition that implies nudity.

bounce card. A white card used to reflect light from a light source back into the subject, set, or scene.

bounce light. Light that does not travel directly from the source but reflects off of something before hitting the subject.

Bourke White, Margaret. *See* appendix 1.

bracket. A device inserted into the camera's tripod mount and used to secure a flash unit (or other accessory) at a distance from the camera body.

bracketing. Producing multiple images at slightly varying exposures to increase the odds of achieving at least one correct exposure. *See also* automatic bracketing.

Brady, Mathew B. *See* appendix 1.

Brandt, Bill. *See* appendix 1.

Brassaï. *See* appendix 1.

brayer. *See* squeegee.

breech lock mount. A system in which the lens is attached to the camera via a rotating ring that is used to tighten it by friction. *Contrast with* bayonet mount *and* screw mount.

bridal photography. The capture of images of a bride-to-be taken before the wedding date or prior to the ceremony. The portraits are typically intended to showcase details of the bride's appearance, such as the gown, hairstyle, etc.

brightfield illumination. A lighting method in which the backlight is directed through an area of the subject. Used in photomicrography.

bright-line finder. A camera accessory that allows photographers to see a wide view of the scene. A bright line frames the field of view of the lens.

brightness. One of three attributes that comprise color; the other two are hue and saturation. The term refers to the differences in the intensity of light reflected from or transmitted through an image independent of its hue and saturation.

brightness/contrast. In image-editing programs, a simple tool used to adjust overall image brightness and contrast.

brightness range. The tonal difference between the brightest area of an image and the darkest area (i.e., the highest scene luminance minus the lowest scene luminance).

brightness resolution. *See* bit depth.

bright spot. The most brilliant highlight area in an image.

bristol board. A thin card stock made of multiple layers of rag paper and used to mount carte-de-visite (visiting-card) images.

British System (BS). Developed by the British Institute of Standards, a rating system for film speed and sensitivity that employs the scale used in the ASA system. It has been replaced by the ISO rating system.

broadband. *See* wideband.

broad lighting. A style of portrait lighting where the main light is positioned to illuminate the near (broad) side of the sub-

ject's face, projecting the nose shadow onto the opposite side of the face.

brolly. British term for umbrella.

bromide. A halide compound used to produce silver halides. A major component of silver bromide gelatin emulsions. Also used as a restrainer in alkaline developers. *See also* bromine.

bromide paper. Paper coated with a light-sensitive silver bromide emulsion used for black & white printing.

bromine. One of the four halogens employed in silver halide photography. *See also* bromide.

bromoil print. A pigment-process image made by producing an enlargement (preferably with low contrast and no strong blacks) on bromide paper and developing it in an amidol-based developer (though others can be used).

Bronica. Manufacturer of cameras and lenses.

bronze. A color shift that occurred when the silver chloride of printing-out papers was overexposed. The effect was most prominent when high-contrast negatives were printed.

Broughton, Alice. *See* appendix 1.

Brownie, Kodak. An inexpensive camera introduced in 1900 that made photography affordable for the masses. Reached peak popularity from 1952 to 1967, selling millions of units.

KODAK BROWNIE.

brown print. A print with a brown background and white lines produced by contact-printing a negative on sensitized paper. Synonymous with Van Dyke print.

brush development. A method used by Talbot when processing calotypes, designed to limit the amount of developer used on paper negatives. Brushes may also be used to selectively apply developer during platinum printing and with slow-working developers in the silver-bromide printing process.

brush tool. In image-editing programs, a tool that allows users to paint color (or, in some applications, images) onto a photo or blank canvas using brushes of various shapes and textures. Also called a paintbrush tool.

BS. *See* British System.

bucket tool. *See* paint bucket tool.

Buckle's brush. An easy-to-clean, easily replaced darkroom tool made of a wad of cotton pulled through a glass tube.

buckling. Distortion of photographic materials, characterized by a lack of flatness due to chemical degradation, shrinking, etc.

buff. A tool used by daguerreotypists to apply a final polish to silver plates. Usually made of a paddle covered in flannel or cotton and then wrapped in velvet, chamois, or buckskin.

buffer. (1) A darkroom chemistry (e.g., sodium acetate, sodium carbonate, or sodium metaborate) used to drive an acidic or alkaline solution to a certain pH and maintain that pH. (2) In computing and digital photography, a memory area where data is temporarily stored.

built-in flash. A limited-range electronic flash unit permanently installed in many cameras and often automatically activated to provide illumination in low-light situations. Synonymous with internal flash. *See also* electronic flash.

built-in meter. A reflected-light exposure meter contained in a camera that allows the photographer to take a light reading from the camera position.

bulb. (1) In early photography, a rubber bulb connected to a piston via a long tube that was used to trip the shutter. Two different exposure options were available. The first allowed for the shutter to open instantly; the second option allowed the shutter to remain open as long as the bulb was squeezed (the source of the term "bulb mode" on modern cameras). (2) *See* flash bulb.

bulb mode (B). A shutter-speed setting available on some cameras in which the shutter stays open as long as the release button remains depressed. *Contrast with* time (T) setting.

bulk back. A device that allows the loading of multiple feet of 35mm or 70mm film at once.

bulk film. Film sold in long lengths for use in a bulk back, in a bulk loader, or for assignments requiring a long, continuous-shot session.

bulk loader. A lighttight device used to wind film from 50- or 100-foot rolls into smaller 35mm film magazines.

Bullock, Wynn. *See* appendix 1.

bump mapping. The process of adding texture to a surface by simulating minor imperfections.

bundle. A term used to refer to a purchased product and its "free-with-purchase" package components (e.g., the complementary image-editing program packaged with a digital camera).

burned out. An image area that lacks detail as a result of over- or underexposure. Also called blown out or blocked up.

burning. Darkroom technique in which specific areas of the image are given additional exposure and thereby darkened. Synonymous with printing-in. *See also* burn tool.

LEFT—ORIGINAL IMAGE. **RIGHT**—IMAGE WITH BURNING.

burnisher. A tool consisting of two rollers (the first smooth and heated, the second textured) through which a mounted

print is passed. Used to compress and rub the print's surface and apply a glossy finish.

burnt-in photography. *See* ceramic process.

burn tool. In image-editing programs, a tool that darkens the image areas over which it is passed.

burst. The transfer of data at a constant, high speed.

burst mode. Setting on many cameras that allows you to take a series of shots in rapid succession while fully depressing the shutter release button. This is useful when photographing fast-moving subjects or when it is difficult to judge the correct timing needed to get the desired image. Some cameras offer more than one mode, giving the photographer a choice of low, medium, and high capture rates. Synony-

BURST MODE ICON
FOUND ON MANY CAMERAS.

mous with continuous shooting mode and film advance mode. *Contrast with* single shooting mode.

burst rate. The number of consecutive frames a motor drive, winder, or digital camera can handle in 1 second. This is measured in frames per second (fps).

bus. The electronic interface between a computer's motherboard and the cards in the expansion slots.

butterfly lighting. A portrait lighting style in which the main light is positioned high above and in front of the subject to produce a butterfly-shaped shadow under the subject's nose. Also known as Paramount lighting.

byte. Unit of measure equal to 8 bits. Used to measure computer memory and storage in kilobytes (1000 bytes), megabytes (1 million bytes), or gigabytes (1 billion bytes).

bytes per second (Bps). A quantitative measure of the frequency at which bits pass a given physical or metaphorical point in a 1-second time span.

C. *See* cyan.

C-22 process. A darkroom chemistry used for processing negative films. Superseded by the C-41 process.

C-41 process. Kodak's color film development process (called CN-16 by Fuji, CNK-4 by Konica, and AP-70 by Agfa).

cabinet card. A studio photograph, introduced in 1866, typically measuring 6.5x4.25 inches and mounted on card stock.

cable. Bound wires that serve as a conductor for transmitting electrical signals, optical signals, or electric power.

cable release. A cable with a button or plunger that attaches to a camera and allows the shutter to be tripped without touching the camera, eliminating camera shake.

cache. Auxiliary memory used for high-speed retrieval.

cadmium chloride. A component of collodion-chloride printing-out emulsions.

cadmium iodide. Colorless crystals used as an iodizer in collodion formulas, especially for negatives.

cadmium sulfide. A photoconductive chemical compound employed by exposure meters. *See also* photoelectric cell.

calcium carbonate. Acid-soluble compound used to neutralize gold toning baths.

calcium chloride. Component of iodized collodion formulas and collodion emulsions. Also used for its dehydrating properties.

calendered. Smooth surface resulting from a paper being passed through polished rollers or steam-heated rollers.

calibration. Adjusting a device to bring its behavior into accordance with a known specification.

Callahan, Harry. *See* appendix 1.

calorimetry. The science of measuring heat.

calotype. The first negative/positive photographic process used to print an image on paper coated with silver iodide. Developed by William Fox Talbot in 1841. Also known as a talbotype.

camera. A lighttight device containing an opening (aperture) through which light enters and is focused onto a light-sensitive medium to produce an image.

camera image file format. *See* CIFF.

camera lucida. An accessory, often clipped on a drawing board, that employs a four-sided reflecting prism or an equivalent grouping of mirrors to create an image of a subject on a piece of paper. The projected image can then be traced by hand.

camera movements. *See* movements.

camera obscura. A dark chamber with a tiny hole through which light waves are sharply focused to create an image. This basic construction is still used in pinhole photography.

camera phone. A cell phone with picture-taking capability. Camera phones are usually equipped with CMOS sensors.

camera profile. Values used to describe how a camera captures color. This may be a standard color profile, such as Adobe RGB or sRGB, or a custom profile created by the photographer.

camera-ready artwork. Illustrations in hard copy form that can be photographed to produce negatives or printing plates.

camera shake. Camera movement during exposure, which may degrade image sharpness. *See also* mirror slap.

Cameron, Julia Margaret. *See* appendix 1.

Canada balsam. *See* balsam.

candela (cd). A unit of luminous intensity.

candid photography. A photographic style in which the goal is to capture images of the subject acting naturally.

Canon. A Japanese corporation that specializes in imaging and optical devices including cameras and lenses.

canvas size. In Photoshop, a command that allows you to add or remove work space around an existing image. *Contrast with* image size.

Capa, Robert. *See* appendix 1.

carbon black. *See* lamp black.

carbon print. Photographic print produced by soaking a carbon tissue in a dilute potassium bichromate solution that contains carbon, gelatin, and a coloring agent. Created to counter the problem of fading prints that resulted from early photographic processes. Patented in 1864 by Joseph Wilson Swan.

carbon tissue. Paper coated with pigmented gelatin used for carbon print images. In the photogravure process, carbon tissue serves as a photoresist that is transferred onto a copper plate and etched through the exposed gelatin relief image.

carbro print. A photograph made using a combination of the carbon and silver bromide processes. The resulting print has a raised, slightly waxy surface.

cardboarding. A visual phenomenon of discontinuous depth that causes subjects to appear to be cut out of cardboard. This perception is common in images where there are few distance cues between major objects. *Contrast with* plasticity.

card reader. A device that accepts memory cards and is used to upload images to a computer via a USB or FireWire connection. Some are designed for use with multiple card formats; others can be used with only one type.

CARD READER.

carriage. The component of a scanner that moves over a source (e.g., document or photograph) to capture a digital likeness of the original. A lamp is mounted on the carriage to provide light for the image. Also known as a scanner head.

carriage lock switch. Mechanism on most scanners that prevents the carriage from moving and becoming damaged in transport. The lock must be disengaged prior to making the first scan.

carte de visite (visiting card). A tiny (2.125x3.5-inch) albumen print popular from the mid-1850s in Europe and from 1860 in the United States. Traded among friends and collected into albums typically displayed in Victorian parlors.

Cartier-Bresson, Henri. *See* appendix 1.

cartridge. Lighttight container that allows unexposed film to be loaded into a camera in the light. Also called a cassette.

cassette. *See* cartridge.

cast. *See* color cast.

catadioptric lens. *See* mirror lens.

catalog photography. Photographs created to accurately and attractively showcase products for sale.

catchlight. The usually desirable reflection of a light source (man-made or natural) in the eye of the subject, thought to add sparkle and interest to the eyes. Synonymous with eyelight.

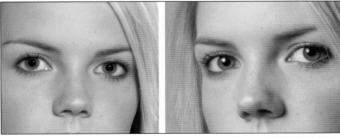

LEFT—WITHOUT CATCHLIGHTS. **RIGHT**—WITH CATCHLIGHTS. IMAGES BY JEFF SMITH.

cathode ray tube (CRT) monitor. A type of monitor that is easy and inexpensive to produce. CRTs provide sharp, accurate images, but their large size can be a drawback.

CRT MONITOR.
PHOTO COURTESY OF VIEWSONIC.

CCD. *See* charge-coupled device.

CCITT. Lossless compression techniques used for black & white images. Supported by the PDF and PostScript formats.

C-clamp. A mechanical device often used to secure lights to another object.

C curve. In composition, any real or implied line that approximates the shape of the letter C. *See also* S curve.

CD. (1) *See* compact disc. (2) *See* candela.

CD-R. *See* compact disc.

CD-RW. *See* compact disc.

celluloid. An early cellulose nitrate film base that had a tendency to unexpectedly catch fire. For this reason, acetate film was called "safety film" in earlier days. Today, most film has a flame-retardant cellulose or polyester base.

cellulose nitrate. A product of treating cellulose (usually cotton) with fuming nitric and sulfuric acids. With a plasticizer, this forms the base of celluloid films. Synonymous with nitrated cotton, gun cotton, and cotton gun. *See also* nitrate base.

center gray filter. Synonymous with center-weighted neutral density filter. *See* neutral density filter.

center spot filter. A photographic filter that is clear in the center. This isolates the filter effect to the edges of the frame.

center weighted. A type of automatic exposure system that evaluates the center area of an image and uses the reading as a basis for adjusting the exposure. *See also* matrix metering *and* spot meter.

TYPICAL CENTER-WEIGHTED
METERING ICON.

center-weighted neutral density (ND) filter. *See* neutral density filter.

central processing unit (CPU). The element in a computer that interprets program instructions and processes data.

ceramic process. The permanent fusing of a photographic image onto glass or a glass-like surface. This process is popularly used for jewelry, ceramic décor items, and for placing images on tombstones.

CF card. *See* CompactFlash card.

C format. *See* Advanced Photo System.

changing bag. A black, lighttight bag used to handle film when not in a darkroom.

channel. In digital imaging, component grayscale images that store different types of information about a digital image. *See also* alpha channel, color channel, *and* spot color channel.

channeling. Buckling of emulsion produced due to a shrinking film base.

characteristic curve. A graphical representation of the way various photosensitive materials respond to a light source. The curve shows the way in which density (plotted on the vertical

axis) is affected by an increase in exposure (plotted on the horizontal axis). Also called the D/log E curve, H and D curve, response curve, and film characteristic curve.

CHARACTERISTIC CURVE OF KODAK PLUS-X PAN FILM.

characterization. The process of creating a profile for a device. *See also* profile.

charge-coupled device (CCD). An image-sensor chip found in most digital cameras and some scanners. *See also* SuperCCD *and* complementary metal-oxide semiconductor.

chemical decay. A chemical reaction that negatively affects atomic and molecular structure. This includes the breakdown of pigments, staining caused by acidic materials, etc.

chemical focus. *See* actinic focus.

chemical sensitization. Increasing the sensitivity of the emulsion by use of chemical additives.

chiaroscuro. A compositional term that refers to the arrangement of light and dark areas within a photographic image.

chilling table. A device used to set the hot gelatin emulsions applied to glass plates prior to placing them in a drying box.

chloride paper. A printing-out paper dating back to 1802.

chlorine. Poisonous gas used as a halide in silver halide photography and as an accelerator in the daguerreotype process.

chlorophyll. A plant-based dye sensitizer for collodion bromide plates.

chroma. (1) The purity of a color (or absence of gray). Also known as saturation. (2) A primary in the LCH color model.

chromakey photography. Photography of a subject against a bright blue or green background that can be easily replaced in postproduction.

chromatic. A color with at least one available hue and a discernable level of color saturation. *Contrast with* achromatic.

chromatic aberration. (1) A lens defect in which various wavelengths of light are differently focused across the entire image area. (2) A lens defect in which each color's image point is of a different size. This produces peripheral color fringing.

chromatic adaptation. The ability of the human eye to neutralize various color temperatures of light to preserve the appearance of an object's color.

chromatic dispersion. *See* dispersion.

chromaticity coordinates. A set of values that describe the chroma of a test color and its position on a chromaticity diagram.

chromaticity diagram. (1) In *x,y* or *xyΥ* diagrams, a two-dimensional graph of coordinates that shows the location of a color on a plane of constant lightness. (2) In UCS (uniform chromaticity scale) diagrams, a three-dimensional graph of chro-

maticity coordinates that attempts to show a visually accurate relationship between colors.

chromatype. Contact-printing process using a very slow paper treated with chromate of copper and potassium bromate.

chrome. Colloquial term for a color transparency.

chromium intensifier. *See* intensifier.

chromogenic film. Non-silver black & white film that can be developed using color negative processing. *See also* C-41 process.

chrysotype. A process developed by Sir John Herschel, who used ferric ammonium citrate to sensitize paper, contact-printed it, then treated it in a weak gold chloride solution.

Cibachrome. *See* Ilfochrome.

CIE. *See* Commission Internationale d'Eclairage.

CIE chromaticity diagram. *See* chromaticity diagram.

CIE LAB (CIE L*a*b, CIE Lab). A color model, derived from CIE XYZ, that describes color using three synthetic primaries: L* (luminance), a* (color oppositions between green and red), and *b (color oppositions between yellow and blue). The most complete color model used conventionally, describing all the colors visible to the human eye. Often called Lab color.

CIE LUV. A color model created in 1960 and updated in 1976, CIE LUV is a revised version of CIE XYZ that alters and elongates the original chromaticity diagram in an attempt to correct its nonuniformity.

CIE standard illuminants. Data sets used to describe the spectral components of different light sources. *See also* illuminant A (CIE), illuminant C (CIE), *and* illuminants D (CIE).

CIE standard observer. A hypothetical observer used to represent "normal" human color vision and the eye's color-matching functions.

CIE tristimulus value. The amount of three primaries needed to match a color sample. Determined in relation to a CIE standard illuminant and observer. *See also* tristimulus.

CIE XYZ color space. An early color model, employing synthetic primaries, produced by the CIE to describe color based on human perception.

CIFF (camera image file format). A digital image storage format used by many camera manufacturers.

Cinefoil. A dark aluminum material used to mask light leaks, direct light output, and minimize reflections. Also called black-wrap or Black Foil.

cinematography. The art of photographing and processing moving images for the purpose of cinematic viewing.

circle of confusion. A disc-shaped bright area in the image where a point of the subject is not brought into sharp focus. The smaller the circles of confusion, the sharper an image appears.

citric acid. An acid originally obtained from lemons or limes. Now synthetically produced. Often used as a restrainer in the collodion process and for sensitizing salted and albumen papers.

clay-coated paper. *See* porcelain paper.

clean and tight. Terms used to describe a well-composed image free of distracting or unimportant elements.

CHROMATICITY DIAGRAM.

clearing time. How long a negative or print is submerged in fixer. Too little clearing time yields a milky appearance.

click stop. A point of physical resistance (constructed, for example, by a ball bearing and recess) that allows for shutter speed, aperture changes, etc., to be made by touch. *See also* detent.

clipboard. A software feature used for the short-term storage of data to be transferred between documents or applications.

clipping. The elimination of colors or tones that fall outside of a predetermined limit.

clipping path. In image-editing programs, a device used to define transparent areas in images to be used in page layouts.

clip test. *See* snip test.

clone stamp tool. In image-editing, a tool used to sample pixels from one area of an image and paste them into another, usually to conceal a flaw. Synonymous with rubber stamp tool.

closed-loop calibration. A method of calibration in which a factory-supplied target is printed on the desired printer, then scanned. The results are compared with the original file data and used as the basis for creating a set of color corrections that can be applied to subsequent scans to be output on the same printer.

close focus distance. *See* minimum focus distance.

close focusing mode. A camera setting (usually designated by an icon of a flower) that allows the lens to focus on subjects that are only a few inches away.

CLOSE-FOCUSING ICON ON MANY CAMERAS.

close-up. A general term referring to a photograph taken at close range. The term is often used to describe portraits that feature only the face or a portion of the subject's face.

CLOSE-UP PORTRAIT. PHOTO BY BARBARA A. LYNCH-JOHNT.

close-up filter. *See* close-up lens.

close-up lens. A filter-like accessory that attaches to the front of a lens to enhance its close-focusing abilities. Useful when photographing small objects.

close-up photography. Creating images of small objects from close distances. Specialized lenses (called macro lenses) can be used to ensure sharp focus on a wide range of subjects.

cloud negative. Negatives of dramatic skies made to replace those captured (and painted out) in blue-sensitive plates, which tended to record clouds at the same density as the sky.

cloud shutters and stops. Special shutters and stops designed to decrease the exposure in the lower portion of the image on landscape plates, which allowed for a better exposure of the sky.

cloudy day white balance. A white-balance setting that warms up a scene a little more than does the daylight mode.

CLOUDY DAY WHITE BALANCE ICON FOUND ON MANY CAMERAS.

CMM. *See* color engine.

CMOS. *See* complementary metal-oxide semiconductor.

CMS. *See* color engine.

CMY. A color model that uses three primaries (cyan, magenta, and yellow) to reproduce colors. These are the subtractive primary colors and, theoretically, form black when combined at full strength. However, due to the chemical properties of ink, the resulting color is actually a muddy brown. Therefore, the CMYK model (where black ink is added) is more common.

CMYK. A color model that uses four primaries (cyan, magenta, yellow, and black [represented by the letter K]) to reproduce colors. Each pixel is assigned a percentage value for each of the primaries. This is the color model used in process printing.

CN-16 process. *See* C-41 process.

CNK-4 process. *See* C-41 process.

coating. *See* lens coating.

coating machine. Device used to apply collodion and gelatin emulsions on rolls of paper backing. Superceded by machines that applied emulsions onto glass plates and, finally, ones that coated a flexible film support with gelatin emulsions.

cobalt glass. A specially formulated glass used to transmit near-infrared radiation. Synonymous with Woods glass.

code. Identifying information printed on the rebate area of film. Also called film edge marking. *Contrast with* DX coding.

codec. A routine or algorithm implemented as software or put onto a microprocessing chip that is used to compress and decompress data sent across a network (e.g., JPEG, MPEG).

coherent light. Light in which the waves have the same frequency and color and are in phase.

coincident rangefinder. Optical device that employs triangulation to measure the distance from the observer to an object.

Cokin. Manufacturer of photographic filters.

cold cathode enlarger. *See* enlarger.

cold mirror. A mirror that reflects visible light wavelengths and transmits infrared wavelengths.

cold mounting tissue. *See* mounting tissue.

cold-toned paper. A photosensitive printing paper that produces deep, rich blacks as opposed to brownish blacks. *Contrast with* warm-toned paper.

collimated light. A beam of light in which all rays are parallel. Condenser enlargers produce such light.

collodion. A viscous solution of cellulose nitrate in alcohol or ether used in the wet plate process.

collodion bottle. Apothecary bottles used to prevent particles of dried collodion from falling onto the plate.

collodion enamel. A material employed to add a glossy surface to prints.

collodion process. *See* wet plate process.

collotype. A photomechanical process developed in 1855 in which a ground glass plate is coated with bichromated gelatin,

then baked to achieve a mezzotint-like surface. The treated plate is exposed to a negative under UV light, and the gel hardens in relation to the exposure. The plate is washed so the unexposed gelatin washes away. Lithographer's ink is rolled onto the remaining gelatin, and the image is printed to paper.

color. (1) The response of the human eye to different wavelengths of light striking the photoreceptors of the retina. (2) Images that contain hues (i.e., not black & white images).

colorant. A material used to produce color, such as dyes, inks, or phosphors.

color balance. (1) The way the overall colors are reproduced in an image. (2) The way film responds to colors. Color film emulsions are balanced for use with light of a specific color temperature (e.g., daylight-balanced film). In digital imaging, the corresponding control is white balance. (3) A tool in Photoshop used to finesse image color rendition.

color balance shift. A change in the tonality of an image due to instability of dyes. In some processes, yellow dyes rapidly fade, eventually resulting in an overall magenta cast. In other cases, an overall yellow cast results due to staining.

color balancing filters. *See* color compensating filters.

color bleeding. The lateral movement of a colorant from one area into adjacent image areas through the base or beyond the image plane onto a contact print.

color blindness. Inability of a device or the human visual system to perceive and process portions of the visible spectrum.

color cast. A tint of color across an entire image that is usually most visible in the light- or medium-density neutral areas.

color channel. Component grayscale images representing the individual primaries that constitute the color in the image. An RGB image has color channels for red, green, and blue (plus a composite channel used for editing the image).

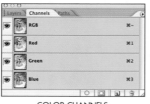
COLOR CHANNELS.

color compensating (CC) filters. Pale blue, green, red, yellow, magenta, and cyan filters, available in different densities, used to produce small shifts in the way colors are rendered. These can be used during capture or in color printing.

color conversion. The act of changing the color model or color space used in a digital image.

color conversion filters. Blue and orange filters used to modify light sources that do not match the color balance of the film or white balance.

color correction. (1) Adjusting a color photograph in order to achieve an overall neutral color balance. (2) Reduction of chromatic aberration in a lens accomplished by bringing two spectral colors into common focus.

color coupler. A chemical component of photosensitive papers that creates image-forming dyes during processing.

color depth. *See* bit depth.

color engine. In color management, software that adjusts the numerical values sent to or received from different devices so that the perceived color remains consistent. Because of their unique logarithms, different color engines may produce different results when processing the same data. Also called color man-

agement module, color management method, color matching method, or color management software. *See also* Apple ColorSync *and* Microsoft Image Color Management.

color filter array. The arrangement of filter dyes placed over each pixel on the surface of a CCD or CMOS chip. The Bayer pattern is the most popular type of color filter array.

color fringing. A chromatic aberration caused when the camera lens focuses differing wavelengths of light onto different focal planes or magnifies two or more wavelengths differently. *See also* chromatic aberration.

color gamut. *See* gamut.

color harmony. An aesthetically pleasing array or balance of the hues displayed in a photographic image.

colorimeter. An optical instrument used to measure the relative intensities of red, green, and blue light reflected from, emitted by, or transmitted through a color sample.

colorimetric. (1) Pertaining to the measurement of color. (2) A rendering intent in which in-gamut colors are unchanged but out-of-gamut colors are clipped. *See also* absolute colorimetric rendering intent *and* relative colorimetric rendering intent.

colorimetry. The measurement of a color's qualities, including hue, saturation, and brightness.

color intensity. A feature available on most inkjet printers that allows users to vary the brightness of images by adjusting the amount of ink applied to the page.

colorize. To handcolor a black & white print or digitally add color to an image without affecting the original lightness values.

LEFT—BLACK & WHITE IMAGE. **RIGHT**—COLORIZED BLACK & WHITE IMAGE.

color management, digital. A process designed to help ensure consistency when transferring color data from one device or program to another. *See also* ICC color management *and* PostScript color management.

color management method (CMM). *See* color engine.

color management module (CMM). *See* color engine.

color management software (CMS). *See* color engine.

color mapping. *See* mapping.

color match. The state at which two or more samples are perceived by a viewer as having the same color or hue, though the actual lightness or saturation values may differ.

color matching method (CMM). *See* color engine.

ColorMatch RGB color space. An RGB working space that is the native color space of Radius Pressview monitors. Today, Adobe RGB (1998), which offers a slightly larger gamut, is a more widely used color space.

color mode. In digital imaging software, a setting that determines what color model is used to display and print the image being worked on.

color model. A mathematical method for describing color, usually in terms of varying amounts of primary colors.

color picker. An application in Photoshop used for creating color schemes, choosing/editing colors, color management, and

more. Once a color is selected, it can be applied to the canvas using any of the program's painting or drawing tools.

color printing filters. Acetate filters used with a compatible enlarger to correct the color balance when printing color photos.

color profile. *See* ICC profile *or* device profile.

color rendering dictionary (CRD). The PostScript equivalent of an ICC output profile.

color rendering index (CRI). A numeric system used to measure how well a light source renders a range of colors. Sunlight renders colors well (e.g., has a rating of 100); conversely, monochromatic light does not and therefore has a lower numeric rating (e.g., 20).

color reversal. Film designed to make a normal positive image when exposed in the camera. To view the image, light must be transmitted through the film using a projector, light box, or other light-emitting device.

color sampler tool. In Photoshop, a tool used to place numbered, crosshair-shaped targets at important image areas. The color values for these sample points can then be monitored in the info palette. *See also* eyedropper tool.

color saturation. *See* chroma *or* saturation.

color sensitivity. *See* spectral sensitivity.

color separation. The process used to convert an image in RGB or CIE LAB mode to CMYK.

color sequence. On a printing press or in proofs, the order in which the cyan, magenta, yellow, and black inks are applied.

color shift. The distortion or inaccurate representation of color in an image due to problems with film and/or film processing, white-balance errors, reciprocity failure, etc.

color space. A geometric representation of the colors that can be produced by a color model.

color space array (CSA). In PostScript color management, analogous to an ICC source profile.

color space, device-dependent. Color that is determined by physical colorants, such as the inks in a printer or the phosphors in a monitor.

color space, device-independent. Color that is defined based on human perception, independent of physical colorants. Also called a reference color space.

ColorSync. *See* Apple ColorSync.

color synthesis. The combination of two or more other colors to reproduce an original color. May be done through an additive (primary color) or subtractive (secondary) color synthesis.

color temperature. The temperature at which a blackbody would emit radiation of a given color. This is measured in Kelvin (K) degrees. Color temperature is used to describe the color qualities of light sources, film, and white-balance settings. Warm or red colors have a low color temperature; cool or blue colors have a higher color temperature.

candlelight	1930K	midday light	5400K
tungsten	2400K	average daylight	6500K
photoflood	3400K	blue sky	18,000K

COLOR TEMPERATURES OF COMMON LIGHT SOURCES.

color temperature meter. A tool that measures the relative proportions of red, green, and blue in a given light source to determine the quality of the light.

color temperature white balance. A feature that allows you to set the digital camera's white balance to the precise color temperature of a light source in degrees Kelvin. Also called Kelvin white balance.

color wheel. The visible spectrum's continuum of colors, arranged in a circle with complementary colors located directly across from each other.

COLOR WHEEL.

coma. An aberration that causes light rays that enter the lens from an angle to be captured as a comet-shaped blur of light in the image.

combination printing. Using two or more photographs in conjunction with one another to produce a single image.

comet. In the wet plate process, a flaw in the image that appears as a speck with a tail. Caused when dried particles of collodion fall onto the plate.

commercial photography. Images created for the purpose of selling a product, service, or concept.

Commission Internationale d'Eclairage (CIE). The International Committee on Illumination, an international standards group concerned with color and color measurement.

comp. A detailed sketch used to demonstrate how a graphic or page layout will appear once it is complete.

compact disc (CD). A high-density storage media onto which a large amount of information can be stored for access by a computer. CD-Rs can be written to only once; CR-RWs can be written to and erased approximately a thousand times.

compact disc (CD) burner. A device that allows you to write data onto CD-Rs (for one-time writing) or CD-RWs (for multiple-session writing or rewriting) for archival purposes.

CompactFlash (CF) card. A memory card format used by many digital cameras. Type I cards are 3.3mm thick; type II cards are 5.0mm thick. Width and length dimensions are the same for both types.

COMPACTFLASH CARD.

compensating developer. A chemical formula that more actively develops low-density areas of a negative than high-density areas, producing a less contrasty negative.

complementary colors. Colors opposite each other on the color wheel. When combined in the right proportions, these produce white light. *See also* primary colors.

complementary metal-oxide semiconductor (CMOS). A type of image sensor found in some digital cameras—particularly digital SLRs. This sensor type offers some advantages when producing very high-resolution images and is less costly to manufacture than a CCD. *See also* charge-coupled device.

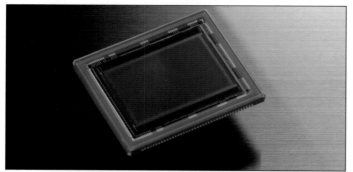

THE CMOS FROM A NIKON D300 CAMERA. PHOTO COURTESY OF NIKON.

complementary wavelengths. Two wavelengths of light that, when combined, produce gray.

COM port. *See* serial port.

composite. (1) An image made by digitally combining parts of two or more images to create a single final image. Sometimes referred to as a photo montage. (2) A file that contains all channels (e.g., the R, G, and B channels) of an image. (3) Term that refers to an RGB file that has not been separated into CMYK.

composition. The placement and prominence (visual weight) of primary and secondary subjects, lines, shapes, colors, and tonalities in a photograph. An important factor in the visual impression an image creates.

compound lens. A lens system containing two or more lens elements positioned on the same axis.

compound shutter. A mechanical leaf shutter usually located between lens components. Such shutters may have settings for T (time), B (bulb), and times from 1 second down to $\frac{1}{100}$ second or less. Also known as a leaf or diaphragm shutter.

compressed air. Used to remove dust from slides and negatives prior to scanning and to clean computer components.

compression. Arranging image data so it is more efficiently stored or removing extraneous data to reduce the file size.

computer to plate (CTP). A technology for converting digital page layout files to press-ready printing plates, without needing to first produce film. Synonymous with direct to plate.

concave lens. *See* negative lens.

concavo-convex lens. A lens that features a concave surface as well as a convex surface. When the curvature of both sides is equal, the lens is called a meniscus lens.

Conceptual Art. *See* appendix 2.

condenser. A type of lens that concentrates light into a single beam. Used in slide projectors, spotlights, and enlargers.

condenser enlarger. *See* enlarger.

cones. Photoreceptors in the retina of the eye that are sensitive to high levels of light. There are three sets of cones in the eyes: one sensitive to the red spectrum of light, one to green, and one to blue. *Contrast with* rods.

constant aperture zoom lens. A zoom lens that offers the same maximum aperture across the range of available focal lengths. Synonymous with fixed aperture zoom lens. *Contrast with* variable aperture zoom lens.

constringence. *See* Abbe number.

Constructivism. *See* appendix 2.

contact image sensor (CIS). A limited-resolution image sensor used in some smaller, low-cost scanners.

contact print. Photograph made by placing a negative in direct contact with a photosensitive surface and shining light through the negative to create a print of the same size.

contact-printing frame. Device used to make contact prints. Generally comprised of a simple frame with a glass top that holds the negative and light-sensitive paper in close contact.

contact-printing paper. *See* printing-out paper.

contact sheet. A sheet of paper on which thumbnail images are printed for review.

contamination. Presence of trace chemicals that can impede development, cause staining, or create other problems.

Contax. Manufacturer of photographic equipment.

continuous autofocus. A focus mode in which the lens

CONTACT SHEET.

actively hunts for the best focus as you move the camera around. Useful when tracking moving subjects. *See also* AI servo.

continuous inkjet. A printer that continuously applies a stream of ink from a reservoir during printing. This type of printer is capable of outputting dots of ink of variable sizes, therefore producing excellent apparent resolution in prints.

continuously variable neutral density (ND) filter. *See* neutral density filter.

continuous shooting mode. *See* burst mode.

continuous spectrum. Spectrum of light in which all wavelengths are represented and are of a relatively equal strength.

continuous tone (CT). An image that contains an uninterrupted range of colors and/or tonal values (such as a C-type print) without being broken up into small patterns of dots (as seen in an image printed on an offset press). Also used to distinguish photographic images from vector-based graphics.

contouring. Synonymous with banding and posterization.

contract. A binding agreement between two or more persons (e.g., the photographer and a client) that is enforceable by law.

contract proof. A proof typically created by a printer and delivered to a client. This proof legally serves as an assurance that the final print quality will closely match the proof.

contra jour. French for "against the daylight." *See* backlight.

contrast. (1) The overall tonal difference between the darkest and lightest parts of an image. (2) The tonal difference between two areas of an image.

contrast control. (1) The adjustment of highlights and shadows in a digital image via image-editing programs. (2) A device on an enlarger that allows the user to set the contrast grade for variable-contrast papers.

contrast filter. A hardware or software filter used to adjust the tonal differences in an image.

contrast grade. *See* paper grade.

contrast threshold. The level at which the brightness difference between two areas becomes perceptible.

control panel. A monochrome top-deck LCD screen that displays important camera settings such as aperture, shutter speed, and shots remaining.

convergence. A phenomenon by which the parallel lines of a subject appear nonparallel in the image. This is a common issue when photographing architectural subjects and may be corrected using perspective-control lenses.

CONVERGENCE.

converging angles. *See* convergence.

converging lens. *See* positive lens.

converging lines. *See* convergence.

converging meniscus. A lens design consisting of one concave and one convex surface that converges incident light rays.

converter. *See* teleconverter.

convertible lens. A lens type consisting of two or more components that can be used jointly or separately. Also known as a separable lens.

convex lens. *See* positive lens.

convolution. In linear-system theory, the multiplication of a function by another function. For example, the transformation of the values of a single pixel or groups of pixels in a bitmap image, without changing the number or position of any pixel, in order to enhance the image.

convolution kernel. A group of pixels transformed using a mathematical function during the processing of an image or via the application of image-editing filters. *See also* convolution.

cookaloris. *See* cukaloris.

cookie. *See* cukaloris.

cool colors. Colors in the blue-green area of the color spectrum, which are thought to impart a feeling of calm and visually recede. *Contrast with* warm colors.

copper. A malleable metal with a pinkish color used in the daguerreotype process.

copperas. *See* ferrous sulfate.

copper bromide. Solution traditionally used as the bleaching step for intensifying collodion and gelatin negatives.

copper chloride. Halide added to printing-out and silver bromide emulsions to allow for enhanced contrast.

copper-red toning. Traditional toning process requiring a single- or double-bath process. Tends to lighten shadow areas and may produce solarization in the highlight areas.

copper sulfate. A substance used to make the copper bromide bleach used in intensifying and toning. Also used as a restrainer in ferrous sulfate developers for the collodion process.

copy. In text and graphics programs, a command that adds text or pictures to the clipboard while leaving the original data unchanged. Often used in conjunction with the paste command.

copying camera. A camera-and-easel system designed for copying flat originals like manuscripts or prints. When the material to be copied is placed on the easel, the camera can be moved along a track to achieve proper orientation while keeping the camera back parallel to the original.

copy lens. A lens designed to produce superior image quality when used at short to moderate distances from the subject.

copyright. The exclusive legal right to reproduce, publish, sell, or distribute a created work.

copy stand. A device used to support a camera vertically for copying documents or photographing small objects, such as coins or stamps.

THE SUPER-REPRO COPY STAND.

Corel Painter. An image-editing program that allows users to impart painterly effects that mimic traditional watercolor and oil paintings, plus a wide range of other artistic effects.

corporate photography. The capture of images of executives, factories, and other business-related subjects for annual reports, advertising, etc.

correction filter. A colored filter used in black & white image capture to ensure that tones are reproduced with the same relative brightness as perceived by the human eye.

corrector plate. An optical element used to correct for spherical aberration.

correlated color temperature (CCT). The warmth or coolness of a light source, measured in degrees Kelvin, in relation to a blackbody heated to a specific temperature.

corruption. Damage to a digital file that may render the data irretrievable or garbled.

cotton gun. *See* cellulose nitrate.

coulomb. Standard unit of electric charge named after Charles-Augustin de Coulomb. One coulomb is the amount of electrical current carried in 1 second by a current of 1 ampere.

coupled rangefinder. Mechanism that integrates the rangefinder measurement with the focusing mechanism of the lens.

coupler. (1) Chemical used in color processing that reacts or combines with development by-products to form a colored dye. (2) Device that connects two components or systems.

cove. A seamless backdrop lacking a horizon line. Synonymous with infinity cove.

covering power. A characteristic of lens design that provides satisfactory image sharpness and uniform illumination for a given film/sensor format.

CPU. *See* central processing unit.

CR2. A proprietary raw file format used on Canon digital cameras.

crape marks. In the wet plate process, wavy lines that appear near the corner where excess collodion was poured from the plate. Caused by the evaporation of solvents or water.

crash. The failure of a computer program to function and respond to other parts of the system. The problem is usually corrected by restarting the computer. Synonymous with freeze.

crayon enlargement. Faintly printed enlargements created via solar enlargers and generally made from copy negatives taken from cabinet-card originals. Such prints were used as a guide for tracing with ink, watercolor, crayon, pastels, or other media.

CRD. *See* color rendering dictionary.

crest. The top of a light wave.

CRI. *See* color rendering index.

crime scene photography. *See* forensic photography.

critical angle. The smallest angle of incidence at which light is totally reflected (not transmitted or refracted).

critical aperture. The aperture that produces the optimal rendition of a scene (e.g., the best-possible balance between aberration and rendition of contrast in a scene).

crop. To remove extraneous areas from the edges of an image in order to strengthen the composition.

crop tool. In image-editing programs, a tool used to trim pixels from the edges of an image to strengthen the composition.

cross-eyed boke. *See* boke *and* mirror lens.

cross key. *See* cross light.

cross light. To illuminate a subject from both sides.

cross platform. A term used to describe a computer program, software, or file format designed to run on Microsoft Windows, Linux, and Macintosh systems.

cross process. To intentionally process film in a chemistry designed for another film type in order to create unusual color or contrast effects. The same effect can be simulated digitally.

LEFT—ORIGINAL IMAGE. **RIGHT**—CROSS-PROCESSED IMAGE. PHOTO BY JEFF SMITH.

cross-screen filter. Synonymous with star filter.

crown glass. Glass with low dispersion, an Abbe number higher than 50, and a refractive index greater than 1.6 (or an Abbe number greater than 55 and a refractive index of less than 1.6). Used with flint glass to create an achromatic lens.

CRT. *See* cathode ray tube monitor.

crushed. *See* blocked up.

CRW. Proprietary raw file format on Canon digital cameras.

crystalotype. An albumen-on-glass negative process developed by John Whipple. Also refers to the prints, which were made on salted paper. Whipple also used the term for a brief time to refer to prints he made using the collodion process.

crystoleum. The process of making photographs by combining a black & white transparency with a handcolored image.

CSA. *See* color space array.

CT. *See* continuous tone.

CTP. *See* computer to plate.

C-type print. A color print containing at least three emulsion layers of light-sensitive silver salts, each sensitized to a different primary color (red, blue, or green) to record different information about the color makeup of the image. Chemicals added during processing form dyes that color the emulsion layers.

Cubism. *See* appendix 2.

cukaloris. Device placed in front of a light source to create a pattern of shadows on a backdrop or subject. Also called a cookie or cookaloris.

Cunningham, Imogen. *See* appendix 1.

cupric chloride. *See* copper bromide.

curtain. One of two lightproof components of a focal plane shutter that move across the aperture in the same direction, one after the other, forming an opening that allows light to expose the film/image sensor. Also called a shutter curtain.

curvature of field. A lens defect that causes the plane of sharp focus to be curved.

Curves. In Photoshop, a feature that allows users to improve contrast and correct color in the individual color channels or in the composite channel.

curvilinear distortion. *See* barrel distortion *and* pincushion distortion.

custom color. A specially formulated ink that is used with black ink or added to the separation colors in process printing. Also refers to a spot color.

custom palette. A selection of colors used for a particular purpose (e.g., a limited number of colors used in the reproduction of an image to ensure a smaller file size).

custom shape tool. *See* shape tool.

custom white balance. A digital camera setting that allows you to sample a known gray/white reference under the lighting in which the subject or scene will be photographed. The corrections needed to render this area as neutral are saved for use with ensuing images made in the same lighting.

cut. To remove a section of text or part of an image from a digital file. This data can be stored temporarily on a clipboard and applied (pasted) to another file or program.

cut film. Negative film available in flat sheets, typically 4x5- or 8x10-inches. Synonymous with sheet film.

cutoff filter. Type of filter used in infrared photography to reduce or eliminate the transmission of visible light, allowing infrared light to create the image. *See also* high-pass filter *and* hot mirror.

cutoff wavelengths. Wavelengths reflected (blocked) by a filter. Wavelengths are deemed "cut off" if less than 5 percent of those wavelengths are transmitted.

cutter. A large black flag.

cyan (C). A subtractive primary and one of the four process ink colors. Cyan is the complementary color to red. *See also* CMY, CMYK, *and* primary colors.

cyanide. *See* potassium cyanide.

cyanotype. A contact-printing process that yields a blue image on a white background. Also called the blue print or Prussian-blue process.

cylindrical lens. A lens with one or more surfaces that are cylindrical in shape. Such lenses can transform a point of light into a line image; they can also magnify a scene in one dimension and can be used for stretching images. Synonymous with anamorphic lens and toric lens.

D. *See* density.

D50. CIE standard illuminant that represents a color temperature of about 5000K. This is the color temperature under which images are normally evaluated in viewing booths.

D65. The CIE standard illuminant that represents a color temperature of 6504K.

DAC. *See* digital-to-analog converter.

Dadaism. *See* appendix 2.

Daguerre, Louis Jacques Mandé. *See* appendix 1.

daguerreotype. Invented in 1839 by Louis J. M. Daguerre, a direct positive photographic process in which the image is exposed onto a mirror-polished surface of silver with a coating of silver halide particles. The first successful photographic process to allow an exposure time suitable for portrait photography.

damping. A mechanical system used in cameras to absorb sound and vibrations (e.g., from mirror slap).

dappled light. Lighting with intensity variations that produce patches of light and shade. Often produced with a cukaloris.

dark adaptation. Adjustment of an individual's visual perception to a low level of light, resulting in increased sensitivity.

dark beam. Device that produces a narrow beam of light, allowing labels, instructions, etc., to be read in the darkroom.

dark box. Lightproof box used for storing photosensitive materials. Generally equipped with light traps that permit access to materials without allowing light to enter.

darkcloth. Dark fabric placed over the photographer's head and the camera back to aid in the viewing of images on the ground-glass screen of view cameras.

dark current. (1) The reading of a photoelectric meter (e.g., a densitometer) when no light is falling on the receptor. The size of the dark current impacts the ability of the meter to measure weak light levels. (2) The leakage of charge from a CCD when no incident light is present. Also known as black noise.

dark-field illumination. Side lighting technique used to photograph organisms or other close-up subjects so that the subject, but not the background, is illuminated.

dark noise subtraction. Reducing noise by taking the photo with the shutter closed (mapping the noisy pixels), then with the shutter open. Any noise present in the dark frame is then subtracted, reducing but not entirely eliminating noise.

darkroom. A workspace made dark to allow photographers to process film and make photographic prints.

darkroom cloth. Lightproof cloth used in film-changing bags and for focusing cloths on view cameras. *See also* darkcloth.

darkslide. Device placed in front of a sheet-film holder to shield the emulsion from light.

dark tent. A device comprised of a wooden frame and covered with two layers of fabric—one black, the other a nonactinic color—used by traveling and landscape photographers to prepare and process wet collodion plate images upon exposure.

data. The numbers that make up a digital file.

database. A collection of data organized to allow for easy access, management, and updates.

data compression. *See* compression.

data packets. Units of data that can be transmitted from one computer to another via telephone, cable, or other line. All information sent over the Internet, regardless of its content, is divided into data packets.

data reader. A device that can be attached to some film cameras to transfer a text file of recorded shooting data to a memory card. This file can then be used with data management programs.

date back. Any camera that prints date information onto film.

day for night. A simulated nighttime effect achieved through the use of filtration or underexposure in daytime conditions.

day-for-night filter. *See* nuit américain.

daylight. (1) Light that comes from the sun and has a color temperature of about 5400–5900K (up to 6500K with a blue sky). The brightness, quality, and color of daylight are highly variable depending on time of day/year, cloud cover, and other factors. (2) An artificial light source that produces light with a color temperature of approximately 5500K. (3) Materials calibrated for use in daylight.

daylight-balanced film. An emulsion designed to render natural colors when the color temperature of the light source is about 5500K.

daylight-balanced fluorescent lamp. *See* fluorescent lamp, daylight-balanced.

daylight enlarger. Early enlarger type that used light streaming from a hole in a window to cast light on the negative.

daylight filter. *See* Wratten numbers.

daylight loader. A film-winding device that allows photographers to easily spool bulk film for loading into film canisters.

daylight loading film. Refers to 35mm film, the first film marketed in lightproof canisters. This allowed photographers to

load film in subdued daylight conditions rather than in complete darkness.

daylight tank. A lightproof film-processing container.

daylight vision. *See* photopic vision.

daylight white balance. A digital camera setting that ensures neutral tones under most sunlit conditions and with daylight-balanced light sources.

DAYLIGHT WHITE-BALANCE ICON FOUND ON MANY CAMERAS.

DC (direct current). The voltage utilized by most battery-powered photographic equipment.

DCR. Proprietary raw file format on Kodak digital cameras.

DCS. *See* Photoshop DCS 1.0 *and* Photoshop DCS 2.0.

dead pixels. On LCD monitors, pixels that fail to respond. If these are numerous, the effect may impede viewing.

deblurring. Restoring image sharpness via a Wiener filter or other means in digital images that are blurry due to linear motion in a single direction or due to lack of depth of field.

decamired. A system used to describe color filters. Often employed by continental European manufacturers in lieu of Wratten numbers.

decantation. Transferring liquid (generally using a siphon) from one container to another without disturbing any particulate matter at the bottom of the bottle.

decisive moment. The moment of peak action or emotion that best expresses the story or action.

deckled. A torn-edge photographic effect produced with a special cutting tool. Also refers to the simulation of the effect imparted via image-editing programs.

decompression. The process of restoring the full data content of a compressed file.

dedicated flash. A camera-and-flash system where a sensor measures the flash through the camera lens and turns it off when enough light is emitted to produce a proper exposure.

default. A setting for a camera, computer, or other electronic device that is in effect until a new preference is set by the user.

definition. The clarity and quality of detail (sharpness) captured in an image.

defocus. The deliberate introduction of unfocused areas in an image for artistic purposes.

defringe. The blending of the outermost pixels of a selected area to ensure that it melds seamlessly with the background.

degauss. The elimination of excess static charge that builds up on CRT monitors to eliminate distortions. Often accomplished through use of a color monitor face plate.

degradation. A loss of image quality or sharpness. May be intentional (for effect) or unplanned as a result of some environmental or mechanical influence.

dehumidifier. Device containing a desiccant material used to remove moisture from small storage spaces.

delayed action. *See* self-timer.

delta. A symbol (Δ) used to note a change in a variable.

delta-E. *See* delta error.

delta (Δ) error. A theoretical measurement of the smallest color difference that can be detected by someone with normal color vision. Also called delta-E.

Demachy, Robert. *See* appendix 1.

demosaicing. A process used to interpolate a complete image from the raw data captured by a color-filtered image sensor. *See also* Bayer pattern.

dense. Term used to describe a negative or portion of a negative in which a large amount of silver has been deposited. A dense negative transmits little light.

densitometer. Device used to measure optical density.

density. The ability of a material to absorb light. The darker the material, the higher the density. Density is commonly denoted as D or OD (for optical density).

depth. The measure of camera-to-subject distance. Short distances are described as "shallow"; long distances as "deep."

depth of field (DOF). Area between the nearest and farthest points from the camera that is considered acceptably sharp in the image. Depth of field is increased as the lens is stopped down.

LEFT—DEPTH OF FIELD AT F/32. **RIGHT**—DEPTH OF FIELD AT F/4.

depth of field preview. Camera function that briefly stops down the lens to the selected aperture setting to allow the photographer to gauge the depth of field that will be produced.

depth of field scale. Scale on the barrel of a lens that shows the near and far limits of depth of field that will be attained when the lens is set at a specific focus and f-stop.

DEPTH OF FIELD SCALE.

depth of focus. Ability of a lens to create an acceptably sharp image at different distances at a specific aperture.

derived image. Image created by sampling an original image file to a lower resolution, using lossy compression, or altering an image using one of various image-processing techniques. The resulting file usually contains less information than the original.

desaturate. To make the colors in an image less vivid.

descreening. An electronic process applied by a scanner or image-processing program to remove the moiré pattern that results when photographing a subject with a regular pattern (e.g., a subject wearing a striped shirt).

desensitizer. A dye or oxidizing agent used to reduce an emulsion's sensitivity to light.

designated flash. *See* dedicated flash.

deskewing. The process of using an image-editing program to straighten an image that has been crookedly scanned.

desktop. (1) Working area of a computer screen. (2) Equipment, such as a personal computer, suitable for use on a desk.

desktop color separation (DCS) file. *See* Photoshop DCS 1.0 *and* Photoshop DCS 2.0.

desktop picture. An image shown as a background on many home computers. May be built into the computer's operating system or selected from the owner's image collection.

desktop publishing. Production of printed material by means of a personal computer, graphics software, and a printer.

despeckle. To eliminate or reduce spots of dust introduced during capture or scanning.

destination profile. In a color conversion, the profile to which an image is converted.

destructive interference. A phenomenon in which the crest parts of one light wave overlap the trough parts of another wave, resulting in a wave of diminished amplitude.

detective camera. Victorian-era camera designed to resemble a pocket watch, binoculars, or Bowler hat, or one enclosed in a portable wooden box that was much more compact than the standard cameras of the time.

detent. A point of slight physical resistance encountered before the shutter button is fully depressed at which the camera records exposure or focus information. *See also* click stop.

developer. A chemical used in the darkroom to convert the exposed silver salts of a latent image into metallic silver, thereby creating a visible image.

developing tank. A lighttight container into which exposed film is loaded and developer is added for processing.

development. Treating negatives or photographic papers with various chemicals to produce a visible, permanent image.

development temperature. A variable in the darkroom processing of film. Manufacturers generally supply a recommended temperature for each film.

development time. The duration of time that a print is immersed in developer. Shorter development times produce images with lower density and reduced contrast.

device dependent. Software designed for use with a specific device. *See also* color space, device dependent.

device driver. A software component that manages direct interaction with a hardware device.

device independent. A file format or program that can be used with multiple computing devices to produce identical results. *See also* color space, device independent.

device profile. Values that describe how a given device perceives, produces, or displays colors. By comparing and adjusting for the color profiles of each device in a system, it is possible to maintain consistent color results throughout the process of capturing, editing, and outputting images. *See also* ICC profile, monitor profile, camera profile, scanner profile, printer profile, image profile, color space, *and* working space.

diamond. Gem chip set into a housing with a handle and used to score glass for breaking.

dialog box. An interactive window in image-editing programs that appears on-screen when some tools are activated, allowing users to adjust settings and customize the way the tool is applied.

Diana. *See* toy camera.

diaphragm. The internal mechanism of a lens made up of overlapping metal blades that allows the reduction of the aperture and thereby controls the amount of light that is allowed to strike the film or image sensor. The design of the diaphragm and the number of blades used varies from camera to camera.

diaphragm shutter. *See* leaf shutter *or* compound shutter.

diapositive. *See* slide.

diathermic mirror. Dichroic mirror used in slide projectors.

diazo. An abbreviation for diazonium compounds, which decompose under the influence of intense blue or ultraviolet radiation and produce an image in an azo dye.

dichroic. A term used to refer to a material that displays two colors—one by transmitted light, the other by reflected light.

dichroic filters. Glass filters treated with various vacuum-deposited metals or metal oxides to absorb light waves of certain frequencies. Commonly used in the production of color enlargements, dichroic filters allow for more precise and convenient color control than acetate or gel filters.

dichroic fog. A purplish-green area that appears on negatives during the formation of silver in the presence of an acid.

dichroic head. An enlarger head containing yellow, magenta, and cyan filters that can be moved into or out of the light beam in calibrated stages to change the color balance of the light.

didymium filter. A filter that contains traces of neodymium and praseodymium, two rare earth elements with certain wavelength absorption patterns. These filters enhance or strengthen reds and are often used to photograph nature scenes such as fall foliage or reddish landscapes.

differential focusing. Selecting camera controls that ensure minimum depth of field to limit image sharpness to a particular image area (e.g., the eyes in a portrait).

diffraction. Change in direction and intensity of light as it passes through an aperture, opaque surface, or other obstacle. When using tiny apertures, fringing may result.

diffraction filter. A colorless filter inscribed with a network of parallel grooves that break white light up into its component colors, imparting a prism-like effect to highlights.

diffraction grating. A specialized optical attachment designed to separate light into its constituent colors.

diffuse. Spread over a wide area.

diffused image. *See* soft focus.

diffused light. Light that has been reflected or passed through a translucent material to make it softer and eliminate glare or harsh shadows. Often used in portraiture.

LEFT—UNDIFFUSED LIGHT. **RIGHT**—DIFFUSED LIGHT.

diffuser. An accessory typically made of semitranslucent material, frosted acrylic, or loosely woven fabric that is attached to or positioned in front of a light source to disperse and soften the light falling on a scene or subject.

diffusion disc. A flat glass accessory inscribed with a pattern of lines or concentric rings that break up and scatter light from an enlarger or camera lens, softening detail in an image.

diffusion dithering. A type of dithering that employs random dots instead of patterns.

diffusion enlarger. An enlarger that evenly scatters light from multiple angles across the surface of the negative. Image detail is not as sharp as that produced with a condenser enlarger, but blemishes in the negative are minimized.

diffusion filter. Accessory used to increase the apparent softness on a subject or in a scene.

diffusion flat. *See* scrim.

digicam. Slang term for digital camera.

digital. (1) Method of representing information by binary digits, or "bits." Binary information has two states, "0" and "1," or "on" and "off," and can be easily processed by electronic devices. *Contrast with* analog. (2) A device or technology that relies upon the manipulation of information in binary code.

digital camera. A camera that captures light rays using an image sensor rather than film.

digital duplicates. Image copies produced by scanning an original analog image then processing the digital file using a digital printing or recording device.

digital envelope. A secure data "wrapper" that protects the contents of a data packet from being viewed by anyone other than the intended recipient.

digital film. *See* memory card.

digital filter. Software used to mathematically manipulate digital data to produce special image effects or to replicate effects traditionally produced by photographic (e.g., gelatin or glass) filters.

digital halftone. *See* halftone.

Digital ICE (Image Correction and Enhancement). A proprietary technology developed by Applied Science Fiction that allows scanners to prevent dust and scratches from being recorded during a scan.

digital-image filtering. *See* digital filter.

digital imaging. The recording of digital image information so that it can be viewed on a computer and edited (e.g., color corrected, retouched, dodged, burned, etc.) or treated with special effects using an image-editing program.

digital internegatives. Internegatives that are created by scanning the original transparency to create a digital image file, and then using a film recorder to record the image onto a negative film stock.

digital negative. Uncompressed and largely unmodified data from a camera's image sensor. *See also* raw format.

digital negative format (DNG). *See* Adobe DNG.

digital picture frame. A small LCD screen surrounded by a decorative frame that allows the user to upload images for display as a continuous image or a multi-image slide show.

digital plates. Printing plates made from digital data.

digital printer. Any printing device that translates digital data into hard copy prints.

digital printing. Printing using digital data.

DIGITAL PICTURE FRAME.
PHOTO COURTESY OF NIKON.

digital print order format (DPOF). A format that allows the photographer to embed printing information (e.g., which images to print and the number of copies) on the camera's memory card. Some direct photo printers use this information to automate printing as specified.

digital proofs. A proofing system reliant on digital data rather than film. This may include images printed on paper, presented online, recorded onto CD, or shown via slide show projection on a studio wall or a laptop computer.

digital shutter. *See* electronic shutter.

digital signal processor (DSP). Computer chip specially designed to quickly perform the complex mathematical calculations that are required to process digital images, sounds, etc.

digital slave unit. *See* slave flash.

digital SLR. A single-lens reflex camera that uses an image sensor to capture images. Also called a DSLR.

digital-to-analog converter (DAC). A device used to convert a digital (binary) code to an analog signal (current, voltage, or charges). Simple switches, a network of resistors, current sources, or capacitors may be used to create the conversion.

DIGITAL SLR.
PHOTO COURTESY OF CANON.

digital video disc. *See* DVD.

digital watermark. Data encoded into a digital image that contains copyright information. Well-designed watermarks can survive cropping, recompression, and image editing.

digital zoom. A simulated zoom effect whereby the camera's internal software enlarges an image area through interpolation. This process does not alter the focal length of the lens and results in a loss of image quality. *Contrast with* optical zoom.

digitize. To convert a photographic print into a binary form via a scanner so that the resultant image file can be stored and/or manipulated on a computer system.

digitizer. Device that converts analog data to a digital form.

digitizing tablet. *See* graphics tablet.

dilute albumen print. Variation of the albumen process in which the albumen is diluted with saltwater to reduce the gloss. This produces a matte image with fine detail and tonality.

dilution. The reduction in the strength of a liquid by mixing it with water.

dimensional stability. The ability of a medium to withstand shrinking or expanding over time.

dimensions. The height and width of an image or object, measured in centimeters or inches. In the United States, width is generally given first, but in Europe height is denoted first.

dimmer. Device used to reduce the brightness of a light source, usually resulting in a decrease in color temperature.

DIN (Deutsches Institut für Normung). The German industrial standards organization. *See also* DIN speed.

DIN speed. System developed by DIN, in which film speeds are indicated by a number and degree symbol. A 3-degree increase doubles the speed. Superceded by the ISO system.

diodes. The light-sensitive electronic elements used in digital capture. Diodes function as one-way valves that sense the presence or absence of light and create a digital signal that the computer converts into pixel values.

diopter. (1) Unit of measurement used to describe the focal length of a lens. One diopter is equal to a 1-meter focal length. (2) Device used to adjust the camera's viewfinder eyepiece to suit the photographer's eyesight.

dip and dunk. A film processing device with a deep tank containing developing chemicals into which film is dipped. Unlike some other processors, dip and dunk machines do not pull film through a shallow tank on rollers, so the risk of negatives being scratched is minimized.

dipper. A hook used to lower trays holding albumen and collodion plates into silver nitrate solution.

direct current. *See* DC.

direct image sensors. *See* Foveon X3 direct image sensor.

direct light. Unobstructed light that shines onto the subject and produces strong highlights and deep shadows.

direct memory access. The ability of a device to use memory without using a software interface.

directory folder. In computing, an icon resembling a file folder where other files are stored for data organization. These folders represent any drive or directory contents in the system.

direct photo printer. Photo printer equipped with a memory card reader so it can be used without a computer.

direct positive. A high-contrast positive image slide made from camera-ready originals without use of a negative.

direct positive print. A print made from a transparency, without an internegative, onto a direct positive color paper.

direct printing. *See* direct photo printer.

direct to plate. *See* computer to plate.

direct vision camera. A simple camera designed with a separate direct vision viewfinder and taking lens. Many direct vision cameras do not provide any form of focus aid. However, rangefinder cameras offer direct vision viewfinders as well as a rangefinding focus aid. *See also* direct vision viewfinder.

direct vision viewfinder. A simple window or reversed Galilean-type telescope the photographer looks through to gauge the field of view of the taking lens.

disc. Generic term used to refer to digital storage media like CDs and DVDs.

disc film. A film format introduced by Kodak in the 1980s that consisted of tiny square negatives mounted in a star-shaped pattern on plastic discs.

DISC FILM.

discharge lamp. A light source (e.g., an electronic flash) that provides illumination when an electrical charge is applied to gas particles in a glass tube.

discontinuous spectrum. *See* discrete spectrum.

discrete spectrum. A spectrum of wavelengths in which the patterns appear as distinct bright lines of different colors because there are large gaps between the wavelengths of some colors. Synonymous with discontinuous spectrum.

Disderi, Andre Adolphe-Eugene. *See* appendix 1.

dish development. The processing of film or photosensitive paper by immersing it in a shallow tray of developer and rocking the dish back and forth.

disk. A magnetic storage device (e.g., the hard disk built into a computer).

disk drive. Device used to store or retrieve information from a computer. Some drives feature a slot that allows the user to insert and remove a variety of media. Others, such as hard disks, may be permanently built into a computer or other housing.

disk operating system (DOS). Software used by computers to manage storage devices (e.g., hard drives, CDs, DVDs) and the information that is stored on them.

dispersion. A phenomenon whereby white light is separated into a spectrum of wavelengths, producing a rainbow effect around points and edges. Also called chromatic dispersion.

display technology. The type of technology used in monitors, such as CRT (cathode ray tube), LCD (liquid crystal display, LED (light-emitting diode), or gas plasma.

disposable camera. An inexpensive camera designed to be used only once, then returned to a lab for the production of prints and/or downloading of digital files. Also called a one-time-use or single-use camera.

DISPOSABLE CAMERA.
PHOTO COURTESY OF FUJIFILM.

distance symbols. Marks found on the focus controls of simple cameras. Used as an aid in obtaining accurate focus.

distortion. The inability of a lens to capture lines as straight across the entire image area. *See also* barrel distortion *and* pincushion distortion.

dithering. A setting on a digital device that alters the values of adjacent dots or pixels to create the appearance of an increased number of tonal values or colors to eliminate banding.

diverging lens. *See* negative lens.

D/log E curve. *See* characteristic curve.

Dmax. Maximum density. The most dense area that can be captured by a medium or image capturing device.

Dmin. Minimum density. The least dense area that can be captured by a medium or image capturing device.

DNG. *See* Adobe DNG.

docking station. A cradle in which a digital camera is placed in order to provide a connection to the computer. Docking stations often offer a one-touch button that begins the uploading of files from the camera to the computer.

CAMERA IN DOCKING STATION.
PHOTO COURTESY OF KODAK.

documentary photography. Capture of images that realistically depict actual situations. The subject of such work is often an event of sociological or political import, but the term may also be used to describe the capture of the activities surrounding special occasions such as birthdays, weddings, and other milestone events.

document profile. *See* image profile.

dodge. In film photography, preventing light from striking the paper in order to produce lighter tones. *See also* dodge tool.

LEFT—ORIGINAL IMAGE. **RIGHT**—IMAGE WITH DODGING ON TREE TRUNK.

dodge tool. In image-editing programs, a tool used to selectively lighten areas of the image over which it is passed.

DOF. *See* depth of field.

Doisneau, Robert. *See* appendix 1.

dolly. A small platform on wheels used to hold a heavy object, often a motion-picture camera.

domain. An area of a network over which administrative control is exercised.

domain name. A name by which a computer connected to the Internet is identified.

dominant wavelength. The wavelength of the color corresponding to the nominal notion of hue (i.e., perceived color).

dope. A retouching medium applied to negatives to achieve a suitable retouching surface.

DOS. *See* disk operating system.

dot. Smallest raster image element. *See also* dots per inch.

dot gain. A printing defect in which dots are rendered larger than intended, resulting in darker colors or tones.

dot matrix. In general, any arrangement of dots on a grid. However, the term is generally used to refer to a type of printer popular in the 1980s that produced images by applying a series of dots to a page via tiny electromagnetically activated wires.

dot pitch. Measurement used to determine the sharpness of a CRT monitor. The smaller the number, the finer the picture.

dots, halftone. Tiny symmetrical subdivisions of the printing surface formed by a halftone screen. *See also* halftone.

dots per inch (dpi). A measurement used to describe the dot density in a printed image. *See also* resolution.

double exposure. The recording of two photos in an image frame, usually done for special effect. *See also* multiple exposure.

double extension. A characteristic of large-format cameras that allows the bellows to be extended to twice the focal length of the selected lens. Useful for close-up photography.

double neutral density (ND) filter. *See* neutral density filter.

doublet. A lens design comprised of two elements grouped together. Sometimes the two elements are cemented together, and other times they are separated by an air gap. Examples of this type of lens include achromatic close-up lenses and high-quality magnifiers or loupes.

double transfer. In the carbon process, technique of transferring a print to a temporary support, then to a final support.

double truck. A layout in which an image (usually a horizontal or panoramic image) extends across and "bleeds" off the edges of two facing pages.

double-weight paper. A type of photographic paper with a relatively thick base. *Contrast with* single-weight paper.

download. To transfer a file from another digital device or the Internet to your computer.

downsampling. Reduction of the number of pixels in an image, resulting in a loss of detail. Synonymous with res down.

downsize. To reduce the file size of an image by downsampling and/or scaling down the dimensions of the image.

DPI. *See* dots per inch.

DPOF. *See* digital print order format.

drag and drop. The process of selecting and moving text, graphics, or photos to different locations in a digital document.

dragging the shutter. Selecting a shutter speed slower than the flash sync speed to allow more ambient light to register in the image. This enables the recording of detail in areas of the scene not illuminated by flash. *See also* night portrait mode.

DRAM. *See* dynamic random access memory.

driver. A software utility designed to tell a computer how to operate an external device like a printer or scanner.

drive speed. The speed (RPM) at which a drive mechanism rotates. The faster the drive speed, the faster data is transferred.

drop-in loading. In Advanced Photo System (APS) cameras, a feature that eliminates film-loading problems by automatically accepting the leaderless cassette and loading the film.

droplet. Format in which a Photoshop action can be saved to the computer. To apply the action, you simply drag an image icon or folder onto the droplet icon. Photoshop need not be open.

DROPLET ICON.

dropout. (1) A flaw in the image reproduction process in which image information is lost or not displayed. (2) An image comprised of pure black and pure white tones, with no intermediate gray values, usually created on high-contrast lith film. (3) In monitors and printers, pixels that do not register a proper value and instead appear black or white.

drop shadow. A shadow that is offset from an object or text. Used to create a sense of dimension.

DROP SHADOW.

drop shutter. The first shutter that allowed for instantaneous exposures. Usually consisted of a wooden track with a thin piece of wood with a hole in it, which was activated by hand or hose and piston and dropped in front of the lens.

drum camera. Specialized device used to record a brief event. The photographic film is wrapped around a drum that spins quickly as the shutter opens to make the exposure.

drum scanner. A high-quality image-capture device. The image that will be scanned is wrapped around a drum that spins quickly while a light source scans across it to capture a digital version of the image.

dry brush. An effect produced by slightly moistening a paintbrush with paint to apply streaked, not solid, paint. The effect can be replicated in many image-editing programs.

dry down. Term that refers to the degree to which a print darkens and becomes less contrasty once it has dried.

drying cabinet. Vented cabinet in which film is hung to dry.

drying marks. Areas of uneven density on film emulsion caused by uneven drying.

drying rack. A screened device upon which processed prints are placed faceup so that air can freely circulate and dry the paper. Also called a drying screen.

drying screen. *See* drying rack.

dry mounting. The process of affixing a print to a support by heating shellac tissue between the print and mounting board and applying pressure until the softened adhesive material hardens.

dry mounting press. *See* mounting press.

dry mounting tissue. *See* mounting tissue.

dry plate. A term used to refer to a gelatin-coated plate when the wet collodion process was popular.

dry plate process. A historic method that employed a glass plate coated with a light-sensitive gelatin-based emulsion.

DSLR. *See* digital SLR.

dual layer DVD. *See* DVD.

dulling spray. Product that creates a temporary matte finish on shiny surfaces, making them easier to photograph.

duotone. (1) Two-color halftone reproduction from a monotone image. (2) In Photoshop, a color model used to create monotone, duotone (two-color), tritone (three-color), and quadtone (four-color) images using one to four custom inks.

dupe. In film photography, a copy of a slide or transparency made without an internegative or special duplicating film.

duplex. (1) A scanner feature that allows the device to simultaneously scan both sides of a document. This requires two scanner cameras and often dual processing boards. (2) On some laser printers, a device that enables automatic double-sided printing.

dusting-on process. A traditional printing process that used a gum arabic–covered support coated with sugar, honey, or glucose sensitized with a bichromate. After exposure, the surface was brushed with dry pigment and sprayed with fixative.

dust removal system. *See* sensor cleaning system.

DVD (digital video disc). An optical storage medium that offers a storage capacity of 4.6GB. Discs may be capable of being written to only once (R) or multiple times (RW). There is not yet a single standard for DVDs; competing formats are denoted as "–R(W)" or "+R(W)." Cross-compatible discs are often noted as "±R(W)." Dual-layer DVDs (DVD+R DL or DVD+R9) are also available and offer a storage capacity of up to 8.55GB.

DVD burner. A drive that allows you to save digital image files, videos, word-processing files, music, and other file types onto a DVD for archival purposes.

DVD+R. *See* DVD.

DVD–R. *See* DVD.

DVD+R9. *See* DVD.

DVD+R DL. *See* DVD.

DVD+RW. *See* DVD.

DVD–RW. *See* DVD.

DX coding. A bar code printed on a 35mm film cassette that tells the camera what ISO should be used to produce correct light metering and exposure.

dyad. Two complementary colors, or any two colors that are considered visually harmonious.

dye. A soluble substance used to add color to a material.

dye bleach process. *See* dye destruction process.

dye cloud. Microscopic point of chromogenic dye formation.

dye coupling. A film photography process in which a colored image is created by the reaction between the by-products of color development and couplers.

dye destruction process. A system of color reproduction in which dyes in the image are selectively reduced via bleaching. The Ilfochrome process is the best-known example of this method. Also referred to as the dye bleach process.

dye-image monochrome films. Black & white negative films designed for color processing. *See also* C-41 process.

dye sensitization. To modify blue-sensitive materials to make them responsive to green, yellow, orange, or red light. Also called optical sensitization.

dye-sublimation printer. A printing technology that rapidly heats dry colorants held in close contact with a receiving medium. The heat turns the colorants into a gas, which is then transferred to the receiving layer and solidifies. High-end models produce continuous-tone images that are almost indistinguishable from a chemically produced photograph.

dye toner. *See* dye toner, straight *and* mordant.

dye toner, straight. Dye that does not convert the silver and impacts all areas of the print equally. *See also* mordant.

DYE-SUBLIMATION PRINTER.
PHOTO COURTESY OF CANON.

dye transfer process. A method of producing color photos using three color-separation negatives. The three negatives are used to make positives, which are dyed in subtractive primaries and printed in register.

dynamic random access memory (DRAM). RAM that requires the computer's attention to maintain the storage of data. The memory is lost when the computer is turned off.

dynamic range. The maximum range of tones, from darkest shadows to brightest highlights, that can be produced by a device or perceived in an image. Also called tonal range.

dynamism. Photographs captured to convey a sense of movement and action.

E-6 process. The most common slide-film processing system used today, developed for Kodak's Ektachrome line. Though similar films made by other manufacturers have different chemical compositions, many support E-6 processing.

easel. The base portion of an enlarger designed to hold photographic paper during exposure, usually equipped with an adjustable metal mask for framing.

Eastman, George. *See* appendix 1.

Eastman Kodak. *See* Kodak.

Eberhard effect. In a developed image, a border effect that appears as a dark line along a high-density edge and a light line along a low-density edge. It occurs most often in plates developed flat in a tray of solution that is insufficiently agitated.

ecological glass. Optical glass created using earth-friendly materials (e.g., titanium instead of lead).

edge detection. Software that finds the points of an image at which luminous intensity sharply changes, a quality generally exhibited at an object's edges. Used by some sharpening filters.

edge lighting. Light positioned behind and to one side of a subject to provide separation from the background.

edge numbers. Data (typically frame numbers, film manufacturer, etc.) printed by light at regular intervals along the side of 35mm roll films and visible only after the film is developed.

Edgerton, Harold. *See* appendix 1.

edge sharpening. Increasing local contrast at points in the image where significant color changes occur, while leaving the balance of the image unaffected.

edging. The process of applying dilute albumen, gelatin, or rubber solutions to the edge of glass plates to keep the collodion or gelatin binders from peeling.

editorial photography. Photography created and used to support the written word (e.g., in magazine articles).

effective aperture. Of all the light rays striking the first lens element, the diameter of the beam that will actually pass through the lens at a given f-stop setting.

effective focal length. *See* focal length multiplier *and* 35mm equivalent focal length.

effective megapixels. The actual number of pixels that comprise the viewable image captured by a digital camera. This may be lower than the total number of megapixels, because there are often a number of masked-off pixels at the edge of image sensors. These pixels are typically used to establish a baseline (totally dark) from which the camera calculates light levels.

effective pixels. *See* effective megapixels.

effective resolution. The resolution of an image once it has been digitally scaled. When an image is enlarged, the effective resolution is decreased (unless interpolation is employed); when an image is scaled down, there are more pixels per inch, so the image has a higher effective resolution.

effective watt-seconds. Rating system used to describe the power of an electronic flash. True watt-seconds measure the electrical power discharged with each flash. Effective watt-seconds describe the actual light output.

effects filter. An optical filter attached to a lens and used to produce diffusion, multiple-image photos, or any of a number of other special effects. *See also* digital filter.

Efke. A brand of films, photo papers, and chemicals manufactured by Fotokemika d.d., in Croatia.

EF mount. Bayonet-style mount that allows EF (electrofocus) lenses to mount on any of the Canon EOS cameras. There are no mechanical links between moving parts in the lens and the camera, and aperture and focus settings are controlled via electrical contacts, with motors inside the lens.

EGG CRATE.

egg crate. Large grid attached to the diffusion surface of a softbox or other light to create a more directional light source. *See also* swimming pool *or* fish fryer.

EI. *See* exposure index.

eighteen-percent gray. *See* middle gray.

EIS. *See* electronic image stabilizer.

Eisenstaedt, Alfred. *See* appendix 1.

Ektachrome. Kodak's color transparency process. *See also* E-6 process.

EL. (1) Exposure lock. Synonymous with automatic exposure lock. (2) *See* electroluminescent. (3) Line of Hasselblad cameras.

electro-focus. *See* EF mount.

electroluminescence. The direct conversion of electrical energy into light.

electroluminescent (EL). A lighting system commonly used as backlights in cameras or watches that generates light but virtually no heat.

electromagnetically controlled shutter. A shutter operated by an electromechanical system (a motor involving electromagnets). Most automated cameras feature shutters of this type.

electromagnetic radiation. *See* electromagnetic spectrum.

electromagnetic spectrum. The massive range of frequencies or wavelengths over which electromagnetic radiation extends. Only wavelengths between roughly 400 nanometers (nm) and 700nm are visible. Other wavelengths are photographically useful but cannot be perceived by human vision. *See also* infrared, ultraviolet, visible light, X-ray, *and* spectrum.

0nm	100nm	200nm	300nm	400nm	500nm	600nm	700nm	800nm	900nm	1000nm	1100nm

ULTRAVIOLET | VISIBLE | NEAR INFRARED

THE PHOTOGRAPHICALLY USEFUL RANGE OF THE ELECTROMAGNETIC SPECTRUM.

electronic display. The presentation of images on a computer monitor.

electronic document. An analog document that has been scanned and digitized, or one originally created on a computer. HTML and PDF are popular electronic document formats.

electronic flash. Artificial light source consisting of a gas-filled tube that is fired by an electrical charge. The flash can be mounted directly on the camera hot shoe (which links the shutter firing to the flash firing) or on a bracket or stand connected to the camera via a sync cord. Also known as a flash gun, strobe, or speedlight.

LEFT—ELECTRONIC FLASH UNIT DESIGNED FOR ON-CAMERA USE. RIGHT—HANDHELD ELECTRONIC FLASH UNIT. PHOTO COURTESY OF METZ.

electronic image stabilizer (EIS). A feature built into some cameras that minimizes the impact of camera shake.

electronic media. Any type of media used to publish information digitally rather than in print.

electronic photography. A term formerly used to refer to what we now know as digital photography.

electronic publishing. The creation of a digital document, typically comprised of text and images, for display on the Internet (e.g., as a web page) or via a computer presentation program.

electronic rangefinder. A camera feature that presents the photographer with focus-assist symbols for use when manually focusing. *See also* automatic focus sensor.

electronic retouching. The refinement of digital images (e.g., softening wrinkles or editing out blemishes in a portrait) via an image-editing program before the image is printed.

electronic shutter. A shutter system timed by electronic circuitry rather than mechanical action. Synonymous with digital shutter.

electronic viewfinder. A small LCD that allows the photographer to compose an image and preview camera settings such as shutter speed and aperture.

electrophotography. A technology used in photocopiers that allows for the creation of images by altering the electrical properties of the sensitive material (e.g., an electrostatically charged drum) as a result of the action of light.

electro selective pattern (ESP) metering. A metering system similar to matrix metering.

element. (1) A single piece of glass that makes up one component of a compound lens system. (2) Substances that cannot be broken down by chemical processes. Identified by a one- to three-letter symbol. (Li, for example, represents lithium.)

Elements. *See* Adobe Elements.

ellipse tool. *See* shape tool.

elliptical dot. A type of halftone screen dot used in printing noncontinuous-tone images. Using an elliptical (as opposed to circular) dot shape sometimes produces better tonal gradations.

Elon. Eastman Kodak's trade name for methylaminophenol sulfate (more commonly known as Metol). *See also* Metol.

e-mail. An electronic file that can be sent between computers worldwide. Other files (e.g., photographs, documents, etc.) can be attached to and sent along with an e-mail.

embedded profile. An ICC profile stored in an image file that defines how the color data should be interpreted.

embedding. Applying a color profile to an image as a point of reference for when the image is taken to the next device in the workflow or supplied to another user. Synonymous with tagging.

embossing. Effect used to make an element (e.g., a graphic or photograph) appear to be raised above the surrounding paper's flat surface. *See also* bas relief.

Emerson, Peter Henry. *See* appendix 1.

emery. A stick coated with an alumina, silica, or iron powder used to take sharp edges off of glass plates used in the wet plate process. Also used to produce tooth on the surface of varnished collodion negatives.

emissive object. An object that emits light, usually as a result of a chemical reaction (e.g., the sun's burning gasses or a light-bulb's heated filaments).

emulsification. The dispersion of fine droplets of one substance in a liquid in which it is not soluble.

emulsion. The light-sensitive component of film or photographic paper. In black & white films, the emulsion generally consists of fine silver halide grains suspended in gelatin, which blacken when exposed to light. Color film emulsions contain molecules of dye in addition to silver halides. Emulsion can also be purchased in liquid form and applied to various substrates.

emulsion number. *See* batch.

emulsion side. Side of the film that is coated with emulsion. In contact printing and enlarging, the emulsion side of the film (the dull side) and the emulsion side of the photo paper (shiny side) should face one another.

emulsion transfer. *See* Polaroid transfer.

enameling. Permanently transferring images onto enameled metal plates or forming images in enamel on uncoated plates.

encapsulated PostScript (EPS). *See* EPS.

encaustic paste. A wax or varnish coating applied to salted prints to produce richer depth of tone and enhance archivalness.

encryption. A technique used in preventing unauthorized persons from viewing sensitive information (such as credit card numbers) as it is being uploaded or downloaded.

endoscope. A flexible fiber-optic device that allows for image capture in small spaces or areas that are difficult to access.

energiatype. *See* tin-type process.

engagement portrait. A portrait of a couple (usually posed) made prior to their wedding day. Often used in a newspaper engagement announcement and sometimes displayed at the wedding, incorporated in a family album or wedding album, etc.

enhanced-back printing. An Advanced Photo System (APS) feature that records picture information such as the date and time, exposure settings, etc. Photo printing equipment could

read this data to determine the print's aspect ratio, print information on the back (or, rarely, the front) of the photograph, or to improve print quality. *See also* Advanced Photo System.

enhanced parallel port (EPP). A high-speed, two-way computer port used by some digital cameras and scanners.

enhancement. To improve the overall quality of a photo by correcting color, cropping, retouching, etc.

enhancing filter. *See* intensification filter.

enlargement. A photograph printed larger than the original negative used to produce it. Made by projecting an enlarged image of the negative onto light-sensitive paper.

enlargement ratio. Ratio used to express the amount of linear (not area) enlargement between a print and the negative from which it is printed.

enlarger. A device used to project an image of a negative onto light-sensitive paper. An enlarger typically consists of a flat base (upon which a sheet of light-sensitive paper is placed) and an enlarger head. Light shines down from the light source, passes through the negative, and exposes the paper below. Condenser enlargers use condenser lenses to collimate the light output from an incandescent bulb. Ground glass diffuser enlargers contain ground glass plates to diffuse the light from an incandescent bulb. Cold cathode enlargers also use ground glass diffusers but employ a fluorescent bulb rather than an incandescent one.

ENLARGER. PHOTO BY BARBARA A. LYNCH-JOHNT.

enlarger head. The portion of an enlarger that contains the light source, negative carrier, and lens. An enlarger head also contains a filter drawer or a built-in filtration system.

enlarging easel. *See* easel.

enprint. A commercially produced enlargement (usually 3.5 inches wide) with dimensions of a fixed ratio, output via an automated printer.

entrance pupil. From the front of the lens, the diameter of the aperture through which light enters the camera. Used to calculate the f-stop of the lens. Synonymous with effective aperture. *Contrast with* exit pupil.

environmental portrait. A portrait created somewhere other than in a studio (often, the subject's home or workplace), typically to show a more personalized view of the subject.

EOS. A popular line of Canon cameras.

eosin. A generic name referring to the phthalein group of sensitizing dyes.

EPP. *See* enhanced parallel port.

EPS (Encapsulated PostScript). A file format based on Adobe Systems' PostScript that is capable of containing both vector and bitmap graphics. Supported by most graphic, illustration, and page-layout programs. *See also* PostScript.

Epson. Manufacturer of printers, scanners, desktop computers, and other electronics.

equalization. An image processing technique in which the lightest pixel in the image is mapped to white and the darkest pixel is mapped to black. This expands the range of tones or colors in an image, producing a more pleasing image.

equivalent focal length. The distance measured along the optical axis of the lens from the rear nodal point to the plane of best average definition over the entire field used in a camera. Synonymous with effective focal length *and* 35mm equivalent focal length. *See also* focal length.

erase. In digital imaging, to partially or fully remove information from memory or storage. *See also* eraser tool.

eraser tool. In image-editing programs, a tool used to change the current color of pixels to the background color. *See also* background eraser tool *and* magic eraser tool.

ergonomics. The design of a product to ensure it is as easy and comfortable to use as possible.

Ernst Leitz GmbH. *See* Leica.

erotic photography. The capture of images designed to arouse sexual desire in the viewer.

erythrosine. A dye sensitizer for the yellow-green and yellow wavelengths for collodion and gelatin emulsions.

ESP (electro selective pattern) metering. *See* electro selective pattern metering.

etching. Dissolving away selected areas (e.g., imperfections) of a surface while shielding the other portions with a mask. Etching is used as a creative drawing medium and in making halftone plates on copper or zinc.

etching knife. In traditional retouching, a tool used to reduce the density of a negative in microscopic dimensions.

ETCHING KNIVES AND ABRADING TOOLS. PHOTO BY BILL HURTER.

ether. A liquid compound used in combination with ethyl alcohol as a solvent of cellulose nitrate when making collodion.

ethyl alcohol. A clear liquid used in many applications: (1) Combined with ether, it served as a solvent of cellulose nitrate when making collodion. (2) A component of spirit-based varnishes used to coat photographic plates. (3) Used to fill spirit lamps, which were employed to heat liquids and plates before varnish was applied. (4) Added to gelatin emulsions to promote archival stability.

E-TTL. *See* evaluative through-the-lens exposure system.

Euroscale. CMYK working spaces used in the European printing industry for printing to coated and uncoated papers.

EV. *See* exposure value.

evaluative metering. Computerized light metering system that divides an image into multiple zones, examines the light levels in each zone, and then applies algorithms to determine the best exposure setting. Synonymous with matrix metering.

evaluative through-the-lens (E-TTL) exposure system. A type of exposure system that uses a brief pre-flash before the main flash is fired to determine a more accurate exposure.

Evans, Frederick Henry. *See* appendix 1.

Evans, Walker. *See* appendix 1.

evaporating dish. A wide dish with a spout on one end used in the darkroom to prepare various chemistries.

ever-ready case. A camera case with a hinged front flap that, when opened, uncovers the lens, viewfinder, and camera controls so that the camera may be operated while inside the bag.

everset shutter. A shutter type that requires the depression of a single button to tension and fire the shutter.

exchangeable image file (EXIF). Format created by the Japan Electronic Industry Development Association (JEIDA) for digital-image marker tags (called metadata) that contain useful information about the photo (e.g., camera, shutter speed, aperture, metering mode, focal length, ISO, white balance, etc.).

exchange club. A group of photographers who share their favorite images and techniques with each other.

excitation light. A high-energy (short-wavelength) light source used in fluorescence photography. This light causes the electrons of the subject's atoms to be temporarily raised to higher-energy orbits. When they naturally return to their original orbits, energy is released in the form of light.

exhausted. A thoroughly used-up chemical solution that is no longer able to produce its intended effect.

EXIF. *See* exchangeable image file.

existing light. *See* ambient light.

exit pupil. From the image side of the lens (the focal plane), the diameter of the image (beam of light) that passes through the aperture. This is one factor used to calculate the f-number of the lens. *Contrast with* entrance pupil.

expansion board. In a computer, a circuit board that fits into an expansion slot on the motherboard. Some are installed during the computer's manufacture, and others may be added at a later time to enhance functionality. *See also* expansion slot.

expansion slot. A receptor on the motherboard that accepts the pins of an expansion board.

expiration date. The "best before" date stamp on most film boxes. Indicates the date before the film should be used to ensure its published speed and contrast are maintained.

ExpoDisc. A white-balance filter that collects light from a 180-degree angle and averages it to ensure proper color rendition when a custom white-balance setting is required.

EXPODISC.

export. To transfer data from one device or piece of software to another (e.g., moving images stored on a memory card to a hard drive). *Contrast with* import.

exposure. Allowing light to strike the surface of a photosensitive material in order to produce an image. The amount of light that strikes the material is controlled by the shutter speed, aperture size, and ISO rating. *See also* automatic exposure mode *and* manual exposure mode.

exposure bracketing. *See* bracketing.

exposure compensation. Altering a camera's exposure setting to be more or less than the camera's autoexposure system thinks the exposure should be. Exposure compensation is also possible on many electronic flash units. Also known as exposure value compensation.

exposure factor. A number by which the exposure indicated for an average subject and/or processing should be multiplied to ensure desirable results in non-average conditions. Not normally used with through-the-lens (TTL) exposure meters.

exposure index (EI). Numeric description used to indicate a film's sensitivity to light and also the film sensitivity setting on a camera. Often referred to as the film speed or ISO rating.

exposure latitude. Amount by which it is possible to over- or underexpose light-sensitive material and, with standard processing, achieve an acceptable image.

exposure lock. A feature on many cameras that allows you to lock in an exposure setting for a duration of time, despite changing light conditions. The feature is often activated by depressing the shutter halfway. (With autofocus cameras, this may also lock the focus distance; consult the user's manual.)

exposure meter. Instrument used to measure the intensity of light to determine the shutter and aperture setting required to obtain correct exposure. Some camera models are equipped with built-in meters, but accessory meters are available. *See also* incident light meter, reflected light meter, *and* spot meter.

exposure mode. A camera setting designed to help photographers ensure the best-possible exposure. These vary from camera to camera but may include:

EXPOSURE MODE DIAL.

manual: A nonautomatic mode of operation in which the photographer must set the shutter speed and aperture. Typically represented by the letter M.

full program mode: A mode of operation in which the camera automatically selects the shutter speed and aperture. The results are correct in a majority of cases. Typically represented by the letter P.

aperture priority: A mode of operation in which the photographer selects an aperture setting and the camera determines the shutter speed required for proper exposure. Typically represented by the letter A.

shutter priority: A mode of operation in which the photographer selects the shutter speed and the camera determines the aperture required for proper exposure. Typically represented by the letter S.

exposure setting. The aperture and shutter speed combination used to allow light to strike the film or image sensor and record an image in a camera.

exposure time. The duration of time a light-sensitive material is exposed to light.

exposure value (EV). A scale of numbers that serves as a shorthand notation for all combinations of shutter speed and aperture that result in the same exposure.

exposure value compensation. *See* exposure compensation.

Expressionism. *See* appendix 2.

extended graphics array. *See* XGA.

Extensible Metadata Platform. *See* XMP.

extension bellows. A device used to create the additional separation between the lens and image plane that is required for close-up photography.

extension. A three- or four-letter sequence following a file name (and separated from it by a period) used to indicate the format of the file. *See also* file format.

EXTENSION TUBE.

extension tube. A tube inserted between the lens and camera body to provide increased magnification for macrophotography. *Compare with* bellows.

external flash. A flash unit that is controlled via a cable, hot shoe, or other means.

external modem. A modem that resides outside the computer and attaches to it via a cable.

extinction meter. Predecessor to today's electronic exposure meters. To obtain an exposure reading, photographers would look through the meter, manipulate a control to admit more or less light until it became just visible, then read the calibrations on the meter to determine the recommended exposure settings.

eye cup. A rubber ring positioned around the camera eyepiece that reduces the amount of stray light entering the viewfinder and provides some cushioning for the user.

eyedropper tool. In image-editing programs, a tool used to collect a sample of a color from a source so that it can be used as the new background or foreground color or added to the program's color palette. *See also* color sampler tool.

eye-level viewfinder. A device on a camera that allows the photographer to hold the camera to their eye to compose the image. *Contrast with* waist-level viewfinder.

eyelight. *See* catchlight.

eyepiece. The part of the viewfinder into which the photographer peers to view the subject or scene. Also called an ocular.

eyepiece shutter. A sliding or rotating cover built into some cameras that blocks light from entering the viewfinder eyepiece.

eye relief. The distance, in millimeters, that an optical device must be held from the eye for the full field of view to be comfortably observed. Viewfinders with short eye relief require pressing the eye directly onto the viewfinder to see the full scene. Longer eye relief is beneficial to photographers who wear glasses.

eye-start automation. A camera feature that automatically activates/deactivates the autofocus and autoexposure when the photographer brings the camera to their eye.

F

F. A classic Nikon camera, introduced in 1959. The camera (and subsequent models) used a basic bayonet lens mount design, also known as Nikon F.

face recognition. A camera technology offered in many point-and-shoot cameras that detects the triangle of the eyes and nose and automatically selects an optimal focus on the face.

factor. *See* filter factor.

fading. A decrease or change in the color density of an image. Accelerated by exposure to sunlight.

Fahrenheit. A nonmetric system of temperature measurement devised by D. G. Fahrenheit. The scale defines 32 degrees as the freezing point of water and 212 degrees as the boiling point of water. This system of measurement

IMAGE EXHIBITING FADING.

is often used in the darkroom, where precise temperature control of the chemistries used is critical.

fair use. A clause in copyright law that allows for certain uses of parts of a copyrighted work—for criticism, journalism, research, scholarship, and teaching. What constitutes fair use is highly variable and best determined by an attorney.

falling front or back. Camera movements that shift the center of the lens away from the center of the image-recording area, allowing for correction of converging verticals and other effects.

falloff. (1) The decrease in light intensity as the distance from the source increases. (2) Darkening toward the outer areas of a negative or print due to a decrease in light intensity on these areas. This is one means of creating a vignette.

false attachment. A compositional technique in which part of one object is seen behind another so that lines, shapes, or tones seem to join up. Used to produce images in which foreground and background objects appear to occupy the same plane.

false ceiling. A translucent material stretched above a set that transmits light but appears solid from below.

false color. A type of color film or printing paper designed or processed in such a way that colors in the final image do not accurately represent the colors in the original source.

Faraday shutter. A shutter that consists of two crossed polarizers divided by dense flint glass within a magnetic coil. When a voltage passes through the coil, it changes the plane of polarization and allows light to pass through the second polarizer. Allows shutter speeds of about 1 microsecond, making it useful in high-speed photography. Also called a magneto-optical shutter.

far infrared. Infrared radiation with wavelengths beyond 1200nm. Wavelengths in this range are not perceptible to photographic cameras. *See also* near infrared *and* infrared.

Farmer's reducer. A common type of cutting reducer comprised of potassium ferricyanide and sodium thiosulfate used to decrease the amount of silver in a developed image. Used in traditional black & white photography and named after its inventor, English photography instructor E. Howard Farmer.

fashion lighting. Soft, nearly shadowless lighting produced by placing the main light on or very close to the lens axis.

FASHION LIGHTING. PHOTO BY JEFF SMITH.

fashion photography. Creating images of models wearing clothing or accessories. Often made for fashion magazines.

fast film. Film with a high sensitivity to light (such as ISO 800 and 1600) and often an increased appearance of grain.

fast lens. (1) A lens with a very wide maximum aperture (small f-stop number). These can be used in lower light levels and produce a brighter viewfinder image. (2) The operating speed of a lens with an autofocusing motor.

fatigue. A loss of efficiency, sensitivity, or response of a meter when used in low light immediately after use in bright light.

FD. A manual lens system manufactured by Canon in the 1970s and 1980s. Superseded by Canon's EOS system.

feathering. (1) An image-editing process that allows for the softening of the edge around a selection. Used to seamlessly blend elements in a composite image. (2) To adjust a light source so that its dim edge is used to illuminate the subject.

Fellig, Arthur. *See* appendix 1 (Weegee).

felt trap. Black fabric at the opening of a 35mm film roll that prevents light from entering and exposing the film.

ferric ammonium citrate. Compound combined with potassium ferricyanide and used to sensitize cyanotype paper. Also used for blue toning and lantern slides.

ferric ammonium oxalate. Compound combined with potassium ferricyanide in the cyanotype printing process. Also used as a cold developer for the printing-out platinum process.

ferric chloride. A bleaching chemistry used on negatives. *See also* bleach.

ferric cupric process. An iron salt process that produces a range of red and purple tones.

ferric gallic process. An iron salt process used to create a direct-positive image of black lines on a white background.

ferric oxalate. Highly light-sensitive iron salt used in the platinum and kallitype processes.

ferrotype process. *See* tin-type process.

ferrous ammonium sulfate. Compound used as a developer in the wet collodion process. Considered more stable than ferrous sulfate.

ferrous nitrate. Compound used as a developer in the collodion process, which whitens the reduced silver.

ferrous oxalate. One of the first developers for silver bromide gelatin plates.

ferrous sulfate. Reducing agent used in the wet collodion process. To prevent reduction of nonimage silver, it was used with an acid or organic restrainer. Synonymous with iron sulfate, green vitriol, copperas, and protosulfate of iron.

festoon. Long, continuous loops of machine-gathered gelatin-emulsion coated papers, hung from poles to save space.

FF. *See* full frame.

fiber-based paper. Water-absorbent, light-sensitive photographic paper that lacks a resin coating. The processing times required for fiber-based papers are longer than for other papers, but the resulting images are more archival. Also called fiber paper. *Contrast with* resin-coated paper.

fiber optics. Optical system that uses glass or transparent plastic fibers to transmit data in the form of pulses of light. The medium suffers little signal loss and transmits data over long distances at a high speed. Also used for lighting areas when access by more standard sources is difficult or impossible.

fiber paper. *See* fiber-based paper.

field camera. Sheet film camera, suitable for location shoots, that operates in much the same way as a view camera and has similar features. *See also* view camera *and* technical camera.

field curvature. A common lens aberration or defect that causes an image to be formed along a curved, rather than flat, plane. This usually results in image blur.

field lens. A simple lens positioned at or near the focal plane of another lens. This may flatten the image from the primary lens and can prevent darkening in the corners.

field of view. The area of a subject or scene taken in by a given lens. This varies from lens to lens and is dependent on the lens's focal length.

figure study. Portrait of a nude or seminude subject, often created as an artistic exploration of lighting or composition.

file. A discrete group of digital data organized logically into a single unit (e.g., a digital image or text document).

file converter. Hardware or software used to convert files from one format to another that a specific application can read.

file format. The "language" in which a digital image or other digital document is written. The format tells an application how

to handle the data in a file so that it may be opened and displayed correctly. *See also* extension.

file server. A computer on a local area network (LAN) used to store files shared among the network's users.

file size. The amount of memory or disk space required to store and/or process a digital file. The file size of a digital image is largely dependent upon its resolution and file format.

▼ 📁 Chapter 04	Nov 26, 2005, 11:34 AM	7.4 MB	Folder
📄 Photo 8.jpg	Nov 18, 2005, 5:45 PM	312 KB	Adobe Photoshop JPEG file
📄 Photo 9.jpg	Nov 18, 2005, 5:52 PM	140 KB	Adobe Photoshop JPEG file
📄 Photo 10.jpg	Nov 17, 2005, 3:27 PM	2.2 MB	Adobe Photoshop JPEG file
📄 Photo 11.jpg	Nov 17, 2005, 3:36 PM	220 KB	Adobe Photoshop JPEG file
📄 Photo 12.jpg	Nov 17, 2005, 2:58 PM	956 KB	Adobe Photoshop JPEG file
📄 Photo 13.jpg	Nov 17, 2005, 2:59 PM	224 KB	Adobe Photoshop JPEG file
📄 Photo 14.jpg	Nov 26, 2005, 11:07 AM	912 KB	Adobe Photoshop JPEG file
📄 Photo 15.jpg	Nov 26, 2005, 11:09 AM	132 KB	Adobe Photoshop JPEG file
📄 Photo 16.jpg	Nov 18, 2005, 6:04 PM	1.1 MB	Adobe Photoshop JPEG file
📄 Photo 17.jpg	Nov 18, 2005, 6:05 PM	224 KB	Adobe Photoshop JPEG file
📄 Photo 18.jpg	Nov 18, 2005, 6:09 PM	836 KB	Adobe Photoshop JPEG file
📄 Photo 19.jpg	Nov 26, 2005, 11:34 AM	232 KB	Adobe Photoshop JPEG file

FILE SIZE.

file transfer protocol. *See* FTP.

fill. (1) In image-editing, to apply color, a pattern, or other data across a selected image area. (2) *See* fill-in *and* fill flash.

fill factor. A ratio that describes the size of the light-sensitive photodiode relative to the pixel's surface. As extra electronics are required around each pixel, the fill factor is generally very small, especially for active pixel sensors, which have more per-pixel circuitry. To combat this problem, an array of microlenses is often added to the top of the sensor.

fill flash. The use of flash illumination to supplement ambient light and fill in (add light to) shadows when subjects are backlit, illuminated by high-contrast lighting, or in shadow.

LEFT—WITHOUT FILL FLASH. **RIGHT**—WITH FILL FLASH.

fill-in. A secondary light source (often flash or reflectors) used in tandem with the main light to add light to dark shadow areas of the subject. Called fill flash when electronic flash is used.

fill light. Any source of illumination used to lighten shadows and control contrast and lighting ratios.

film. A thin, transparent, flexible acetate or polyester base, coated with light-sensitive emulsion used in a camera to record a photographic image. *See also* negative *and* reversal film.

film advance mode. *See* burst mode *and* single shooting mode.

film back. On some medium-format cameras, an interchangeable component that houses the film and part of the film transport mechanism, enabling you to easily switch from one film stock to another without having to rewind one roll of film and spool the next. In film photography, Polaroid (instant film) backs are often used to preview the effects of a lighting setup.

film base. The transparent acetate or polyester portion of film, which is coated with light-sensitive emulsion.

film chamber. The cavity within the camera body in which film is housed.

film chamber lock. A safety feature available on some cameras that prevents the photographer from opening the camera back if there is unwound film in it.

film characteristic curve. *See* characteristic curve.

film clips. Metal or plastic clips used to hold drying film straight to prevent curling.

film dryer. A temperature-controlled device that gently fans newly developed film for faster drying.

film edge marking. *See* code.

film holder. (1) *See* film back *and* film pack. (2) A lighttight device used to store film. (3) A device used to support film for scanning.

film leader. *See* leader.

film loader. A device used to transfer bulk film into a cassette.

film notches. *See* notching code.

film pack. A container used to hold multiple sheets of film. When it is affixed to the camera, the photographer pulls a tab to remove an exposed sheet of film and replace it with another. Commonly used with Polaroid film.

film plane. The position of the film within the camera or film magazine. Focusing distances are measured from this point.

film plane mark. At the top of some camera bodies, a small circle bisected by a long line that indicates the location of the film plane. Useful to macrophotographers, who sometimes need to know its precise position. Synonymous with focal plane mark.

film pressure plate. In a camera back, a mechanical component that, when closed against the film guide rails, forms a tunnel that ensures the film is flat for optimal sharpness.

film rails. In a roll-film camera, raised metal or plastic sections that support the film as it runs between the shutter opening and pressure plate.

film recorder. A device used to output digital images onto film (often, to create slides). CRT recorders create the images by means of a cathode ray tube and RGB filters; drum-based recorders use white light or lasers to output the images.

film reflectance. A measure of the light reflected off of the film's surface. Useful to consider in a dedicated flash system, where the sensor measures the light reflected from the film plane.

film retrieval tool. Small plastic device inserted into the film cassette to pull out the leader.

film safe. Box designed to protect film from dust, moisture, and the X-rays used in airport security scanning devices.

film scanner. A device used to scan slides and negatives to produce a digital image.

film sensitivity. *See* film speed.

film speed. Number used to describe an emulsion's sensitivity to light. Films with a higher ISO value have a higher sensitivity to light; films with lower ISO values are less sensitive to light. *See also* ISO.

film tongue. *See* leader.

FILM SCANNER.
PHOTO COURTESY OF NIKON.

film trailer. The piece of protective film following the exposed frames in a roll of film.

film winder. *See* winder.

film writer. *See* film recorder.

filter. (1) A piece of colored glass, gelatin, plastic, or other material that attaches to or over the camera or enlarger lens to selectively absorb (or otherwise alter) the light passing through it. Filters can be used to enhance color or contrast, remove reflections, reduce haze, soften focus, or produce a variety of special effects. (2) A device used in image-editing programs to apply a specialized effect. (3) Papers or cotton placed in the neck of a funnel when pouring chemistries.

filter adapter. *See* step ring.

filter factor. Loss of light caused by the use of a filter over the camera lens. To compensate, the unfiltered exposure reading must be multiplied by a factor (normally noted on the filter or in its documentation) to ensure a correct exposure. This process is unnecessary with through-the-lens (TTL) metering systems if the filter is attached during the metering process.

FILTER FACTOR	EXPOSURE INCREASE (IN STOPS)	FILTER FACTOR	EXPOSURE INCREASE (IN STOPS)
1	0	4	2
1.2	⅓	5	5⅓
1.4	½	6	2⅔
1.5	⅔	8	3
2	1	10	3⅓
2.5	1⅓	12	3½
2.8	1½	16	4
3	1⅔	32	5

FILTER FACTORS.

filter frame. *See* filter holder.

filter holder. A device that attaches to the front of the lens and has multiple slots to accept round and/or square slide-in filters. Synonymous with filter frame.

filter pack. Several filters used together to create specific colors of light output. Filter packs are often used in enlargers for color printing or when duplicating slides, in order to obtain the best or desired color rendition in the photograph.

filter threads. Thin, raised circular strips that encircle the end of a lens and allow you to attach screw-on filters and other light-altering accessories. Some European lenses have bayonet-style filter mounts rather than threads.

finality development. The process of extending the amount of development time, allowing exposed silver halides to convert to silver until no further image density improvement occurs.

finder. *See* viewfinder.

finder screen. *See* focusing screen.

fine art photography. The production of images to fulfill the creative vision of a photographer. Generally sold to dealers, collectors, or curators as high-quality archival prints. These prints are also sometimes produced for exhibition in an art gallery. Synonymous with art photography.

fine grain. (1) Film that produces images in which areas of uniform tone appear smooth, with no clumping of the image-forming silver particles. (2) Developer (e.g., Kodak's Microdol-X) used to produce images with a small grain structure.

finger. A slim, rectangular scrim placed in front of a light source to decrease illumination in a narrow subject area.

fire. (1) To press the shutter button and capture a photograph. (2) To set off or trigger an electronic flash.

firewall. Part of a computer system, usually an Internet gateway server, that limits access between networks to protect the resources of one network from users of another.

FireWire. A type of high-speed data transfer between peripheral devices and a computer. Also known as IEEE 1394.

fireworks mode. A scene mode in which the camera holds the shutter open longer than normal in order to capture the light streaks in the dark sky.

firmware. Instructions, in the form of a program or software, that run a computer or digital camera. This can be permanently recorded to ROM or stored in flash memory to permit upgrades.

first-curtain sync. The standard mode of operation for flash photography on focal-plane shutter cameras. The flash is fired immediately after the shutter's first curtain has fully opened. *See also* second-curtain sync.

first-generation copy. A duplicate image made directly from an original. Second-generation copies can show a degradation in quality. This is not an issue when duplicating digital images.

fisheye lens. A very wide-angle lens that produces images with extreme barrel distortion. Such fisheye lenses cover 180 degrees vertically (a 35mm-equivalent focal length of 8mm) or 180 degrees diagonally (a 35mm-equivalent focal length of 15–16mm). Vertical-coverage types capture circular images; diagonal-coverage types produce full-frame images.

fish fryer. A large photographic light that is suspended overhead by attaching it to a ceiling or a large boom stand. Often used for automobile photography. Synonymous with egg crate and swimming pool.

FISHEYE LENS.
PHOTO COURTESY OF OLYMPUS.

fixation. *See* fixer.

fixed aperture zoom lens. *See* constant aperture zoom lens.

fixed focal length lens. *See* prime lens.

fixed focus lens. *See* focus-free lens.

fixer. A chemical solution that dissolves unexposed silver halide crystals, leaving the developed silver image on the film or print and making it stable in white light. Synonymous with hypo.

flag. A type of gobo used to shield an area of the subject from light or prevent lens flare. Flags are generally black, but frosted flags are also available for situations in which more diffuse lighting effects are desired.

flare. Bright shapes or lack of contrast caused when light is scattered by the surface of the lens (common when it has been scratched or is not clean) or reflected off the interior surfaces of the lens barrel or the camera body. This is most often seen when

FLARE CAUSED BY MIST ON LENS.

the lens is pointed toward the sun or another bright light source. Flare can be minimized by using optical coatings, light baffles, low reflection surfaces, or a lens shade.

flash. (1) An artificial light source that emits a brief but very bright burst of illumination. Synonymous with strobe. *See also* monolight *and* power pack. (2) Illumination of a scene by a brief burst of artificial light, typically from an electronic flash unit. (3) A type of memory card. *See* flash memory.

flash bracket. A metal bracket used to hold a flash head away from a lens, commonly used to prevent harsh shadows and red-eye in portraits.

flash bulb. A single-use bulb containing a fine filament, metal wool, or metal foil. The glass bulb's contents burn up in a brief and brilliant flash of light when a low voltage is passed through it. The units were commonly used until the 1980s.

flash card. *See* flash memory.

flash cube. An obsolete artificial light source containing four small flash bulbs built into a single unit. When one bulb fired, the unit rotated automatically to the next usable bulb; once all four bulbs were used, the flash cube was discarded.

flash drive. *See* jump drive.

flash duration. The amount of time it takes for a flash to fire. This generally ranges from about $\frac{1}{1,000}$ to $\frac{1}{20,000}$ second in automatic flash modes. Short flash durations are useful for preventing blur when photographing moving subjects.

flash exposure lock (FEL). A feature that lets you set and lock flash exposure settings, then recompose the image. Much like autoexposure lock.

flash factor. *See* guide number.

flash fill. *See* fill flash.

flash gun. Synonymous with electronic flash.

flashing. Briefly and evenly exposing a light-sensitive material to white light. This reduces image contrast, decreases color saturation, and can slightly enhance shadow detail.

flashlight. Light produced by the ignition of a chemical (often ammonium nitrate, potassium nitrate, or magnesium).

flash memory. A solid-state memory chip that has the ability to retain image data once the device has been powered off. Many digital camera memory card formats fall into this category, including CompactFlash (CF), SecureDigital (SD), xD, Smart-Media, and Memory Stick. *See also* firmware.

flash meter. A device used to read the brief bursts of light from an electronic flash and indicate the aperture required for correct exposure. Some flash meters double as ambient light meters.

FLASH METER.
PHOTO COURTESY OF SEKONIC.

flash output compensation. Similar to exposure compensation, a flash mode on some cameras that allows the photographer to manually adjust the value of the flash output power in situations where the camera's flash metering system is not effective in

FLASH OUTPUT COMPENSATION ICON FOUND ON MANY CAMERAS.

achieving a correct exposure. Depending on the camera, the compensation may be adjusted in full or partial stops, or by selecting a high, low, or normal setting.

FlashPix (FPX). An image format that stores images in multiple resolutions and offers JPEG compression.

flash powder. A chemical powder comprised of metallic magnesium and an oxidizing agent. When ignited, it produces a brilliant flash of light. A predecessor to flashbulb photography.

flash RAM. A type of rewritable memory that is often used for the temporary storage of information such as digital image files.

flash range. The distance range over which a flash can effectively illuminate a subject. This range is dependent on the amount of flash output available. Photographing close-up subjects requires a lower flash output; distant subjects require a higher output. The distance range of a unit varies depending on the selected aperture setting, ISO speed, etc.

flash shadow. The harsh, unflattering shadows often cast on or by subjects illuminated by on-camera flash (especially when undiffused). To reduce this problem, many photographers rely on a flash bracket to raise the flash above or to the side of the camera. Diffusion attachments and bounce-light techniques can also be used to minimize or eliminate these shadows.

LEFT—WITH STRAIGHT ON-CAMERA FLASH. **RIGHT**—WITH BOUNCED FLASH.

flash sync. *See* synchronization, flash.

flash white balance. A white-balance setting used to warm up the scene to compensate for the bluish color temperature of flash illumination.

flat. (1) Term referring to a scene, negative, or print with very low contrast between light and dark areas. Also called flat gradation. (2) Low-contrast lighting or illumination that provides little or no shadow. (3) Short for diffusion flat. *See* scrim.

flat bed. A component of many view cameras that attaches to a tripod and allows for camera movement. *See also* monorail.

flatbed camera. A camera mounted on a vertical column and used for photographic duplication of documents or artwork.

flatbed scanner. A digital scanning device used to record optical information, usually from flat objects. Flatbed scanners consist of a glass platen and a motorized scanner carriage containing sensors that move below the glass, recording the image of anything placed upon it.

flat field lens. Lenses exceptionally well corrected for field curvature. Required for copy work and color separation.

flat gradation. *See* flat.

flat lighting. *See* flat.

flatten. In image-editing programs, the merging of multiple layers and other elements of a digitally manipulated or composite image. When working with layers, this is typically the final step prior to saving the image in a standard image file format (rather than the native file format).

flicker. A perceptible increase and decrease in the brightness levels of a displayed image. This problem is often seen in CRT monitors with a vertical scan rate lower than 50Hz.

flint glass. Optical glass to which lead has been added, yielding a higher refractive index.

flip. To reverse a selected area of image data top to bottom (vertically) or left to right (horizontally).

floating elements. A wide-angle lens design with movable elements. Used in retrofocus wide-angle designs to improve the image quality when focusing at close distances.

floating selection. In image-editing programs, an active selection above a layer that can be moved and manipulated without affecting the underlying pixel data.

flood lamp. *See* floodlight.

floodlight. An artificial light source with a 125- to 500-watt (or higher) tungsten filament lamp, fitted with a reflector dish. A floodlight produces a broad, fairly diffuse beam of light.

flopping. *See* lateral reversal.

Florence, Hercules. *See* appendix 1.

flour paste. An adhesive that is made of wheat flour and water. Used for mounting albumen and salted-paper prints to card stock.

fluid head. A type of tripod head that is filled with thick, viscous oil sealed in a housing or heavily lubricated with grease. This facilitates smooth panning motions.

fluorescence. Process in which radiant energy of a certain wavelength is absorbed, then instantly reemitted at another, typically longer wavelength.

fluorescence photography. Creating images of subjects that fluoresce when exposed to ultraviolet light. The radiation the subject reflects has a longer wavelength than the ultraviolet light

LEFT—INCANDESCENT LIGHT. **RIGHT**—ULTRAVIOLET LIGHT.

and is therefore perceived by the human eye as a typical fluorescent color.

fluorescent lamp. Glass lamps containing mercury vapors that fluoresce, producing ultraviolet light when voltage is passed through them. Most fluorescent bulbs have a green cast that may be counteracted by the use of a magenta filter or fluorescent-light white-balance setting. Daylight fluorescent bulbs can also be used to prevent the color cast. *See also* fluorescent lamp, daylight-balanced.

fluorescent lamp, daylight-balanced. A fluorescent light source that is manufactured to produce a color temperature of approximately 4800K so that image color is rendered accurately when a digital camera's daylight white-balance setting is selected.

fluorescent white balance. A mode on digital cameras that compensates for the greenish color of fluorescent light.

fluorescent whites. Brilliant highlights achieved by applying a fluorescent agent to photographic paper. The print can also be treated with a fluorescent whitener once it has been washed.

fluorite. Calcium fluorite, a synthetic crystal with a very low refractive index used in some lenses. The material controls chromatic aberration, especially on longer focal length lenses.

f-number. *See* f-stop.

foamcore. Rigid white board used to reflect light onto a subject without introducing shadows.

focal length. Distance from the principal plane to the point at which the lens forms an image of a subject at infinity. The higher the focal length, the smaller and more magnified the area of the scene included in the photographic frame. This value, normally stated in millimeters, is engraved on each lens. *See also* 35mm equivalent focal length *and* focal length multiplier.

focal length factor. *See* focal length multiplier.

focal length multiplier. On cameras with an image sensor smaller than a 35mm film frame, a value used to calculate the effective focal length (the actual field of view) that a lens will achieve. *See also* 35mm equivalent focal length.

focal plane. A plane perpendicular to the principal axis that passes through the focal point. This allows for sharp focus when the lens is set at infinity. Also called the film plane or image plane.

focal plane (FP) flash. A kind of flash or a mode of operation of an electronic flash unit that allows for an extended flash duration so that the image area of the film or sensor is fully exposed when the focal plane shutter opens.

focal plane mark. *See* film plane mark.

focal plane shutter. Located immediately in front of the focal plane, a rectangular shutter comprised of narrow blinds or curtains that expose the film or image sensor as they move. Most SLRs utilize shutters of this type. *Contrast with* leaf shutter.

focal point. The point on the optical axis where all rays of light reflected by a subject converge to produce a sharp image.

focal range. The area of a subject or scene that is in focus. Also called depth of field.

focus. The physical point at which rays of light from a lens converge to form a properly defined image of the subject.

focus-free lens. In low-end point-and-shoot cameras, a lens with the focal point set to its hyperfocal distance. Depth of field is relied on for focus, so the lens is usually set to a relatively small aperture. Synonymous with fixed-focus lens.

focusing. The act of moving the lens in relation to the image plane to obtain optimal sharpness in the subject or scene.

focusing, close. *See* macrophotography *and* macro mode.

focusing cloth. A dark cloth that fits over the back of a view camera, and over the photographer's head, to block ambient light and make the image on the ground glass easier to see.

focusing glass. A device placed on the glass focal plane of a camera obscura for viewing the image.

focusing helical. Spiral-shaped threads within a lens that allow certain lens elements to move closer to or farther from the film/image plane to achieve sharp focus.

focusing hood. Lightproof cowl used on TLRs and most roll-film SLR cameras to shield the focusing screen from light other than that which comes from the scene being photographed.

focusing magnifier. A mounted magnifying glass used to enlarge the image as seen on the ground glass viewfinder of a large-format camera to allow for precise focusing.

focusing ring. Device that is rotated to manually focus a lens.

focusing scale. Scale of distances marked on the focusing ring of a lens and used to facilitate manual focusing.

focusing scope. *See* grain focuser.

focusing screen. A ground glass or plastic plate located inside the camera and used to focus or compose the image. This may be embellished to increase brightness, feature a grid to help ensure the correct positioning of architectural elements, include split circles or prisms to assist in achieving focus, or be illuminated with active auto-focus points. Also called a viewing screen.

focusing spot. A type of flash that can focus light into a concentrated beam and be used with a cukaloris or gobo to project patterns of light and shadow onto a subject.

focus limiter. A switch on some lenses that allows the photographer to restrict the focal range that a camera will use when autofocusing, preventing it from focusing too closely.

focus lock. On autofocus and focus-assist cameras, a system that allows the photographer to focus on and meter a centered subject, then move the camera so that the subject is positioned in a more desirable area of the frame.

focus prediction. A mode on some cameras that allows the camera to analyze the speed of a moving subject and adjust the lens to the appropriate position to ensure sharp focus. Also known as predictive autofocus or focus tracking.

focus priority. An autofocus mode in which the camera will not take a photo unless the subject is in focus. Some cameras allow you to switch into this mode; others only employ focus priority in specific focus modes. *Contrast with* release priority.

focus range. The range of distance within which a camera can effectively achieve focus on a subject.

focus shift. A change in the position of the plane of optimal focus, generally due to a change in focal length when using a zoom lens, and in some lenses, with a change in aperture.

focus tracking. *See* focus prediction.

fog. A dense area on film or light-sensitive paper that results when the material has been (usually inadvertently) exposed to light or darkroom chemicals. Often, the fogging results from a camera body with light leaks or exposure to X-rays. Fogging can also be introduced intentionally, for effect. *See* flashing.

fog filter. An accessory used to soften the focus of the lens and lower image contrast. Used to simulate atmospheric fog in outdoor scenes.

folding camera. A camera with simple controls that can be folded into a compact shape when not in use.

FOLDING CAMERA.

foliage mode. A scene mode in which saturation is boosted to produce bold colors in foliage.

foot candle. A unit of light measurement, defined as the illumination received by a surface at a distance of 1 foot from a source with an intensity of 1 international candle (the predecessor of the candela as the standard unit of light intensity). Illuminance is now measured in lux; 1 foot candle is equivalent to 10.76 lux.

foreground. The area of a composition that is closer to the lens than the main subject.

foreground color. In image-editing programs, the color used when painting, drawing lines, filling shapes with color, and creating text. The default foreground color is black, but another color can be selected.

forensic imaging. *See* forensic photography.

forensic photography. Creating photographs to aid police in gathering evidence, documenting crime scenes, etc. Synonymous with crime scene photography and forensic imaging.

foreshortening. When the lens is very close to an area of the subject, distortion that makes the area appear disproportionately

FORESHORTENING.

large. Though this is generally undesirable, it can be used for artistic expression.

format. (1) The size and dimensions of paper, film, or a camera's viewing area. (2) *See* formatting.

Formatt. Manufacturer of photographic filters.

formatting. Removing data from and resetting a memory card for the camera in which you intend to use it.

forming gas. An industrial gas used for gas hypersensitization of film. Typically made up of hydrogen and nitrogen.

forty-five degree lighting. *See* Rembrandt lighting.

four-color process. *See* process color.

four-thirds sensor. *See* 4/3 sensor.

Foveon X3 direct image sensor. A proprietary type of CMOS chip that contains three layers of pixels to take advantage of the fact that red, green, and blue light penetrate silicon at different depths. This allows the sensor to simultaneously capture all three primary colors at every pixel position.

FP. *See* focal plane flash.

fps. *See* burst rate.

FPX. *See* FlashPix.

fractal image. An image made of mathematically generated geometric shapes containing an infinite amount of image detail. Such images can be reproduced at any size.

frame. (1) A single exposure captured on a roll of film. (2) Viewfinder image boundary. *See* framing. (3) A decorative border (usually wood, metal, or plastic) applied to finished, mounted prints for display purposes. (4) One of the still photographs that comprise a video.

frame buffer. A portion of RAM memory set aside to hold the data used for screen display.

frame camera. A specialized camera that allows for high-speed capture of an event of a short duration or a high-speed continuous event, recording the images in discrete frames.

frame counter. In film cameras, a window or digital screen showing the number of frames that have been exposed or the unexposed frames remaining.

frame grabber. A device that allows you to capture individual frames from a video camera or video saved to storage media.

frames per second (fps). *See* burst rate.

framing. In composition, using scene elements at the outer limits of the image as a border for the subject in order to draw the viewer's eyes into the image.

THE TREE AND STONE WALL FRAME THE RIVER VALLEY.

freelance. A self-employed photographer who sells or licenses photographs to magazines, newspapers, web sites, agencies, etc. The photographer may work on assignment or commission or may license their photos to generate income.

freeware. Software made publicly available to be copied or used without cost.

free working distance. *See* working distance.

freeze. The apparent stalling out or locking up of a computer system that requires its restart. Synonymous with crash.

freeze focus. *See* preset focus.

frequency. The number of lines per inch in a halftone screen.

Fresnel lens. (1) In some SLR cameras, an acrylic condenser lens used in combination with the ground-glass viewing screen to produce enhanced corner brightness. A Fresnel lens also ensures a more even brightness on the focusing screen when a camera's shift and tilt controls are used.

FRESNEL SPOTLIGHT.
PHOTO COURTESY OF PROFOTO.

Also called a Fresnel plate. (2) A condenser lens used on a spotlight to gather and focus into a single beam the rays of light coming from a source.

Fresnel magnifier. *See* Fresnel lens.

Fresnel plate. *See* Fresnel lens.

frilling. Wrinkling and separation of an emulsion along the edges of its supportive base.

fringing. A white fringe that appears on an object's edges. Fringing usually occurs when a digital image is sharpened after capture but can also occur as a result of compression.

frisket. A thin, transparent, adhesive film that can be cut and applied to a photographic print prior to toning to selectively mask and protect areas of a print.

frisking material. *See* frisket.

front curtain synchronization. *See* first-curtain sync.

front element focusing. A compound lens designed so that only the front component moves forward and backward to adjust focus.

front nodal point. The point at which all the rays of light entering a lens converge.

front projection. A technique in which a previously photographed background scene is projected from the camera position onto a special reflective background screen so that the image can be used as a background for the photograph.

front-silvered mirror. A type of mirror with a reflective silver coating applied to the front. Commonly used in SLRs.

f-stop. A number that describes the relative size of the lens aperture. This is obtained by dividing the lens focal length by its effective aperture; therefore, the larger the aperture, the smaller the f-number, and vice versa. The f-stops available on most lenses are f/1.0, f/1.4, f/2, f/2.8, f/4, f/5.6, f/8, f/11, f/16, and f/22 (large-format lenses offer apertures up to f/64). An increase or decrease in f-stop value either doubles or halves the aperture size. The f-stop setting is used in conjunction with the shutter speed and ISO rating to affect an exposure.

f-stop ratios. Numeric ratios printed on lenses that indicate the largest f-stop the lens can achieve. A ratio of 1:1.8, for example, means you can open up to f/1.8. A ratio that includes a numeric range (e.g., 1:3.5–4.5) is used to designate a zoom lens with a maximum aperture that varies over the zoom range.

FTP (file transfer protocol). A system that allows for the high-speed transfer of files from computer to computer across the World Wide Web.

Fujifilm. Major Japanese film manufacturer. Fuji also manufactures some specialty cameras (e.g., panoramic cameras) and digital cameras that are compatible with Nikon lenses.

full-face view. A pose in which the subject's face is square to the camera, allowing the lens to capture its entire area.

FULL-FACE VIEW. PHOTO BY JEFF SMITH.

full frame (FF). (1) In film photography, a negative with an image area of 36x24mm (equivalent in size to a 35mm film frame) rather than the less common half-frame format of 18x24mm. (2) In digital photography, a camera with an image sensor equivalent to 36x24mm, as opposed to the smaller sensors used in many digital cameras. (3) In printing, to show all of the image area; typically designated NC (no cropping).

full-length. A pose in which the entire body, from head to toe, is included in the frame.

full program mode. *See* program mode.

full-range black. A black channel that exhibits dots across the entire tonal range of the image. Also called full-scale black.

full scale. An image that exhibits a wide range of tones, from pure black through many shades of gray to pure white.

full-scale black. *See* full-range black.

full stop. A change in exposure setting (aperture or shutter speed) that admits either half as much or twice as much light.

full-time manual (FTM). A feature available in some Canon EOS autofocus lenses that allows the photographer to manually adjust and fine-tune the focus, even when the camera is in autofocus mode.

fuming. A historic process in which iodine or ammonia fumes were used to sensitize or reveal a latent image.

fungus. In the tropics and other moist geographic areas, fungi can make their way inside of lenses, eating away at the lens coatings and causing growths on the lens surface. This "infection" cannot be easily cured, so care must be taken to prevent the problem. The use of climate-controlled cases with dehumidifiers or silica gel packed inside a moisture-proof camera bag can be a photographer's greatest ally in protecting the lens.

Futurism. *See* appendix 2.

fuzziness. In digital images, the amount of anti-aliasing along the edges of a selection.

G. A series of electronically controlled Nikkor lenses. Not compatible with older Nikon cameras.

G4 compression. A compression technique used with TIFF files for black & white images and also used in Adobe Acrobat (PDF) files.

gaffer. Chief electrician for a movie production.

gaffer's tape. A wide, heavy-duty adhesive tape made of thick matte fabric. This is useful for temporarily securing backdrops, cables, and other equipment.

gain. The relationship between the input and output signals in an electronic system. In imaging, gain effects the light sensitivity of CCD and CMOS sensors.

gain and level. Digital imaging terms that are roughly equivalent to the brightness and contrast controls found on a television. Gain corresponds to contrast; level corresponds to brightness.

Galilean. *See* reverse Galilean.

gallic acid. A compound used to develop-out lightly printed silver chloride or whey prints in the 1950s.

galvanography. Process of depositing metal onto a gelatin relief image to produce a photomechanical printing plate.

gamma. (1) A curve that describes how the middle tones appear in an image. Gamma is a nonlinear function that is often confused with brightness or contrast; however, adjustments to gamma leave the white and black of an image unaltered.

SETTING THE TARGET GAMMA ON A MACINTOSH COMPUTER.

(2) Gamma adjustment is often used to control luminance on computer monitors. The standard gamma setting for Macintosh computers is 1.8. For television screens and PC monitors, the

standard gamma setting is 2.2. This disparity can cause an image to look fine on one computer but too dark or light on another.

gamma correction. The process of preconditioning or adjusting an image to correct for the gamma of the device used to print or display it. Without correction, the image may appear too dark or too light.

gamut. (1) All of the colors that are present in a specific scene or photograph. (2) All of the colors that are capable of being produced by a particular output device or medium. (3) The range of colors a color model can represent.

gamut alert. *See* gamut warning.

gamut clipping. *See* clipping.

gamut compression. The process of reducing a large color gamut (such as that of transparency film) to fit within a smaller gamut (such as that of color printing).

gamut mapping. *See* mapping.

gamut warning. A software function that alerts the user when colors in an image fall outside of a targeted gamut.

LEFT—ORIGINAL IMAGE. **RIGHT**—IMAGE WITH GAMUT WARNING ACTIVE (GRAY AREAS REVEAL COLORS THAT WILL POTENTIALLY BE PROBLEMATIC WHEN CONVERTING).

gang scan. The simultaneous scanning of multiple images of the same density and color balance range.

gas discharge lamp. *See* discharge lamp.

gaslight paper. A silver chloride gelatin emulsion paper that could be handled in a darkroom with a gaslight placed a few feet away without any resultant fogging.

gas plasma monitor. A display device that mixes red, green, and blue pixels from plasma bubbles that are selectively powered and turned on or off. Such monitors can create full-color displays and can be manufactured to be very thin.

gatefold. A double-sided, hinged, or folded page in an album that can be opened up to reveal a panoramic format.

gateway. A computer server that allows for the connection of one network to another that uses different protocols or designs.

Gaussian blur. In Photoshop, a filter used to produce an image-softening effect. A bell-shaped curve is used to calculate the pixels to be blurred, resulting in a less "processed" look.

LEFT—ORIGINAL IMAGE. **RIGHT**—IMAGE WITH GAUSSIAN BLUR.

GB. *See* gigabyte.

GCR. *See* gray component replacement.

gel. A thin sheet of gelatin or polyester, usually colored and used as a filter either on the camera lens or in front of a light source to change the color, amount, or quality of light. Gels are flexible, generally fade resistant (with the exception of blue gels), and typically offer high image quality since they can be made very thin.

gelatin. A transparent, water-soluble material obtained from animal by-products commonly used in film emulsion and filters. Also called gelatine. *See also* gel.

gelatine. *See* gelatin.

gelatin filter. *See* gel.

gelatin silver print. A photograph produced on paper coated with a gelatin emulsion containing light-sensitive silver salts. The resulting image is suspended on the surface, not embedded in the paper's fibers.

gelatin sugar process. Daylight printing process using paper with a sugar and dichromate coating that hardens when exposed to light.

generation loss. The loss of quality that occurs when analog material is duplicated (e.g., in creating internegatives).

generator pack. *See* power pack.

geometric distortion. A change in the apparent shape of objects that appear at the outer edges of the frame in images created with a wide-angle lens.

German socket. *See* Prontor/Compur cable.

ghost. (1) Glowing patches of light that appear in a photograph due to lens flare. (2) Streaking that appears in an image as a result of camera motion or subject movement during the exposure. (3) Streaks or faint images of subjects that result from use of slow shutter sync speeds. (4) Faint images that appear in double- or multiple-exposure photographs. (5) Bright reflections that can appear in the final image when a subject or scene is captured using a poorly coated or uncoated filter. (6) A pale, low-contrast image that is used as a background in web sites and graphic designs.

GHz. *See* gigahertz.

giclée. A high-resolution digital print often seen in fine-art photography applications. The term originally referred only to prints made using an expensive Iris inkjet printer, preferably printed onto thick paper or canvas and treated with ultraviolet-resistant coatings. Today, the term is loosely applied to describe any fine-quality inkjet print.

GIF (graphics interchange format). A file format developed by CompuServe and widely used on web sites. The format supports a bit depth of only 8 bits (256 colors). GIF files are compressed using an LZW (lossless) file compression standard.

GIF 89a. An updated GIF format that offers the same capabilities as the original format but also allows for an assigned color to be rendered as transparent.

gigabyte (GB). A unit of data measurement equal to one thousand million bytes, often used to describe the storage capacity of hard drives and digital camera microdrives.

gigahertz (GHz). A unit of measure used to describe the internal processing speed of a computer. Equivalent to a signal frequency of one billion cycles per second.

gilding. Gold chloride and sodium thiosulphate toning technique used to improve the contrast and tonality of daguerreotypes. Also offered some protection of the fragile print surface.

Gitzo. Manufacturer best known for their tripods.

glamour photography. Portraits designed to showcase the subject's physical beauty, often with a sensual or sexy feel.

glare. Bright reflections from an object's surface. A small amount of glare can sometimes add interest, but excessive glare is usually considered objectionable. Polarizing filters can be used to decrease glare on some surfaces.

glare angle. *See* angle of reflection.

glare zone. The angle within which lights will produce glare on a subject.

glass. A slang term used to refer to camera lenses.

glass positive. Term referring to ambrotypes, daguerreotypes on glass, and other positive images on glass rather than paper.

glaze. A glossy surface on some fiber-based printing papers produced by placing a wet print face down on a drum or clean polished surface, which is heated to dry the print. Medium blacks appear more dense in glazed prints than they do on matte papers.

global positioning system (GPS). On some digital cameras, a system that can record the precise latitude and longitude at which each photograph was taken and save the data using EXIF tags.

glossy. (1) A printing paper with a sheen on the surface. Prints made on glossy paper generally have good contrast and detail but tend to show fingerprints and reflect light. *Contrast with* matte. (2) A print made on glossy paper.

glycerin. A natural substance derived from fats and used to enhance the porosity of films, slow the chemical action of developers, and preserve wet collodion plates that were washed and developed but could not be immediately fixed.

gobo. From "go-between." A device placed between a light source and the subject to modify the way the light falls on the subject. *See also* cukaloris, flag, *and* scrim.

gold. Metal dissolved in a mixture of nitric and hydrochloric acids (called aqua regia) to produce gold chloride.

gold chloride. Soluble chemical found in gold toners.

golden hour. *See* magic hour.

gold hyposulfate. *See* sel d'or.

golden mean. A compositional technique used to determine the best-possible position of the main subject in the frame. This

THE GOLDEN MEAN.

is determined by bisecting the frame diagonally then drawing a line from the two remaining corners of the frame to perpendicularly intersect the longest line. The subject should be placed at a point where the lines meet.

gold reflector. A light modifier with a gold or yellow surface used to bounce a warm-colored light onto a subject or scene.

gold toning. A process in which a silver/gelatin print is soaked in a gold chloride toner to produce an image with rich red or brown tones.

GOST (Gosstandart of Russia). A film rating system used in Russia and Eastern Bloc states that, until 1987, used numbers roughly equal to 90 percent of an ISO value. Today, the GOST values match the ISO numeric values.

gradated filter. *See* graduated filter.

gradation. *See* gradient.

grade. *See* paper grade.

gradient. A transitional blend between two or more colors, between black and white, or between an area with color and one with no color information.

GRADIENT.

gradient fill. In image-editing programs, a fill that gradually transitions from one color, tone, or transparency to another.

gradient tool. In Photoshop, a tool used to apply a gradient to an image.

grad ND. *See* neutral density filter.

graduate. A glass container featuring markings used to measure fluid volume.

graduated filter. A type of filter in which the density gradually changes across the filter's field. Some varieties (graduated neutral density filters) are clear at one end and dark at the other. Other graduated filters feature an uncommon color, or two different colors, and are used for special effect.

graduated neutral density filter. *See* neutral density filter.

graduated scrim. A scrim comprised of thick layers of screen at one end that gradually thin toward the opposite end. This allows the full intensity of the light to be achieved at one end, while a dimmer effect is achieved at the opposite end. The result is more even illumination when a subject is positioned in such a way that one area is much closer to the light than another.

Graflex. Press camera popular from the 1930s to the 1950s.

grain. A visually perceptible speckled pattern of silver halide particles produced in the process of exposing film. Grain is also produced in the development process; however, this grain is responsible for the image tone. Fast films tend to have a coarser grain structure than slow films. Fine-grained films and some special developers can be used to reduce noise. The term is also used when discussing color and black & white chromogenic film, though they have dye clouds, not traditional grain. *See also* noise.

grain focuser. In the traditional darkroom, a simple device used with photographic enlargers to magnify the grain and allow for precise focus. Also called a focusing scope.

grain sharp. A term that describes an enlargement that matches, as closely as possible, the sharpness of the negative from

which the print is made. Grain focusers are used to ensure that the grain of the film is accurately focused.

granularity. The degree to which silver halide grains have clumped together within an emulsion.

graphic arts camera. A device, superceded by scanners, once widely used to produce high-contrast film for a printing press.

graphics interchange format. *See* GIF.

graphics tablet. An electronic device, used in place of a mouse, that employs a pen-shaped stylus to draw on a pressure-sensitive tablet. Used for digital painting and drawing. Synonymous with digitizing tablet.

GRAPHICS TABLET.
PHOTO COURTESY OF WACOM.

graphic user interface (GUI). A design or interface heavily dependent on the use of icons, graphics, and text to facilitate a user's interaction with the computer.

graphite. A synonym for black lead, a material applied in powdered or pencil form for retouching negatives.

gray balance. (1) In offset printing, the technique of ensuring proper neutral tones by adding extra cyan, relative to the proportions of magenta and yellow. (2) Occasionally used synonymously with white balance.

gray card. A matte gray card with 18 percent reflectance used to make an accurate reflected-light exposure meter reading or to provide a known gray tone in color work.

gray component replacement (GCR). In offset printing, a process in which portions of an image that contain all three process colors (cyan, magenta, and yellow) have an equivalent amount of gray replaced by black. This produces purer, more vivid colors and reduces the overall ink requirements.

gray level. A discrete shade of gray assigned to a pixel or group of pixels. *See also* grayscale.

gray market. Goods imported to a country by someone other than the manufacturer's authorized agent. Some manufacturers do not honor warranties on gray-market merchandise.

grayscale. (1) An image containing shades of gray, black, and white. (2) A color model in which shades of gray are assigned to pixels to create the tonal variations in a monotone image. The brightness values of these pixels can be expressed from 0 (black) to 255 (white) or as percentages of black ink coverage, from 0 percent (white) to 100 percent (black). (3) A chart containing gray tones ranging from black to white, often photographed as part of a scene, which is then referenced by lab technicians to ensure accurate printing.

green (G). A color of light with wavelengths of around 550nm. Green, along with red and blue, is one of the three additive primary colors. *See also* RGB *and* primary colors.

green-eye. A green glow that appears in the eyes of animals when the flash hits the tapetum lucium, a reflective membrane that human eyes lack.

green screen. *See* chromakey photography.

green vitriol. *See* ferrous sulfate.

GretagMacbeth. Company specializing in products for color management.

grid. (1) *See* honeycomb *and* egg crate. (2) An overhead system of pipes and tracks used in the studio to support lights and cables. (3) In graphics programs, a tool used for systematically laying out elements, often used in conjunction with guides. (4) *See* array.

gridspot. A spotlight fitted with a honeycomb.

grip. (1) The handgrip portion of a camera. (2) An accessory handgrip that can be added to the camera. Some grips feature duplicate camera controls for shooting in portrait orientation and/or supplementary batteries.

ground glass screen. *See* ground glass viewfinder.

ground glass viewfinder. Translucent glass sheet found on all large-format and some reflex cameras, used for focusing and composing an image. In many newer cameras, an etched plastic sheet is used instead of ground glass. *See also* focusing screen.

group. (1) The close assembly of multiple lenses in the lens body. Often, the lenses are affixed to one another with transparent glue. Grouping the elements reduces the glass–air surfaces among the elements, thereby reducing reflections. (2) *See* link.

GUI. *See* graphic user interface.

guide. In graphics programs, nonprinting lines that float over the image or document and are used as markers for placing elements. Guides can be set so that graphic elements placed near them automatically snap into alignment. *See also* grid.

guide factor. *See* guide number.

guide number. Number used in flash photography to calculate the correct f-stop for the flash-to-subject distance and ISO in order to achieve an accurate exposure. To determine the required f-stop, divide the guide number by the distance. To determine the best subject distance, divide the guide number by the f-stop. Synonymous with flash factor and guide factor.

gum arabic. Water-soluble gum obtained from the acacia tree and used as a glaze on the surface of some traditional hand-colored prints to produce darker tones in selected areas. Also used to desensitize nonprinting areas of a printing plate.

gum bichromate. A contact printing process revered for its impressionistic effects. When the paper is coated with a mixture of gum, potassium bichromate, and a colored dye, then exposed to light behind a negative, the unexposed areas are soft and can be washed away, leaving only the hardened, colored areas of the print behind. Multiple applications can be used to add other colors to the print. Also known as the photo aquatint process.

gum platinum process. The process of adding one or more layers of gum bichromate over a platinum print. This enhances the richness of the image tones and produces added depth.

gun cotton. *See* cellulose nitrate.

gutter. The inside centermost area of a book or an album (i.e., the area near the book's binding).

gyroscopic camera mount. *See* gyroscopic stabilizer.

gyroscopic stabilizer. A device containing motorized spinning wheels in which a camera is placed to protect against movement or vibration from outside sources. This can help photographers create images in unstable shooting conditions. The advent of image stabilizing lens technology has largely superseded the use of these devices in still photography, but gyroscopic stabilizers are still common in cinematography.

Haas, Ernst. *See* appendix 1.

hair light. A light unit positioned slightly behind the portrait subject to create a halo-like effect that separates the hair from the background.

hairline. (1) An extremely narrow scratch on the surface of film. (2) A tiny crack in a camera body or the glass of a lens, usually as a result of being dropped or knocked into something.

halation. Ring of diffused light at the edges of a highlight area. Occurs when light passes through the film and is then reflected back through it by the film base or the back of the camera, recording slightly out of register.

half frame. (1) Type of 35mm film with an image area of 18x24mm as opposed to the standard 36x24mm size. (2) A camera (notably, certain rangefinders manufactured in the 1960s) that allowed photographers to double the number of photographs recorded on a roll of film.

half plate. Negative format measuring 4.25x6.5 inches (glass) or 4.5x5.5 inches (tin-type) produced by some early cameras.

half-silvered mirror. A mirror that reflects a certain percentage of light and allows the rest to pass through. Often used in SLRs, where some of the light is reflected into the viewfinder and some continues through to illuminate the autofocus sensors. Also used by beam-splitting devices.

halftone. Process of converting continuous tones into a specific pattern of tiny dots. This dot pattern is then duplicated by printing devices that cannot produce continuous tones (such as offset presses) to produce images that, from a standard viewing distance, look like continuous-tone photos.

halftone factor. *See* quality factor.

halftone screen. A transparent, finely ruled plate or film used in halftone reproduction.

halo. (1) *See* halation. (2) In digital images, a light line that appears around an object's edges. This is often produced by excessive sharpening.

LEFT—ORIGINAL IMAGE. **RIGHT**—OVERSHARPENED IMAGE WITH HALOS.

halogen. (1) A group of chemical elements consisting of fluorine, chlorine, bromine, iodine, and astatine. Bromine, iodine, and chlorine are used to create light-sensitive silver halides. (2) A type of tungsten lamp containing a halogen-gas-filled quartz bulb. Halogen lamps burn brighter than traditional tungsten lamps and operate at a higher temperature.

Halsman, Phillipe. *See* appendix 1.

handcoloring. Traditionally, the process of applying colored inks, dyes, pencils, or paint to a photographic print. The effect can be simulated in most image-editing programs.

H and D curve. *See* characteristic curve.

handholding. Capturing an image while supporting the camera in one's hands. To avoid blurring, the shutter speed should be the reciprocal of the focal length of the lens or faster.

hand tool. In Photoshop, a tool that allows you to move around within an image without using the scroll bars.

hanger. A frame used to hold sheet film while it is processed in a tank.

hard. (1) A scene, negative, print, or digital image file that exhibits high contrast. (2) *See* hard light.

hard copy. An image or document presented as a print as opposed to being viewed on a monitor.

hard disk. A rigid magnetic disk with a high storage capacity. *See also* hard drive.

hard disk drive. *See* hard drive.

hard drive (HD). (1) A high-capacity data-storage device built into or connected to a computer. Contains a read–write mechanism and one or more hard disks in a self-contained unit. Also called a hard disk drive. (2) *See* microdrive.

hardener. A chemical (e.g., potassium or chrome alum) used in conjunction with a fixing bath in order to strengthen an emulsion.

EXTERNAL HARD DRIVE. PHOTO COURTESY OF LACIE.

hard gradation. An abrupt transition in contrast.

hard light. Light produced by a small, undiffused source. Characterized by sharp, dark shadows and high contrast. Also called specular light. *Contrast with* soft light.

hard negative. *See* intense negative.

hard paper. *See* paper grade.

hard proof. Any proof that is output onto paper or film, as opposed to being displayed on a monitor. *Contrast with* soft proof.

hardware. The physical components of a computer system (monitor, printer, etc.).

Harris, George. *See* appendix 1.

Hartmann mask. Opaque lens cover drilled with multiple holes used as a focus-assist device in astrophotography. The out-of-focus images generated by each hole merge when the telescope is properly focused. *See also* Scheiner disk.

Hasselblad. Swedish manufacturer of cameras and lenses. Pioneered medium-format SLRs with interchangeable lenses.

Hasselblad, Victor. *See* appendix 1.

hat trick. Term used in astrophotography to describe the act of opening a shutter and controlling the exposure by covering the lens with an opaque object, such as a hat, and removing it for the length of time required to ensure a correct exposure.

haze. An atmospheric condition characterized by moisture, fine dust particles, or smoke in the air. Haze scatters light and diminishes contrast in an image.

haze filter. Accessory used to filter out ultraviolet (UV) radiation, which can cause a bluish fog and loss of detail in distant objects. Also used by some photographers to protect the front lens element from dust, moisture, and scratches.

HD. (1) *See* hard drive. (2) *See* high definition. (3) *See* high density.

HDR. *See* high dynamic range processing.

head-and-shoulders pose. A portrait presentation in which the subject is shown from the top of the head to an area below the shoulders but above the waist.

header. Metadata that precedes the actual file data. A header often describes the contents of an image file, provides information regarding ownership, image dimensions, etc.

head rest. A height-adjustable device used by 19th-century portrait photographers to keep the subject's head still during the long exposure time required.

head stand. *See* head rest.

healing brush tool. In Photoshop, a tool that samples pixels from an image or pattern and matches the texture, lighting, transparency, and shading of the sampled pixels to the pixels being painted over so that the repaired pixels blend seamlessly into the rest of the image. *See also* spot healing brush tool.

heat filter. A thick glass attachment used to absorb infrared light emitted by a source, reducing heat radiation without diminishing output.

heat waves. A phenomenon whereby extreme heat causes certain surfaces to radiate "shimmering" waves, which are emphasized when captured by a long lens.

heliography. Generic term for the intaglio printing process developed by Nicéphore Niépce around 1813 and perfected by 1822. Involved coating a polished pewter plate with bitumen of Judea, a material that hardens when exposed to light.

Herschel effect. The destruction or reduction of an exposed (latent) image by infrared radiation.

Herschel, Sir John Frederick William. *See* appendix 1.

hertz (Hz). A unit of frequency equal to one cycle per second. A stroboscopic flash with a rating of 10Hz, for example, can flash ten times in 1 second.

Hewlett-Packard (HP). A company known for their computing, printing, and digital imaging products.

H format. *See* Advanced Photo System.

hide. A device with a camouflage surface used as a barrier between nature/wildlife photographers and their subjects. Also called a blind.

HiFi printing. Process printing that employs additional ink colors that supplement the traditional four colors (cyan, magenta, yellow, and black), thereby increasing the gamut.

high bit. Term used to describe an RGB system or image that contains more than 24 bits of color data per pixel.

high color. Synonym for 15- or 16-bit color.

high contrast. A photographic scene, negative, print, or digital image containing a wide range of densities.

high-contrast developers. Chemical solution used to develop high-contrast images. Such solutions have higher concentrations of hydroquinone and lower concentrations of Metol than is used in normal developers and tend to use strong alkalis such as sodium hydroxide to elevate pH into the 11 to 12 range.

high definition (HD). A standard that increases the quality of digital video to make images closer to the quality achieved with 35mm film. *See also* high dynamic range processing.

high density (HD) disk. 5.25-inch floppy disks that hold 1.2MB, and 3.5-inch disks that hold 1.44MB.

high dynamic range (HDR) processing. A technique in which software is used to take the best tones from a series of exposures and combine them in a single image. This ensures a wider tonal range and greater detail than could be captured in a single exposure.

high eye point. A term referring to a viewfinder that allows photographers wearing glasses to view the entire frame in the viewfinder from a close distance from the eyepiece.

HIGH KEY.
PHOTO BY BARBARA A. LYNCH-JOHNT.

high key. Photographic style in which the overall tones of the image (e.g., clothing, props, and background) are mostly white or light in tone. Such an image has very little mid-range tonality or shadowing. *Contrast with* low key.

highlight. The whitest or brightest part of a photograph. In a negative, the highlight areas are represented by dense deposits of black metallic silver. *Contrast with* shadow.

highlight, blown out. An overexposed, brilliant white area of a print that lacks detail.

LEFT—DETAILED HIGHLIGHTS. **RIGHT**—BLOWN-OUT HIGHLIGHTS DUE TO OVEREXPOSURE.

high-pass filter. (1) A type of filter that allows only high-frequency light to pass. *See also* cutoff filter *and* hot mirror. (2) In Photoshop, a filter used in image sharpening procedures.

high resolution. Images intended for offset or lab printing. Typically 250dpi or higher.

high-speed photography. Photography that uses extremely short exposures to freeze rapidly moving objects. Generally shot in a darkened room using a short burst of electronic flash.

high-speed shutter. A shutter capable of speeds of at least ½₂,₀₀₀ second.

high-speed sync. A feature that allows an electronic flash unit's light output to be pulsed for use with higher shutter speeds than the normal flash-sync limit of the camera. Despite the name, it is not intended for use in high-speed photography.

Hill cloud lens. Lens with an ultrawide (180 degree) angle of view, used for photographing cloud formations and other meteorological work. Precursor to modern ultrawide-angle lenses.

hillotype. A historical direct color positive process in which images were made on silver plates.

Hine, Lewis Wickes. *See* appendix 1.

histogram. Two-dimensional graph showing the tonal distribution of pixels in an image. Values are plotted along the horizontal axis, with the number of pixels at each level plotted on the vertical axis. Data skewed heavily to the left indicates a dark image; data skewed to the right indicates a light image.

HISTOGRAM.

history brush tool. In Photoshop, a tool that re-creates data from a specified source, allowing you to paint it onto the image. *See also* art history brush tool.

history palette. In Photoshop, a palette that lists the actions used in processing an image and allows you to step forward or backward to a certain point.

HLS. A color model that describes color in terms of hue, lightness, and saturation. HLS closely models the qualities most apparent in human perception of color. Sometimes called LCH (lightness, chroma, hue) or HSL (hue, saturation, and lightness).

HMI (Hydragyrum Medium arc-length Iodide) lamps. Daylight-balanced continuous light sources commonly used by videographers and cinematographers. They produce less heat than tungsten or carbon-arc lamps but are rather expensive.

hold back. (1) To selectively reduce the amount of light striking the film or image sensor from a too-bright area in the composition (e.g., a light sky). This can be accomplished during capture by using a graduated neutral density filter or placing a graduated scrim over the light. (2) In the darkroom, dodging is used to hold back exposure in a print; in image-editing programs, the dodge tool is used to achieve the same result.

Holga. *See* toy camera.

hologram. A three-dimensional image produced using laser technology. *See also* holography.

holography. Creating images (called holograms) that appear three-dimensional when suitably illuminated.

honeycomb. A grid-like modifier that makes light from a flash (or other source) more directional. Honeycomb grids are rated in degrees (e.g., 10 degrees, 20 degrees, 30 degrees, etc.). The lower the degree rating, the more narrow the beam of light.

hood. *See* lens shade.

horizon. Line at which the earth and sky appear to meet. Its position in a composition can be altered by adjusting camera position during capture or by postproduction cropping.

horizontal format. *See* landscape orientation.

horizontal resolution. The number of vertical lines that a system can produce (counted on a horizontal axis).

horizontal shutter. A focal plane shutter that moves across the longest dimension of the rectangle (i.e., horizontally). Superseded by shutters with a vertical movement.

host. In a network, the computer that performs centralized functions (e.g., providing other stations with access to files).

hot. A term used to describe an undesirable concentration of light on a subject. *See also* hot spot.

hot glass. *See* radioactive glass.

hot lamp. An incandescent light source (e.g., tungsten photofloods or halogen lamps). Named for the high amount of heat they generate. As continuous light sources, they offer photographers the ability to preview highlight and shadow effects. *Contrast with* electronic flash *and* fluorescent lamp.

hot mirror. A type of dichroic mirror that reflects infrared wavelengths but transmits visible light. Built into most digital cameras. *See also* high-pass filter *and* cutoff filter.

hot pluggable. In digital imaging, a device that can be disconnected without risk of damage (though data loss may occur if you disconnect in the middle of a data transfer).

hot restrike time. The time required after turning off a discharge lamp before it can be turned on again.

HOT SHOE.

hot shoe. An accessory mount usually located on the top of camera bodies that accepts a battery-powered flash. The hot shoe's connector pins allow the camera to communicate with the flash unit.

hot shoe adapter. A device that enables flash sync cords fitted with standard PC-type plugs to connect to a camera via the hot shoe.

hot spot. A small, bright area of concentration of light on a subject or in an image. *See also* highlight, blown out.

Hoya. Manufacturer of photographic filters.

HP. *See* Hewlett-Packard.

HSB. A color model that describes color in terms of hue, saturation, and brightness. Synonymous with HSV.

HSI. A color model that describes color in terms of hue, saturation, and intensity. This closely models the qualities most apparent in human perception of color. The same basic model is also called LCH (lightness, chroma, hue), HLS (hue, lightness, saturation), and HSL (hue, saturation, lightness).

HSL. A color model that describes color in terms of hue, saturation, and lightness (also referred to as luminance or luminosity). This closely models the qualities most apparent in human perception of color. The same basic model is also called HSI (hue, saturation, intensity), HLS (hue, lightness, saturation), and LCH (lightness, chroma, hue).

HSV. A color model that describes color in terms of hue, saturation, and value. Synonymous with HSB (hue, saturation, brightness).

HTML (Hypertext Markup Language). An encoding format used to create and design documents (e.g., web pages) for the World Wide Web.

hue. (1) The aspect of color that differentiates it from another color (what makes a color red, yellow, blue, green, etc.). Technically, hue is the dominant wavelength in the light emitted from a light source or reflected off of an object. (2) Used as a primary in the HSB color model.

hue error. The difference between the printed color and the color it is intended to represent.

hue/saturation. In image-editing programs, a simple tool used to increase and decrease overall image hue and saturation.

humectant. Beer, honey, sugared preservatives, and other substances used to keep photographic materials wet during the wet collodion process. Also added to gelatin emulsions and used to keep pigmented gelatin carbon tissue flexible.

hunting. The forward and backward motions of a lens when a camera is unable to attain automatic focus. This most often occurs when shooting in low light levels, photographing a tightly spaced pattern, or shooting a subject with a wide expanse of color and no contrast. *See also* focus limiter.

Hurrell, George. *See* appendix 1.

hyalotype. Invented in 1848, the first photographic positive transparency process. Negative and positive plates were made using the albumen-on-glass process.

hybrid imaging. A type of electronic imaging system that combines traditional silver-halide (film) and digital-capture technologies.

hydrobromic acid. A strong acid that is liberated during the development process and is an important component in the manufacture of film emulsions.

hydrochloric acid. A strong acid that is used in some bleaching solutions and is an important component in the manufacture of film emulsions.

hydrogen peroxide. A chemical component of hypo clearing agents.

hydrometer. A device that is used to measure the gravity of liquids. Popularly used to measure the strength of silver baths for albumen and salt printing, as well as the wet plate collodion process.

hydroquinone. A reducing agent used in developers to provide high-contrast results in the presence of a strong alkali. Also known as Quinol.

hyperfocal distance. Distance between the camera and the hyperfocal point. This is dependent on the film format/sensor size, the focal length of the lens, and the selected aperture. Fixed focus cameras are usually focused to the hyperfocal distance.

hyperfocal point. When a lens is focused to infinity, the point nearest to the camera that is considered acceptably sharp. When the lens is focused on the hyperfocal point, everything beyond it to infinity and everything halfway between the camera and the hyperfocal point will be rendered acceptably sharp.

hypering chamber. *See* hypering tank.

hypering tank. A vacuum chamber used in the hypersensitization process. Also known as a hypering chamber.

hyperlink. A graphic or string of text that, when clicked, jumps to a new web page or a new location in the current page.

hypermedia. Digital media comprised of images, audio, text, created by and distributed via a computer.

hypersensitizing. Method of increasing the light sensitivity of a photographic emulsion prior to exposure. This can be done by exposing the light-sensitive materials to mercury vapor, a diluted solution of various chemicals, or exposing the material to weak uniform light. The practice is often used in astrophotography due to the required long exposure times.

hypertext markup language. *See* HTML.

hypo. Sodium thiosulphate/thiosulfate, a fixer chemical. The term comes from sodium hyposulphite, a misnomer applied to the chemical in the 19th century. Synonymous with fixer.

hypoclear. *See* hypo clearing agent.

hypo clearing agent. Chemical bath used to convert residual fixing agent (hypo) on an emulsion to a chemistry more easily dissolved by water. Use of such an agent speeds film washing and reduces the amount of water required. Also called washing aid, hypoclear, and hypo eliminator.

hypo eliminator. *See* hypo clearing agent.

hypostereo. A stereographic image made with a stereo base (the distance between the left and right lenses) of less than 65mm.

Hz. *See* hertz.

ICC. *See* International Color Consortium.

ICC color management. An open-framework system for achieving reliable and reproducible color. The three major components of this system are a device-independent color space, device profiles, and a color engine (also called a color management module). *See also* PostScript color management.

ICC profile. Standard format for a data file that describes the color behavior of a device or color model in terms of a device-independent color model, such as CIE LAB.

ICM. *See* Microsoft Image Color Management.

icon. A small symbol used on cameras, computers, and other electronic devices to represent various functions and features. In computer programs, an application or function can often be activated by clicking on its representative icon.

ideal format. A format with dimensions in a 4:3 ratio (e.g., 6x4.5cm). Some manufacturers and many photographers consider this the ideal aspect ratio for both vertical and horizontal compositions.

IEEE 1394. *See* FireWire.

igniter. A component that provides the high-voltage electrical current required to start a discharge lamp.

Ilfochrome. A method of making richly colored prints directly from transparencies. Ilfochromes use a color dye bleaching process with azo-metallic dyes. They are printed onto a plastic base, rather than paper, for enhanced dimensional stability. Formerly known as Cibachrome. *See also* R-type print.

Ilford Photo. Manufacturer of photographic films, paper, and chemicals, known for their black & white films and papers, as well as Ilfochrome and Ilfocolor color printing materials.

illuminance. The strength of illumination of a surface or incident light falling upon a surface. Described in lux.

illuminance meter. *See* incident light meter.

illuminant. A light source with a known spectral power distribution.

Illuminant A (CIE). CIE standard illuminant for incandescent illumination, which is yellow-orange in color and has a correlated color temperature of 2856K.

Illuminant C (CIE). CIE standard illuminant for tungsten illumination that simulates average daylight. This is bluish in color, with a correlated color temperature of 6774K.

illuminant metamerism. *See* metamerism.

Illuminants D (CIE). CIE standard illuminants for daylight, based on actual spectral measurements of daylight. D65, with a correlated color temperature of 6504K, is commonly used. Others include D50, D55, and D75.

image. A two-dimensional visual representation of an object, produced by focusing rays of light. In the context of photography, this visual information is captured and recorded by a device such as a camera.

image area. The recording area of film or a digital image sensor. In film photography, the image size varies according to the film format in use and the dimensions used by the camera. In digital imaging, the image size depends on the size of the image sensor. Light that enters a lens but falls outside of the image area is not recorded.

image capture. The creation of a digital image file using a digital camera or a scanner. Occasionally used to refer to the process of creating a photo on film, as well.

image circle. The circular shape that a lens casts onto the focal plane. The image circle extends past the edges of the image area, so the curved edges of the image circle are effectively cut out of the composition. Because a lens's image circle must be larger than the image area, lenses designed for 35mm cameras cannot be used with medium- or large-format cameras. The size of the image circle also determines the coverage range of a camera that supports movements; if the lens is moved too far in relation to the image area, vignetting will occur.

IMAGE AREA AND IMAGE CIRCLE.

Image Color Management (ICM). *See* Microsoft Image Color Management.

image distance. The space between the rear nodal point and the focused image. The distance increases when the lens is focused on closer objects and is minimized when the lens is focused on infinity.

image-editing program. Any of several computer software programs used to carry out image-enhancing effects, including but not limited to retouching images, cropping, altering color and contrast, and applying creative effects. Photoshop is the industry standard; however, there are numerous similar programs on the market.

image file size. *See* file size.

image format. *See* file format.

image mode. *See* exposure mode *and* scene mode.

image plane. The plane within the camera at which a sharp image of the subject is formed. The closer the subject is to the camera, the greater the distance between the lens and the image plane must be to maintain focus.

image processing. Using software to carry out an array of tasks related to the finessing of a digital image. Processing tasks may include file compression, retouching, the application of digital filters, image distortion, image display, and more.

image profile. A set of values that define the appearance of color in an image. Tagging an image with a profile helps ensure color accuracy when transporting it to other devices and applications. Also called a document profile.

image quality. A digital camera setting that allows you to select the file format for shooting and, if applicable, the amount of compression applied to each image.

image resolution. *See* resolution.

image sensor. A chip (or group of chips) that detects incoming light rays and records the information as digital data. How much data can be recorded is described in megapixels. *See also* charge-coupled device, complementary metal-oxide semiconductor, *and* Foveon X3 direct image sensor.

imagesetter. A device that uses laser light to expose film at a resolution of 1200dpi or higher, up to a maximum of 4000dpi.

image size. (1) The actual physical dimensions of an image, as opposed to the size at which it is viewed on a given display device. (2) In Photoshop, a dialog box that lets you adjust the pixel dimensions, print dimensions, and resolution of an image. *Contrast with* canvas size.

image stabilization (IS). A computerized system that allows the lens to compensate for small camera movements. Such lenses contain gyroscopic sensors that detect motion and small motors that shift a moving lens element or group to compensate. This allows for sharper images when using longer exposures with a handheld camera. Synonymous with vibration reduction lens.

image-stitching software. A program used in postproduction to combine a sequence of overlapping photos into a single panoramic image.

image support. Indicates the ability of hardware or software to process a given image format (i.e., the image formats a device or program will recognize).

imaginary line. Implied lines formed by the way objects are placed in the picture area. For example, in a portrait of a couple,

there may be an implied diagonal line between the heads of a standing and seated subject. Implied lines are used to direct the viewer's gaze to important elements of a subject or scene within the photographic frame. Synonymous with implied line.

Imaging USA. Professional Photographers of America's annual convention, featuring a photographic print competition, lecturers, and photographic supply exhibitors. *See also* appendix 3 (Professional Photographers of America, Inc.).

imperial. A photographic mount, measuring either 6.875x10 or 7.875x9 inches, popular in the 19th century.

implied line. *See* imaginary line.

import. To transfer data from one device, storage medium, or program into another. Digital image files can be imported into Photoshop, for instance, from a memory card via a card reader. *Contrast with* export.

Impressionism. *See* appendix 2.

incandescent lamp. A lightbulb in which the filament radiates visible light when heated in a vacuum by an electrical current. Regular household lightbulbs and halogen lamps are incandescent light sources. *See also* tungsten lamp.

incident light. The light that falls upon a subject. This may not be the same as the amount of light reflected by the subject. *Compare with* reflected light.

incident light attachment. An accessory that can be affixed to a reflected light meter so it can take incident light readings. This accessory is permanently attached in some meters.

incident light meter. A hand-held exposure meter that measures the light falling on the subject and therefore provides an accurate reading regardless of the color or tonality of the subject. The reading is taken by standing at the camera position and pointing the meter's dome at the subject.

incoherent light. Ordinary light (from the sun and artificial light sources) that consists mainly of light waves of varying wavelengths (colors). Light comprised of the same wavelengths tends to be out of phase as well. *Contrast with* coherent light.

INCIDENT LIGHT METER. PHOTO COURTESY OF SEKONIC.

indexed color. A color model that produces image files with up to 256 colors. These colors are based on a table of standard colors; if a color in the original image does not appear in the

LEFT—ORIGINAL IMAGE. **CENTER**—INDEXED COLOR IMAGE WITH 100 COLORS.
RIGHT—INDEXED COLOR IMAGE WITH 20 COLORS.

table, the program chooses the closest one or uses dithering to simulate the color using available colors. Using this color mode can reduce file size yet maintain the visual quality needed for multimedia presentations and web pages.

index of refraction. *See* refractive index.

index print. A machine-made print containing thumbnail images of all the pictures processed from a roll of film.

Indian red. A retouching medium made by combining finely ground earth pigments and a binder. Often applied to sky areas of calotype, albumen, and gelatin negatives.

indicator chemical. A neutral chemical that may be added to a solution to determine its pH level or the presence of hypo.

indoor film. *See* tungsten-balanced film.

indoor mode. A scene mode in which the camera biases the white balance toward tungsten or fluorescent lighting and avoids using flash when possible. To reduce camera shake, higher shutter speeds are given preference; to compensate, wider apertures and higher ISO settings are often used.

infectious development. A process in which the development of slightly developed grains adjacent to well-exposed grains is hastened. This results in a very high-contrast image and is commonly used in processing lith film.

infinity. (1) The farthest distance marked on the focusing ring of a lens, generally about 50 feet. Typically designated by an infinity symbol (∞). (2) The distance from the camera beyond which any object will be reproduced sharply when the lens is at its infinity setting.

infinity cove. *See* cove.

infinity focus. *See* infinity.

infinity setting. A camera setting that allows for infinity focus. This is designated by the infinity symbol (∞).

infinity stops. Adjustable stops on the focus rails of some bellows-type cameras that allow you to adjust the position of different focal length lenses for correct infinity focus.

info palette. In Photoshop, a palette that shows color values as the eyedropper tool is moved over the image.

infrared (IR). Electromagnetic energy found at the red end of the spectrum, which is invisible to the human eye. Infrared energy is often employed by the autofocus systems of point-and-shoot cameras. *See also* infrared photography, far infrared, *and* near infrared.

infrared compensation mark. *See* infrared index mark.

Infrared Data Association (IrDA) communications. An Infrared Data Association–developed standard for communication between devices (such as computers, PDAs, and mobile phones) over short distances using infrared signals.

infrared film. A black & white film that is highly sensitive to infrared radiation. Color infrared film, an infrared-sensitive type of false color film, is also available. *See also* infrared photography.

infrared filter. (1) A filter that transmits near-infrared wavelengths and absorbs some or all wavelengths in the visible spectrum. The Wratten 25 (red) Wratten 87C (opaque) filters are commonly used. (2) An image-editing filter that can be applied to images to simulate the look of an infrared image.

infrared focus. *See* infrared focus compensation.

infrared focus compensation. The process of adjusting a lens to focus infrared waves (rather than visible light) on the film or

image sensor. For this purpose, many lenses have infrared index marks printed on them. To ensure accurate focus for infrared, the photographer focuses normally for visible light then turns the focus ring to the infrared index mark. Most infrared compensation is based on an assumed wavelength of 750–800nm, but some lenses have other index marks to deal with infrared films that are sensitive to different wavelengths. Focus compensation is not critical when using red filtration (Wratten red 25) due to the amount of visible light that is recorded. With an opaque filter (e.g., Wratten 87C), or when doing close-up photography, focus compensation is very important.

infrared index mark. Mark designed to assist photographers in adjusting a lens to focus infrared (rather than visible) light. This may be designated by the letters IR in red or orange paint, or by a red dot, line, or diamond (often with a red letter R).

infrared photography. The photographic capture of infrared wavelengths of light. This renders many subjects differently than they are seen by the human eye, producing a surreal effect. Infrared images can be captured on infrared film stock with the aid of an infrared filter. Digital cameras typically feature an internal hot-mirror filter that blocks much or all of the infrared light in order to produce better visible-light images; this filter can be removed to make the camera sensitive to infrared (although this voids the warranty and creates an infrared-only camera).

LEFT—COLOR IMAGE. **CENTER**—BLACK & WHITE IMAGE.
RIGHT—BLACK & WHITE INFRARED IMAGE.

infrared setting. *See* infrared focus compensation.

inkjet printer. A type of printer that sprays extremely tiny droplets of liquid ink onto the surface of the paper or other ink receptor. Home inkjet printers are relatively inexpensive and produce mediocre image quality. Some high-end inkjet printers yield extremely high-quality images.

WIDE-FORMAT INKJET PRINTER.
PHOTO COURTESY OF KODAK.

input. The transfer of data to a computer via a camera, hard drive, keyboard, modem, scanner, etc.

input/output (I/O). Operations, programs, or devices used to transfer data to or from a computer. Some devices are input-only devices (e.g., keyboard and mouse); others are primarily output devices (e.g., printers); still others provide both input and output of data (e.g., CDs, DVDs).

input profile. *See* device profile, camera profile, *or* scanner profile. *Contrast with* source profile.

install. To load and configure software on a computer.

Instamatic camera. A compact camera manufactured by Kodak and popular in the 1960s and 1970s. The camera featured simple controls, accepted 126 film, and yielded a 28x28mm negative.

instant camera. A type of camera with self-developing film and simple controls. There are many cameras in this category, though the Land camera is most notable. *See also* Polaroid back, Polaroid camera, *and* instant film.

AD FOR A KODAK INSTAMATIC.

instant film. Specially formulated film packs containing all the photochemicals needed to develop the photograph. When the photographs are removed from the instant camera, pressure rollers spread the chemicals across the surface of the film, developing the image in minutes without the need for a darkroom or processing facilities. The most popular brand is Polaroid film.

instant print. *See* instant film.

instant return. An SLR designed so that the mirror flips back down immediately upon capture of a photograph. With early SLRs, when you pressed the shutter release button, the mirror flipped up to expose the film then stayed in that position until the photographer advanced the film.

instrument metamerism. *See* metamerism.

integral tripack. A film base coated with three emulsions, each sensitive to a different primary color. Also used in some specialized black & white films.

integration. (1) Acquisition of electronic data from a CCD array. (2) The process of making separate software and hardware systems and devices communicate with each other. (3) A method of averaging density values to determine exposure in the camera or darkroom.

intellectual property. A work created by the human mind that has commercial value (e.g., photographs, literature, etc.). Such intellectual efforts can be protected through copyrights, trademarks, etc.

intelligent scanner. Scanner with additional processing capabilities including but not limited to OCR and bar-code reading.

intense negative. Term for an underexposed, overdeveloped negative. Synonymous with hard negative.

intensification. A means of chemically increasing the density of negative materials. *See also* intensifier.

intensification filter. An accessory used to increase the saturation of certain colors by absorbing specific wavelengths of light. Synonymous with enhancing filter. *See also* didymium filter.

intensifier. (1) A chemical treatment for adding density to an underexposed or underdeveloped black & white negative by adding extra silver or a compound of another metal, such as selenium or chromium. Proportional intensifiers increase image density evenly across the negative. Superproportional intensifiers have a greater effect on dense areas and boost image contrast. Subproportional intensifiers affect areas of low density and reduce contrast. (2) An electronic amplifier circuit that heightens the sensitivity of an image sensor.

intensity. The relative brightness of an image area or illumination source.

intensity scale. An exposure scale in which the exposure time is constant but the intensity of light increases in regular stops.

intensity-scale sensitometer. *See* sensitometer.

intent. *See* rendering intent.

interchangeable lens. A lens that can be removed from the camera body. SLRs typically accept interchangeable lenses; point-and-shoot cameras do not.

interchangeable viewfinders. A design feature found on some cameras that allows the top of the pentaprism housing to be removed and fitted with a different viewfinder.

interface. Connection between two hardware devices (hardware interface) or two pieces of software (software interface).

interference. An interaction of two electromagnetic waveforms that results in areas of increased or decreased amplitude. This signal disruption is a cause of noise in digital images.

interlaced scanning. A scan method used by some monitors in which all odd lines then even lines are alternately scanned and adjacent lines belong in different fields. This method, which often results in artifacts, is inferior to progressive scanning.

interleaving. The simultaneous processing of multiple sheets of photographic paper in one tray of chemicals.

intermittency effect. A rule stating that a number of short, separate exposures will not produce the same result when combined as a single image exposed for an equivalent total duration.

internal flash. *See* built-in flash.

internal focus (IF). A lens in which all moving elements are contained inside the barrel so that the lens does not extend or contract when focusing. This allows for faster focusing, a smaller-diameter focusing ring, and a closer minimum focusing distance. Aberrations are corrected across the focusing distance range. When focusing, these lenses draw in less air (and therefore, less dust and moisture) than other lens types.

International Color Consortium (ICC). A group formed in 1993 by members of the computer and color-publishing industry to develop standards for achieving reliable and reproducible color. *See also* ICC profile *and* ICC color management.

internegative. A negative image created directly from a positive one (such as a slide). This is then used to create another positive image.

Internet. A collection of networked computers that operate worldwide using a common set of communications protocols.

Internet service provider (ISP). A company that provides Internet access to individuals and businesses. ISPs provide local access from your personal computer to their computer network, from which you are connected to the Internet.

interpolated resolution. The final resolution of an image file that has been resampled by an image-editing program. *See also* interpolation.

interpolation. Changing the resolution of an image via computer-generated mathematical calculations that determine the values that new pixels should have based on surrounding pixels. Interpolation can result in artifacting.

interpolation method. In image-editing programs, a function used to assign color values to any new pixels created when an image is resampled.

interpositive. A positive transparency image produced as an intermediate step when creating a positive enlargement from a negative or positive material.

interrupt. Signal telling computer's microprocessor to briefly stop what it is doing and do something else. Once the new task is completed, the original task resumes.

intersection of thirds. *See* rule of thirds.

intervalometer. A timing mechanism that allows a camera to capture multiple images at set intervals. Such timers are useful for time-lapse photography. Synonymous with interval timer. *Contrast with* self-timer.

interval timer. *See* intervalometer.

inverse square law. A law of physics that defines the relationship between a light source and its intensity when positioned at varying distances. The law states that the illumination from a point source falls off inversely to the square of the distance. For example, when a light positioned 10 feet from a subject is moved to 20 feet, it will have only ¼ the original lighting intensity. If it is moved to 40 feet, it will have just ¹⁄₁₆ the intensity.

inverted telephoto lens. *See* retrofocus lens.

inverting. To reverse image tones to their opposite values, creating a negative image.

invisible light. Term referring to electromagnetic energy that can be optically altered but is invisible to the human eye. *See also* infrared *and* ultraviolet light.

I/O. *See* input/output.

iodine. A chemical component of reducers and bleachers.

iPod. A portable hard drive on which digital images can be stored. To transfer images to or from the device, the iPod is connected to the computer via a FireWire or USB port.

IrDA. The Infrared Data Association. *See also* Infrared Data Association (IrDA) communications.

iris diaphragm. A continuously adjustable device consisting of metal leaves that move inward or outward to increase or reduce the aperture size, allowing more or less light to pass through. The more blades, the closer the aperture is to a circular shape.

IRIS DIAPHRAGM.

iron. A highly reactive element that rusts when exposed to moist air. Iron-based compounds are noted as ferric or ferrous and are an important component of various chemistries and processes.

iron salt process. One of a variety of historic photographic processes that rely on the action of light on ferric salts.

iron sulfate. *See* ferrous sulfate.

irradiation. The spreading of light through the film due to reflection by silver halide grains. The effect is most noticeable when there are objects in front of a bright light source and light appears to cut into the object in the final image.

ISA. A 16-bit bus for PCs. *See also* bus.

I setting. Mark found on some inexpensive box cameras that indicates an instantaneous shutter speed of roughly ¹⁄₅₀ second.

ISO (International Standards Organization). (1) Agency responsible for coordinating photographic standards, including film speeds. (2) Film speed rating system using the same num-

bers as the obsolete ASA system. Low numbers indicate slow film; high numbers indicate fast film. (3) On digital cameras, adjustable sensitivity settings expressed in terms of ISO ratings.

ISO-3664. The ISO's standard for viewing conditions in graphic technology and photography. This details the steps that should be taken to ensure a proper environment in which to evaluate the appearance of photographic images.

ISO-9660. A file system format standard developed for CD-ROMs and supported by Microsoft operating systems, UNIX, and Macintosh.

isochromatic. *See* orthochromatic.

isolation layer. *See* subbing layer.

ISP. *See* Internet service provider.

IT8. An industry-standard chart used to calibrate input and output devices.

ivorytype. A historic process in which a handcolored photograph was impregnated with wax and squeegeed facedown on hot glass. The base was then backed by ivory-tinted paper to give the impression of a painting made on ivory.

IX (Information Exchange). The ability of photo devices to read and interpret a wide range of data printed in magnetic ink on each frame of APS film. This data allows the developer and printer to tailor the print output to the conditions under which the photos were taken.

J2K. *See* JPEG2000.

Jackson, William Henry. *See* appendix 1.

jaggies. In digital images, a stair-like pattern that appears where there should be smooth lines or curves. This can be caused by insufficient output resolution. Jaggies may also result when an image is upscaled or when a high compression ratio is selected with JPEG compression. The appearance of jaggies can be reduced somewhat by anti-aliasing. Some printers and applications also employ a feature known as smoothing to reduce the appearance of jaggies. Also known as aliasing and pixelization.

Japan Camera Industry Institute (JCII). Formerly the Japan Camera Inspection Institute, an organization responsible for ensuring strict quality control for all Japanese camera products exported overseas.

Japanning. *See* Japan varnish.

Japan varnish. A glossy black coating made of asphaltum, solvent, and Canada balsam used to finish an ambrotype. It is also used to coat the iron plates used in the melainotype process. The varnish is also known as Japanning.

JAS. Proprietary compressed graphic format used by Jasc Paint Shop Pro.

Java. A multi-platform, object-oriented programming language developed by Sun Microsystems used in writing interactive software for the Internet.

Javascript. A scripting language developed by Netscape Communications and employed in HTML web pages.

JCII. *See* Japan Camera Industry Institute.

JFIF (JPEG file interchange format). Technically, the file format used by most JPEG documents. (The term JPEG refers to a file compression algorithm, not a file format. In practice, however, people use the term JPEG, not JFIF, to refer to files that employ JPEG compression.) Also noted as JIF and JIFF.

JIF. *See* JFIF.

JIFF. *See* JFIF.

Joint Photographic Experts Group. *See* JPEG.

Joly plate. The first commercially available additive color process, applied to linear screen plates. The process was obsolete once Kodachrome was introduced, but it is the basis of the technology used in televisions and monitors.

joule. Unit of measure used to describe the light output of electronic flash. One joule is equal to 1 watt-second or 40 lumen seconds. The measure is used to compare the power output of flash units.

JPEG (Joint Photographic Experts Group). (1) An international committee of computer imaging experts. (2) A lossy compression algorithm that allows for a reduction in the amount of memory required for image storage. There are several versions of JPEG available, some of which are proprietary. JPEG analyzes images in 8x8-pixel squares and selectively reduces detail within each block. Users may select from various levels of compression. At higher levels, artifacting becomes more visible and an objectionable loss of detail may result. *See also* JFIF.

JPEG2000. A JPEG compression standard used in digital cameras and software manufactured since 2001. The algorithm allows for higher compression but with less image degradation. The extension *.j2k is commonly used to denote this file type.

JPG. *See* JPEG.

JTF (JPEG Tagged Interchange Format). A format based on TIFF, with JPEG compression. Such files may contain EXIF data and other JPEG-supported metadata.

jukebox. (1) A storage unit that houses multiple optical discs and one or more disc drives and automatically selects or changes discs as needed. (2) A proprietary name for Kodak's automated Photo CD library.

jump drive. A portable device that employs flash memory to store data and a USB interface to communicate with the computer. Synonymous with thumb drive, flash drive, and USB key.

JUMP DRIVE.

juxtapose. To position two objects close together or side by side to compare or contrast them. The technique is often helpful in showing scale in an image.

K. (1) *See* Kelvin. (2) In CMYK printing, the letter K is used to represent black. *See also* CMYK *and* black. (3) *See* kilobyte.

K 14. Proprietary chemical process used to develop Kodachrome slides.

Kaesemann. (1) A German manufacturer of polarized material. (2) A type of polarizing filter (usually sold under the brand name B+W) possessing high uniformity and color neutrality. These filters are sealed around the edges to discourage delamination. Also spelled Käsemann.

kallitype. An obsolete printing process used to produce prints that, when toned with gold or platinum toner, mimic those made using the platinum process—at a fraction of the cost. These prints have a reputation for fading.

kaolin. A porcelain clay used to clean glass before the coating stage of the wet collodion process.

Karsh, Yousuf. *See* appendix 1.

Käsemann. *See* Kaesemann.

KB. (1) *See* keyboard. (2) *See* kilobyte.

keeping quality. The stability of photographic chemistries when stored as recommended by the manufacturer.

Kelvin (K). A temperature scale in which 0 degrees (absolute zero) is the temperature at which all molecular motion ceases. This scale is used to measure the color temperature of light.

Kelvin white balance. *See* color temperature white balance.

Keplerian viewfinder. A viewfinder with magnifying qualities that increases the field of view. Such viewfinders are similar to a type of viewfinder that was designed for telescopes by Johannes Kepler.

kernel size. The number of pixels sampled as a unit during image editing and sharpening processes.

kerning. The amount of space between letters and/or other typographical elements. This is initially determined by the design of the font but can be increased or decreased in many programs for aesthetic reasons.

LEFT—KERNING SET TO 0 (ZERO). CENTER—KERNING SET TO 100.

Kertész, André. *See* appendix 1.

keyboard (KB). A device containing a number of buttons printed with numbers, letters, and typographical/mathematical symbols, etc., that is used in the operation of a computer.

KEYBOARD.

keyboard shortcut. A combination of keystrokes used to access a command in lieu of using the drop-down menu.

COMMAND	SHORTCUT	COMMAND	SHORTCUT
SELECT MARQUEE TOOL	M	SELECT GRADIENT TOOL	G
SELECT LASSO TOOL	L	SELECT BLUR TOOL	R
SELECT MOVE TOOL	V	SELECT DODGE TOOL	O
SELECT MAGIC WAND TOOL	W	SELECT TYPE TOOL	T
SELECT CROP TOOL	C	SELECT PEN TOOL	P
SELECT BRUSH TOOL	B	SELECT EYEDROPPER TOOL	I
SELECT CLONE STAMP TOOL	S	SELECT HAND TOOL	H
SELECT HISTORY BRUSH TOOL	Y	SELECT ZOOM TOOL	Z
SELECT ERASER TOOL	E		

KEYBOARD SHORTCUTS FOR CHOOSING TOOLS IN PHOTOSHOP.

keyed emulsion sensitivity. Refers to the color response of printing papers with peak sensitivities to the three dye colors present in the same manufacturers' color negatives.

keying. *See* chromakey photography.

key light. The brightest light illuminating the subject. Used to control the tonal level of the main area of the subject, particularly in a studio lighting situation. Synonymous with main light.

keyline. A black line indicating the exact placement for a color or black & white image. This acts as a placeholder in the layout.

keystoning. Distortion that occurs in a projected slide or movie when the projector's lens axis is not at a 90-degree angle to the screen. The image will appear wider at one edge than on the opposite, resulting in a trapezoidal shape. Also, the image will not exhibit uniform sharpness. Many projectors now employ optical and electronic methods that eliminate this problem.

kicker light. Directional lighting on the subject that comes from behind and the side (typically the side opposite the main light). This provides highlights for background separation.

kids and pets mode. *See* sports mode.

KICKER LIGHT ADDS HIGHLIGHTS ON THE SUBJECT'S BACK. PHOTO BY TIM SCHOOLER.

kilobits per second (Kbps). A unit of measure used to describe transmission speed in a digital connection. Equal to one thousand bits of data per second.

kilobyte (KB, sometimes K). A unit of measurement commonly used in descriptions of computer memory (RAM, document size, etc.). One kilobyte is equal to 1024 bytes. *See also* byte, gigabyte, *and* megabyte.

kilowatt (KW). A unit of measure that describes the power of an electrical light unit. One kilowatt is equal to 1000 watts.

kinetic. A type of photography concerned with movement and motion.

Kirlian photography. The photographic capture of objects mounted on plates subjected to high-voltage electricity. The subjects appear to be surrounded by an ethereal glow (often thought to be an aura) when photographed; this is a result of the gas ionization from the water present in all living matter.

kit. (1) Consumer-level SLRs are often sold in sets containing the camera body, a zoom lens, and some accessories (e.g., a camera case, a small tripod, or a camera strap). The lenses available in such kits are often called kit lenses. (2) Slang for camera gear, often contained in a camera bag. (3) In historical photographic processes, a wooden reducing frame that allowed camera plate holders to accommodate smaller plates.

kite aerial photography (KAP). Aerial images captured by lightweight, remotely operated cameras suspended on kite lines.

kit lens. *See* kit.

knifing. The act of removing blemishes from the surface of a print by gently scraping with the tip of a sharp knife.

knockout. (1) In multicolor printing, to remove the background color behind a graphic or text so that ink colors will not mix and appear contaminated. For example, yellow text printed on a blue background will appear greenish. To prevent this, the background color (blue) is knocked out (removed). (2) In Photoshop, a layer setting that allows you to create image elements that punch through underlying layers.

TEXT LAYER KNOCKED OUT TO REVEAL UNDERLYING LAYER.

Kodachrome. The proprietary term for a type of color reversal film manufactured by Kodak. Kodachrome slides are known for their vibrant color, fine grain, exceptional sharpness, and colorfastness. They are produced via a complicated chemical process in which dyes are selectively added during development. Koda-chrome is not widely used today and must typically be mailed in to Kodak for processing. Most photographers now use E6 or Ektachrome slides, which are less expensive to produce.

Kodak. Renowned for the breakthrough Brownie camera in 1900, Kodak manufactures a wide variety of products for amateur and professional photographers. The company's full name is Eastman Kodak.

Kodak PhotoCD. A CD storage system designed by Kodak in the early 1990s for digitizing and storing photos. The discs were designed to hold from 25 to 100 high-quality images, depending on the number of resolutions written for each file. Files are labeled with the extension *.pcd.

Kodak Picture CD. A CD created when film is processed. Image files are saved in the JPEG format and offer sufficient resolution to make an 8x10-inch print. The CD also provides tools that help you zoom and crop, reduce red-eye, e-mail, and print your images. Images can be opened on any platform. However, original Picture CDs provided additional content for only Windows operating systems.

Kodalk. *See* PMK developer.

Konica. *See* Konica Minolta.

Konica Minolta. A worldwide manufacturer of cameras, camera accessories, laser printers, and other imaging products.

Kostinsky effect. A darkroom phenomenon in which, relative to each other, dense image points move apart and light image points move together. This results when developer is not evenly distributed and rapidly exhausted when heavily exposed image points are close together.

Kromskop. Early viewing instrument that used mirrors and color filters to capture a full-color image. The device allowed monochrome transparencies made from separation negatives to be rear-illuminated through blue, green, and red filters. When combined in register, these appeared as a single, color image.

Kyocera. A Japanese company known for its production of printing-related devices, imaging products, and 35mm and medium-format cameras.

lab. A private or commercial room or facility equipped to process film, make enlargements, print photographs, etc.

Lab color. *See* CIE LAB.

lag time. *See* shutter lag.

lamp. A general term used to describe artificial light units.

lamp black. Pure carbon pigment, made from unburned fuel residue (soot). Also called carbon black.

lamp house. The portion of an enlarger or projector that contains the light source.

LAN (local area network). Communications network that is physically connected by cables and enables multiple computers to exchange files and share peripherals. *See also* WAN.

Land camera. Instant film camera manufactured by Polaroid and named for the company's founder, Edwin Land.

Land, Dr. Edwin. *See* appendix 1.

landscape lens. A simple lens (typically a single-element lens—a plano-convex or meniscus lens mounted in a frame) common in early photography. Such lenses produce significant distortion and require long exposure times.

landscape mode. Mode in which the camera selects a small aperture to increase the depth of field, keeping as much of the scene in focus as possible. This works well for wide scenes with points of interest at different distances from the camera.

landscape orientation. An image that is wider than it is tall. On printers, this term is used in setting the paper orientation. Synonymous with vertical orientation and horizontal format. *Contrast with* portrait orientation.

LANDSCAPE MODE ICON FOUND ON MANY CAMERAS.

landscape photography. Photographing the visible features of an area of land, normally for their aesthetic appeal.

Lange, Dorothea. *See* appendix 1.

lantern slides. (1) Transparencies produced on glass and projected onto a wall or screen by a magic lantern. These predated photography by several decades. (2) An alternate but antiquated name for transparencies.

large format. (1) In still photography, a camera that accepts sheets of film 4x5-, 5x7-, 8x10-inches, or larger. Most large-format cameras are view cameras. (2) In the motion picture industry, the term refers to 70mm film.

large hole film. *See* 120 film.

laser disc. The first commercially available optical disc data-storage medium.

laser light. Light consisting of a single wavelength. Lasers are sometimes used for adjusting and calibrating lenses and to remotely trigger the shutter.

laser printer. A high-quality output device commonly used in an office setting. A computer-controlled laser beam writes a static charge onto a rotating drum. One or more powdered toners are adhered to the statically charged sections of the drum and are then transferred onto the paper. A heat roller melts and permanently affixes the plastic toner onto the paper. *Contrast with* dye-sublimation printer *and* inkjet printer.

LASER PRINTERS BY CANON (LEFT) AND HEWLETT-PACKARD (RIGHT).

lasso tool. In Photoshop, a tool used to make free-form selections. Its variants, the magnetic lasso and polygonal lasso, allow you to change the way the tool detects and selects edges.

latensification. A method of increasing relative film speed by fogging (via light or chemicals) after exposure and before development.

latent image. The physical or chemical changes that occur in the silver halide grains in a photographic emulsion upon exposure to light. The image is undetectable until chemical development has taken place.

latent image deterioration. Term referring to the image degradation that results when an exposed image is not promptly processed.

lateral reversal. (1) An image that appears flipped left to right (e.g., as viewed in some viewfinders). (2) Horizontally flipping an image using an optical reversing device, by flipping the negative, or using an image-editing program. Also called flopping.

LATERAL REVERSAL.

latitude. *See* exposure latitude.

lavender oil. An essential oil used to dilute asphaltum in the heliograph process. It was also mixed with white petroleum and used to dissolve unexposed asphalt. As an ingredient in 19th-century varnishes, the oil helped to prevent gum varnish from drying too fast and cracking the layer carrying the image.

layer. In image-editing programs, a discrete, transparent "sheet" of data that can be accessed, worked on, and moved without affecting other layers.

layer mode. *See* blending mode.

LCD (liquid crystal display) monitor. A lightweight monitor that provides sharp, clear images. LCD monitors do not exhibit the glare problems that can be a factor with CRT monitors. Also called a flat screen or studio monitor. *Compare with* cathode ray tube monitor *and* gas plasma monitor.

LCD MONITORS IN A VARIETY OF SIZES. PHOTO COURTESY OF APPLE.

LCD protector. A clear plastic device that is placed over a camera's LCD screen in order to protect it from fingerprints and scratches. *See also* LCD shade.

LCD PROTECTOR. PHOTO COURTESY OF NIKON.

LCD screen. A display screen found on many digital cameras that allows users to review captured images. The display screen also serves as an interface for some camera controls. Synonymous with preview screen. *See also* LCD viewfinder.

LCD SCREEN.

LCD shade. A rigid black plastic device that attaches to the back of a camera and folds out to shade the LCD screen and reduce glare. When retracted, the shade also helps protect the LCD from fingerprints and scratches.

LCD viewfinder. An LCD screen used to view and compose the photographic subject prior to capturing the image. Using a rear LCD screen in this way is not possible with most digital SLRs, as the image sensor is blocked by the reflex mirror. *See also* LCD screen *and* live view.

LCH. A color model that describes color in terms of lightness, chroma, and hue. This closely models the qualities most apparent in human perception of color. The same basic model is also called HSI (hue, saturation, intensity), HLS (hue, lightness, saturation), and HSL (hue, saturation, lightness).

lead. A poisonous substance historically used in photographic solutions and to make acid-resistant liners used to protect wooden darkroom sinks.

lead acetate. A poisonous powdered component of some toning and intensifying solutions.

lead chromate. A compound used in a dye employed to make orange curtains used to cover doors and windows in 19th-century darkrooms.

leader. A small piece of film that protrudes from the cassettes of 35mm films and facilitates the loading of film in cameras with slotted take-up spools. Also called a tongue or film leader.

leader-out. A feature on some cameras that allows the photographer to rewind the film mid-roll but leave the film leader protruding from the canister so that it may later be reloaded.

leading. The vertical spacing between lines of type, measured in points.

| THE SWIFT RED FOX JUMPED OVER THE LAZY BROWN DOG. THE SWIFT RED FOX JUMPED OVER THE LAZY BROWN DOG. THE SWIFT RED FOX JUMPED OVER THE LAZY BROWN DOG. THE SWIFT RED FOX JUMPED OVER THE LAZY BROWN DOG. THE SWIFT RED FOX JUMPED OVER THE LAZY BROWN DOG. THE SWIFT RED FOX JUMPED OVER THE LAZY BROWN DOG. | THE SWIFT RED FOX JUMPED OVER THE LAZY BROWN DOG. THE SWIFT RED FOX JUMPED OVER THE LAZY BROWN DOG. THE SWIFT RED FOX JUMPED OVER THE LAZY BROWN DOG. THE SWIFT RED FOX JUMPED OVER THE LAZY BROWN DOG. THE SWIFT RED FOX JUMPED OVER THE LAZY BROWN DOG. |

LEFT—LEADING SET TO 7 POINTS. **RIGHT**—LEADING SET TO 11 POINTS.

lead nitrate. Compound used to bleach silver images before toning with a sulfide.

leaf shutter. A shutter located within the lens (a between-the-lens shutter) or in the camera body near the lens mount. This circular shutter is comprised of overlapping metal leaves that open up to allow light to expose the film or image sensor. Such a shutter can be synchronized with a flash at any speed. Also called a compound or diaphragm shutter.

LED (light-emitting diode). A small semiconductor device that emits light (but almost no heat) when electricity is passed through it. LEDs are red, green, yellow/orange, blue, or white and are employed in various camera features/functions (e.g., data displays, self-timer countdown lights, etc.).

Lee. Manufacturer of photographic filters.

legacy files. Files created in an earlier version of an application and accessed in a newer version of the application. Such files may not support (or may not fully support) features available in the newer version.

Leica. German manufacturer known primarily for their high-quality cameras and lenses. Leica also produces microscopes, binoculars, projectors, and other equipment. Formerly called Ernst Leitz GmbH.

lens. A glass, plastic, or crystal optical element molded into a curved shape that can bend and focus rays of light. Simple lenses feature a single convex or concave lens. Most photographic lenses feature multiple elements housed in a single lens barrel that cancel out each element's weaknesses to produce a sharp image. The size of the individual lens elements and their positions determine the angle of view and focal length of the lens.

lens, accessory. *See* accessory lens.

lens aperture. *See* aperture.

Lensbaby. A special-effects lens developed by photographer Craig Strong that allows for manual control of lens tilts and

swings (like a view camera) and creates a "sweet spot" of focus, rendering the balance of the image as if it were affected by motion blur. Invertible plastic aperture rings make it possible to change the effective aperture.

lens barrel. A metal or plastic tube with a blackened inner surface in which the lens elements and mechanical components of the lens are mounted.

lens cap. A protective plastic, rubber, or metal cover designed to fit over the front or back of the lens.

lens circle. The circle of coverage; the area of focused light rays falling on the film plane or image sensor.

lens cleaning cloth/paper. Specially designed microfiber cloths or tissue paper used to rub away dust spots, fingerprints, and other marks on lenses, prints, and negatives without damaging delicate optical elements and other fragile materials.

FRONT LENS CAP.

lens coating. A thin application of antireflective material applied to the surface of lens elements (in one layer or many). By decreasing the reflection of light striking the lens, more light is transmitted to the film/image sensor.

lens-drive system. In autofocus SLR cameras, a motor located inside the lens or camera body that turns the lens via a drive shaft.

lens element separation. A splitting apart of optical elements due to cement breakdown. The separated lens elements show reflective areas when you look into the lens barrel and produce poor-quality images.

lens formula. The specifications of all the optical components that go into the design of a lens (the lens elements and groups, the type and size of elements, the materials used in each element, the way the elements are arranged, etc.).

lens hood. *See* lens shade.

lens mount. The mechanical/electronic attachment system used to fasten a lens to a camera. Adapter rings may be required to attach some lenses to the camera bodies. However, adapted lenses generally suffer a loss of functionality (e.g., aperture control or autofocusing capability). *See also* bayonet mount, breech lock mount, EF, F, FD, M42, screw mount, *and* T mount.

lens-mount cap. *See* rear lens cap.

lens mount index. Marks (often red dots) found on a lens mount and the lens barrel that show how the lens should be fitted to the camera. To attach the lens, you align the marks and, for bayonet-mount lenses, rotate the lens barrel to lock it.

lens names. Collective name given by lens manufacturers to a group of lenses with a particular lens formula (e.g., Tessar, Sonnar, Nikkor, etc.). This allows photographers to distinguish one lens from another—regardless of focal length—according to the optical design of the lens.

lens register. *See* register distance.

lens separation. *See* lens element separation.

lens shade. A plastic, metal, or rubber device that attaches to the front of a lens to shield it from extraneous light, thus preventing flare, ghost images, and diminished contrast. Shades come in a variety of shapes, including slightly flared short cylin-ders, short cylinders with cutout notches (often known as "perfect" lens shades), square or rectangular designs, and flexible rubber shades that can be adjusted to fit the coverage area of different lenses. A dedicated lens shade is one designed to fit one specific model of lens made by one manufacturer and no other. Lens shades also offer added physical protection against accidental blows. Synonymous with sun shade and lens hood.

lens shutter camera. A type of camera in which the shutter is built into the lens.

lens speed. The largest available aperture on a lens (the smallest f-stop to which the lens can be set). This is indicated on the lens barrel (e.g., f/2.8). *See also* fast lens *and* slow lens.

lens support. When shooting from a tripod with a very long lens, a device used to support the weight of the lens and reduce stress on the lens mount.

LENS WITH ATTACHED SUPPORT. PHOTO COURTESY OF NIKON.

lens system. A term used to describe a collection of lenses available for use with a particular camera.

lenticular screen. (1) On some exposure meters, a screen containing a number of tiny lenses employed to gather light and determine the angle of acceptance of light by the meter. A lenticular screen comprised of multiple lenses arranged in rows can be used at the camera stage to synthesize binocular vision and produce stereoscopic images. (2) A projection screen surface characterized by silvered or aluminized embossing and designed to reflect maximum light over wide horizontal and narrow vertical angles. Also called silver screen or silver lenticular screen.

leptographic paper. The first collodion-chloride printing-out paper that was commercially available. Dates back to 1870.

levels. (1) In Photoshop, a feature that lets you correct the color balance and tonal range of an image by making adjustments to the shadows, midtones, and highlights sliders in the composite channel or one of the individual color channels. A histogram is used to illustrate the overall tonal distribution in the particular image. (2) *See* gain and level.

LEVELS DIALOG BOX.

license. An agreement that outlines the terms by which a copyrighted image can be used by a second party. This is typically granted upon payment of a licensing fee.

life expectancy. A rating system used to describe the archival stability of a medium.

light. Electromagnetic energy in wavelengths that range from roughly 380nm to 720nm and can be sensed by the human eye. Different wavelengths of light are perceived as different colors. Synonymous with visible light. *Contrast with* infrared *and* ultraviolet light.

light-balancing filter. An accessory used to warm or cool the color balance in a scene to make it compatible to the film being used.

light booth. A device used to provide controlled viewing conditions with color balanced temperature and consistent illumination. Images are placed inside the booth to allow for better color evaluation. Light booths are available in a variety of shapes and sizes, and some allow you to adjust the color temperature and brightness. Also called a viewing booth.

light box. (1) A box fitted with a translucent glass or plastic top that contains a white-balanced light source (typically fluorescent tubes or small incandescent bulbs) used to illuminate the surface. Transparencies or negatives placed on the surface are illuminated from underneath and are examined with a loupe or magnifying glass. Battery-powered, notebook-sized light boxes are also available. (2) Sometimes used synonymously with light table.

LIGHT BOX.

light-emitting diode. *See* LED.

lightfast. A colorant manufactured to be more resistant to the bleaching effects of sunlight (i.e., offering increased archival stability).

light hose. A flexible fiber-optic tube used to direct light of various colors onto a subject that is photographed in a darkened room, with the camera in bulb mode. The glowing-edge effect the tool produces was often used in product photography in the 1990s.

lighting. The art and science of using light to present a given subject or scene in the most flattering manner possible. Many variables are at play in designing the best lighting concept, in-cluding but not limited to the positioning of the various light sources, the quality and color temperature of the light(s), the number of units employed, the size of the lights, the modifiers used to adjust the quality of the light, the highlight and shadow patterns formed, and the light ratio (contrast) achieved.

lighting ratio. A numeric description of the difference in intensity between the highlight side of a subject (illuminated by the main light) and its shadow side (illuminated by fill light).

lighting schematic. A drawing of a lighting setup used to communicate the lighting strategy to other photographers or clients.

light interference. *See* interference.

light leak. A flaw in a camera body that allows light to seep in, exposing the photosensitive material to non-image-forming light. This may result in streaks or blotches of light or fogging.

light level. *See* intensity.

light meter. An instrument used to measure the intensity of light to determine the shutter and aperture setting required to obtain correct exposure. Some camera models are equipped with built-in meters, but accessory meters are available. Some meters can be used to measure light from a particular part of the subject (spot metering) or to take an overall reading. *See also* incident light meter *and* reflected light meter.

lightness. (1) The property of a color that distinguishes white from gray or black, and light objects from dark. Synonymous with value and brightness. (2) The L (lightness or luminance) channel in the CIE LAB color model.

light painting. *See* painting with light.

light panel. A large white translucent fabric panel modifier with a steel frame used to produce a soft, diffuse quality of light.

light pipe. A transparent material that transmits light, directing illumination to another location. Optical fibers, for example, are a type of light pipe.

lightproof. A container, room, or other space into which light cannot enter. Properly designed and correctly operating cameras, for example, will only allow light to enter through the lens diaphragm. Light that enters the camera in any other way can cause fogging. Unexposed film and traditional photographic paper is stored in lightproof containers or wrappers. Synonymous with lighttight.

light ratio. *See* lighting ratio.

light source. A general term used to describe any source of illumination that is cast upon or reflected onto a scene. This includes natural and artificial light.

light table. (1) A large, free-standing device used in tabletop photography. This consists of a flat, translucent white surface over a base that contains a light source. Placing objects to be photographed upon the illuminated surface ensures that the areas around them will record as pure, shadowless white. (2) Sometimes used synonymously with light box.

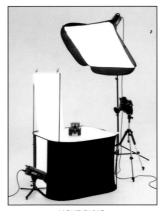

LIGHT TABLE.
PHOTO COURTESY OF LASTOLITE.

light tent. A tent-like light modifier consisting of diffusion fabric stretched over a frame. Small objects are placed in the tent and photographed in the diffuse, soft light shining through the walls. This helps prevent unwanted shadows or reflections.

LIGHT TENT (WITH THE BACK OPEN). PHOTO COURTESY OF LASTOLITE.

lighttight. *See* lightproof.

light trail. The recorded streak of light produced in an image when a point of light is shifted during exposure.

TAILLIGHTS OF A MOVING CAR CREATE LIGHT TRAILS.

light trap. (1) Any device used to block light from entering a camera, film canister, darkroom, etc., to expose photosensitive materials. Felt pads or strips are often employed to keep light from entering film cassettes and cameras, and a simple revolving door is often employed in the darkroom to keep ambient light out of the work area. (2) In a photographic image, a distracting spot of bright light in an otherwise darker area (such as a small area of white sky showing through dark foliage).

light value. *See* exposure value.

Li-ion batteries. *See* lithium ion battery.

limiting aperture. The actual size of the opening formed by the iris diaphragm at any setting.

linear array. A photo-detector that consists of a straight line of light-sensitive components. Used in flatbed scanners.

linearity. The degree to which the input of a signal mirrors signal output.

linearization. The process of adjusting the performance of an imaging system (e.g., scanner, imagesetter) to ensure that it produces a straight-line relationship between input and output across its tonal range. Synonymous with sensor linearity.

linear perspective. In a two-dimensional image, the apparent convergence of parallel lines with increasing distance, which helps to imply a sense of a third dimension. This can be used to the photographer's advantage in some subjects (e.g., when photographing a long, curving road in a landscape image) but is undesirable in others (e.g., when trying to create an un-distorted image of a skyscraper). *See also* convergence.

LINEAR PERSPECTIVE.

linear polarizing filter. *See* polarizing filter.

linear response. A relationship in which an increase in stimulus will result in an equal increase in response.

linear scanner. A scanning device that employs a linear array CCD, which "reads" one line of the image at a time. The linear array is moved over the image or the image is moved across the linear array in steps in order to capture the whole image area.

line art. (1) Images containing only black and white pixels, with no intermediate shades of gray. (2) One-color images, such as mechanical blueprints or drawings.

line film. *See* lith film.

line image. A specialized high-contrast film used to produce images that resemble pen and ink drawings (e.g., black lines on a white background, or vice versa, with no intermediate gray tones). *See* also lith film.

line screen. The resolution of a halftone in lines per inch.

lines per inch (lpi). A measurement used to describe resolution (typically the screen frequency in halftone images).

line tool. *See* shape tool.

Linhof. Manufacturer of large-format cameras.

link. In Photoshop, a method by which two layers are joined together so that an action performed on one will also be performed on the other. Linked images are also called a group.

Linked Ring Brotherhood, The. *See* appendix 2.

Lippmann emulsion. A very fine-grained, high-contrast emulsion used in the Lippmann process.

Lippmann, Gabriel. *See* appendix 1.

Lippmann process. An early color process by Gabriel Lippmann. The exposure is made using a camera in which the plate rests against a layer of mercury that reflects back the light from the subject. The interference between reflected and incident light produces a latent image that can be processed as a black & white image, but when backed with a mirror appears in color. The image colors are not the result of the use of dyes or pigments, but interference patterns from light at different wavelengths.

liquid crystal display. *See* LCD monitor, LCD protector, LCD screen, LCD shade, *and* LCD viewfinder.

liquid emulsion. An emulsion type that can be painted onto various surfaces, rendering them light-sensitive.

liquify filter. In Photoshop, a filter that allows you to push, pull, rotate, reflect, pucker, and bloat any area of an image. Useful for retouching or to produce artistic effects.

lith film. Very high-contrast line film that exhibits pure blacks and whites and no grays when used with a special lith developer. It is used to mimic lithographic printing and is useful for the reproduction of line art.

lithium. A soft, silvery metal used in compounds employed as halogens. Also used in batteries.

lithium bromide. A white crystal soluble used in the production of collodion dry plate emulsions.

lithium chloride. A compound used in the manufacture of collodion-chloride printing-out emulsions. Also employed to increase contrast in gelatin-chloride printing-out emulsions.

lithium ion (Li-ion) battery. A battery that is lightweight, has a high energy density (holds a great deal of power in a small area), and can be quickly recharged. These batteries can typically be charged only a few hundred times and tend to have a life span of only two to four years.

LITHIUM ION BATTERIES.

lithographic film. *See* lith film.

lithography. A printing method using plates and a water-based solution that repels oil-based ink from non-image areas of the plate. The image is transferred to a rubber sheet before it is offset to paper. Also called offset lithography.

lith paper. A type of high-contrast paper that produces some gray tones with all but the most contrasty negatives.

litmus paper. A paper that turns red when submerged in acid solutions and blue when dipped in alkaline solutions. The rapidity with which the paper turns blue gives a sense of the strength of an acidic solution.

live view. A mode on some DSLRs that allows the LCD on the back of the camera to be used for composing images.

lm. *See* lumen.

local control. The act of masking portions of a print to increase or decrease exposure in select areas.

location scouting. Visiting a shooting locale before the session to determine its suitability or to evaluate what will be needed to achieve the desired results at the site.

long exposure photography. The act of photographing a (typically) moving subject using a slow shutter speed, generally to capture motion blur and light trails.

long focus. A lens with a focal length that is much greater than the diagonal of the film or image format with which it is used.

long lens. Colloquial term for a telephoto lens.

look-up table (LUT). The table of colors a computer can display at a given time. It is used by the computer to replace an out-of-gamut color with one from the range of available colors.

loop lighting. A portrait lighting pattern with a loop-shaped shadow below the nose on the shadow side of the subject's face. The light placement is similar to that used in Paramount lighting, but the main light is placed slightly lower and farther to the side of the subject.

lossless compression. A compression method that examines an image file and reduces its overall size by searching out repetitive patterns and compressing them. No original data is thrown out, so there is no loss in quality when the file is uncompressed. Lossless compression cannot create file sizes as small as can lossy compression. *Contrast with* lossy compression.

lossy compression. A compression method that examines an image file, selects redundant information, and throws it away. The result is a smaller file size, but image quality is degraded (the degree to which this occurs depends on the compression algorithm and the quality setting the user selects). Lossy compression can cause artifacting, especially when the file is aggressively or repeatedly compressed. *Contrast with* lossless compression.

loupe. A small handheld magnifying glass mounted in a frame that keeps the lens raised a fixed distance from the surface being examined to ensure constant focus. Used to examine details on slides, negatives, prints, etc., often when placed on a light box.

LOUPE.

low-contrast filter. A camera accessory that reduces image contrast by adding subtle fog in dark areas.

low-dispersion glass. Optical glass with a lower refractive index than regular glass. This is generally used on telephoto lenses to minimize the appearance of chromatic aberration.

Lowepro. Manufacturer best known for their camera bags.

low-intensity reciprocity failure (LIRF). A failure of reciprocity that occurs when an image is exposed with weak light for a long duration, such as in astrophotography.

low key. A photographic style in which the overall tones of the image (e.g., clothing, props, and background) are primarily black or dark in tone. Such an image has few highlights. *Contrast with* high key.

LOW KEY.

low-pass filter (LPF). Anti-aliasing filter in a digital camera.

low-res. *See* low resolution.

low resolution. Images intended for on-screen viewing, typically at 72dpi.

lpi. *See* lines per inch.

LPT port. *See* parallel port.

lubricant. A coating typically made from beeswax, paraffin, or castile soap mixed with turpentine, whale oil, or lavender oil and applied to mounted prints prior to burnishing.

lumen (lm). Unit of luminous flux, a measure of the power of a light source as perceived by the human eye.

lumen second (lms). A metric unit used to describe the total light output by a source in 1 second.

Lumiére, Auguste and Louis. *See* appendix 1.

luminance. (1) The density of luminous intensity in a given direction. Measured in candelas per square foot/meter or foot-lamberts. (2) A component of an HSL image. It is the highest RGB values plus the lowest RGB values, divided by 2.

luminance meter. *See* exposure meter *or* light meter.

luminescence. Visible light emitted by an object at a different wavelength than that at which it is absorbed.

luminosity. The brightness of light output by a source or reflected by a surface.

luminous energy. The energy associated with visible light, measured in lumen seconds.

luminous flux. The intensity of a light source as perceived by the human eye. Measured in lumens. *Contrast with* radiant flux.

luster. A photographic paper with a surface quality between matte and glossy. Also called semigloss and semimatte.

LUT. *See* look-up table.

lux (lx). A unit of light measurement equal to 1 lumen per square meter. One lux is approximately equal to 10 footcandles.

LZW (Lemple-Zif-Welch). Lossless compression supported by TIFF, PDF, GIF, and PostScript language file formats. It is best used with images containing large amounts of a single color.

M42. The name commonly given to the 42mm screw-fit lens mount used on many manual focus SLR cameras. Also known as Pentax screw fit.

Macbeth color checker. *See* patch chart.

machine print. A photographic print produced by an automated, self-contained photo printing machine (i.e., a minilab). The quality of such prints can vary wildly depending on the type of machine used and the care and expertise of the operator.

Macintosh. A line of computers that run the MacOS operating system. These computers, produced by U.S. manufacturer Apple Computer, are favored by many graphic designers and other creative professionals.

mackie line. An aberration in a negative or print in which a light line forms along the boundaries of the darkest image areas. Caused by the diffusion of exhausted developer, lack of agitation, or solarization.

macro attachment. Any of a variety of devices that can be affixed to a normal lens to allow for extreme close-ups of a subject. *See also* close-up lens *and* extension tube.

macro lens. A lens designed to render a subject with 1:1 or higher magnification. The term is sometimes used by lens manufacturers to describe lenses that are not capable of 1:1 photography without the aid of a close-up filter or extension tube. Note that some Nikkor macro lenses are called micro lenses.

macro mode. A setting (usually designated by a flower icon) on many digital point-and-shoot cameras that allows you to capture an image just inches from your subject and still produce a crisp, sharply focused image. The depth of field in macro images is extremely limited, so focus is critical. On some point-and-shoot cameras, this is called the close focusing mode.

macrophotography. The close-up photographic capture of subjects at life size or greater magnification using a macro lens or a normal lens fitted with an extension tube or close-up filter. Synonymous with photomacrography. *Contrast with* photomicrography *and* microphotography.

MACROPHOTOGRAPHY.

macro setting. *See* macro mode.

macro–zoom lens. A variable focal length lens designed to allow for close focusing.

magazine. (1) A lighttight container used to hold roll film. (2) A interchangeable camera back, commonly seen on medium-format cameras, that houses film and film advance mechanisms.

magazine camera. An early handheld camera featuring a series of slots that held plates in a vertical orientation for exposure, then stored them in a horizontal position once exposed.

magenta (M). A subtractive primary and one of the four process ink colors. Magenta is the complementary color to green. *See also* CMY, CMYK, *and* primary colors.

magic eraser tool. In Photoshop, a tool that changes all similar pixels when you click on a layer. When working in the background, or a layer with locked transparency, the pixels change to the background color; otherwise, they are erased to transparency. You can erase contiguous pixels or all similar pixels on the layer. *See also* eraser tool *and* background eraser tool.

magic hour. The hour after sunrise or before sunset when the sun is low in the sky. Portrait photographers consider this a more flattering light source than overhead light. This is also called the golden hour.

magic lantern. A camera obscura that contains a light source used for projection. The magic lantern predates photography and used hand-painted glass transparencies.

magic wand tool. In Photoshop, a selection tool used to isolate portions of an image based on color.

magnesium. A malleable metal used as a powder or formed into long ribbons. It was used in the 19th century to remove free silver from used fixing baths and to produce man-made actinic light for making exposures or printing. *See also* flashlight.

magneto-optical shutter. *See* Faraday shutter.

magnification. The size of the image relative to the size of the subject. Magnification is expressed as a ratio. When the object distance is equal to the image distance, the ratio is 1:1 (i.e., the subject is life-sized); when an object is twice as large as life-size, the ratio is 2:1.

LEFT—1:1 MAGNIFICATION. RIGHT—2:1 MAGNIFICATION.

magnification ratio. *See* magnification.

magnify. To increase the physical dimensions of an original image or image element. Also to increase image resolution via interpolation.

magnifying power. *See* magnification.

magnifying viewfinder. A viewfinder attachment used to magnify the central portion of the viewing area, typically by a factor of about 2.5 to 6. This allows for easier focusing for challenging situations like macro work, astrophotography, etc.

Magnum Photos. *See* appendix 2.

main light. The principal source of light and generally the brightest light source directed at a subject or scene. Synonymous with key light.

mains flash. British term for studio flash.

Mamiya. A Japanese manufacturer that produces a wide range of medium-format cameras and lenses.

mammoth plate. Term generally applied to the large (20x24-inch) wet collodion negatives used by photographers in the American West and in some metropolitan areas elsewhere. The term is sometimes used to refer to plates 10x12 inches or larger.

manual camera. A camera not equipped with autofocus capability. Autofocus lenses can be used with such models, but the lenses must be manually focused.

manual exposure mode. A nonautomatic camera setting in which the photographer must set the shutter speed and aperture. Typically represented by the letter M.

manual focus. A mode of camera operation in which all focus settings are selected by the photographer. Some older cameras (and all sheet-film cameras) offer only manual focus. Other cameras offer both manual and automatic focus, usually selected by adjusting a switch or choosing the desired mode via the camera's built-in software.

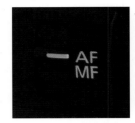

A SWITCH ON THIS LENS SETS IT TO EITHER MANUAL OR AUTOMATIC FOCUS.

manual mode. *See* manual exposure mode.

mapping. The process of assigning the colors in one color space to the available colors in another color space. This may result in clipping, color shifts, and adjustment to the black point and/or white point. *See also* color engine *and* rendering intent.

Mapplethorpe, Robert. *See* appendix 1.

marching ants. *See* selection indicator.

marquee tool. In image-editing programs, a tool used to select a square, rectangular, circular, or oval area of an image. *See also* selection tool.

Martin, Paul. *See* appendix 1.

mask. (1) To protect or hold back parts of an image while allowing others to show (e.g., by using a masking frame, frisket, or liquid masking material). *See also* unsharp mask. (2) In Photoshop, a selection tool that allows you to isolate areas of an image as you apply changes to the rest of the image. (3) Painted wooden device used in the back of multi-

MASK (RED) ON SKY.

plying cameras to allow two nonoverlapping images to be made on a single plate. (4) A contact-exposed negative that is sandwiched in register with the original transparency and collectively exposed (with additional time to compensate for the mask) as a means of contrast control.

masking frame. A device with an adjustable frame that holds printing paper in position under the enlarger during exposure. Also called an enlarging easel.

masking negative. *See* mask.

master. Original analog or digital image, containing any desired enhancements, from which photographic duplicates are made. Also called a master file or master image file.

master file. *See* master.

master image file. *See* master.

mastic varnish. A flexible varnish applied to negatives to provide the texture (or "tooth") required for retouching.

mat. Cardstock or conservation board, typically with a cutout center used to display prints. Sometimes prints are mounted directly on top of the mat. Also called matboard or overmat.

matboard. *See* mat.

match-needle metering. A light metering system built into many cameras manufactured in the early 1960s and 1970s. A small moving needle visible in the viewfinder indicated correct exposure when the needle was horizontal (sometimes vertical, depending on the location of the display). A needle positioned upward or downward from that point indicated over- or underexposure. Some modern cameras contain simulated matchneedle metering systems using an array of tiny LED dots that move much like a mechanical needle.

mat cutter. A knife consisting of an ergonomically designed handle and disposable blades, used to precisely cut beveled edges on mats. Synonymous with mat knife.

maternity photography. Creation of portraits that show the rounded form of a pregnant subject to document the life-changing event.

mat knife. *See* mat cutter.

matrix. (1) The flat array of CCD sensors. (2) Mathematical technique used in programming digital filters. (3) Term used to refer to a relief image (typically made of gelatin) used for dye transfer printing.

matrix array. *See* matrix.

matrix metering. An automated through-the-lens (TTL) camera metering system. Light reflected by the subject passes through the lens and into the viewfinder, where it is broken into numerous discrete cells that are metered independently. The camera's internal computer examines every cell and compares the result to an internal database of prestored lighting conditions. The camera selects an appropriate metering setting that will ensure the best overall exposure value for the scene. Also called averaging.

MATRIX METERING ICON ON MANY CAMERAS.

matt. See mat *or* matte.

matte. A paper surface with a slightly rough, nonshiny texture. Photos printed on such paper exhibit lower contrast and detail than glossy paper but do not show fingerprints and light glare as readily. Some manufacturers refer to a slightly shinier variation of this type of finish as "pearl." *Contrast with* glossy.

matte box. A mask employed to make photographs suitable for wide-screen projection.

matte field. In viewfinder optical systems, a textured surface that displaces light to produce a clear image.

maximum aperture. The largest aperture setting available on a lens. This is often indicated in the ratio printed on the lens. For example, a ratio of 1:1.8 means that the lens's largest aperture is f/1.8.

MC. A mark used on a lens or filter to show that it has been treated with one or more layers of antireflective coating.

McDonough's process. Additive color transparency process based on a tri-color screen. Similar to the Joly plate process.

measles. Dark blotches visible through paper, usually due to improper fixing or an overworked fixing bath. The flaw was common in the salted paper and albumen printing processes.

mechanical decay. A breakdown (warping, cracking, distortion, etc.) of the physical structure of an object due to environmental stressors (e.g., heat, humidity force, etc.).

media. Any material to which information is written or stored (e.g., CDs, memory cards, etc.).

media cards. *See* memory card.

medium format. A camera requiring film that falls in between the 35mm and 4x5-inch formats. This is commonly sold as type 120 or 220 roll film or 70mm film. Depending on the camera, a variety of aspect ratios may be produced. The most common aspect ratios are square (6x6cm), rectangular (6x4.5cm, 6x7cm, 6x9cm), and panoramic (6x17cm). The 6x4.5cm format is often called 645. Image resolution is higher with medium format than 35mm because of the large negative size. These cameras tend to be more expensive, and lenses tend to be large, since medium-format film requires a larger image circle. *See also* 645 format, 120 film, *and* 220 film.

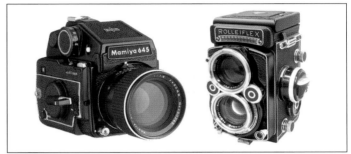

MEDIUM-FORMAT CAMERAS BY MAMIYA AND ROLLEI.

Mees, Dr. C. E. Kenneth. *See* appendix 1.

megabyte (MB). A unit of data measurement equal to one million bytes. The storage capacity of memory cards and hard drives, as well as image file sizes, are often described using this unit of measure.

megahertz (MHz). A unit of measure equal to one million hertz. Often used to describe a computer's processing speed.

megapixel. A measurement of the image size an image sensor can capture. The number of pixels a camera's sensor can produce is determined by multiplying the height of the sensor (in pixels) by the width of the sensor (in pixels) and dividing by one million. Though a higher megapixel rating means a better-quality image in theory, it is important to note that image quality is also dependent on the type, size, and quality of the image sensor, the type of lens used, the type of anti-aliasing algorithms used by the camera, and other factors. *See also* effective megapixels.

melainotype. *See* tin-type process.

melt. Slang term for a batch of gelatin emulsion.

memory. A computer's physical workspace, in which instructions, programs, and data needed to accomplish the tasks executed by the processor are stored in individual bits (binary digits—on and off values). *See also* flash memory, virtual memory, nonvolatile memory, *and* volatile memory.

memory card. A small removable device on which images are stored once they are captured by a digital camera. When the card is full, the images can be downloaded from the card, allowing it to be reformatted and reused. Though memory cards are sometimes referred to as "digital film," they don't record images, they just store them. There are a variety of formats, with varying storage capacities, available to fit a variety of camera models. Also called a storage card or media card.

memory card reader. *See* card reader.

memory chip. A device that stores bits of data for use in electronic devices (e.g., televisions, computers, etc.).

memory effect. A phenomenon that occurs when NiCad batteries are recharged before they have been completely discharged. The battery "remembers" the point where recharging began and suffers a sudden drop in voltage at that point during subsequent uses. Some camera models are now built to withstand this reduction in voltage long enough to return to normal operation.

memory mate. A cardstock folder, typically with two openings, used to accommodate photos. Popular method for packaging team sports photographs.

Memory Stick. A flash memory module developed by Sony and used in their digital cameras and other products.

MEMORY STICK.
PHOTO COURTESY OF SONY.

meniscus lens. A lens with one convex and one concave side with equal curvature. Synonymous with concavo-convex lens.

menu. A list of options in a computer program, camera, etc., that allows users to access features or perform a desired action.

mercuric chloride. Chemical component of some intensifiers.

mercury. A heavy, silver-colored liquid, the fumes of which were used to make visible the latent image on a daguerreotype.

mercury vapor lamp. A high-intensity artificial light source that is produced by passing current through mercury vapor in a tube. Mercury vapor lamps emit light with a blue-green color cast.

merge. To combine two or more data files or layers.

metadata. Information about a particular data set (e.g., a digital image) that may describe how, when, and by whom it was received, created, accessed, and/or modified and how it is formatted. Some metadata (e.g., file dates and sizes) can be viewed by anyone with access to the image file; other information is embedded and cannot be accessed by computer users who are not technically adept. *See also* XMP *and* exchangeable image file.

METADATA.

metafile. A file that can be shared between applications.

metal print. A photographic image printed on a sensitized metal surface.

metamerism. (1) Phenomenon where two colors viewed under one light source appear the same or similar but seem to shift in a nonuniform manner when viewed under a different source. Often occurs with dye colorants. (2) Phenomenon in which two colors that appear identical are registered as different by a scanner, or two colors that appear different are accepted as identical by the scanner. Also called instrument metamerism.

meter. *See* light meter, exposure meter, flash meter, *or* color temperature meter.

metered manual. An exposure mode in which the camera recommends exposure values to achieve correct exposure, but the photographer must set the aperture and shutter speed values. This mode is typically designated by the letter M.

methyl alcohol. A volatile, poisonous spirit used as a substitute for pure alcohol in some photographic processes. Also known as wood alcohol.

methylaminophenol sulfate. *See* Metol.

methylated spirit. *See* methyl alcohol.

Metol. Agfa's trade name for methylaminophenol sulfate. A popular developer that builds image detail quickly and is affected little by changes in temperature or the presence of large amounts of restrainer. Can reduce silver halides without an accelerator but is typically used with carbonate. A key component of general-purpose developers (with hydroquinone; abbreviated MQ) for prints and negatives. The developer is also known as Elon, Pictol, and Rhodol. *See also* MQ/PQ developers.

metolquinone. *See* MQ/PQ developers.

MF. (1) *See* manual focus. (2) *See* medium format.

MHz. *See* megahertz.

mica. A silicate mineral with a layered structure that can be delaminated to produce thin, flexible transparent films. The material was used by amateurs in the 1850s as a base for collodion negatives. Commercial photographers produced portraits on the material for use in jewelry.

MICRODRIVE.
PHOTO COURTESY OF HITACHI.

microdrive. A tiny hard drive compatible with the CompactFlash (CF) Type II standard. Commonly used in more advanced digital cameras, these drives offer high storage capacity at low cost. The downside is the device's susceptibility to data loss when bumped or dropped.

microfiche. A sheet of microfilm used to store printed material. The source material is recorded in a smaller format and is viewed on the screen of a microfiche reader at an enlarged size.

microfilm. A film used to record a document in reduced size for viewing via projection.

microflash. A specialized unit that outputs a very brief burst of light and is used to illuminate subjects traveling at a very high rate of speed. *See also* high-speed photography.

micro lens. (1) Lens used for the photography of microscopic subjects. (2) Name given to some Nikkor macro lenses. (3) Special lenses that are placed on top of CCD and CMOS sensors to enhance pixel sensitivity and focus light into the pixel well.

micrometer. *See* micron.

micron. A unit of measure equal to one millionth of a meter. Synonymous with micrometer.

microphotograph. *See* microphotography.

microphotography. (1) The photographic capture of subjects at life size to about a 10x magnification, often using bellows and other specialized equipment. *Contrast with* photomicrography. (2) The creation of very small photographs that are viewed using a microfilm reader. (3) The creation of tiny novelty images mounted on microscope slides or cut from an original plate and mounted faceup onto the glass of a miniature viewing lens.

microprism. Type of viewfinder used in SLRs manufactured in the 1960s and 1970s. The viewfinder's central area consists of a number of tiny prisms. If the image is not in focus, the center of the viewfinder appears broken up. Such screens tend to be most useful when handholding the camera, because the broken-up effect is more pronounced when the view shifts slightly.

microprism collar. A grid-type ring comprised of multiple plastic or glass prisms. The collar is located in the center of a viewfinder screen (usually surrounding a split-image screen) and is used as a focusing aid. An in-focus image appears sharp and clear; an out-of-focus image appears broken up.

micro reciprocal degrees. *See* mired.

Microsoft Image Color Management (ICM). The color management system built into the Windows operating system.

middle gray. A printed value that reflects 18 percent of the light striking it. Light meters are theoretically calibrated to this value, though some manufacturers' meters stray slightly from this standard. Synonymous with 18 percent gray, average scene brightness, and zone 5 (zone V) in the Zone system.

middle key. Style in which the overall brightness of the tones in an image is roughly equivalent to middle gray.

midroll rewind. Winding the film back into its canister before the entire roll has been exposed. On manual cameras, this is done by turning a crank lever, often with the shutter release button pressed; on automated motor drive cameras, this is accomplished by pushing a midroll rewind button. *See also* leader-out.

midtone. A tone of middle brightness (i.e., roughly midway between black and white).

Mie scattering. Atmospheric scattering caused when radiation interacts with suspended particles in the air whose diameter is roughly equivalent to the wavelength of the radiation. This causes the clouds to appear white. *See also* Rayleigh scattering.

milk glass. A translucent white glass base used in the creation of positive images.

Miller, Lee. *See* appendix 1.

millions of colors. *See* 24-bit.

miniature camera. A term that generally refers to cameras with a format size of less than 35mm.

minilab. (1) A self-contained, automated machine that completes all film development processes quickly and with minimal intervention from a lab technician. (2) A term referring to a facility that operates such a machine.

Minimalism. *See* appendix 2.

minimum focus distance. The closest subject distance on which a camera lens can focus. Also called close focus distance.

Minolta. *See* Konica Minolta.

Minox. Camera manufacturer best known for their line of tiny spy cameras invented by Walter Zapp.

MINOX SPY CAMERA.

minus development. Decreasing development time to contract (decrease) th tonal range from shadows to highlights. This technique is used in the Zone system for contrast control. Also called normal–1 (N–1) or normal–2 (N–2) development.

mired (micro reciprocal degrees). A value often used in converting light from one color temperature to another using a color conversion filter. To determine the mired value, divide 1 million by the color temperature (e.g., 1,000,000/5500 = 182). The decamired system is often used by continental European manufacturers in lieu of the more random Wratten system.

mirror. (1) In camera systems, a device that reflects light efficiently and does not absorb, scatter, or refract much incoming light. SLRs and TLRs contain at least one mirror. Also used in catadioptric or mirror lenses. (2) A light modifier used to bounce light onto the scene or subject. *See also* half-silvered mirror *and* mirror blackout.

mirror blackout. Term referring to the photographer's inability to see the scene through the viewfinder when the camera's reflex mirror has flipped up to allow light to reach the film.

mirror box. A box containing one or more mirrors, usually positioned at an angle to the light beam, as in the main body of an SLR camera.

mirror lens. Lens system using mirrors within its construction. Usually telephoto models, most mirror lenses have a mixture of reflecting and refracting optics, a construction that allows for shorter lens barrels. In this design, one of the mirrors must be mounted at the front of the lens, blocking part of the light path. Consequently, out-of-focus areas tend to turn into little rings, and more detailed areas tend to create double lines (called cross-eyed boke). Mirror lenses have fixed apertures, so you must use ND filters or shutter speed adjustments to control the exposure. Synonymous with catadioptric lens and reflex lens.

mirror lockup (MLU). A feature that allows the photographer to manually flip the mirror up prior to taking a photograph to prevent vibration due to mirror slap and avoid potential motion blur. *See also* mirror prefire.

mirror prefire. An SLR camera mode in which the mirror is flipped up a couple of seconds before the photo is captured, allowing mirror vibrations to subside. Similar to mirror lockup.

mirror slap. The clicking sound made when the mirror in an SLR flips up as an image is captured. The noise is generally un-

desirable, but it has its uses in fashion photography, as models know an image has been captured and can change their pose. The term also refers to the vibrations inside the camera caused by the movement of the mirror. With long telephoto lenses or slower shutter speeds, motion blur can result. Mirror lockup or mirror prefire may be used to prevent the effect.

mise-en-scene. *See* composition.

MLU. *See* mirror lockup.

mode. The prime operating function of SLR cameras (e.g., manual mode, aperture priority mode, etc.).

model. (1) Any person who poses for a portrait. *See also* subject. (2) A professional who is paid for his or her services as a photographic subject. Common in fashion photography.

modeling. A three-dimensional effect produced by the use of side lighting. *Contrast with* flat lighting. *See also* modeling light.

modeling flash. A rapidly pulsed burst of light output that allows the photographer to preview the effect of a flash unit and assess highlight and shadow patterns. This consumes a great deal of battery power and increases the risk of overheating and burning out the flash tube. *See also* modeling light.

modeling light. An incandescent lamp that allows the photographer to preview the effect of a flash unit and assess highlight and shadow patterns. *See also* modeling flash.

model release. A form signed by a model (or, in the case of minors, the model's parent or legal guardian) that defines the terms under which photographs taken of the model can be used.

modelscope. A device used to photograph scale models from an apparent eye-level viewpoint.

modem. A device that changes signals into a form of data that can be exchanged between a telephone system and computer.

Modernism. *See* appendix 2.

modular enlarger. An enlarger that allows for the use of interchangeable filtration heads and illumination systems.

modulation transfer function (MTF). A comparison of contrast between a test chart and the reproduced image. Used to measure the quality performance of a lens during the manufacturing process. *See also* transfer function.

Moholy–Nagy, Laszlo. *See* appendix 1.

moiré pattern. An undesirable pattern of irregular wavy lines that may appear in an image when halftones and screen tints are made using improperly aligned screens; when a pattern in a photo (e.g., a plaid in a subject's shirt) interfaces with a halftone dot pattern; as an artifact of the grid system that underlies computer graphics; when an image sensor isn't detecting full RGB color and must interpolate color information for the R, G, and B pixel groups; and when scanning a photo produced using the halftone process.

monitor. A light-producing screen that displays information in a raster format. *See also* cathode ray tube monitor, gas plasma monitor, *and* LCD monitor.

monitor calibration. *See* calibration.

monitor profile. A set of values used to describe how a specific monitor is currently reproducing color.

monitor RGB. *See* RGB.

mono bath. A single chemistry that combines developer and fixer and is used for processing black & white negatives. It does not allow for development control.

monobloc. British term for monolight.

monochromatic. (1) Light consisting of a single wavelength (e.g., laser light). Filtered white light can approximate this quality. (2) An image with only one color or varying tones of a single color.

monolight. A light unit with a self-contained flash head and power supply. Powered by AC current, not battery packs.

monopack. Antiquated name for a film carrying system.

monopod. A telescoping pole with a mounting head that provides more stability than handholding the camera but less security than a tripod. Synonymous with monopod.

SHOOTING WITH THE CAMERA MOUNTED ON A MONOPOD.

monorail. A component of many view cameras that attaches to a tripod and allows for camera movements. *See also* flat bed.

monorail camera. A view camera in which all the components are mounted on a heavy tube or rail and can be moved to accommodate add-on components, to adjust focus, etc.

monotone. Of a single color.

montage. A photograph consisting of a number of images cut out and glued onto a single sheet of paper, or a number of negatives projected onto a single sheet of paper. The digital equivalent can be easily created in image-editing programs.

moony 11 rule. A simple mathematical calculation (based on the sunny 16 rule) used to take a photo of the moon without a light meter. Simply set the aperture to f/11 and select the shutter speed closest to the reciprocal of the ISO (for ISO 100, 1/90 second, for example). This rule works because moonlight is simply reflected sunlight.

mordant. Dye toners that contain bleach, which affects the silver in a print so that the dye can adhere. These affect the base color of the paper and are less lightfast than other toners.

Morgan, Barbara. *See* appendix 1.

morgue. In photojournalism, informal term for a newspaper's collection of old photos, clippings, and other information.

Mortensen, William. *See* appendix 1.

mosaic. (1) *See* Photomosaic. (2) Achieved using a traditional or digital filter, an image that is made up of small, solid-colored blocks or tiles. (3) *See* array.

motherboard. The main circuit board of a computer, which contains the microprocessor, memory, and connectors for plug-in cards and input/output devices.

motion blur. Unsharpness in an image due to camera or subject movement during exposure. A common problem at slower shutter speeds, this can be minimized by using a tripod.

motor drive. An internal electric motor found in most SLR cameras that automatically advances the film to the next frame when an exposure is made.

motorized telescope mount. A motorized device that is used to pan a telescope at the same rate of speed as a selected object moving across the sky. This is used to keep the object in the viewfinder.

mottle. A processing fault characterized by the uneven appearance of a printed surface (particularly in solid ink coverage areas) or the nonuniform distribution of fibers in photo paper.

mount. (1) A backing (e.g., mat) and/or frame used to stabilize and protect prints and transparencies. (2) To affix a photographic image to matboard or another stabilizing surface. (3) The physical connection between the lens and camera body. *See also* lens mount.

LENS MOUNT.

mounting paste. An archival adhesive used to affix a photograph to matboard or another surface.

mounting press. A device that applies pressure and heat to affix a photograph to a support using a tissue coated with a heat-softenable adhesive. Also called a dry-mounting press.

mounting tissue. A thin paper coated on both sides with a heat-softenable (called "dry") or pressure-sensitive (called "cold") adhesive used to affix a photograph to a support.

mouse. A pointing device used to control the position and movement of a cursor on a computer screen.

mouse-over effects. An on-screen effect (e.g., a shift in the color of text, a change in the appearance of an image, etc.) that occurs when you move your cursor across a visual element.

movements. The adjustments a camera with the lens attached to the body by flexible bellows can make: tilting at varying angles, shifting up or down, etc. Useful for correcting perspective in architectural photography and other uses. Tilt/shift and perspective control lenses can be used with 35mm and medium-format cameras to allow for the same adjustments.

MOVEMENTS.

move tool. In image-editing programs, a tool that allows you to reposition a layer, selection, or image.

movie mode. A mode on some digital cameras used to record moving pictures and sound.

Moving Picture Experts Group (MPEG). *See* MPEG.

MPEG (Moving Picture Experts Group). (1) A subgroup of the International Standards Organization (ISO) that sets the standards for encoding audio and video in digital format. (2) A motion picture compression system developed by MPEG.

MOVIE MODE ICON FOUND ON MANY CAMERAS.

MQ/PQ developers. Universal developing solutions that contain the reducing agents Metol and hydroquinone or phenidone and hydroquinone. *See also* Metol.

MRW. Proprietary raw file format in Minolta digital cameras.

M-synch. A flash setting or socket available on some older cameras that synchronizes the firing of the shutter with the peak light output of a (now obsolete) medium-speed flashbulb.

MTF. *See* modulation transfer function.

muddy. A photographic image with an undesirable low contrast resulting from poor lighting, incorrect exposure, problems with lab chemistry, poor-quality optics, and/or other factors.

LEFT—NORMAL IMAGE. RIGHT—MUDDY IMAGE.

multiband photography. The simultaneous capture of two or more images of a scene using cameras that are sensitive to different wavelengths in the spectrum to record different subject characteristics. Synonymous with multispectral photography.

multichannel. A color model using 256 levels of gray in each channel. Useful in specialized printing applications.

multicoated. A lens with two or more antireflective coating layers. Such lenses are designed to reduce flare.

multigrade paper. Paper capable of supporting different contrast levels depending on the color of light used to expose it. This allows for greater flexibility than fixed paper grades. Also called variable contrast paper.

multimedia. A presentation that combines two or more media (e.g., video, audio, graphics, etc).

MultiMedia Card (MMC). A tiny removable memory card used to store images in a digital camera.

multimode camera. A 35mm camera that will operate in several modes (e.g., manual mode, program mode, aperture priority, shutter priority, etc.).

multiple exposure. Exposing a film frame or light-sensitive paper more than once, thereby creating a combined image. In automatic film cameras, the frame can be exposed two or more times when in the multiple-exposure mode (often designated by the letters ME). Some mechanical cameras don't advance the film if you keep the film rewind button pressed while cocking the shutter. With digital cameras, multiple exposure usually isn't possible during capture, but the effect can be replicated using image-editing programs. A multiple-exposure photo that includes only two images is called a double exposure.

multiple flash. The use of two or more flash units, usually firing simultaneously, to light a subject.

multiple image filter. A group of filters that feature several glass surfaces with differing shapes and positions. Different types can be used to create a central image surrounded by repeated images, multiple images without a center focal point, or parallel images in which the subject is fully pictured in one image but partially pictured in others. Also called a multiple image lens.

multiple image lens. *See* multiple image filter.

multiple key. The use of more than one main light, often to light from opposing angles two subjects who are facing each other. Synonymous with cross light.

multiple scanning. *See* overscan.

multiple spot metering. *See* multi-spot metering.

multiplying camera. A camera that allows for the capture of more than one image on a plate by moving the plate or lens.

multispectral photography. *See* multiband photography.

multi-spot metering. A feature found on some SLR cameras that allows metering of multiple points across a scene. The photographer spot meters several areas of the subject or scene, pressing a button after each meter reading. The camera then averages the readings to achieve a correct meter reading. Also called multiple spot metering.

multitasking. A mode of operation that allows multiple tasks to run concurrently, taking turns using the computer's resources. This allows the user to easily switch and share information between applications.

Munsell color charts. *See* Munsell color system.

Munsell color system. An early color modeling system developed by artist Albert H. Munsell in an effort to numerically describe colors. The qualities Munsell used to define colors were hue, saturation, and chroma. The system is the foundation of many modern color models, such as HSB and HLS.

muslin. Washable fabric commonly used as a backdrop in studio or location portraiture.

Muybridge, Eadweard. *See* appendix 1.

N. *See* normal development.

Nadar. *See* appendix 1.

nadir. The lowest point in a spherical virtual-reality photographic image. *Contrast with* zenith.

nanometer (nm). A unit of measurement equal to one billionth of a centimeter. This is the unit of measurement normally used when discribing wavelengths of light.

nanosecond. One billionth of a second.

naphtha. A volatile, petroleum-based solvent often used in film-cleaning products.

narrow-band filter. Filter that transmits a very restricted range of wavelengths. Also called a narrow-cut filter. *Contrast with* notch filter.

narrow-cut filter. *See* narrow-band filter.

narrow lighting. *See* short lighting.

native file format. The default file format used by a specific software application. This is often a proprietary format that preserves features or settings unique to the software and is, therefore, not meant to be transferred to other applications.

ADOBE PHOTOSHOP	*.PSD	MICROSOFT PICTUREIT	*.MIX
ADOBE ILLUSTRATOR	*.AI	MICROSOFT POWERPOINT	*.PPT
COREL DRAW	*.CDR	MICROSOFT WORD	*.DOC
COREL PAINTER	*.RIFF	ULEAD PHOTOIMPACT	*.UFO
MICROSOFT EXCEL	*.XLS	PAINT SHOP PRO	*.PSP

NATIVE FILE FORMATS.

Naturalism. *See* appendix 2.

natural light. Light that originates from the sun.

naturally flat (NF). Term used to describe a CRT monitor in which the front of the screen is flat.

nature photography. A genre of photography devoted to capturing images of wildlife, landscapes, plants, and other features of the earth—particularly in a picturesque manner.

NATURE PHOTOGRAPHY.

navigation. The process of moving through the various parts of a web site or multimedia program, usually by means of links.

NC. In printing, a notation for "no cropping."

N development. *See* normal development.

ND filter. *See* neutral density filter.

ND grad. *See* neutral density filter.

nearest neighbor resampling. A type of interpolation in which the value of the new pixel is an average of the neighboring pixels. This significantly reduces the conversion time compared with downsampling but results in images that are less smooth and continuous. Also called subsampling.

near infrared. Electromagnetic energy with wavelengths from about 700nm to 900nm. This is the energy recorded in most infrared photography.

near point. Point closest to the lens that is rendered in focus.

near ultraviolet. Electromagnetic energy with wavelengths from about 250nm to 400nm. Most photographic emulsions are sensitive to this range.

NEF. A proprietary raw file format used by Nikon digital cameras and film scanners.

negative. (1) An image in which the tonalities and colors are reversed from the original scene. (2) An exposed and developed piece of film on which tones are reversed from the original scene. This is used to produce a positive print.

LEFT—POSITIVE IMAGE. **RIGHT**—NEGATIVE IMAGE.

NEGATIVE FILM STRIP.

negative carrier. A frame used to support a negative in an enlarger or film scanner.

negative, digital. *See* digital negative.

negative envelope. A paper storage sleeve or pouch used to protect negatives.

negative fill. Using a light-absorbing panel just out of camera view to create shadows by blocking light from the subject.

negative holder. (1) A metal or plastic device used to support a negative for scanning or printing. (2) The enclosure used to bring sensitive film or plates to and from the camera.

negative lens. A simple concave lens that causes rays of light to diverge away from the optical axis. Also called a diverging lens or a concave lens.

negative number. A unique sequence of figures assigned to a negative in order to catalog it for future use.

negative pages. Archival polyethylene pages used to provide safe, long-term storage for negatives.

negative-positive paper. Photosensitive paper used to print a positive image from a negative.

negative-positive process. Photographic process in which multiple positives can be made from one negative.

negative scanner. A device used to digitize negative images on transparent media.

negative sleeves. *See* negative pages.

negative varnish. *See* varnish.

negative viewer. *See* slide viewer.

neo-coccine. Red dye used in traditional retouching.

neodymium. *See* didymium filter.

Neo-Impressionism. *See* appendix 2.

Neo-Romanticism. *See* appendix 2.

net. (1) A webbed material used in many scrims. *See* scrim. (2) A colloquial term for the Internet.

network. A number of interconnected computers sharing a common protocol for communications.

neutral. (1) A color without any hue. (2) A substance, such as water, with a pH of 7 (neither an acid or a base).

neutral balance. *See* white balance.

neutral density (ND) filter. A gray filter that absorbs light evenly throughout the visible spectrum. Such filters are useful for taking photos in bright light using fast film, or for taking longer exposure photos than would otherwise be possible with the film speed or ISO setting in use. There are several types:

center weighted: Made to compensate for the vignetting effect of large-format, wide-angle lenses. Synonymous with center-gray filter.

double (or continuously variable): Contains two rotating sheets of polarizing material, allowing variations in the exposure reduction.

graduated: Density is strong at one edge, then fades away across the filter. Used to balance, for example, a bright sky with a darker landscape. These are available in different strengths and with softer and harder transitions. Also called a "grad ND" or "ND grad."

NEUTRAL DENSITY FILTER USED TO PERMIT A LONG SHUTTER SPEED.

neutralizer. A chemical designed to make inactive another chemical solution.

neutral pH paper. *See* acid-free paper.

Newman, Arnold. *See* appendix 1.

New Objectivity. *See* appendix 2.

New Realism. *See* appendix 2.

Newton, Helmut. *See* appendix 1.

Newton rings. Irregularly colored concentric circles that appear when light is refracted between two pieces of adjacent transparent material. Can occur when using photographic filters, scanning transparent media, or using glass negative carriers.

New Topographics. *See* appendix 2.

NF. *See* naturally flat.

NiCad. *See* nickel cadmium battery.

nickel cadmium (NiCad) battery. A popular type of rechargeable battery for digital photography. A common problem with NiCad batteries is the "memory effect," which can occur if these batteries are recharged before they have been fully discharged. This causes the battery to prematurely experience a sudden drop in voltage, as if it has been discharged.

nickel metal hydride (NiMH) battery. A type of rechargeable battery that can have two to three times the capacity of an equivalent size NiCad battery. NiMH batteries have an insignificant memory effect.

Niépce, Joseph Nicéphore. *See* appendix 1.

night landscape mode. A scene mode designed to assist in photographing landscape images under low light conditions.

night mode. *See* night portrait mode *or* night landscape mode.

night photography. A genre of photography devoted to capturing images of subjects available only at night (such as the moon or nocturnal animals) or subjects that take on a different appearance at night (such as city lights).

NIGHT PHOTOGRAPHY.

night portrait mode. On many digital cameras, a preprogrammed scene mode that allows you to balance a dark background with a flash-lit foreground subject. This is achieved by dragging the shutter. *See also* dragging the shutter *and* slow sync.

Nikkor. Brand name of lenses manufactured by Nikon.

Nikon. Manufacturer of cameras, lenses, and other imaging equipment.

Nikon Electronic Format. *See* NEF.

NiMH. *See* nickel metal hydride battery.

ninth plate. A 2x2.5-inch plate popularly used in the creation of daguerreotypes, ambrotypes, and melainotypes.

nit. A unit of luminance equal to one candela per square meter.

niter. *See* potassium nitrate.

nitrate base. A transparent plastic base that was used for photographic film in the United States until 1949. Obtained from the treatment of cellulose with nitric acid.

nitrated cotton. *See* cellulose nitrate.

nitrate decay. Degradation of cellulose nitrate film base that may cause yellowing, buckling, and film distortion.

nitre. *See* potassium nitrate.

nitric acid. A highly corrosive substance used in emulsion manufacturing, toners, and bleaches.

nitro-cellulose. *See* nitrate base.

nitrogen burst. Method of processing in which chemicals are agitated by bubbling nitrogen through the solution.

nm. *See* nanometer.

nocturnal vision. *See* scotopic vision.

nodal plane. An imaginary line through the nodal point and perpendicular to the optical axis.

nodal point. (1) In a compound lens, the front nodal point is the point in the optical system at which all the rays of light entering the lens converge. (2) In a compound lens, the rear nodal point is the point on the optical axis from which the emergent ray radiates. The focal length of the lens is measured from the rear nodal point. (3) Simple lenses, such as magnifying glasses, have one nodal point; the front and rear points are the same. *See also* principal point.

node. Computer linked to others in a network.

noise. Any disturbance that affects a signal in an unwanted fashion. In digital photography, noise manifests as random dots or color value changes in an image. This can be affected by temperature and ISO setting. It is also amplified by the JPEG compression algorithm.

LEFT—NORMAL IMAGE. **RIGHT**—IMAGE WITH VERY VISIBLE GRAIN.

noise filter. Software used to increase the appearance of noise in an image. *See also* noise reduction software.

noise reduction software. A program specifically designed to preserve detail while minimizing the appearance of noise in digital captures or digitized film images.

non-actinic. A wavelength of light that does not affect light-sensitive materials.

non-chromogenic film. An alternate term used for traditional, silver-based black & white film. *Contrast with* chromogenic film.

nonlinear. (1) A relationship between two variables that is not constant. (2) Method used by hard disks to store data so that it is accessible in any order. (In contrast with tape drives, for example, from which data can only be read sequentially.)

non-lossy compression. *See* lossless compression.

non-read color. Ink that dries to a highly reflective finish and cannot be read by a scanner. Also called non-scan ink.

non-scan ink. *See* non-read color.

non-silver process. An image-making process that does not require the use of metallic silver, such as the gum bichromate process.

non-substantive film. A color film in which the color couplers are not contained within the emulsion. Instead, they are introduced during processing.

nonvolatile memory. Memory chips that retain data even when power is not applied. ROM and flash memory are forms of nonvolatile memory.

normal–1 (N–1) development. Decreasing development time sufficiently to contract the tonal range by one zone. *See also* Zone system *and* normal development.

normal–2 (N–2) development. Decreasing development time sufficiently to contract the tonal range by two zones. *See also* Zone system *and* normal development.

normal+1 (N+1) development. Increasing development time sufficiently to expand the tonal range by one zone. *See also* Zone system *and* normal development.

normal+2 (N+2) development. Increasing development time sufficiently to expand the tonal range by two zones. *See also* Zone system *and* normal development.

normal (N) development. In the darkroom, using the manufacturer's recommended times for the film/developer combination. Extreme variations from normal exposure or development will result in negatives that are very hard or impossible to print. *See also* plus development, minus development, normal–1 (N–1) development, normal–2 (N–2) development, normal+1 (N+1) development, *and* normal+2 (N+2) development.

normal lens. A lens with a focal length that is roughly equivalent to the diagonal of the light-sensitive, image-recording area within the camera. This roughly approximates the perspective perceived by human vision. Also called a standard lens.

Norman. Manufacturer of professional photographic lighting systems.

notch filter. A filter designed to block a very narrow range of wavelengths. *Contrast with* narrow-band filter.

notching code. V- or U-shaped cuts in the margin of sheet film that allow the type of film and its emulsion side to be identified in the dark.

notes tool. In Photoshop, a tool used to add text and audio notations anywhere in the digital file.

nox. Measurement equal to one-thousandth of a lux. Used in low light.

NTSC (National Television System Committee). The name of both the committee that released the 525-line 60Hz video standard used in North America and Japan for regular television in 1953 and the standard itself. This standard is incompatible with the PAL standard used in Western Europe and the SECAM standard used in France and much of Eastern Europe.

nucleus. The handful of exposed silver atoms in a latent image around which a visible image grain grows. Also a clump of silver halide crystals that grow during the film ripening process.

nude. A photograph of a naked or mostly naked person.

nudge. To move a graphic in small increments.

nuit américain. French for "American night." A type of filter that makes a scene recorded in daylight look as though it was recorded at twilight. This filter causes about a two-stop underexposure and adds a bluish color cast to the images. Also called a day-for-night filter.

null lens. A lens used to test the accuracy of aspheric lenses.

Nyquist criterion. *See* Nyquist theorem.

Nyquist limit. *See* Nyquist theorem.

Nyquist rate. *See* Nyquist theorem.

Nyquist theorem. A mathematical way of determining when a high-frequency sample will be imaged and displayed without distortion. In digitization, if the digital sampling rate falls below a given level (generally twice the highest frequency in the analog sample), artifacts will be introduced. Also referred to as the Nyquist limit, the Nyquist criterion, and the Nyquist rate.

FORMAT	FRAME SIZE	DIAGONAL	NORMAL LENS
35mm	2.4x3.6cm	43.27mm	50mm, 45mm
6x4.5cm	5.6x4.2cm	70.00mm	75mm
6x6cm	5.6x5.6cm	79.2mm	80mm
6x7cm	5.6x6.8cm	88.09mm	90mm
6x9cm	5.6x8.2cm	99.30mm	105mm
4x5-inch	10.16x12.7cm	162.64mm	150mm
8x10-inch	20.32x25.4cm	325.27mm	355mm

NORMAL LENS.

O. *See* opacity.

object distance. The distance between the front of the lens and the subject. Also called subject distance.

object glass. *See* objective lens.

objective. *See* objective lens.

objective glass. *See* objective lens.

objective lens. The lens that receives the first light rays from the object being observed. Also called the object lens, object glass, and objective glass.

objective photography. An image in which the photographer attempts to accurately document a subject or event without reflecting his or her own feelings, such as in photojournalism or evidence photography.

OBJECTIVE IMAGE DOCUMENTING THE DEVASTATION
OF HURRICANE KATRINA IN NEW ORLEANS.

object lens. *See* objective lens.

object-oriented graphic. An image composed of autonomous objects such as lines, circles, and boxes, that can be moved independently.

oblique lighting. Lighting a scene or subject from an angle to better reveal detail.

occipital lobes. The part of the brain containing the primary visual centers.

occultation. When one object obscures or passes in front of another, blocking it from view. This contributes to a sense of depth in a photograph, because objects are assumed to be farther away than the things that occult them.

OCR. *See* optical character recognition.

ocular. *See* eyepiece.

oculis dexter (OD). Latin phrase meaning "right eye."

oculis sinister (OS). Latin phrase meaning "left eye."

oculis uterque (OU). Latin phrase meaning "both eyes."

OD. (1) *See* oculis dexter. (2) Optical density. *See* density.

OEM. *See* original equipment manufacturer.

off axis. Away from the center of an axis, such as the optical axis. *See also* optical axis.

off-axis lighting. In portraiture, a lighting setup in which the main light is placed at an angle to the subject's nose (which forms the "axis" of the face) so that it strikes one side of the face more than the other. *Contrast with* axis lighting.

off-camera. A flash unit that is positioned and fired from a point that is not directly adjacent to the lens. This can mean that the flash is attached to the camera via a bracket, handheld, or is remotely fired from a light stand. *Contrast with* on-camera.

off-line. (1) A device, such as a scanner or printer, that is not active or available for access. (2) Not connected to the Internet.

offset lithography. *See* offset printing.

offset printing. A process in which ink is transferred from a photomechanical plate, to a roller or blanket, and then to the paper

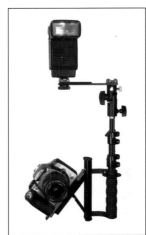

BRACKET ALLOWS FLASH TO
BE USED OFF-CAMERA. PHOTO
COURTESY OF ARAGRAPH.

itself. This is the most common commercial printing process in use today.

off-the-film (OTF) metering. A metering system that measures light bouncing off the film surface. TTL flash metering, invented by Olympus and now used by all major manufacturers, works this way.

oil color. Paints/pigments commonly used in traditional handcoloring processes. *See also* handcoloring.

oil mounting. In scanning, using optical oil to mount a transparent image to a drum scanner. When the image to be scanned is scratched (or when extremely large scans are needed), this improves the quality of the resulting digital file.

oil print. A contact print produced on a sheet of paper coated with bichromated colloid. After soaking in water, unexposed areas reject the subsequent application of ink, while exposed areas accept the ink, becoming the shadows and midtones.

oil reinforcement. A method of altering the tonal range of prints on matte or textured fiber papers. The dried print is rubbed with a medium consisting of two parts turpentine, one part mastic varnish, and one part linseed oil. Artists' oil color is then applied locally to the print.

old-time photography. A style of photography in which modern subjects are photographed in period costumes and sets to create an image that appears antique. Such images are usually black & white or sepia-toned.

olive oil. In early photography, used to improve the contact printing process when creating heliographs. Also used as a lubricant for polishing daguerreotypes. Synonymous with sweet oil.

Olympus. Manufacturer of cameras, lenses, and other imaging equipment.

OM. A now-discontinued line of SLRs produced by Olympus, starting with the famous OM-1 in 1972.

on-axis lighting. *See* axis lighting.

on-camera. (1) A flash unit mounted to and fired on the camera, usually from a position adjacent to the lens. (2) A flash unit that is built into a camera. Synonymous with built-in flash and internal flash. (3) Occasionally used to describe a flash unit on a bracket attached to the camera. This distances the flash from the lens.

ON-CAMERA FLASH.

one-quarter tones. *See* quarter tones.

one-shot. (1) A focusing mode on some SLRs. This mode does not perform focus tracking; once focus has been achieved, it locks. *See also* AI servo. (2) Colloquial term for a processing solution, especially a developer, designed to be discarded after one use.

one-shot back. Digital camera back for large- or medium-format cameras that can shoot a scene in one pass like ordinary film (not three, like the RGB scanning backs). Therefore, it can be used with live subjects, not just still lifes.

one-shot color camera. An obsolete plate camera that made three color-separation negatives from a single exposure.

one-shot developer. *See* one-shot.

one-time use. A publication or broadcast license that permits a buyer to use an image only once.

one-time-use camera. *See* disposable camera.

one-to-one (1:1). An image that renders the subject at the same size as it is in real life.

one-twenty film. *See* 120 film.

online. (1) A device, such as a scanner or printer, that is active or available for access. (2) A computer or other device that is connected to the Internet. (3) Pertaining to content or activities conducted on the Internet.

online photo printer. A company that receives digital photos uploaded to its web site, prints them, then sends the prints back to the photographer or a third party.

on-screen. Term applied to any content viewed (or intended to be viewed) on a computer monitor.

OO-stereoscope. Like the O-stereoscope, this device is used to view 2x2-inch mounted split-frame slides. In this case, however, it is used when the camera is fitted with a miniature pair of lenses with parallel axes. In such a setup, the frame halves must be transposed by the OO-stereoscope.

opacity (O). The degree to which an object or material blocks light (or, in image-editing programs, your view of underlying image data). In traditional photographic materials, opacity is expressed as a ratio of the incident light to the transmitted light. In image-editing programs, it is typically expressed as a percentage. In optics, opacity is commonly denoted by the letter O.

LEFT—DAISY OVERLAYS LEAF AT 100 PERCENT OPACITY. **CENTER**—OPACITY OF DAISY REDUCED TO 80 PERCENT. **RIGHT**—OPACITY OF DAISY REDUCED TO 60 PERCENT.

opal glass. A type of semitranslucent white glass used to diffuse light (as in household lightbulbs).

opal lamp. A filament lamp with an opal glass bulb for optimum diffusion.

opalotype. An obsolete printing process in which a carbon-process image is transferred onto translucent opal glass.

opaque. Term used to describe a material that does not transmit light. *See also* opacity.

opaque bag. A black plastic storage bag used to protect film or printing paper from light.

opaque liquid. A dense red or black pigment that is dissolved in water to form a liquid paint. This is used to block out portions of a negative so that they will not allow light to pass during printing, ensuring these areas will print as pure white.

Op Art. *See* appendix 2.

open flash. A technique of illuminating a dark scene with a flash unit and an open camera shutter. The photographer sets the camera on a tripod, opens the shutter in bulb mode, triggers the flash manually (often multiple times and from different positions), then closes the shutter.

open up. Increasing the size of the lens aperture or decreasing the shutter speed to admit more light to reach the camera's image sensor or film.

operating system (OS). The software that supports a computer's basic functions.

optical. (1) Of or using light. (2) Of or having a lens.

optical activity. The ability of a medium to rotate the plane of polarization of incoming light. Also called optical rotation.

optical axis. An imaginary line through the optical center of a lens and perpendicular to the plane of its diameter. Light traveling along this axis would not be deflected in any direction.

optical bench. A device for measuring the optical performance of lenses.

optical blackening. Material used to absorb light within a lens tube and prevent internal reflections.

optical brightener. *See* whitener.

optical character recognition (OCR). Software that allows a computer to convert documents that have been scanned and saved in a graphics format back into editable text.

optical density. *See* density.

optical disc. A direct-access storage device that is written to and read from by laser light. CDs and DVDs are optical discs.

optical filtering. Selectively transmitting or blocking a range of wavelengths of light.

optical glass. Glass, used in lenses and prisms, that is manufactured to be free of defects and distortion as well as to withstand heat and humidity. Each type is classified according to its refractive index and light dispersive quality. Two or more types of optical glass are typically used in photographic lenses.

optical relay. A component used to collect the image from the lens or focusing screen and project it to the film. Also known as a relay.

optical resolution. The true resolution of a scanner. This is the determining factor in the amount of detail that is visible in a scanned image. *See also* interpolated resolution.

optical rotation. *See* optical activity.

optical sensitization. *See* dye sensitization.

optical slave unit. *See* slave flash.

optical spectrum. Wider than the visible spectrum, the optical spectrum includes wavelengths from far ultraviolet (about 40nm) to far infrared (about 1200nm).

optical system. The arrangement of lens elements, prisms, or mirrors through which light passes on its way to the image sensor or film.

optical transfer functions (OTF) test. Evaluates lens performance in terms of resolving power, contrast rendition, and aberrations.

optical viewfinder. The most common type of viewfinder used on digital cameras. Optical viewfinders display about 80–90 percent of what the camera sees, not the total image.

optical wedge. A strip of material that is clear at one end and gradually increases in opacity. This is used to determine the effect of light intensities on sensitized materials.

optical zoom. The use of a combination of lenses to magnify the image prior to being registered by the image sensor or film. By altering the focal length of the lens ("zooming"), you can alter the angle of view of the image. *Contrast with* digital zoom.

optics. The science and technology of light, including its properties, the ways it is created, how it travels through space and various media, and its modification by prisms, lenses, etc.

Optiflex. Manufacturer of photographic filters.

optimization. Making contiguous sectors of a hard disk available for storage in order to increase read/write speeds.

optimum aperture. The f-stop at which a lens produces the sharpest image it is capable of producing. *See also* aperture.

opto-electronic. Terms used to describe devices, such as image sensors, that combine the use of electronics and light.

orange peel. Term used to describe the surface texture of poorly polished lenses.

ordinary emulsion. A photographic emulsion that is only sensitive to ultraviolet and blue light. To make these emulsions sensitive to other colors of the visible spectrum, sensitizing dyes are added. *See also* dye sensitization.

ordinary paper. *See* plain paper.

ORF. A proprietary raw file format used by Olympus digital cameras.

organic materials. Derived from once-living things, these materials are susceptible to deterioration from changes in humidity and are sensitive to light.

orientation. The direction that the long side of an image (or printed page) faces. If it is vertical, the orientation is called portrait. If it is horizontal, the orientation is called landscape.

LEFT—PORTRAIT ORIENTATION. **RIGHT**—LANDSCAPE ORIENTATION.

orientation sensor. A sensor in a digital camera that detects when you turn it to take a vertical shot. The camera then rotates the picture so it won't be displayed on its side when viewed.

original. (1) An image as it appeared at the time of capture (i.e., without any postproduction processing). (2) In film photography, the physical material on which an image was first recorded (as opposed to a duplicate). (3) For purposes of copyright, a unique image.

original equipment manufacturer (OEM). (1) A company that supplies products or components to other companies to resell or incorporate into a product using the reseller's brand name. (2) More recently, the term is used to refer to the company that acquires the component and reuses or incorporates it into a new product with its own brand name.

ortho. *See* orthochromatic.

orthochromatic. An emulsion that is sensitive to blue and green light but not red light. These materials can be handled using red safelights and are commonly used for special black & white films for darkroom use, such as lithographic film. Also known as ortho or isochromatic.

orthographic camera. A camera that uses parallel projection to generate a two-dimensional image of the objects in a three-dimensional model.

orthographic film. A specialized emulsion that is sensitive to blue, green, and ultraviolet light.

orthoscopic lens. A lens that produces an image with no curvilinear distortion.

OS. (1) *See* oculis sinister. (2) *See* operating system.

O-stereoscope. A special transparency stereoscope designed to view 2x2-inch mounted split frames. Since the system transposes the images on their way into the camera, the O-stereoscope only needs to widen the viewing path by means of prisms or mirrors. *See also* OO-stereoscope.

Ostwald ripening. *See* ripening.

Ostwald, Wilhelm. *See* appendix 1.

OTF metering. *See* off-the-film metering.

OTF test. *See* optical transfer functions test.

OU. *See* oculis uterque.

outdated. Photosensitive material that has passed the expiration date supplied by the manufacturer. This material may have some degree of fogging or be less sensitive than it should be.

This depends on the type of material, the conditions under which it was stored, and how far it is past the expiration date.

outgassing. The tendency of some materials, such as acetate and nitrate film bases, to give off potentially dangerous vapors as they decay.

out of focus. An image that appears blurred or fuzzy because the rays of light passing through the lens fall upon a plane that is in front of or beyond the point at which they converge to form a sharp image.

LEFT—OUT OF FOCUS. **RIGHT**—IN FOCUS.

out-of-gamut colors. Colors that cannot physically be produced by a given device (such as a monitor) or on a given medium (such as a printing paper).

output. Information that has been processed by a computer and is displayed on a monitor, rendered as a hard copy, or saved in a digital format.

output device. Any hardware device capable of producing or displaying computer data in a visible form.

output profile. *See* device profile, monitor profile, *or* printer profile.

output resolution. The detail and clarity that will be visible when the image is displayed or printed. This is dependent on the resolution capability of the display or printing device.

LEFT—CORRECT OUTPUT RESOLUTION. **RIGHT**—INSUFFICIENT OUTPUT RESOLUTION.

output simulation. Synonymous with soft proof.

outtake. An image that has been removed from consideration and not used.

overcoat. A protective layer applied to a substrate. Also called a supercoat.

overdevelopment. A term indicating that the amount of development recommended by the manufacturer has been exceeded. This can be caused by prolonged development time or an increase in development temperature. It usually results in an increase in density and contrast. Synonymous with overprint.

overexposure. Allowing more than the normal amount of light to strike the image sensor, film, or printing paper. This produces a dense negative or a very light image file, print, or slide.

LEFT—NORMAL EXPOSURE. **RIGHT**—OVEREXPOSURE.

overlay. To superimpose graphic elements.

overlight. To use light of an excessively high intensity, particularly on a studio portrait subject.

overmat. *See* mat.

overprint. *See* overdevelopment.

override. To neutralize a setting or interrupt the action of an automatic device in order to take manual control.

overrun lamp. A tungsten light source specifically used at a higher voltage than normal to increase light output and achieve constant color temperature.

oversample. To digitize at a frequency or resolution that is more than is needed.

overscan. To create multiple scans of an analog original. These can be combined to produce results superior to any individual scan. Also called multiple scanning.

oxalic acid. Soluble white crystals used in some toners.

oxbile. *See* oxgall.

oxgall. In early photography, bile fluid applied to the surface of albumen prints to improve adhesion when applying watercolors. Also called oxbile.

oxidation. (1) The process of combining oxygen with some other substance. (2) A chemical change in which an atom loses electrons. Silver-based photography relies on oxidation and reduction chemistry to capture images. *See also* reduction.

oxidation product. The chemical produced by a color developer during the conversion of exposed silver halides to black metallic silver.

oxidation-reduction (redox) reaction. A collective term for two related chemical processes involved in silver-based photography. *See also* oxidation *and* reduction.

ozotype. A carbon-based method of pigment printing.

package. (1) Products, often software, designed to work together. (2) To combine materials for marketing or distribution.

pack photography. *See* pack shot.

pack shot. A simple studio setup to photograph numerous similar products in quick succession, usually for an advertisement, brochure, or catalog.

page formats. The standard paper sizes used across the industry are as shown in the chart below:

A0	.33.125x46.75 INCHES
A1	.23.375x33.125 INCHES
A2/SRA2	.16.5x23.375 INCHES
A3	.16.54x11.69 INCHES
A4	.8.25x11.75 INCHES
A5	.5.83x8.25 INCHES
A6	.4.125x5.875 INCHES
B5	.6.93x9.84 INCHES
TABLOID	.11x17 INCHES

PAGE FORMATS.

paintbrush tool. *See* brush tool.

paint bucket tool. In image-editing programs, a tool that automatically applies a selected color to pixels that are adjacent and similar in color value to the pixels you click.

Painter. *See* Corel Painter.

painting with light. A technique in which the tripod-mounted camera is set for a long, timed exposure. The photographer then moves continuously around the subject, casting light on it from different positions. Also called light painting.

THE LIGHTSTICK FROM PROFOTO CAN BE USED IN LIGHT PAINTING.

PAL. *See* phase alternation line.

palette. (1) The number of available colors on a computer or other device. (2) In image-editing programs, a window that remains open on-screen and allows you to adjust settings, select tools, and control the effects applied.

palladium. Soft white metal found in copper and nickel ores.

palladium print. A type of black & white contact print created using palladium to replace iron salts. Like platinum prints, palladium prints are extremely archival.

pan. (1) Colloquial term for a parabolic reflector. (2) A technique used to photograph moving subjects. While the shutter is open, the camera is moved in the same direction as the subject. This creates a blurred background but a sharp subject. (3) Abbreviation for panchromatic.

PANNING THE CAMERA.

pan and tilt head. A type of tripod head that allows the camera to be tilted up and down or turned through a 360-degree arc. *Contrast with* ball head.

Panasonic. Manufacturer of digital cameras and other consumer electronics.

panchro. *See* panchromatic.

panchromatic. Films that are sensitive to all the colors of the visible spectrum and to a certain amount of ultraviolet light. Most silver-based (non-chromogenic) black & white film sold today is of this variety, which is why many have "pan" in the name. Also called panchro or pan.

panchromatic vision filter. A filter through which the subject can be viewed approximately as it would appear in monochrome as recorded by a panchromatic emulsion.

pannotype. Direct positive collodion images made on glass and then transferred to black oil cloth, patent leather, or black enameled paper.

panorama. *See* panoramic image.

panoramic camera. A camera used to create a panoramic image in a single frame (rather than by combining multiple frames using image-stitching software). This may have a special type of scanning lens that rotates on its rear nodal point to produce an image of the scanned area on a curved plate or film, or it may be a static-lens camera with a wide format. Some point-and-shoot cameras create simulated panoramic images by cropping a 35mm film frame to a panoramic aspect ratio. Also called a pantoscopic camera. *See* panoramic image.

PANORAMIC IMAGE.

panoramic image. An image that is proportionally more rectangular than a 35mm film frame and features an extremely wide angle of view. Such images can be produced using a panoramic camera or by using image-stitching software. *See also* Advanced Photo System, image stitching, *and* scene modes.

panoramic mode. A mode in which the camera assists in the shooting and alignment of a series of overlapping images that can later be combined into a single panoramic image. Called stitch mode on some cameras.

pan reflector. *See* parabolic reflector.

pantograph. In photography, a scissors-like mechanism that can be used to raise and lower studio lights.

Pantone colors. A system of over 1,200 standard colors developed by Pantone, Inc. The PMS (Pantone Matching System) is a swatch book that describes colors by assigning numbers.

SELECTING PANTONE COLORS FOR A DUOTONE IMAGE IN PHOTOSHOP.

Pantone Matching System (PMS). *See* Pantone colors.

pantoscope. (1) An apparatus for viewing photographs. (2) A type of ultrawide-angle lens.

pantoscopic camera. *See* panoramic camera.

paparazzi. Photographers who take surreptitious photographs of well-known people, often in embarassing situations, to sell to tabloid newspapers and celebrity magazines.

paper base. Support for the emulsion used in printing papers.

paper characteristic curve. A graphic showing the relationship between the exposure values and image density of a printing paper. The curve can be altered by using different developers, development times, temperatures, and toning.

paper grade. A numerical and terminological description of photographic paper contrast. Numbers zero to one are soft; number two is normal; number three is hard; numbers four and five are very hard; and number six is ultra hard. Similar grade numbers from different manufacturers do not necessarily have the same characteristics. Also called contrast grade.

paper negative. Negative with a paper base. Used in some early photographic processes. *See also* waxed paper process.

paper safe. A lighttight container for storing unexposed photographic paper.

paper white. In printing, the color of the substrate. Normally, this dictates the lightest tone that can be produced in the print.

parabolic mirror. *See* parabolic reflector.

parabolic reflector. A bowl-shaped reflective device used to produce near parallel rays from a light source positioned at its center. Also called a pan reflector or parabolic mirror.

parallax. In rangefinder cameras, the difference between the image seen by the lens and the viewfinder. In TLR cameras, the difference between the image seen by the taking lens and the viewing lens. This discrepancy does not occur in SLR cameras.

parallax error. Inaccuracies in framing and composition that occur due to parallax. Parallax errors become more pronounced as the subject moves closer to the camera.

parallax focusing. A focusing technique that relies on a ground glass with a reticle, a small mark such as crosshairs, etched or engraved onto its surface. The photographer looks at the mark and moves his or her eye. If the reticle appears stationary, then the subject is deemed to be in focus. The technique exploits parallax differences and needs a magnifier attachment to be effective. Also called reticle focusing.

parallax stereogram. An old autostereogram technique in which a vertical grid is placed in front of a composite stereogram. The placement is such that the wires block the right view to the left eye and vice versa. This allows only a single view to be seen by an observer standing at the correct position.

parallel port. A connector on a computer that allows you to attach other devices, such as a printer. Also called an LPT port.

parallel processing. Ability of an array of processors to work simultaneously. This speeds processing.

parallel scanning. Method of scanning in which a row of sensors on one axis is moved along the other axis. This is used in flatbed scanners, scanning-back cameras, and other devices. Also called pushbroom scanning.

parameter RAM (P-RAM). In Macintosh computers, area of memory that stores basic settings such as the time and date.

Paramount lighting. *See* butterfly lighting.

paraphenylenediamine. A reducing agent used in some fine-grain and color developers.

paraphotography. A general term for non-silver-halide image forming processes.

paraxial. The rays nearest the optical axis of a lens.

parfocal lenses. Lenses that can be exchanged without a change in focus.

parity bit. Information appended to a data set to ensure that the received data is identical to transmitted data.

Parks, Gordon. *See* appendix 1.

partial metering. Restricting metering to a small area at the center of the viewfinder or around the current focus point. This area, typically 6.5 to 10.5 percent of the total image area, is larger

than that sampled by a spot meter and is therefore called the partial metering area.

partitioning. The division of a hard disk into smaller volumes that behave as though they were separate.

passband. The wavelengths that are transmitted by a filter.

passé-partout. French term used to describe a window mat.

passive autofocus. Most SLRs use passive autofocus systems, which detect changes in contrast in the image rather than relying on projected light or sound beams—though they may use autofocus-assist lights when light levels are low. Passive autofocus works on the principle of phase detection. *Contrast with* active autofocus.

paste. (1) Command used in many applications to insert cut or copied data into a digital file. (2) *See* mounting paste.

paste into. In Photoshop, a function in which the contents of the source selection appear masked by the destination selection.

pastel. Light, low-saturation colors.

pastel portrait. A photographic enlargement colored extensively with pastels.

PAT. *See* photographic activity test.

patch chart. A checkerboard arrangement of squares in a scientifically determined range of colors. This is used as an objective standard for comparing, measuring, and analyzing color balance and color reproduction. The Macbeth ColorChecker is a commonly used example.

MACBETH COLORCHECKER PATCH CHART.

patch tool. In Photoshop, a tool that allows you to repair a selected area with pixels from another area or a pattern. These are automatically blended to match the area being corrected.

USING THE PATCH TOOL.

patent. The sole right to make, use, or sell an invention.

patent plate. A polished glass plate used in many early photographic processes.

path. In image-editing programs, an outline of a shape that can be changed by editing its anchor points.

path-reversal principle. In optics, the assumption that light follows the same path when entering an optical system as it does when exiting the system.

pattern. In graphics applications, an image that is repeated and used to fill a layer or selection.

APPLYING A PATTERN IN PHOTOSHOP.

pattern stamp. In Photoshop, a tool used to selectively apply a pattern to an image.

PC. *See* personal computer.

PCB. *See* printed circuit board.

PC cable. *See* Prontor/Compur cable.

PC card. *See* Personal Computer Memory Card International Association card.

PC connector. *See* Prontor/Compur cable.

PCD. *See* Kodak PhotoCD.

PC lens. *See* perspective-control lens.

PCMCIA card. *See* Personal Computer Memory Card International Association card.

PCS. *See* profile connection space.

PC socket. *See* PC terminal.

PCT. *See* PICT.

PC terminal. On cameras, a socket used to attach an external flash without using the hot shoe connector.

PCX. An image file format, using the extension *.pcx, that supports several color modes and the RLE compression method.

PDF. *See* portable document format.

peak. The maximum output intensity.

pearl. A paper surface that is slightly shinier than matte paper.

PEC. *See* photoelectric cell.

peer-to-peer. A network in which there is no central server.

PEF. A proprietary raw file format on Pentax digital cameras.

pellet process. A non-silver photographic process that is very similar to the cyanotype process and occasionally referred to as a positive cyanotype.

pellicle (pellicule). A thin skin, cuticle, membrane, or film.

pellicle mirror. In SLR cameras, fixed half-silvered mirrors that both direct light to the viewfinder and to the film surface. This prevents mirror blackout, mirror-slap sound, lag time, and blurring vibration associated with mirror motion. Because some light is diverted to the viewfinder, there is typically $2/3$ stop less light available to the film and the viewfinder is a bit dimmer.

pencil. (1) A cylinder, generally wood, filled with lead and used in retouching. (2) A very thin brush.

pentaprism. Five-sided prism found on SLR cameras. This optical device corrects the image, which is reversed by the lens, to allow eye-level viewing and focusing with the viewfinder. *See also* prism *and* finder.

pentaprism finder. *See* pentaprism.

Pentax. Manufacturer of film and digital cameras, as well as optical equipment for business and medicine.

Pentax screw fit. *See* M42.

pen tool. In Photoshop, a tool used to create paths.

penumbra. An area where light is only partially blocked from hitting the subject. *Contrast with* umbra.

PePax. Colloquial term for the distortion that results from nonstandard perspective and/or parallax.

percentage solution. A solution containing a given quantity of a dissolved substance in a given volume of solvent.

perceptual rendering intent. Tries to maintain color relationships by compressing all the colors inward to accommodate out-of-gamut colors. This is often referred to as the photographic rendering intent.

perfect lens hood. *See* perfect lens shade.

perfect lens shade. A petal-shaped lens shade with curved cut-out notches. This design maximizes the amount of shade coverage for the minimum amount of weight and hood area. Also called a perfect lens hood. *See also* lens shade.

perforations. *See* sprocket holes.

perforation streak. Lateral areas of density extending out from the sprocket holes. Caused by insufficient agitation in processing.

peripheral. Any device that plugs into a computer and extends its capabilities. Printers, modems, keyboards, and monitors are all peripherals.

periphery photography. A technique used to photograph the entire inner or outer surface of a cylinder or tube.

permanence tests. Methods of establishing the anticipated longevity of an image.

permanent paper. *See* acid-free paper.

personal computer (PC). In the context of digital photography, a small microcomputer used to store, edit, and manipulate digital images transferred from a camera. Personal computers are also used for business and creative applications such as graphic design, word processing, accounting, and scheduling.

Personal Computer Memory Card International Association (PCMCIA) card. More commonly called PC cards, small credit-card sized expansion cards that can be plugged into a computer or digital camera to enhance its capabilities. PC cards are commonly memory, modem, or hard-drive cards. Type I and II cards fit single-height slots. Type III fit only double-height slots.

personal style. Characteristics of a photographer's work that make it recognizable and unique.

PENTAPRISM. PHOTO COURTESY OF NIKON.

PERFECT LENS SHADE. PHOTO COURTESY OF NIKON.

perspective. The visual representation of a three-dimensional subject or space in a two-dimensional medium. The three dimensions are implied by converging lines and a focal point. This is often controlled by camera angle/height.

THE CONVERGING LINES OF THE ROAD PROVIDE PERSPECTIVE. PHOTO BY BARBARA A. LYNCH-JOHNT.

perspective-control (PC) lens. A specialized lens for architectural photography. Such lenses feature barrel lateral shifting relative to the film or sensor plane. This eliminates the need for the camera to be tilted, thus eliminating keystoning. *See also* shift.

perspective plane. In Photoshop, a tool that allows you to define rectangular planes in an image. *See also* vanishing point.

petroleum ether. *See* benzene.

Petzval, Joseph. *See* appendix 1.

Petzval lens. An early lens system, developed by Joseph Petzval in 1840. Petzval's f/3.7 lens design consisted of four elements and gathered more light than most of its competitors (typically f/14 or f/17), reducing the amount of time that subjects had to remain motionless. Many modern lenses have developed from this design, sometimes adding a fifth lens element.

Petzval sum. *See* Petzval surface.

Petzval surface. The natural parabolic curve of the field of an optical system, a phenomenon first described by Joseph Petzval (1807–1891). Uncorrected lenses project an image onto a curved parabolic surface. Unfortunately, film surfaces are flat. As a result, focus problems arise as you move away from the center of the field caused by this effect. *See also* field curvature.

P format. *See* Advanced Photo System.

pH. A figure expressing the alkalinity or acidity of a solution. On this scale, 7 is neutral. Lower values are more acidic and higher values are more alkaline.

phase alternation line (PAL). Television and video standard used in Europe.

phase-change printer. A printer in which dyes or pigments change phase (from solid to liquid or gas) before being applied to the paper.

phase detection. The principle upon which passive autofocus is based. The autofocus sampling area is split into two areas by a small lens. Each half is projected onto its own half of the autofocus light sensor, and the two halves then compare results.

Phase One. Manufacturer of high-end digital camera backs, as well as raw-file processing, image-capture, and color-rendition software.

phenidone. Reducing agent used in fine-grain solutions.

phenol varnish. A resin used to produce a hard, durable top coating on images. *See also* varnish.

phosphor. A chemical substance on the inside face of a computer screen that becomes illuminated when electrically charged. RGB monitors use three different phosphors to produce red, green, and blue light.

phosphorescence. The ability of a material to absorb light of one wavelength and emit it as light of a different wavelength.

phosphotophotography. Projecting an infrared image onto a phosphorescent surface.

photo aquatint process. *See* gum bichromate.

PhotoCD. *See* Kodak PhotoCD.

photochemical. A substance used in the processing of photosensitive emulsions in traditional chemical-based photography. Usually a compound dissolved in water.

photochemical milling. *See* photoengraving.

photochemistry. A branch of science dealing with the ability of radiant energy to produce chemical changes.

photochromic. Compounds that become dark when exposed to light, then grow clear again when the light source is removed (or when exposed to light of another wavelength).

photoconduction. A substance in which electrical resistance is changed when it is exposed to light.

photodetector. A device designed to capture light and produce a proportional output.

photodiode. A semiconductor measuring or converting light into electrical current, commonly used in scanners and CCDs.

Photodynamism. *See* appendix 2.

photoelectric cell (PEC). A light-sensitive cell used in exposure meters. Selenium PECs generate electricity in proportion to the amount of light falling upon their surface. Cadmium sulfide PECs offer resistance to a small electric charge when light falls upon them. Cadmium sulfide cells are more sensitive than selenium, especially at low light levels.

photoengraving. A process of engraving using photoresist applied to metal. Areas exposed to light through a photographic negative harden. Unhardened areas are then removed by washing in a solvent. Finally, the metal is exposed to an acid (or other etching compound) which dissolves the exposed parts of the metal. Other methods of photoengraving result in shallow depressions in the metal (used for intaglio printing plates) or deep engraving with sloped shoulders (used for stamping dies and printing plates). Also known as photochemical milling.

photo essay. A sequence of photographs intended to tell a story or express an opinion.

photo-etching. A technique of contact printing a lithographic film image on a presensitized zinc plate. This is then processed and chemically etched to give a relief image.

photofinishing. Automated processing and printing of films, generally for amateur snapshots.

Photoflex. Manufacturer of lighting equipment.

photoflood. An artificial light source using a tungsten filament lamp and a dish reflector. Typically 5500K or 3200K.

photogenic. A subject that tends to look particularly attractive in photographs.

photogenic drawing. The name given by William Fox Talbot to his earliest method of recording camera images.

photoglyptie. French term for woodburytype.

photogram. (1) An image produced by placing opaque or transparent objects on top of a light-sensitive emulsion, exposing it to light, then developing it. *See also* rayograph. (2) An image created by placing a three-dimensional object on the platen of a flatbed scanner.

DIGITAL PHOTOGRAM.

photogrammetry. The science of making measurements from photos. Often used in producing maps.

photograph. Traditionally, an image that is recorded on light-sensitive material. The term now refers to any two-dimensional still image recorded using some optical process.

photographer. A person who creates photographs, either professionally or as a hobby.

photographic activity test (PAT). Evaluates chemical or photographic interactions between photographic materials and enclosure materials. Important in achieving archival permanence.

photographic rendering intent. *See* perceptual rendering intent.

photography. A term meaning "writing with light" from the Greek "photos" (light) and "graphos" (writing).

photogravure. French for "photo engraving," this is an etching method used to reproduce photographs using a copper plate covered with material that hardens upon exposure to light. The exposed area of the copper plate is etched in an acid bath, then inked and printed to transfer the image onto paper.

Photojournalism. *See* appendix 2.

photojournalist. A person who reports on stories through the use of photographs, often working for newspapers, news

PHOTOJOURNALISTIC IMAGE DOCUMENTING A BLIZZARD'S AFTERMATH.

agencies, and news magazines. Many wedding photographers also refer to themselves as photojournalists because they cover the story of the wedding day in the same fashion as a news photographer, seeking to capture key moments without influencing the events. *See also* appendix 2 (Photojournalism).

Photokina. Annual German photo marketing show where manufacturers often introduce new photographic products.

photolamp. A tungsten filament photographic lamp with a large, diffused bulb, giving light of 3200K.

photolinen. A laminate of linen and paper coated with black & white photographic emulsion.

photolithography. A lithographic printing process using an image formed by photographic means.

photomacrography. *See* macrophotography.

Photo Marketing Association (PMA). *See* appendix 3.

photomechanical. Producing an image with ink (usually on paper) using photographically produced plates.

photometer. An instrument for measuring light being reflected from a surface. It works by comparing the reflected light to a standard source within the photometer.

photomicrography. Photography of objects under a microscope, often to reveal biological structure.

photomontage. A collage formed by cutting and pasting together multiple photographs. Also called a composite.

Photomosaic. A patented and trademarked process that uses software to select unrelated images of a particular brightness and color to replace each small area of a picture. The result is a photo made up of thousands of tiny subphotos.

photo multiplier tube (PMT). A device used in drum scanners and densitometers to produce an amplified signal from a photodetector.

photon. A particle of light energy, it is the smallest quantity of radiant energy that can be transmitted between two systems.

photonegative. A substance in which electrical conductivity decreases with increased exposure to light.

photonics. The science of using light for image capture, communications, etc.

photo op. A staged event, typically with a celebrity subject, designed to allow multiple photographers to create images simultaneously for publication in the news media.

photo paper. Heavy paper with a glossy finish designed for printing photographs on an inkjet printer.

photopic vision. Vision at light levels sufficient to stimulate the cones, resulting in a perception of color. Also called daylight vision. *Contrast with* scotopic vision.

photo printer. An inkjet or other printer that can be used to print photographs.

Photorealism. *See* appendix 2.

photorealistic. Output devices capable of producing results roughly comparable to conventional photographs.

photoreceptor. A mechanism that emits an electrical or

PHOTO PRINTER.
PHOTO COURTESY OF CANON.

chemical signal in response to light that strikes it. CCDs and the rods and cones in the human eye are photoreceptors.

photo-reportage. *See* appendix 2 (Reportage).

photoresist. A protective but removable layer applied to a surface to prevent chemical solutions from reaching the covered areas. Sometimes called resist. *See also* photoengraving.

photoresistor. A photoelectric cell in which electrical resistance varies with light intensity. Most decrease in resistance as the light intensity increases.

Photo-Secession. *See* appendix 2.

photosensitive. A substance that undergoes a chemical change in the presence of light.

Photoshop. *See* Adobe Photoshop.

Photoshop DCS 1.0. Desktop color separation file format that saves the four separate CMYK channels as individual PostScript files.

Photoshop DCS 2.0. Desktop color separation file format that saves a single alpha channel and multiple spot channels. Color information can be stored separately (as in the Photoshop DCS 1.0 format) or in a single file.

Photoshop document. *See* PSD.

Photoshop large document (PSB) format. A file format, using the extension *.psb, that permits the saving of extremely large files (those larger than 2GB or exceeding 30,000 pixels in either dimension).

Photoshop Raw format. A flexible file format, using the extension *.raw, designed for transferring images between applications and computer platforms. *Contrast with* raw format.

photo sensor. Term often used interchangeably with either photoreceptor or image sensor.

photo silk screening. A method of silk screening images using a stencil that is produced photographically.

photosite. The small area on the surface of a photodiode that captures a light level for a pixel in the image.

phototelegraphy. Archaic term for the transmission of pictures between two points by means of radio or telephone lines.

phototransistor. A light-sensitive electronic component that functions as a switch. Used for slave firing of electronic flash heads. *See also* slave flash.

Photovoice. *See* appendix 2.

photovoltaic cell. A photoelectric light detector used in some exposure meters.

photowalking. Walking with a camera for the purpose of taking pictures of interesting subjects. Often done to practice one's photography skills.

PhotoYCC. The CIE-based, device-independent color space used to store images on a Kodak PhotoCD.

pH scale. A numerical system (with ratings from 0 to 14) used to express the alkalinity or acidity of a chemical solution.

physautotype. A resin-based direct photographic process.

physical development. A system of development in which silver is contained in suspension within the developer and is attracted to the emulsion by silver halides that have received exposure.

physical ripening. *See* ripening.

physiogram. A photographic pattern produced by moving a point of light over a photosensitive emulsion.

pica. Unit of measurement used in typography. Approximately 1/6 inch. There are twelve picas in a point.

PICT. A Macintosh file format (with an extension of *.pct) that may contain object-oriented and bitmapped graphics.

PictBridge. A standardized technology that lets you—without a computer—print images from the memory card in a digital camera directly to a printer, regardless of brand.

Pictol. *See* Metol.

Pictorialism. *See* appendix 2.

pictorialist. Term for photographs that are picturesque, decorative, and appealing to the viewer's sense of beauty. *See also* appendix 2 (Pictorialism).

picture angle. Another term for angle of view.

PictureCD. *See* Kodak PictureCD.

piezoelectric. A material that produces electricity (or distorts an electric field) when bent or squeezed.

piezoelectric flash. Small flashbulbs, usually in flash cubes, that can be fired using the current produced by striking a piezoelectric crystal. This allows them to be used without a battery.

piggyback mount. A method of attaching a camera to a motorized telescope mount. Commonly used in astrophotography.

pigment. A substance used for coloring or painting, especially a dry powder that is mixed with oil, water, or another medium to form ink or paint. Unlike dyes, pigments are insoluble.

pigment processes. Collective term for a variety of photographic processes that use pigments and bichromated colloids rather than light-sensitive metal salts in the creation of prints.

pilot lamp. A light indicating that a system (such as a camera's flash) is ready for use.

pinacryptol. Yellow and green dye powders that are used in desensitizing solutions.

pincushion distortion. Lens aberration that causes parallel, straight lines at the edges of the image to curve in toward the lens axis. Computer monitors are susceptible to the same problem, although for different underlying technical reasons. Also known as positive distortion. *Contrast with* barrel distortion.

PINCUSHION DISTORTION.

pinhole camera. (1) Cameras that, instead of lenses, have a fixed aperture made by poking a hole in a piece of metal or other material. This allows light to form an image on the back of the camera, which can be covered by film. (2) In digital photography, the same effect can be created by cutting out a hole in a spare body cap, then fitting it with a thin piece of tin (or other metal) in which a tiny hole has been drilled. Laser-drilled body caps can also be purchased for many SLRs from Lenox Laser.

PINHOLE CAMERA.

pitch. (1) Tilt of a camera away from vertical. (2) The up/down rotation of a tripod head. *Contrast with* yaw. (3) *See* dot pitch.

PIXAR format. File format designed for images to be used on PIXAR computers.

pixel. From "picture element." In digital imaging, the smallest complete discrete element that makes up an image.

pixelated. An image in which, due to low spatial resolution, the individual pixels become visible.

pixel density. The number of pixels in a given area, often described in dots per inch (dpi). *See also* resolution.

pixel depth. *See* bit depth.

pixel dimensions. The horizontal and vertical measurements of an image expressed as the number of pixels. For example, the pixel dimensions of an 8x10-inch image at 300ppi would be 2400x3000 pixels.

pixel dropping. A technique used to reduce the number of pixels in an image by dropping pixels from the image at regular intervals.

pixelization. *See* pixelated.

pixel modulation. A process used in printing that changes the brightness of individual pixels by changing the pixel size.

pixel quality. A generalized term describing a pixel's geometrical accuracy, dynamic range, noise, and artifacts. These qualities depend on the number of photodetectors used to create the pixel, the quality of the lens and sensor, the image file format, and other factors.

pixel skipping. A means of reducing image resolution by deleting pixels throughout the image.

pixels per inch (PPI). A measurement used to describe the pixel density in a digital image or computer monitor. The terms "pixels per inch" and "dots per inch" are often confused and used interchangeably. *See also* resolution.

placeholder. A low-resolution image used in preliminary design processes to keep total file sizes small. When the design is complete, high-resolution files replace the placeholders.

plain paper. In historic photographic processes, paper coated only with chlorides, dissolved in water, prior to sensitizing with silver. Also called ordinary paper.

planar. (1) A flat surface on a three-dimensional object. (2) A type of camera optics designed to reduce a flat field.

plane. An imaginary line, flat area, or field that lies perpendicular to the optical axis.

plane of critical focus. The part of the scene or subject that is (or needs to be) sharply focused.

plane-polarized light. A beam of light in which most of the waves vibrate in the same orientation.

plano-concave. A lens element that has one flat surface and one concave surface.

plano-convex. A lens element that has one flat surface and one convex surface.

plasma display. A display screen that has gas contained between two panels. When specific dots on the panels are electrically charged, the gas in that area glows.

plastic camera. Generally synonymous with toy camera. The Diana and Holga are common examples.

plasticity. The visual perception that objects have roundness. *Contrast with* cardboarding.

plastic lens. Lens made from high-quality transparent plastic or resin.

plate. In early photography, a sheet of glass or metal coated with a light-sensitive emulsion.

plate box. A wood or metal box used to store sensitized plates ready for use in a camera, exposed plates ready for processing, and processed plates for safe storage.

plate camera. A camera designed to take glass plates but often adapted to take cut film.

plate holder. (1) A device designed to hold a plate at the same distance from the lens as the focusing glass. (2) A pneumatic device used to support a glass plate from beneath while coating the surface with collodion.

platen. (1) The glass scanning area on a flatbed scanner. (2) The pressure plate in a roll-film camera.

plate rack. Wooden device with a groove designed to hold multiple plates.

plate vice. Device used to hold plates in place when cleaning or polishing them.

platform. Term for the operating system used by a computer, usually either Windows or Macintosh.

platinotype. *See* platinum print.

platinum. A white metal found in copper ore.

platinum-palladium print. A type of black & white contact print created using a combination of platinum and palladium solutions in order to conserve the more expensive platinum. *See also* platinum print *and* palladium print.

platinum print. A type of black & white contact print created using platinum salts to produce platinum metal. Because platinum is extremely stable, such prints are extremely archival. Synonymous with platinotype.

platinum toning. Treatment of black & white photographs that replaces some of the metallic silver in an image with platinum, resulting in greater archival stability.

platter. Part of a hard disk on which data is stored.

play. Noticeable movement between two components, such as a camera and lens. Modern gear, often made largely of plastic, has more play than older, all-metal gear.

playback mode. Setting on a digital camera that allows stored images to be viewed on the LCD screen.

plug and play. A device that can be installed with little or no setup.

plug-in. A software module that can be used by Photoshop (and other image-editing applications) to provide additional functions including importing raw camera files, file format conversions, and image enhancement filters.

plus development. Increasing development time to expand (increase) the range from shadows to highlights. This technique is used in the Zone system for contrast control. Also called normal+1 (N+1) or normal+2 (N+2) development.

PMA. *See* appendix 3.

PMK developer. A formula designed as a universal developer for a wide variety of emulsions under diverse conditions. PMK is an acronym for Pyro, Metol, and Kodalk.

PMS. Pantone Matching System. *See* Pantone colors.

PMT. *See* photo multiplier tube.

pneumatic release. A type of shutter release that operates by pushing air into a piston. These were developed in the 19th century and continued to be used into the 20th century with a variety of shutter types.

pneumatic shutter. A type of shutter found on 19th-century cameras that operated using pistons. To trip the shutter, the photographer squeezed a rubber bulb attached to the camera via a rubber tube, introducing air pressure to the piston. These were eventually superceded by spring-loaded mechanisms.

PNG. *See* portable network graphics.

point. Unit of measure in typography. Approximately $\frac{1}{72}$ inch. There are twelve points in a pica.

point-and-shoot camera. A compact, non-SLR camera that does not support interchangeable lenses and has controls that are either very simplified or very automated (or both). These cameras are meant to be used to record snapshots without having to learn how to use a camera.

POINT-AND-SHOOT CAMERAS ARE AVAILABLE IN MANY STYLES AND FROM MANY MANUFACTURERS.

point balance. In image-editing programs, a type of tool that allows you to click on an area of an image to balance it to white, neutral gray, or black. This applies a corresponding adjustment to all of the pixels in the image and can be useful for correcting simple color casts and minor exposure problems.

Pointillism. *See* appendix 2.

point process. *See* point balance.

point source. A light source that is concentrated at a point and considered to emit rays that travel in a line no wider than the point itself.

polarization. Light travels in a wave motion along a straight path, vibrating in all directions. Polarization, achieved with a polarizing filter, causes light to vibrate in a single plane only. This can reduce or remove specular reflection from the surfaces of many objects and increase the saturation of colors.

polarized light. Rays of light that have been restricted so that they vibrate in one plane only.

polarizer. *See* polarizing filter.

polarizing filter. Gray filter used over light sources or camera lenses to reduce specular reflections on certain surfaces. Using a polarizing filter also results in an increased saturation of colors, especially in landscapes. Linear polarizers consist of a foil of polarizing material between two sheets of glass. These can cause problems with modern autofocus and autoexposure systems and have been largely replaced by circular polarizers, which do not cause these problems. Also called a pola-screen.

LEFT—UNFILTERED SCENE. **RIGHT**—SCENE WITH POLARIZING FILTER.

Polaroid back. A camera back that uses instant film for proofing a scene. This allows the photographer to check lighting, composition, and basic exposure before shooting with traditional film.

Polaroid camera. A camera designed to use instant film. Also called an instant camera.

Polaroid emulsion lift. A process in which the transparency-like Polaroid film image is floated away from its support backing and applied to an alternative surface.

Polaroid film. *See* instant film.

Polaroid SX-70. Polaroid instant film in a flat cartridge with an integrated battery. Often used in Polaroid transfers.

Polaroid transfer. A process in which a Polaroid image is placed in direct contact with the surface to which it is being transferred. The original substrate is then pulled away, leaving the image in place on the new surface.

pola-screen. *See* polarizing filter.

pole. *See* vertex.

police photography. *See* forensic photography.

polychromatic. Light consisting of more than one wavelength.

polycontrast paper. *See* multigrade paper.

polyester. A family of plastic polymers used to make some film bases and photographic filters. These are very strong and archivally stable.

pop. Term used to describe an image, or a particular area of an image, that stands out strongly or attracts the viewer's eye in a powerful way (e.g., "In that shot, her blue eyes really pop.").

POP. *See* Post Office Protocol.

Pop Art. *See* appendix 2.

pop filters. Strongly colored filters used to achieve special effects with color photography.

pop-up flash. A small built-in flash unit that is retracted and sits close to the camera body when out of use. When the camera detects the need for flash (or the photographer activates it), the flash snaps into a raised position, usually directly over the lens. Also called built-in flash or internal flash.

CAMERA WITH POP-UP FLASH OPEN. PHOTO COURTESY OF FUJIFILM.

porcelain paper. An early photographic paper coated with white clay (or baryta) mixed with gelatin. Also called clay-coated paper.

porro prism. A triangular prism commonly used in binoculars and occasionally in cameras. Invented in 1823 by Italian physicist Ignatio Porro.

port. (1) Opening in an underwater housing (or other similar opening) through which images are shot. (2) To transfer digital image files from one application or system to another. (3) Socket on a hardware device to which a cable can be attached, connecting it to another device or system.

portable document format (PDF). A file format, using the extension *.pdf, that captures the elements of a printed document as an electronic image that you can view, navigate, print, or forward to someone else. This format is useful for documents such as magazine articles, product brochures, or flyers in which you want to preserve the original graphic appearance when viewing online or sharing between users.

portable network graphics (PNG). A lossless image file format, using the extension *.png, that supports variable bit depths and alpha channel transparency.

portal. On a web site, a "front page" that provides controlled access to users.

portfolio. (1) A collection of the photographer's best images that is used when presenting work to a prospective client. (2) The physical case or book in which these images are presented.

portrait. A photograph of a person that is typically created to depict the subject in a flattering way or to reveal something unique about their personality.

portrait lens. A lens produced specifically for portraiture. This type of lens usually has a long focal length (85–135mm for 35mm film) and produces a slightly diffused image.

portrait mode. A preprogrammed exposure and shooting mode that sets up the camera in a way that benefits portraits, typically selecting a wide lens aperture to help blur the background. This mode works best when creating head-and-shoulders portraits of individual subjects.

PORTRAIT MODE ICON FOUND ON MANY CAMERAS.

LEFT—AUTOMATIC MODE. **RIGHT**—PORTRAIT MODE.

portrait orientation. An image that is taller than it is wide. In most cameras, this is created by turning the camera on end. On printers, the same term is also used in setting the paper orientation. Also called vertical orientation. *Contrast with* landscape orientation.

portrait photography. A type of photography devoted to capturing images of people. These images are usually commissioned by the subject or a family member and intended to capture, in a flattering way, the facial appearance of the subject(s).

pose. (1) The position of a human subject for photography. In portraiture, the pose is typically designed in order to flatter the individual subject and emphasize their most attractive features. In other genres, such as fashion photography or editorial imaging, it may be designed to showcase a product or emphasize a garment. (2) Occasionally used in portraiture to describe a combination of background and clothing selection when limiting the extent of the session (e.g., "This session includes three poses.").

posing bench. A small bench used for posing portrait subjects. Typically, posing benches can be folded flat, making them easier to transport than posing stools. As a result, they are often preferred for location shoots.

posing stool. A simple adjustable-height stool used when posing subjects for portraiture.

posing table. A table used next to a subject to provide a support for the arms. These tables can typically be adjusted to control their height and angle.

positive. A print or transparency in which the light areas correspond to light areas in the subject, and the dark areas correspond to the shadow areas in the subject. Also called a slide or transparency.

positive cyanotype. *See* pellet process.

positive distortion. *See* pincushion distortion.

positive lens. A simple lens that causes light rays from a subject to converge to a point. Also called a converging lens or a convex lens.

positive printing. Printing a color transparency directly on paper to produce a positive print.

posterization. A technique that yields an image consisting of a limited number of flat tones, rather than the continuous tones seen in most photographs. In the traditional darkroom, this can be accomplished using a number of tone-separated negatives printed on high-contrast material. With digital images, the same effect can be produced using image-editing programs. Posterization can also be the result of over-manipulation or compression in a digital image. *See also* banding *and* tone separation.

LEFT—ORIGINAL IMAGE. **RIGHT**—POSTERIZED IMAGE.

Postmodernism. *See* appendix 2.

postmortem photography. Dating back to the daguerreotype, the practice of making portraits of recently deceased family members, typically depicting them as if in repose.

Post Office Protocol (POP). A protocol for e-mail retrieval and storage.

PostScript. A page description language created by Adobe Systems and commonly used for professional typesetting and page layout applications. The file extension for this format is *.ps.

PostScript color management. A strategy for color management that employs a color space array (CSA), analogous to an ICC source profile; a reference color space (the CIE XYZ color model); and a color rendering dictionary (CRD), the PostScript version of an output profile.

potassium bichromate. Bright-orange crystal used to make colloids sensitive to light. Also known as potassium dichromate.

potassium bromide. White crystal used as a restrainer in most developing solutions and as a rehalogenizing agent in bleaches.

potassium carbonate. Highly soluble alkaline accelerator used in most general-purpose and print-developing solutions.

potassium chloride. Chemical used in some bleaches and sensitizers.

potassium chloroplatinate. A red crystal used in the platinum printing process and for toning silver prints.

potassium citrate. Chemical used in blue and green toners.

potassium cyanide. White granular salt used in fixing agents. Sometimes simply referred to as cyanide.

potassium dichromate. *See* potassium bichromate.

potassium ferricyanide. Deep-red crystal mixed with hypo and used in Farmer's reducer as a bleach. Also known as red prussiate of potash.

potassium ferrocyanide. A yellow crystal that is used as a developer in some iron processes. Also known as yellow prussiate of potash.

potassium hydroxide. A highly active alkali used in high-contrast developing solutions.

potassium iodide. A chemical used in bleaches, toners, and intensifiers.

potassium metabisulfite. An acidifier used in fixers and stop baths.

potassium nitrate. A chemical used in the manufacture of collodion, flash powder, and ferrous sulfate developers. Also called saltpeter or niter (sometimes nitre).

potassium oxinate. A chemical used in early developers for gelatin plates and as the developer for platinum prints.

potassium permanganate. A chemical used extensively in reducers, bleaches, and toners.

potassium persulfate. A chemical used in super-proportional reducers.

potassium sulfide. A chemical used in sulfide toning.

potassium thiocyanate. A chemical used as a silver solvent in some fine-grain developers. *See also* sodium thiocyanite.

power down. To turn off power to a device.

power pack. Accessory containing batteries to supplement or replace those in the camera.

power-pack strobe. A system in which the individual strobe heads are connected to a central, capacitor-filled power pack from which they draw their power. These are the most flexible and commonly used studio systems but can be inconvenient to use on location due to the number (and length) of cables required.

POWER PACK.
PHOTO COURTESY OF PROFOTO.

power up. To turn on power to a device.

power-up time. The time between when you turn on a device and when that device is ready for use.

power winder. An add-on accessory for some manual-wind cameras. These are battery packs with electric motors that wind each frame.

power zoom. A small electric motor on some SLR lenses and many point-and-shoot cameras that adjusts the focal length of the lens.

PPA. *See* Professional Photographers of America, Inc.

ppi. *See* pixels per inch.

PQ. *See* MQ/PQ developers.

P-RAM. *See* parameter RAM.

praseodymium. *See* didymium filter.

predictive autofocus. A mode on many autofocus cameras whereby the camera attempts to track a moving subject and adjust focus accordingly. This works best with subjects moving at a constant velocity.

preflash. (1) A brief pulse of light from a flash unit, usually for metering purposes. (2) Sometimes used to describe the burst of visible light used in red-eye reduction.

prehardener. A chemical solution used to harden the gelatin of an emulsion before processing.

prepress. The work needed to prepare camera-ready artwork for offset printing.

Pre-Raphaelites. *See* appendix 2.

prescan. A quick, low-resolution preview scan of an image. Also called a preview.

preservative. A chemical, often sodium sulfite, used in developing solutions to prevent rapid oxidation of the reducing agents.

preset focus. Adjusting the focus to a predetermined setting, then releasing the shutter when the subject moves into the focus point. Also called freeze focus.

presoak. A water bath for film or paper used prior to processing to prevent uneven development. It is essential in some color processes.

press camera. A camera used by American news photographers from the 1930s through the 1950s. Speed Graphic cameras, by Graflex, are a popular example.

press focus lever. A lever found on the between-the-lens shutters of many large-format cameras. It allows the shutter blades to be held open for lens focusing, no matter what shutter speed has been set.

pressure plate. A spring-loaded plate inside a camera that holds the film flat to ensure even focus. Also called a platen.

preview. (1) In image-editing programs, a representation showing the effect of applying a particular tool. (2) Another term for a prescan. (3) *See* depth-of-field preview.

preview screen. *See* LCD screen.

previsualization. Imagining the photographic result before taking a photograph, then shooting accordingly.

prewind. Winding the film to the end of the roll when it is loaded into the camera, then winding backwards, pulling it back into the canister as each picture is shot. With this system, the exposed frames are safely wound back onto the spool as you go.

primaries. The components of color in a color model. These may be actual colors that can be perceived by human eyes (as in the RGB color model) or mathematical constructs (as in the CIE LAB color model). *See* primary colors *and* synthetic primaries.

primary colors. A set of colors from which all other colors can be made. The primary colors for pigments are red, yellow, and blue. The additive primary colors for light are red, green, and blue. The subtractive primary colors (which yield the addi-

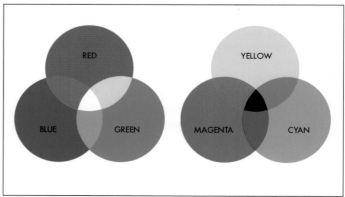

LEFT—SUBTRACTIVE PRIMARY COLORS. **RIGHT**—ADDITIVE PRIMARY COLORS.

tive primary colors when subtracted from white light) are magenta, cyan, and yellow. The additive and subtractive primary colors are the basis for many of the color models used in digital imaging. *See also* synthetic primaries *and* complementary colors.

prime focus photography. The practice of directly attaching cameras to telescopes using an adapter tube and a T-mount adapter ring in place of a viewfinder.

prime lens. A lens with a single, fixed focal length; not a zoom lens. Prime lenses are generally of a higher optical quality than zoom lenses.

PRIME LENS.

principal axis. An imaginary line that passes through the center of curvature of all the lens elements.

principal planes. The imaginary lines that pass through the nodal planes of a lens system.

principal point. The point from which the focal length of a lens is measured. The principal point of a simple lens is located at the center of the lens. Compound lenses have two principal points; *see* front nodal point *and* rear nodal point.

print. An image, normally positive, that is produced by exposing photosensitive paper (or a similar material) to light, or by the application of inks or toners to paper by a printer.

print drier or **dryer.** A device that alows air to circulate over processed prints. In some cases, heat may also be applied to speed the drying process. Synonymous with drying rack.

printed circuit board (PCB). A flat or flexible surface with conductive metal traces and electronic components, used as a support for the components and the basis for the wiring system. Modern computerized cameras typically contain flexible PCBs that can be bent to fit the internal space of a camera.

print engine. In a laser printer, the mechanism used to create an electrostatic image of a page and transfer it to a sheet of paper.

printer. (1) A mechanical device, especially one connected to a computer, used to transfer text, images, or designs to paper. (2) A person who makes photographic prints from negatives or transparencies.

printer driver. The software used by a computer to control the printer.

printer profile. A set of values used to describe how a printer or printing press produces colors when using a specific combination of ink and paper. This allows the CMS to optimally map the colors in a document to colors within the output gamut.

printer resolution. The amount of detail a printer or imagesetter will reproduce. Measured in dots per inch (dpi).

print film. Film that, when developed, yields a negative from which a positive image can be printed on paper.

printing. The process used to produce a photographic image on paper.

printing box. A lighttight wood or metal box used when creating contact prints.

printing easel. *See* easel.

printing frame. Synonymous with easel.

printing-in. Giving additional exposure to selected areas of a print to darken them. Synonymous with burning.

printing-out paper. Antiquated type of photographic paper on which the image appears immediately after being exposed, but will fade unless the paper is fixed and toned. Also referred to as contact-printing paper.

print quality. The overall appearance of a printed image.

print roller. Smooth rubber roller used to apply even pressure on prints when mounting.

print sizes. Common sizes when ordering machine-made prints include (in inches): 4x6, 5x7, 8x10, 8x12, 11x14, 16x20, and 20x30.

print trimmer. Device used to create a straight, clean cut when trimming prints.

prism. A piece of transparent material (e.g., glass or plastic) that is capable of bending light to varying degrees depending on the light's wavelength. Also sometimes the name given to a pentaprism finder.

process color. Four-color mechanical printing system using cyan, magenta, yellow, and black inks to make up the image on a page. Also called four-color process.

processing. A sequence of steps whereby a latent image is converted into a visible, permanent image.

process lens. A lens system designed specifically for high-quality copy work.

process paid. Amateur transparency films that include the cost of processing by the manufacturer's own lab. Once exposed, the transparency film is returned to the manufacturer, slide mounted, and returned to the photographer.

product photography. A specialty that typically involves capturing images of smaller objects (tools, jewelry, food, etc.) for use in catalogs, advertisements, and other promotional materials.

PRODUCT PHOTOGRAPHY.

professional equipment. Products built to a high quality standard and marketed as appropriate for professional use. Professional cameras and lenses, for example, are generally sturdier and offer higher optical quality.

professional film. Film designed for professional photographers. Such film typically features fine grain and consistent color results from roll to roll.

professional photographer. A person who takes pictures in order to earn a livelihood. The term usually implies competence and expertise.

Professional Photographers of America, Inc. (PPA). *See* appendix 3.

profile. (1) A view of a portrait subject where the face is turned at a 90-degree angle to the camera. (2) A data file describing the color behavior of a device, like a monitor or printer, in terms of a device-independent color model, such as CIE LAB. (3) A data file that describes a color space, such as Adobe RGB, in terms of a device-independent color model, such as CIE LAB.

PORTRAIT CREATED IN PROFILE.
PHOTO BY JEFF SMITH.

profile connection space. A color space that acts as a point of connection between a source profile and destination profile. XYZ and LAB are commonly used for this purpose.

profiling. *See* characterization *or* profile.

Profoto. Manufacturer of professional photographic lighting systems.

program. A series of coded software instructions to control the operation of a computer. Synonymous with application.

program AE. An automatic exposure mode that sets both shutter speed and lens aperture according to the internal light meter and the calculations of an internal camera program. Some cameras let you override or adjust this camera-determined setting once it has been determined; others do not.

program mode. A shooting mode in which the camera makes exposure decisions but allows the photographer to override some settings. The adjustable settings vary widely from camera to camera. Also called full program mode.

progressive CCD. A CCD with square pixels especially designed for digital cameras. *See also* charge-coupled device.

progressive JPEG. Principally used on the Internet, a JPEG file that is first displayed in its entirety at a very low resolution, then at increasing resolutions as more data is downloaded to the web browser.

progressive scan. A refresh system for cathode ray tube (CRT) monitors that cuts down on flicker.

projection printing. Making positive prints by projecting a negative image onto photosensitive paper.

projector. A device used to display enlarged still or moving images on a screen.

proJPEG. *See* progressive JPEG.

Prontor/Compur (PC) cable. Cables used to connect cameras and flash units. These carry only a trigger current and do not handle digital data communications of any kind, such as metering information. Prontor and Compur are two manufacturers of leaf shutters used in older and large-format cameras. Sometimes referred to as a German socket. Also called a sync cord.

DIGITAL PROJECTOR.
PHOTO COURTESY OF CANON.

proof. A sample used to demonstrate how the final image will look. *See also* hard proof *and* soft proof.

proof book. A collection of small prints (or contact sheets) that are presented to a client to assist them in selecting the images they wish to order from a photography session or event.

proofing session. A time during which the client reviews their images on a large computer or projection screen at the photographer's studio. With digital photography, this is a popular alternative to presenting a proof book.

prop. An object or element, other than the subject and the background, that is added to a scene to enhance the image.

properties. Attributes (such as color or position) of an image or digital file.

property release. Written permission from the owner (or authorized representative) to photograph a property or to publish/display an existing photograph of a property. This stipulates what a photographer may or, may not do with the image.

ProPhoto RGB. A working space featuring a wider gamut than either sRGB or Adobe RGB (1998).

proportional reducer. A chemical method of reducing excess density and contrast from a photographic negative.

proprietary. Designs for programs, systems, or equipment that are owned by an entity but licensed for use in other applications or systems.

prosumer. An improvised term for photographic equipment that falls between high-end consumer gear and professional gear.

protective filter. A filter put onto a lens to protect it from damage. UV filters are often used for this purpose.

protective toning. A toning process used to protect black & white prints from fading and give archival permanence. Selenium and gold toners are among the most common types.

PROTECTIVE FILTER.

protocol. A set of communications rules between two devices (such as the camera body and a computer-controlled lens) or two pieces of software.

protosulfate of iron. *See* ferrous sulfate.

proxy. A representative version or sample of a larger image. Often used as a placeholder.

Prussian-blue process. *See* cyanotype.

PS. *See* PostScript.

PSB. *See* Photoshop large document format.

PSD. The native file format of Adobe Photoshop.

pseudocolor. (1) An artificial color scheme applied to monochrome images to enhance subtle contrast. (2) Changing the colors in a photograph using image-editing programs.

public domain. A work that is no longer protected by copyright law. This can be because the creator of the work died more than a certain number of years ago or because the creator relinquished their claim to copyright.

pulling film. To expose film at a lower film speed rating than normal, then to compensate in part for the resulting overexposure by giving less development than normal. This permits shooting at a higher light level, slower shutter speed, or larger aperture than would otherwise be possible. This procedure is also called pull processing. *Contrast with* pushing film.

pull processing. *See* pulling film.

pupil. Opening through which light enters the eye.

purge. In Photoshop, a set of commands that allow you to free memory by clearing stored history states, undo states, and/or the clipboard.

purity. (1) The extent to which the main color contains or lacks other colors. (2) Lack of contamination of chemicals.

pushbroom scanning. *See* parallel scanning.

pushing film. To expose film at a higher film speed rating than the normal, then to compensate in part for the resulting underexposure by giving more development than normal. This permits shooting at a dimmer light level, a faster shutter speed, or a smaller aperture than would otherwise be possible. This procedure is also called push processing. Synonymous with uprating. *Contrast* with pulling film.

push processing. *See* pushing film.

push-pull lens. A zoom lens where the focal length is adjusted by physically lengthening or shortening the lens barrel in a telescoping fashion.

pyro. Reducing agent used in developing solutions.

pyrogallic acid. *See* pyro.

pyroxylin. Synonymous with cellulose nitrate.

QCD. *See* quick-control dial.

QD. *See* quartz date.

Q factor. *See* quality factor.

QL. *See* QuickLoad.

QR plate. *See* quick-release plate.

quadtone. (1) Photomechanical printing process using four inks. (2) In image editing, a method of creating a unique reproduction curve for each of four inks.

quality control. Techniques used to ensure that color, sharpness, and other positive attributes of a photograph are properly maintained through various stages of image processing.

quality (Q) factor. Calculation used to ensure that images are not enlarged beyond the requirements of the output device. Also called the halftone factor.

quantization. (1) In image compression, technique that determines what information can be discarded without loss of visual quality. (2) In scanning, the artificial forcing of similar gray levels to the same level as a result of limited tonal depth.

quantum. The smallest indivisible unit of radiant energy.

Quantum Instruments. Manufacturer of batteries, flash units, and other photographic accessories.

quarter plate. A negative or print format measuring about 3x4 inches. It is one-quarter the size of the full plate (8x6 inches) introduced by Daguerre.

quarter tones. Tones between the highlights and midtones in an image. Also called one-quarter tones.

quarter video graphics array (QVGA). Term for a computer display of 320x240 pixels. QVGA displays are most often seen in mobile phones, PDAs, and some handheld games. *See also* video graphics array.

quarter-wave plate. Thin material built into linear polarizing filters that turns them into circular polarizing filters. Also called a quarter-wave retarder.

quarter-wave retarder. *See* quarter-wave plate.

quartz date (QD). Small digital clock in a film camera that can print the current date and/or time onto the film or between film frames.

quartz-halogen lamp. A light source consisting of a tungsten filament in a quartz casing containing a small quantity of a halogen gas, usually iodine.

quartz-iodine lamp. *See* quartz-halogen lamp.

quartz lamp. *See* quartz-halogen lamp.

quasi-fisheye. A lens or lens attachment used to produce a fisheye image that covers the entire frame. A true fisheye lens produces a circular image within the frame.

quenching. Obsolete term for diverting electrical charge from a flash tube to shorten output duration. This is now accomplished by thyristors.

queue. The sequence of events within the computer or peripheral.

quick-control dial (QCD). A rear, thumb-operated dial that permits the photographer to operate much of the camera with one hand.

QuickLoad (QL). Fuji's no-changing-bag-required loading system for 4x5-inch sheet film.

QUICK-CONTROL DIAL.

quick-release (QR) plate. A metal plate that fits between a tripod head and a camera and allows the photographer to quickly attach and detach the camera.

QuickTime. A proprietary software system developed by Apple Computer for video and

QUICK-RELEASE PLATE.

sound recording, editing, and playback. Some digital cameras can also record video clips in QuickTime format.

Quinol. *See* hydroquinone.

QVGA. *See* quarter video graphics array.

R3000. Chemical process for making prints from slides.

RA4. Process for producing slides from negatives.

raccoon eyes. A colloquial expression for the dark circles that appear under the eyebrows of portrait subjects when the main light is high overhead, like the midday sun. Depending on the severity, this may be corrected using an image-editing program.

RACCOON EYES.

rack. (1) Hanger to hold film or prints for drying. (2) *See* rack and pinion.

rack and pinion. A focusing system used on large-format monorail cameras and some bellows units for macrophotography. This system employs a long, fixed metal rack with a sliding section upon which part of the camera system rests. The photographer then turns a small wheel that pulls the sliding section along the rack, achieving focus.

radial gradient lens. A lens in which the refractive index of the material varies across the radius. Also called a Wood lens.

radiant energy. Energy, such as light or heat, that is emitted in the form of rays or waves.

radiant flux. The total power of light emitted by a source. *Contrast with* luminous flux.

radiation shield. A glass filter that fits over a monitor screen. Designed to reduce the level of radiation being emitted.

radioactive glass. Lens glass that contains radioactive rare earth elements, such as thorium, which lower the refractive index of the glass. Also colloquially called hot glass. *See also* rare earth glass.

radiography. A technique of using X-rays, gamma rays, and charged particles to form shadow images on photographic materials. Used in medical and industrial research for its ability to penetrate opaque objects.

radio slave. *See* radio transmitter/receiver *and* slave flash.

radio transmitter/receiver. Device used to trigger remote cameras from great distances or to trigger flash units placed some distance from the camera.

RAF. A proprietary raw file format used by Fujifilm digital cameras.

RAID (Redundant Array of Independent Devices). A set of hard disks, usually mounted in a single enclosure, to which data is simultaneously written to reduce the risk of data loss should any one drive fail.

rake. To place a light source so that it strikes the subject from an angle to better reveal shape and/or texture.

RAM. *See* random access memory.

ramp. A smooth gradient.

random access memory (RAM). Memory used to hold active information that can be read and erased in random sequence. RAM is volatile memory, meaning it does not save its contents when power is turned off. Image-processing applications require a great deal of RAM due to the large amount of data being processed.

rangefinder (RF). A type of focusing system, or a camera using such a system, that is based upon principles of triangulation. In a rangefinder camera, the separate viewfinder and taking lens provide the two fixed points at a known distance required for triangulation. *See also* triangulation, coincident rangefinder, coupled rangefinder, *and* uncoupled rangefinder.

rapid fixer. A fixing solution that uses ammonium thiocyanate or thiosulfate instead of hypo. Minimizing the time the paper is in the fixer improves results when washing and increases overall archival stability.

rapid rectilinear. A lens system composed of two matching lenses placed symmetrically around the focal aperture. This design removes many of the aberrations that are inherent in simpler constructions.

rare earth glass. Glass that contains minute quantities of elements not commonly found in the Earth's crust. This can produce glass with useful qualities; glass containing lanthanum oxide, for example, has a low refractive index. Unfortunately, some rare earth elements are radioactive. *See also* radioactive glass.

raster display. A display that uses pixels in a column-and-row arrangement to display text and images. This is the most common type of display.

raster image. Image made of dots, each containing specific information as to its size, color, and position within the image.

LEFT—RASTER IMAGE. **RIGHT**—VECTOR IMAGE.

For example, computer monitors are raster devices, displaying images as grids of tiny glowing dots. Also called a bitmap image. *Contrast with* vector image.

raster image file format (RIFF). A file format that is used with grayscale images.

raster image processor (RIP). A piece of equipment or software that converts a computer file into a bitmap image that a printer can output. While these processors are normally built into printers or computers, some large professional printers and imagesetters have external RIPs.

rasterization. The process of converting vector images to raster images.

RASTERIZATION DIALOG BOX IN PHOTOSHOP.

raster streak. When photographing a television or computer monitor, a dark stripe that appears on the screen when too fast a shutter speed is used.

raster unit. The distance between the centers of two adjacent pixels.

rating. In film photography, intentionally setting the camera to an ISO other than that specified by the film's manufacturer. *See also* pushing film *and* pulling film.

raw conversion software. An application designed to open raw files, optimize them, and convert the files to a printable format.

raw egg process. A method of extracting albumen for use in the albumen process. *See also* albumen *and* albumen paper.

raw format. A proprietary file format used by many digital cameras to denote a file containing unprocessed data from the camera's image sensor. The following are common raw file extensions for major camera manufacturers:

Canon .*.cr2, *.crw
Fuji .*.raf
Kodak .*.dcr
Minolta .*.mrw
Nikon .*.nef
Olympus .*.orf
Pentax .*.pef
Sony .*.srf

Raw files typically give the photographer the highest-quality output. However, they require special software to open and, because of their larger file size, require more processing time and storage space than other formats, such as JPEG. *Contrast with* Photoshop Raw format. *See also* digital negative.

ray. A straight line in which light travels to a given point.

Rayleigh scattering. The scattering of light by particles much smaller than the wavelength of the light. This occurs most prominently when light passes through gases. Rayleigh scattering of sunlight in the clear atmosphere is the main reason why the sky is blue.

Ray, Man. *See* appendix 1.

rayograph. A term coined by Man Ray for a picture made by placing the subject directly on photographic paper (i.e., a photogram).

RC paper. *See* resin-coated paper.

read. To access a digital file from memory.

reading. A measure of luminance made with an exposure meter.

read only memory (ROM). Permanent memory that does not lose its contents when power is not applied. This memory is programmed by the manufacturer and cannot be modified. Commonly used to store internal operating software, called firmware, used by computers and digital cameras.

ready light. A small light on some devices (particularly flash units) that indicates the unit is ready for use.

real image. (1) The point to which light rays converge as they emerge from a lens. (2) An image that can be seen with the eye or displayed on a monitor. *Contrast with* virtual image.

realist camera. A type of 35mm stereographic camera.

READY LIGHT.

real-time image processing. Digital processing of an image that occurs without a calculation delay that is noticeable by the user.

rear-curtain sync. *See* second-curtain sync.

rear focus (RF) lens. Lenses that contain elements, close to the film plane rather than at the front of the lens, that move to adjust focus. This is a form of internal focus; the length of the lens does not change when focusing. Because these rear lens elements tend to be smaller, this type of focusing also tends to be faster.

rear lens cap. A protective metal or plastic cover that fits over the rear element of an interchangeable camera lens. Also called a lens-mount cap.

rear nodal point. The nodal point of a lens that is situated closest to the film or digital image sensor.

rebadged. A product made by one company but sold under a different brand name.

REAR LENS CAP.

rebate. The the non-image-forming margin of roll film, including the area into which sprocket holes are punched and the area where the frame numbers are printed.

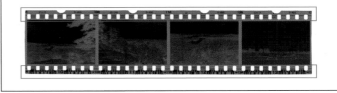
REBATE.

reboot. The process of turning a digital device off and then back on again to reload the software.

recede. Tendency of a tone or color to lose visual prominence in a composition.

rechargeable battery. A multiple-use battery that can be restored to its full charge and repeatedly reused.

reciprocity. The inversely proportional relationship that exists between shutter speed and aperture. For example, taking a photograph at f/8 for ¹⁄₁₂₅ second creates an identical exposure value (EV) as shooting the scene at f/11 for ¹⁄₆₀ second. *See also* reciprocity failure.

reciprocity failure. The breaking down of reciprocity. Most films are designed to be exposed within a certain range of exposure times. When exposure times fall outside of this range, becoming either significantly longer or shorter, the film's characteristics may change. This can result in a loss of effective film speed, contrast changes, and color shifts. Generally, compensation for this characteristic is required when making an exposure longer than 1 second.

reclaim. In the darkroom, extracting silver from exhausted chemical baths. Because silver is a valuable metal, reclamation is an economically viable activity.

reconstituted image. A photograph produced by translating light from the subject into electronic signals.

recovery time. The time between making an exposure and the time at which the camera is ready to make another exposure.

rectangular pixels. Pixels that are not square. Many computers, drawing on television technology, have rectangular pixels. This is undesirable for digital imaging, because circles turn into ellipses when rotated 90 degrees. Some digital cameras also have rectangular pixels. These cameras may output rectangular pixels or use software interpolation to output square pixels. *Contrast with* square pixels.

rectilinear. Lenses that do not introduce significant distortion, especially ultrawide-angle lenses that preserve straight lines and do not curve them (unlike a fisheye lens, for instance). Such lenses are generally expensive, because they are optically complex to manufacture.

recycle time. (1) The amount of time required by an electronic flash unit to recharge its capacitors and be ready to fire again. (2) The time it takes a digital camera to process and save a picture to memory, then get ready to take the next shot.

red (R). A color of light with wavelengths of around 650nm. Red, with blue and green, is one of the three additive primary colors. *See also* RGB *and* primary colors.

redevelopment. A secondary development process conducted to increase the density of a negative.

red-eye. The red glow that appears in the eyes of human subjects when light from the flash bounces off the retina. This is most common in low-light situations, because the subject's pupils tend to be dilated. Built-in flash units, located very close to the lens, are especially likely to cause red-eye.

red-eye pen. A fine-point marker containing dye designed to neutralize the appearance of red-eye when applied selectively to the affected area of a print.

RED-EYE PEN.

red-eye reduction. With built-in flash units, a setting that shines a short burst of light into the subject's face, contracting the subject's pupils just before the image is taken.

red-eye removal. The post-shoot elimination of red-eye from photographs. Many image-editing programs offer a tool for accomplishing this task, as do some photo-finishing labs.

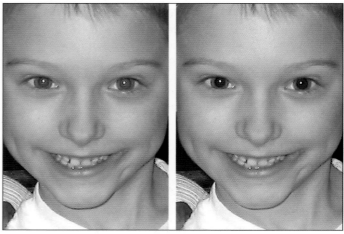

RED-EYE REMOVAL.

red-eye tool. *See* red-eye removal.

redhead. An 800-watt tungsten lamp commonly used in cinematography.

redox reaction. *See* reduction-oxidation reaction.

red prussiate of potash. *See* potassium ferricyanide.

Red Shirt School. *See* appendix 2.

reduced base. *See* hypostereo.

reducer. A chemical bleaching solution that decreases the amount of silver in a black & white negative. This lowers the density.

reducing agent. A chemical in a developing solution that converts exposed silver halides to black metallic silver.

reduction. (1) A photographic image that is smaller than the original—for example, making a 4x5-inch print of an 8x10-inch negative. (2) Treating a negative with a reducer to lower its density. (3) A chemical change in which oxygen is removed. Silver-based photography relies on oxidation and reduction chemistry to capture images. *See also* oxidation.

reduction-oxidation (redox) reaction. A collective term for two related chemical processes involved in silver-based photography. *See also* reduction *and* oxidation.

redundant array of independent devices. *See* RAID.

red-window frame indicator. On some older cameras using 120 film, a transparent red window through which the frame numbers could be read off the film's paper backing. Light leaks in this area are a common source of fogging.

reel. A metal or plastic cylinder with spiral grooves into which roll film is loaded for development.

reference color space. *See* color space, device-independent.

reference white. A target used when setting white balance.

reflect. To redirect light, making it travel in a different direction than that from which it originated.

reflectance. A measure of the percentage of light reflected from a surface. A white surface will reflect most of the light

falling on it, giving it a high reflectance. A black surface will reflect very little light, giving it a low reflectance.

reflected light. Light that is bounced off a subject, elements in a scene, a photographic device designed to redirect light, or a reflective medium (such as a printed photograph). *Contrast with* incident light *and* transmitted light.

reflected light meter. Device used to measure light that bounces off a scene or subject. Such meters can be handheld but are more commonly built into cameras.

reflection. (1) Reversal or redirection of light when it hits a surface. In this process, the reflected ray stays on the same side of the surface as the incident ray. (2) An image or bright spot created by reflected light on a mirror or shiny surface. (3) An image that is laterally reversed, as if seen in a mirror.

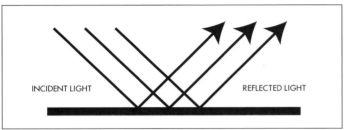

REFLECTION OF LIGHT RAYS.

REFLECTIONS ON WATER.

reflective artwork. Opaque artwork that is viewed by reflected light (rather than transmitted light). *Contrast with* transmissive artwork.

reflector. Any object or material used to bounce light onto the subject. Many devices, in a variety of sizes, surface finishes,

REFLECTORS FROM LASTOLITE (LEFT) AND PHOTOFLEX (RIGHT).
IMAGES COURTESY OF LASTOLITE AND PHOTOFLEX.

and colors, are commercially available for this purpose. Many photographers also choose to construct their own devices, often tailored to a specific application.

reflector holder. An arm-like device that can be attached to a light stand to hold a reflector.

reflex camera. A type of camera in which light is projected to the viewfinder by means of a 45-degree reflex mirror. SLR and TLR cameras are the most common types.

reflex lens. *See* mirror lens.

reflex mirror. The large primary mirror in an SLR camera that permits the user to view the scene through the taking lens prior to shooting the photograph.

reflex viewfinder. A viewfinder that allows you to view the image through the taking lens. Reflex viewfinders, such as those in SLR cameras, contain a mirror that reflects light from the lens to the viewfinder when the shutter is closed, then swings out of the way to allow light to strike the film when the shutter is open.

refraction. The bending of light as it passes between materials of different densities, such as from air to glass.

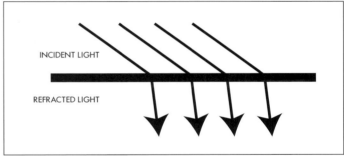

REFRACTION OF LIGHT RAYS.

refractive index. A number describing the ability of a transparent material (glass, plastic, liquid, crystal, etc.) to bend (refract) light. This number is the ratio of the velocity of light in a vacuum compared to the velocity of light in a given medium. The refractive index of a vacuum is 1, and the refractive index of air is very close to 1. Ordinary glass has a refractive index of around 1.5. Water has a refractive index of about 1.3.

refresh rate. The rate at which information on a CRT monitor or television set is redrawn, measured in hertz (Hz). The faster the refresh rate, the more stable an image will appear on the screen.

regional rights. Usage rights to a work that have been transferred or licensed to one party from another on a geographical basis. For example, a photographer may sell the North American rights to a work to one company and the European rights to another.

register. Exact alignment when overlaying separate images.

register distance. The distance between the flange of the lens mount and the film plane. When adapting a lens to a camera system with a different lens mount, this can be problematic. If the lens has a shorter register distance than the camera body, it will be unable to achieve infinity focus because it's the wrong distance from the film plane. Rectifying this requires an adapter to correct the register distance, either mechanically or optically.

register punch. Device used to make alignment holes in film or paper for registering images.

registration. The precise alignment of the color channels within a digital image or the layers of film used in offset printing.

registration marks. Small crosshairs used to align individual layers of film, particularly in offset printing.

rehalogenization. A process by which black metallic silver is converted back to silver halides. It is used in bleaching for toners and intensification.

relative aperture. *See* aperture.

relative colorimetric rendering intent. A rendering intent that converts out-of-gamut source colors to the closest in-gamut colors of the destination color space. Also maps the white value in the source color space to the white value in the destination color space.

relay. *See* optical relay.

release. *See* cable release, pneumatic release, *or* shutter release.

release priority. An autofocus mode in which the camera takes a photo, regardless of whether or not correct focus has been achieved. *Contrast with* focus priority.

relief. (1) An image in which the image-forming material stands out from the surrounding surface. (2) The appearance or fact of depth, such as in carvings or stereography.

Rembrandt lighting. A portrait lighting effect created by placing the main light high and at a 45-degree angle to the subject. This creates a triangular highlight on the subject's far cheek.

remote. A device that allows a camera to be triggered or adjusted from a distance. This can be connected to the camera by a wire or operated wirelessly using infrared or digital radio controllers. These devices can also be used to trigger flash units.

REMOTE.

remote capture. Use of software to remotely fire a digital camera connected to a computer. Each image can then be stored directly onto the computer's hard drive and immediately previewed on the computer monitor instead of using the camera's LCD.

remote control cable. Another term for electronic cable release. *See also* cable release.

removable media. A data-storage device, such as a CD or memory card, that can be removed from a computer or other hardware device.

render. (1) To calculate an image and draw it onto a computer monitor. Three-dimensional computer graphics, in particular, are described as being rendered. (2) To reproduce a color or tone.

rendering intent. In color management, a software setting that determines how the conversion between color

SETTING RENDERING INTENT IN PHOTOSHOP.

spaces is performed and how out-of-gamut colors are handled. *See also* relative colorimetric rendering intent, absolute colorimetric rendering intent, perceptual rendering intent, *and* saturation rendering intent.

Renwick, Frank Foster. *See* appendix 1.

repeating flash. A feature available in some flash units to make multiple bursts during exposure. This is useful for creating motion studies in a single-frame multiple exposure.

replenisher. Substance added to some developers after use to replace exhausted chemicals so that the developer can be reused.

Reportage. *See* appendix 2.

reproduction-quality duplicate. A copy of an original slide or transparency that is of sufficiently high quality and accuracy that it is considered suitable for use in place of the original.

reproduction ratio. In macrophotography, the size of the subject in an image compared to its actual size. If the image on the recording medium is the same size as the subject, the reproduction ratio is noted as 1:1 or 1x. For non-macro subjects, the reproduction ratio is calculated by dividing the focal length of the lens by the camera-to-subject distance.

repro-quality dupe. *See* reproduction-quality duplicate.

resample. Changing the number of pixels in an image.

res down. To decrease the total number of pixels in a digital image. Also called downsampling.

reset. To restore the factory settings on an electronic device.

residual. Levels of a contaminant or defect that do not impair quality or performance.

resin. *See* acrylic resin.

resin-coated (RC) paper. Light-sensitive photographic paper stock with a water-resistant base that dries more quickly than fiber-based paper and requires a shorter washing period to remove chemicals. *Contrast with* fiber-based paper.

resist. *See* photoresist.

resistor. A device having a designed opposition to the passing of an electric current.

resize. (1) Altering the pixel dimensions or resolution of a digital image. (2) Reducing or enlarging a film image.

ABOVE—399x559 PIXELS.
RIGHT—633x887 PIXELS.

RESIZE.

resolution. (1) The ability of the eye or photographic equipment to distinguish fine detail. In a film image, this is dependent upon the resolving power of the lens and the film emulsion. With a digital image, it is dependent upon the resolving power of the lens and the number of pixels that can be detected by the image sensor. (2) The pixel density of a digital image or imaging device, such as a digital camera sensor, scanner, or monitor. Also called dots per inch. (3) The dot density of an image on a printed page. Also called pixels per inch. *See also* high resolution, interpolated resolution, low resolution, optical resolution, *and* screen resolution.

resolution independent. Graphics that are constructed using mathematical equations rather than pixel values and can, therefore, be scaled without concern for loss of image quality. *See also* vector image.

resolution, interpolated. *See* interpolated resolution.

resolution, optical. *See* optical resolution.

resolution target. Chart used to test the resolving power of an optical system.

resolving power. The ability of the eye, lens, or photographic emulsion to determine fine detail. Resolving power is expressed in terms of lines per millimeter that are distinctly recorded or visually separable in the final image.

response curve. *See* characteristic curve.

restore factory settings. On many electronic devices, a tool used to return all settings to their original values.

restrainer. A chemical constituent of developing solutions that helps prevent reducing agents from affecting unexposed halides and converting them to black metallic silver.

res up. To increase the total number of pixels in a digital image. Also called upsampling.

reticle. A frame or scale marked on a viewfinder and seen superimposed over a scene by the viewer. These are often used to indicate the image area.

reticle focusing. *See* parallax focusing.

reticulation. Cracking or distorting of film's gelatin emulsion during processing. This can be caused by extreme changes in temperature or pH during processing.

retina. The area at the back of the human eye that converts incoming light into electrical impulses that are sent to the brain.

RETINA.

retouching. Altering a photograph in some way, either digitally or using traditional materials. This is typically done to improve the appearance of the subject, to eliminate technical flaws, or to produce an image that could not be created in-camera. It may also be done to repair a damaged image.

RETOUCHING TO REMOVE BACKGROUND DISTRACTIONS.

retrofocus lens. Design with a negative lens element positioned in front of the diaphragm and a positive lens element positioned at the rear of the diaphragm. This provides a short focal length with a long back focus or lens-to-film distance, allowing for movement of the reflex mirror in SLR cameras. Sometimes called a reverse telephoto or inverted telephoto lens.

reversal. (1) A still, positive image created photochemically on a transparent base. (2) Process through which a black & white negative is developed, fogged, then redeveloped in order to produce a black & white transparency. (3) Tonal reversal (black for white or vice versa) seen as a result of secondary exposure in the Sabbatier effect. (4) Tonal reversal (black for white or vice versa) seen as a result of overexposure in solarization.

reversal film. Film that yields a positive image when developed. Synonymous with slide film and transparency film.

reverse. To produce a negative image from a positive one, or a positive image from a negative one. This can be done digitally or using traditional photographic materials.

reverse Galilean. Viewfinders that are much like a simple telescope of the kind invented by Galileo Galilei (1564–1642), but turned backward. This causes the optics to reduce the image rather than enlarge it. Most direct view camera viewfinders are of a reverse Galilean design. This is sometimes simply referred to as Galilean.

reverse telephoto. *See* retrofocus lens.

reversing ring. A ring that lets you attach a lens backwards to a camera using the lens's filter threads and the camera's lens mount. This is often done for macrophotography. However, cameras with electronic connections to the lens don't typically support this process without the addition of an expensive wired adapter.

revert. In image-editing programs, returning to the most recently saved version of an image.

revolutions per minute (RPM). A specification often provided with hard drives. The higher the RPM, the faster the data can be read from the drive, increasing overall performance.

revolving back. *See* rotating back.

revolving background. Popular in the early days of portrait photography, a circular background that could be rotated to position the light and dark areas as desired to complement the lighting and the subject's pose.

rewind. (1) To return a roll film to its spool or cassette so it can be removed from the camera. (2) On cameras, the button or knob that activates this process. *See also* rewind knob.

rewind knob. A knob on a roll-film camera that is turned to rewind the film. This often has a foldout lever or handle to facilitate the process.

rez down. *See* res down.

rez up. *See* res up.

RF. *See* rangefinder.

RF lens. *See* rear focus lens.

RGB. A color model that uses three primaries (red, green, and blue) to reproduce colors. Pixels are assigned intensity values from 0 (black) to 255 (white) for each of the primaries. This is the color model used by computer monitors and is the default setting for many digital-imaging programs and devices.

RGB scanning back. *See* scanning back.

Rhodol. *See* Metol.

RIFF. *See* raster image file format.

rifle stock. *See* shoulder stock.

right-angle lens attachment. A tube containing a mirror that fits on the end of a camera lens. The mirror is mounted at a 45-degree angle to the lens axis, allowing you to take candid photographs by pointing the camera around corners or away from the subject you are actually photographing.

right-angle viewfinder. An L-shaped SLR viewfinder attachment containing a mirror mounted at a 45-degree angle to the legs of the L. Fitted onto the eyepiece of an SLR, this lets you look into the viewfinder by peering downward rather than into the back of the camera. This can be useful for macrophotography and in situations where the camera is positioned low to the ground. Also called an angle viewfinder.

right reading. The orientation of a negative or transparency when the image appears as it did to the camera. Both negatives and transparencies should be viewed with the emulsion side (dull finish) down and the base (glossy finish) facing the observer. *Contrast with* wrong reading.

rights-protected image. An image licensed under terms intended to ensure exclusive rights to the user. The license determines the territory, industry, timeframe, and usage permitted.

rim lighting. Lighting in which the subject appears brightly outlined against a dark background. Usually the light source is above and behind the subject (i.e., the subject is between the light and camera).

ring light. A circular flash unit that fits around the end of a camera's lens. This provides flat and even lighting for macrophotography and occasionally for fashion photography.

RIM LIGHTING. PHOTO BY TIM SCHOOLER.

ring motor. Motor in some lenses in which the rotor and stator encircle the optics.

rinse. A brief clean-water wash between steps of a processing cycle to reduce carryover of one solution into another.

RIP. *See* raster image processor.

ripening. The stage in film manufacturing when silver halide grains in the emulsion are recrystallized. The duration of this phase determines the overall film grain size. Also called physical ripening and Ostwald ripening.

riser. A pole that can be added to the top of a studio stand to extend its height.

rising front or back. *See* falling front or back.

Ritts, Herb. *See* appendix 1.

RLE. *See* run length encoding.

Robinson, Henry Peach. *See* appendix 1.

Rodchenko, Alexander Mikhailovich. *See* appendix 1.

rods. Retinal receptors that are sensitive only to variations in brightness, not color. *Contrast with* cones.

roll back. *See* roll-film adapter.

Rollei. A German manufacturer of optical goods.

roller squeegee. *See* squeegee.

roll film. Film supplied in long strips that are wound around spools or inside canisters.

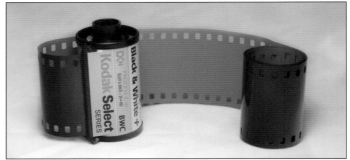

ROLL FILM.

roll-film adapter. An attachment that enables cameras designed for cut film to use roll film. Also called a roll back or roll-film back.

roll-film back. *See* roll-film adapter.

rollout photography. A process that pairs a camera with a vertical slit aperture with a carefully rotated subject to create planar photographs of three-dimensional objects (generally cylinders). This can be used, for example, to provide a complete representation of the artwork on the exterior of a vase.

ROM. *See* read only memory.

Romanticism. *See* appendix 2.

roof mirror. A hollow reflective assembly used in place of the pentaprism in some low-end SLRs. Though roof mirrors are lighter and less expensive to manufacture than pentaprisms, they don't transmit as much light and result in dimmer viewfinders.

rotate. To move in a circle around an axis. In digital imaging, images and layers are commonly rotated—often to switch from landscape to portrait orientation or vice versa.

rotating back. A film or plate holder on a camera that can be rotated to switch between vertical and horizontal images.

rotating lens. A camera lens that is physically rotated during the duration of the exposure. This is usually done to shoot panoramic photographs.

Rothstein, Arthur. *See* appendix 1.

rottenstone. A mineral ground and used for polishing photographic plates. Also called tripoli.

rouge. A fine abrasive used in polishing photographic plates.

Rowell, Galen. *See* appendix 1.

Royal Photographic Society, The. *See* appendix 3.

royalty. A fee paid to an artist or copyright holder in exchange for use of a specific piece of intellectual property. When an image is licensed through a stock agency, the royalty is collected by the agency on behalf of the copyright holder.

royalty-free image. An artistic work, such as a photograph, that is licensed to at a flat rate. Copyright is retained by the artist, but the client may use the picture in almost any way (other than resale) without paying additional fees. No further royalties are levied for its use, unlike images under rights-protected licenses.

RPM. *See* revolutions per minute.

RS232C interface. *See* serial port.

RS422 interface. *See* serial port.

R-type print. A direct reversal print made from a color transparency on color paper with color couplers. The paper is exposed and developed in black & white developer, then exposed to light (or chemically fogged) so that the remaining silver halide can be developed in color developer, causing the color couplers to form dyes. *See also* Ilfochrome.

rubber cement. An adhesive containing rubber in a solvent. This is occasionally used as a masking agent to create selective toning effects in the darkroom. Rubber cement will cause image discoloration if used for mounting prints.

rubber stamp tool. In many image-editing applications, a tool used to retouch flaws by making a copy of a selected area and pasting it elsewhere. Also called the clone stamp tool.

ruby glass. Dark-red glass used in the creation of ambrotypes. The term is also applied to dark glasses of other colors used for the same purpose.

rule of thirds. A compositional guideline that divides the image vertically and horizontally into thirds. According to this rule, dominant points of interest usually look best when situated on one of these $\frac{1}{3}$ lines—or at the intersection of any two lines.

RULE OF THIRDS.

run length encoding (RLE). Lossless compression supported by Targa, BMP, and PCX file formats.

run-time error. A non-syntax program error that causes the computer to crash.

S

Sabattier, Aramand. *See* appendix 1.

Sabattier effect. An effect that is formed when an emulsion is exposed normally, the briefly reexposed to white light during development, and allowed to continue developing. This yields a reversal or partial reversal of tones, particularly in the highlight and shadow areas. Often a line, called a mackie line, appears around the reversed areas. This is also commonly referred to as solarization, which produces a similar effect, albeit by extreme overexposure rather than reexposure.

safelight. A special darkroom lamp emitting light of a color and intensity that will not fog light-sensitive photographic material. In the typical black & white darkroom, the safelight would be red or orange-red, since commonly used black & white paper is largely insensitive to red light.

safety film. Photographic film produced with a base, usually acetate, that is fire-resistant or slow burning.

sag. A short-term drop in voltage.

SAFELIGHT.

Sailwind. Manufacturer of photographic filters.

sal-ammoniac. Ammonium chloride. Used in some high-speed developers.

Salomon, Erich. *See* appendix 1.

salted paper process. The first silver-based, negative-to-positive paper imaging system in photography. Developed by William Henry Fox Talbot.

saltpeter. *See* potassium nitrate.

sample. Determining the value of a color, often so that it will match when used elsewhere in a design. *See also* sampling.

samples per inch (SPI). The number of color samples per inch a scanner's CCD reads as it moves across the image.

sampling. A series of small measurements that are combined to reconstruct the whole. *See also* resample.

Samsung. Manufacturer of digital cameras and other consumer electronics.

sandarac. A component of photographic varnishes.

sandbag. A weight used to stabilize light stands, tripods, and other equipment. *See also* weight bag.

SanDisk. Manufacturer of flash memory cards and memory card readers.

sandwiching. Combining two or more negatives or slides to produce a composite image either on a sheet of printing paper or on a slide-projection screen. Usually, the images are used full frame. The same effect can be produced using image-editing programs.

ABOVE—ORIGINAL IMAGES.
RIGHT—SANDWICHED IMAGE.

SANDWICHING.

Sanyo. Manufacturer of digital cameras and other consumer electronics.

saturation. (1) The purity of a color (or absence of gray). High saturation yields colors that appear vibrant; low saturation results in colors that are pale or muted. This can be adjusted in some cameras and image-editing programs. Black, white, and gray have no saturation. Also known as chroma. (2) A primary in the HSB color model.

saturation rendering intent. A rendering intent that attempts to provide a conversion with saturated color, even if it means shifting hue. This makes it a good choice when converting from a smaller color space to a larger one.

save. In computing, the act of writing data to a storage location so that it may be accessed in the future.

save as. In computing, the act of writing duplicate data to a new storage location. This is often done to back up a file or to preserve a work in progress at various stages in its development.

Savoye format. A wide stereographic format produced by a special attachment on a planar camera.

scalable vector graphics (SVG). Format for web graphics designed to produce high visual quality and small file sizes.

scale. (1) The linear relationship between the size of the subject and the size of its image. (2) To change the proportion of an image by increasing or decreasing its size. To avoid distortion during this process, the original aspect ratio must be maintained. (3) *See* focusing scale.

scanner. A hardware device that reads flat media, such as photographs and film, and converts the readings to digital data. *See also* drum scanner, flatbed scanner, negative scanner, and slide scanner.

scanner bed. The glass area of a flatbed scanner on which materials are placed for scanning. *See also* platen.

FLATBED SCANNER.
PHOTO COURTESY OF CANON.

scanner head. *See* carriage.

scanner profile. A set of values used to describe how a scanner captures color. Some photographers create separate profiles for each type or brand of film they plan to scan.

scanning back. A high-quality digital back for medium- or large-format cameras. This scans the subject in front of the camera in three passes (one each for red, green, and blue) and is therefore only used with still-life subjects. Also called an RGB scanning back or three-pass camera. *See also* one-shot back.

scanning camera. *See* slit camera.

scanning electron microscope. A device commonly used in photomicrography.

scattering. The diffusion of light that occurs when it reflects off of a matte surface, is refracted by airborne particulates (as in smog or fog), or passes through a translucent medium.

scene mode. On digital cameras, a preset control designed to facilitate creating images of common subjects. These are sometimes called image modes or shooting modes. *See also* beach mode, close focusing mode, fireworks mode, foliage mode, indoor mode, landscape mode, macro mode, movie mode, night landscape mode, night portrait mode, panoramic mode, portrait mode, snow mode, *and* sports mode. *Contrast with* exposure mode.

Scheimpflug principle. A geometric rule that affects the correct focus of view cameras with movements. This rule states that sharp focus occurs only when the film, lens, and subject plane are precisely parallel to one another.

Scheiner disc. A simple focusing device used in astrophotography. Though the terms Hartmann mask and Scheiner disk are often used synonymously, Hartmann disks may feature two or more holes; Scheiner disks have only two. *See also* Hartmann mask.

Schlieren photography. Photographs that record changes in the density of a transparent medium, such as air (for example, the waves of heat from a candle flame).

Schneider. Manufacturer of photographic filters.

SCHOOL PHOTOGRAPHY.

school photography. A genre of photography devoted to creating individual portraits of students and group portraits of classes within a school.

Schulze, Johann Heinrich. *See* appendix 1.

Schumann plate. A plate coated with an emulsion that has so little gelatin content the silver halide grains protrude above its surface. Used for ultraviolet photography.

Scitex continuous tone (SCT) format. A file format used for high-end image processing on Scitex computers. These files, often extremely large, are generated for input using a Scitex scanner, then printed to film using a Scitex rasterizing unit. This system produces very few moiré patterns and is often used in professional color work, such as ads produced for magazines.

scotopic vision. Vision at low light levels sufficient to stimulate primarily the rods, resulting in little or no color perception. Also called nocturnal vision. *Contrast with* photopic vision.

scouting. *See* location scouting.

scratch. A long, narrow surface defect.

scratch disk. A virtual memory scheme used to temporarily employ hard drive space in place of RAM.

screen. (1) The viewing area of a computer monitor. (2) On cameras, short for LCD screen. (3) A surface onto which images are projected for viewing. (4) *See* focusing screen.

screen angle. In offset printing, the angle at which halftone screens are placed in relation to one another.

screen capture. *See* screen shot.

screen frequency. *See* screen ruling.

screening. Conversion of a continuous tone image to a halftone image.

screen grab. *See* screen shot.

screen plate. A plate that was used in early additive forms of color photography.

screen resolution. (1) The size of the rectangular grid of pixels displayed on a monitor. (2) The dots per inch displayed on a computer monitor. (3) An image produced at 72dpi and designed for on-screen viewing, rather than printing or some other output method.

screen ruling. The number of lines or dots per inch on a contact screen used to make halftones or separations.

screen shot. An exact copy of the items being displayed on a computer monitor (or an area of the monitor, such as a dialog box). Also called a screen capture or screen grab. Screen shots are often used to illustrate instructional materials.

SCREEN SHOT.

screw mount. A mounting system for filters and (until the 1970s) lenses. Consists of a threaded ring into which the matching threaded cylinder of the filter or lens is screwed.

screw-on filter. A filter with a threaded ring that attaches to the front of the lens using matching threads.

scrim. A device placed in front of a light source to diffuse the light and reduce its intensity. Sometimes called a diffusion flat. There are several types of scrims. Single-net scrims are constructed of a webbed fabric that reduces light by approximately half a stop. Double-net scrims have the same construction but reduce light by approximately one stop. Open (or open-ended) scrims have a frame on only three sides, leaving one side open so that it can be placed in front of a light source without casting a shadow.

scroll. To move text or graphics up or down, left or right, in order to see parts of the file that do not fit on the screen.

SCSI. *See* small computer systems interface.

SCT. *See* Scitex continuous tone format.

S curve. In composition, any real or implied line that approximates the shape of the letter S. *See also* C curve.

S CURVE.

SD. *See* Secure Digital.

SDRAM. *See* synchronous dynamic random access memory.

Sea & Sea. Manufacturer and distributor of equipment for underwater photography.

seamless paper. A large roll of smooth, heavy paper used as a photographic backdrop in studio settings. Also called a sweep.

second-curtain sync. Timing the firing of an electronic flash unit so that it fires shortly before the second curtain of a focal-plane shutter closes. This yields a more natural light trail when used with slow-shutter sync. Also called rear-curtain sync. *Contrast with* first-curtain sync.

second generation. A copy made from a first-generation copy of an original image.

secret photography. The covert creation of images, often associated with investigative work. *See also* spy camera.

secure area. On web sites, areas where personal information can be entered securely by users. Usually indicated by the prefix "https://".

Secure Digital (SD). A format of flash memory card used to store photos in digital cameras.

Seidel aberrations. The five common forms of monochromatic optical aberration described by mathematician Philipp Ludwig von Seidel. These are spherical aberration, coma, astigmatism, curvature of field, and distortion. Also called Seidel sums.

Seidel sums. *See* Seidel aberrations.

Seiko. Manufacturer of digital cameras and other consumer electronics.

Sekonic. Manufacturer of light meters for still and motion picture photography.

sel d'or. An early gold toning solution. Also called gold hyposulfate.

select. In image-editing programs, to isolate a specific image area for manipulation.

selection indicator. In image-editing programs, a flashing black and white dotted line showing the specific area targeted for manipulation. Also called marching ants.

SECURE DIGITAL (SD) CARD.
PHOTO COURTESY OF KINGSTON TECHNOLOGY.

SELECTION INDICATOR AROUND WHITE FLOWER.

selection tool. In image-editing programs, a tool that allows you to isolate a specific area for manipulation.

selective color. In Photoshop, a command that allows a user-selected color to be adjusted independently of other colors in the image.

selective contrast paper. *See* variable contrast paper.

selective development. Developing some areas of a print more fully than other areas. This is usually achieved by applying the developer to the print with a swab or brush.

selective focusing. Using focus to direct attention to a certain area of a scene. This is commonly used with a very narrow depth of field in order to isolate a subject by causing most other elements in the scene to be blurred.

selenium. A nonmetallic element used in semiconductors and in photographic toning. Its light-sensitive qualities also make it

useful in photo cells and exposure meters. *See also* selenium cell, selenium toner, *and* intensifier.

selenium cell. A light-sensitive cell used in many types of exposure meters.

selenium intensifier. *See* intensifier.

selenium toner. A chemical solution containing selenium that is used for toning black & white photographs. This is often done for archival reasons, because selenium is more resistant to atmospheric pollutants than the silver it replaces in the process.

self-portrait. An image of the photographer created by the photographer. Also called an auto-portrait.

self-timer. A camera setting used to delay the opening of the shutter for a given number of seconds after the shutter release has been activated. Also known as delayed action.

self-toning paper. An obsolete silver chloride paper used for contact printing in daylight.

semiautomatic iris. A type of diaphragm that closes to the taking aperture when the shutter is released but must be manually reopened.

SELF-TIMER ICON FOUND ON MANY CAMERAS.

semiconductor. A material that is neither truly conductive of electricity nor a complete insulator. Semiconductors form the basis of many electronic components.

semigloss. *See* luster.

semimatte. *See* luster.

senior portrait photography. Images created during a student's last year in high school in order to document their appearance at this transitional time.

sensitive material. A paper or film that that reacts to light.

sensitivity. The degree of response of a photographic emulsion or image sensor to exposure to light (or various colors of light). *See also* ISO.

sensitizing dye. *See* dye sensitization.

sensitometer. An instrument used to measure the light sensitivity of film over a range of exposures. Depending upon whether the exposures vary in brightness or duration, it may be called an intensity-scale or time-scale sensitometer.

sensitometry. Scientific study of the response of photographic materials to exposure and development. It establishes emulsion speeds and recommended development and processing times.

sensor. In photography, an image sensor in a digital camera or a light-sensing cell used in a light meter. *See also* charge-coupled device *or* complementary metal-oxide semiconductor.

sensor cleaning system. A mode on many DSLR cameras that vibrates the sensor to dislodge any dust particles. Also called a dust removal system.

sensor linearity. *See* linearization.

separable lens. *See* convertible lens.

separation. Differences in density, saturation, or color between adjacent areas in an image.

separation negatives. A set of black & white negatives, made from full-color originals, that divide the original colors in the images into their component primary colors (with one negative for

each primary color). These are most often used in the preparation of plates for offset color printing.

sepia filter. (1) A filter used in front of the lens to replicate the look of a sepia-tone image in-camera. (2) On some digital cameras, a shooting mode designed to produce a sepia-tone image instead of a color image. (3) A software tool used in post-production to replicate the look of a sepia-tone image.

USING AN ON-CAMERA SEPIA FILTER CREATES AN IMAGE WITH AN OVERALL BROWN TINT.

sepia mode. On some digital cameras, a shooting mode designed to create images with a sepia-tone look.

sepia tone. In the traditional photographic darkroom, a reddish-brown color added to a monotone image by submerging the developed print in a toner bath. A number of sepia toners are commercially available for this process, and each provides a slightly different result. Image-editing software is now more commonly used to create this effect.

A MONOTONE IMAGE (LEFT) CAN BE CONVERTED TO A SEPIA-TONE IMAGE USING AN IMAGE-EDITING PROGRAM. PHOTO BY BARBARA A. LYNCH-JOHNT.

serial port. A low-speed transfer interface used on older personal computers to control peripherals. Also called an RS232C or RS422 interface or a COM port.

server. One computer that acts as a networking device for many interconnected computers.

service bureau. A commercial facility equipped with a wide range of imaging equipment, giving photographers access to expensive hardware and skilled staff to operate it properly.

service provider. *See* service bureau.

set. An arrangement of props, backdrops, and/or other elements designed to produce an attractive, convenient area for photography.

settings. Values, set by the factory or the user, that determine how a device or application will perform.

setup. Collective term for the arrangement of subjects and light sources used to create an image.

setup mode. On digital cameras, a mode in which the user can customize settings such as image compression, file size, file format, date and time, and sounds.

seven-eighths view. In portrait photography, a view of the face where the head is turned very slightly to the side. In this view, both ears are still visible to the camera.

shade. (1) Darkness caused by light rays being intercepted by an opaque object. (2) A covering that protects something from direct light. (3) Archaic term for a portrait in silhouette. (4) A slight degree of difference in brightness or luminance between colors. (5) Short for lens shade.

shade white balance. A white-balance setting that slightly warms images to compensate for the cooler light typically found in shady areas.

shadow. A region of darkness where light is blocked. A shadow occupies all the space behind an opaque object with light in front of it.

SHADE WHITE-BALANCE ICON FOUND ON MANY CAMERAS.

shadow, blocked up. *See* blocked up.

shadow detail. Color and/or texture visible in the darkest areas of the subject or image. It is desirable to maintain shadow detail, but there is a risk of decreasing overall contrast if one lightens the shadow too much in order to expose detail.

shadowgraphy. A simple method of visualizing refractive index gradients by photographing the shadow cast by a transparent medium.

shadow/highlight. In Photoshop, a tool designed to help balance the subject and background exposure in backlit images.

shadow point. The darkest tone in an image without being black. All tonal values below this threshold will print or display as solid black.

shake. *See* camera shake.

shallow. A term used to describe a narrow depth of field or a small distance between the subject and the camera.

shape tool. In graphics software, an automated tool used to create polygons, ellipses, lines, and custom shapes (generally selected from a library supplied with the software).

shareware. Software that is free to try but for which payment is requested if the program will be kept and used.

sharp. Term used to describe an image, or an area of an image, that is properly focused (rather than blurry). For emphasis, a very sharp area is sometimes described as "tack sharp."

Sharp. Manufacturer of digital cameras and other consumer electronics.

sharpening. In image-editing programs, a mathematical process of enhancing the apparent sharpness of an image by boosting edge contrast. *See also* edge detection.

sharpen tool. In image-editing programs, a brush-like tool used to selectively apply sharpening to an image.

sharpness. (1) The ability of a lens to render fine detail clearly. (2) The clarity of detail in an image.

IN AN IMAGE THAT IS NOT SHARP (LEFT) FINE DETAIL IS LESS VISIBLE THAN IN AN IMAGE THAT IS SHARP (RIGHT).

sheet film. Film supplied as individual sheets rather than rolls. Commonly used in large-format cameras, the sheets have to be installed and removed from the camera one at a time or in packs. *Synonymous with* cut film.

shelf life. The length of time that unused film, printing paper, or chemicals will remain fresh.

shellac. A natural resin with a low melting point that is used to make photographic varnishes.

shift. A movement on large-format cameras, or special shift lenses in other formats, used to eliminate converging angles.

shim. A small wedge used to fill in a gap or adjust something—for example, to adjust a slightly damaged lens mount or make a loose battery better fit the camera cavity.

shoot. (1) Colloquial term for taking a photograph with a camera. (2) Colloquial term used to describe a planned photography session.

shooter. Colloquial term for a photographer.

shooting distance. The distance between the subject and the film or image-sensor plane.

shooting mode. *See* scene mode *or* exposure mode.

shortcut key. *See* keyboard shortcut.

short lens. Colloquial term for a wide-angle lens.

short lighting. A portrait lighting setup in which the main light illuminates the far side of the subject's face (the side of the face that is turned at least slightly away from the camera). Sometimes called narrow lighting.

shot bag. *See* weight bag.

shoulder. The area of a characteristic curve that corresponds to the high-density portion of the image. *See also* characteristic curve.

shoulder brace. When using a monopod, a device that rests against the photographer's body to provide additional camera stability.

shoulder stock. A camera mount that resembles a rifle and is held up against your shoulder as if you were firing a rifle. Also called a rifle stock.

show card. A sheet of some (usually) matte white material used as a reflector.

shower curtain. Another name for a scrim.

shutter. A device used to control the amount of time during which light is allowed to enter the camera and register on the film or image sensor. *See also* leaf shutter, focal plane shutter, *and* pneumatic shutter.

shutterbug. A colloquial expression, popularized in the 1970s, for a photographer.

shutter button. *See* shutter release.

shutter curtain. *See* curtain.

shutter drag. *See* dragging the shutter.

shutter lag. On digital cameras, the delay between pressing the shutter-release button and when the photo is actually taken.

shutter priority mode. An exposure mode in which the photographer selects the desired shutter speed and the camera automatically selects the aperture that will produce a proper exposure. Typically designated by the letter T or the letters Tv.

shutter release. A button, lever, or other device that is pressed to open the shutter and take a picture. This may be on the camera (in which case, it is often referred to as the shutter button), connected to the camera via a cable, or used remotely to emit a signal that triggers the shutter.

shutter speed. A measurement of how long the camera's shutter stays open. Typical ranges for shutter speed are from 30 seconds to $1/8,000$ second. Each setting is half the duration of the

SHORT SHUTTER SPEEDS CAN BE USED TO FREEZE MOTION.

LONG SHUTTER SPEEDS CAN BE USED TO BLUR MOTION.

preceding one in a constant scale. Fast shutter speeds can freeze action. Long shutter speeds may be required to capture very dark scenes or may be selected to produce blurred motion effects.

side lighting. Light striking the subject from the side, relative to the position of the camera. It produces shadows and highlights to create modeling on the subject.

LEFT—FLAT LIGHTING. **RIGHT**—SIDE LIGHTING.

Sigma. Manufacturer of lenses, cameras, flash units, and associated accessories.

signal-to-noise ratio. The ratio of the usable signal to unusable noise in a scan. A high degree of noise masks shadow detail, regardless of resolution. Often abbreviated as S/N or SNR.

silhouette. A photographic image in which the subject is seen as a solid black shape against a light background.

SILHOUETTE.

silica gel. White powder or granules commonly used to absorb moisture from film or camera equipment.

silicon. A light-sensitive substance that generates a minute current when exposed to light.

silicon photo cell (SPC). A light-sensitive electronic component used in camera light meters. Also called a silicon photo diode (SPD).

silicon photo diode (SPD). *See* silicon photo cell.

silicon release paper. Heat-resistant paper used between a photographic print and textured material in a heated press to prevent the two materials from sticking together.

silk. Another name for a scrim.

silk print. An image made on silk by means of the diazo or dye printing method.

silkscreen. A method of applying inks to paper or similar materials using a nylon stencil produced by photographic means.

silver bromide. *See* silver halides.

silver chloride. *See* silver halides.

silver dye bleach color process. A color process in which the film is impregnated with bright dyes during manufacturing. These dyes are then selectively bleached out during the development process. Ilfochrome (formerly Cibachrome) prints are made using this process.

silver gelatin. Standard black & white prints made using silver halides suspended in gelatin rather than via a chromogenic process.

silver halides. Light-sensitive crystals used in photographic emulsions (e.g., silver bromide, silver chloride, and silver iodide). These crystals change from white to black metallic silver when exposed to light.

silver image decay. An image defect that manifests as spots, silver mirroring, or discoloration.

silver iodide. *See* silver halides.

silver mirroring. In black & white images, oxidation in which the silver migrates to the surface, creating a mirror-like look.

silver nitrate. A photosensitive crystal commonly used in early photography. Today, silver halides are used, but silver nitrate is an intermediate step in manufacturing silver halides.

silver reclamation. A system for recovering silver from exhausted solutions. Also called silver recovery.

silver recovery. *See* silver reclamation.

silver reflector. A reflective device used to redirect light onto a scene or subject. The metallic silver surface yields brighter, more specular light than that from a white reflector but does not affect the color of the light as a gold reflector would.

silver salts. Compounds of silver.

silver screen. *See* lenticular screen.

similar. For purposes of licensing, an image that greatly resembles another image without being identical.

SIMM. *See* single in-line memory module.

simple lens. A lens consisting of a single element, such as a magnifying glass. Most camera lenses are compound lenses with multiple lens elements.

simple mail transfer protocol (SMPT). A protocol used to send text-based messages over the Internet.

simultaneous contrast. Phenomenon in which the perceived color of an area tends to take on a hue opposite that of the surrounding area.

Sinar-Bron. Manufacturer of digital cameras, lenses, lights, and other photography equipment.

Singh-Ray. Manufacturer of photographic filters.

single area autofocus (AF). An autofocus mode in which the photographer manually selects the desired AF focus point.

single autofocus. A mode in which the camera focuses once, then remains at that focus setting until the image is shot or the shutter button is released. *Contrast with* continuous autofocus.

single in-line memory module (SIMM). A type of plug-in RAM module for personal computers.

single lens element. *See* simple lens.

single-lens reflex (SLR). A film or digital camera in which a system of mirrors shows the user the image precisely as the lens renders it.

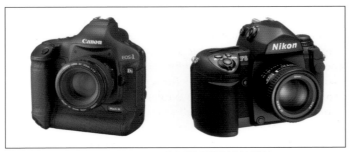

LEFT—DIGITAL SLR. PHOTO COURTESY OF CANON.
RIGHT—FILM SLR. PHOTO COURTESY OF NIKON.

single servo autofocus. A system is which focus remains locked as long as the shutter release button is lightly pressed.

single shooting mode. A camera setting that produces one image each time the shutter button is pressed. *Contrast with* burst mode.

singlet. (1) Simple lens consisting of a single glass element. (2) Single glass element in a multiple-element lens.

single-use camera. *See* disposable camera.

single-weight paper. A type of photographic paper with a relatively thin base. *Contrast with* double-weight paper.

SINGLE SHOOTING MODE ICON FOUND ON MANY CAMERAS.

siphon. A device used to transfer liquid from one vessel to another without disturbing any sediments.

Siskind, Aaron. *See* appendix 1.

sit. To pose for a portrait.

sixth plate. A negative or print format measuring approximately 2.5x3.25 inches. It is one-sixth the size of the full plate (8x6 inches) introduced by Daguerre.

sizing. A very dilute, gluey substance used to prepare surfaces for coating by filling in pores and giving even absorbancy.

skew. To slant a selected item in any direction. Used in graphics applications and desktop publishing.

skin. A protective rubber or plastic housing designed to fit tightly over an electronic device while providing full access to controls.

sky filter. A graduated filter designed to darken the sky while leaving the foreground exposure unaltered.

skylight. Light coming from the sky rather than directly from the sun.

skylight filter. A filter that absorbs ultraviolet radiation and is usually tinted light pink or yellow to neutralize the blueness inherent in skylight.

sky shade. An alternative term for a lens shade.

slave eye. A sensor used to trigger a slave flash unit.

slave flash. Self-contained electronic flash unit that responds to external triggers. Optical slaves are triggered by the light from another flash unit. Digital slaves are triggered by pulses of white light or infrared energy that are encoded with digital messages. This prevents them from accidentally being triggered by another camera's flash (important for wedding photographers). Slave flashes can also be triggered using radio signals. *See also* radio transmitter/receiver. Also called a slave unit.

slave unit. *See* slave flash.

sleep mode. A setting that allows a computer (or other device) to power down when it is not used for a specified amount of time. Waking from sleep mode is quicker than restarting the device.

slide. A positive photographic transparency mounted for projection. *See also* transparency.

SLIDE.

slide copy attachment. *See* slide duplicator.

slide duplicator. A device that fits onto the end of a camera lens and simplifies the process of duplicating slide film. A more complex version of the same consists of an enlarger-like stand with an integral lens and lighting system. Also called a slide copy attachment.

slide film. Film used in making slides. Also known as transparency film, positive film, or reversal film.

slide holder. A metal or plastic device used to support a slide for scanning.

A SLIDE/NEGATIVE HOLDER DESIGNED TO BE PLACED ON A FLATBED SCANNER.

slide mount. A plastic, glass, or cardboard frame used to support an individual slide or transparency and prevent warping.

slide page. Archival polyethylene sheet with pockets used to provide safe, long-term storage for slides.

slide projector. A device used to display enlarged slides on a screen.

slide scanner. A scanner designed to digitize 35mm slides.

slide show. A collection of individual photographs, usually grouped thematically, that are displayed sequentially on a computer monitor, projection screen, or television screen.

SLIDE SCANNER. PHOTO COURTESY OF HEWLETT-PACKARD.

slide viewer. A handheld device that backlights (and often slightly magnifies) a slide or negative for easier viewing.

slim filter. A filter with a low frame designed to minimize vignetting, particularly on wide-angle lenses.

slit camera. A camera that exposes a narrow vertical slice of an image as it rotates around the vertical axis. *See also* rollout photography.

slit shutter. A shutter with a narrow vertical opening. *See also* rollout photography.

slot. *See* expansion slot.

slow film. Film with an emulsion that has a low sensitivity to light. Such films typically have an ISO of 50 or less.

slow lens. A lens with a small maximum aperture, such as f/8.

slow shutter sync. *See* slow sync *or* night portrait mode.

slow sync. Firing the flash in conjunction with a slow shutter speed. The result can be interesting motion blur caused by the ambient light or increased illumination of the background scene. *See also* night portrait mode.

LEFT—AUTOMATIC FLASH. **RIGHT**—SLOW-SYNCH FLASH.

SLR. *See* single-lens reflex.

small computer systems interface (SCSI). Pronounced "scuzzy," a type of computer interface used to attach certain types of peripherals such as hard drives and scanners to a personal computer.

small format camera. A camera designed to use 35mm or smaller roll film.

small format sensor. On digital cameras, a sensor that is smaller than a 35mm film frame. Lenses paired with such a sensor function as longer lenses. Also called a subframe sensor. *See also* focal length multiplier *and* 35mm equivalent focal length. *Contrast with* full frame.

small hole film. *See* 620 film.

SmartDisk. Manufacturer of hard drives, flash drives, film scanners, media readers, PCI cards, and other peripherals and accessories.

SmartMedia. A type of flash memory card used to store photos in digital cameras. Originally called an SSFDC (solid state floppy disc card) by Toshiba, which envisioned it eventually replacing the floppy disk for computer storage.

SMC. *See* super multicoated.

Smith, W. Eugene. *See* appendix 1.

smooth. To average pixels with their neighbors.

smoothing filter. Used to reduce the crosshatch noise pattern that can be created by CCD sensors.

SMPT. *See* simple mail transfer protocol.

SMPTE (Society of Motion Picture and Television Engineers). A group that determines and lists standards for equipment, techniques, and imaging software.

SMPTE-240M. A large-gamut RGB color space for high-definition television.

SMPTE-c. A small-gamut RGB color space for North American NTSC television.

smudge tool. In image-editing programs, a brush-like tool used to blur or smear an image.

S/N. *See* signal-to-noise ratio.

snapshot. An informal photograph, particularly one taken by an amateur photographer with a point-and-shoot camera.

Snell's law. A mathematical relationship describing the extent to which light is refracted by a medium.

snip test. Processing a few frames of film to determine the optimal development time. Also called a clip test.

snoot. A cone-shaped or cylindrical light modifier used to direct a narrow beam of light over a small area.

snow mode. A scene mode in which the camera helps compensate for very bright light to produce correct exposures. It also adjusts the white balance as needed. Similar to the beach mode.

LEFT—AUTOMATIC MODE. **RIGHT**—SNOW MODE.

SNR. *See* signal-to-noise ratio.

Social Documentary. *See* appendix 2.

Society of Motion Picture and Television Engineers. *See* SMPTE.

sodium acetate. Chemical used as a pH modifier in toning baths.

sodium bichromate. Chemical used in intensifiers, toners, and bleaches.

sodium bisulfite. Chemical used in fixing baths as an acidifying agent.

sodium carbonate. Alkaline accelerator used in many general purpose and print developers.

sodium chloride. Chemical used in bleaches and reducers.

sodium citrate. Chemical used as a preservative in albumen papers.

sodium hydrosulfite. Chemical used as a fogging agent in reversal processing.

sodium hydroxide. Alkaline accelerator used with hydroquinone to produce high-contrast developers.

sodium metabisulfite. Chemical used as an acidifying agent in acid fixing baths.

sodium sulfide. Chemical used in sepia toning.

sodium sulfite. Chemical commonly used as a preservative in developing solutions.

sodium thiocyanate. Alternative to potassium thiocyanate. Used as a silver solvent.

sodium thiosulfate. Chemical fixer bath also known as hypo.

Softar. An image-softening lens most commonly used in portrait photography.

softbox. A box or enclosure with a front panel made of a light-diffusing material, inside of which an electronic flash head

is mounted. Softboxes enlarge the light-emitting surface of a light source to produce softer shadows.

soft developer. A paper developer that can be used alone or in combination with other developers to achieve more subtle contrast control.

soft focus. A diffused but correctly focused image. This can be achieved in-camera, during the enlarging stage, or in post-production using image-editing programs.

soft-focus filter. A filter that contains tiny random or patterned elements that cause spherical aberrations and produce a soft-focus effect.

LEFT—ORIGINAL IMAGE. **RIGHT**—IMAGE TAKEN WITH A SOFT-FOCUS FILTER.

soft-focus lens. A lens that is uncorrected for spherical aberrations and used to produce a soft-focus effect.

soft light. Illumination in which the transition from highlight to shadow occurs over a broad area. Such light originates from a source that is large relative to the subject. *Contrast with* hard light.

soft negative. A negative that is overexposed and underdeveloped.

soft paper. *See* paper grade.

soft proof. Reviewing a digital image on a monitor instead of generating a hard copy. Also called output simulation.

software. Instructions that tell a computer what to do. This can take the form of anything from an operating system to an image-editing application.

solarization. An effect caused by extreme overexposure. This yields to a reversal or partial reversal of tones. Often a line, called

LEFT—ORIGINAL IMAGE. **RIGHT**—DIGITALLY SOLARIZED IMAGE.

a mackie line, appears around the reversed areas. A similar effect can be produced using image-editing software. *Contrast with* Sabattier effect.

solid angle. A three-dimensional analog of an angle, such as that formed by two planes meeting at a point. It is measured in steradians.

solid optics. A lens design in which the elements are assembled with no air spaces between them.

solid state. Hardware devices, such as computer memory cards, that are based on transistors. Solid state memory cards are less vulnerable to shock than hard drives because they contain no moving parts.

solid state floppy disc card (SSFDC). *See* SmartMedia.

solubility. The ease with which a solid will mix with water to produce a chemical solution.

solution. A liquid containing a dissolved substance.

Sonnar lenses. Lenses, introduced in 1932 by Bertele, featuring a thick negative meniscus lens and compact design.

sonography. *See* ultrasonic image.

Sony. Manufacturer of cameras, lenses, and other imaging equipment.

source image. A photograph from which elements are copied to a destination image.

source profile. In color management, the profile of the originating device in a color conversion. For example, when an image is scanned and passed to an inkjet printer, the scanner provides the source profile.

spacing bracket. A device used to position the camera at the right distance from the subject in close-up work.

spam. Colloquial term for unsolicited e-mail messages, particularly those that are sent to a large number of people. Most Internet service providers have regulations against sending such messages.

spatial frequency. The variation in brightness between adjacent (or proximate) pixels in a digital image.

spatial resolution. (1) The number of pixels horizontally and vertically in a digital image. (2) A measure of the discernible detail in an image.

SPC. *See* silicon photo cell.

SPD. *See* silicon photo diode.

special-effect filter. A filter designed to distort the shape or color of the subject, or to produce multiple images of the subject in a single frame.

Specifications Web Offset Publications. *See* SWOP.

speckling. Isolated light pixels in dark image areas, sometimes caused by incorrect readings or noise in the scanning device.

spectral curve. *See* spectral data.

spectral data. A way of precisely defining color by measuring the amount of each wavelength that a color sample reflects or transmits. This information is typically graphed on a curve. *See also* spectrophotometer.

spectral power distribution. The amount of light a source produces at each wavelength.

spectral sensitivity. The relative response of a photographic emulsion to each of the colors of the spectrum.

spectrograph. Instrument for forming (and recording on film) the spectrum of a light source.

spectrophotometer. A device used to measure the amount of light that a color sample reflects or transmits at each wavelength. This produces spectral data.

spectrum. (1) A band of colors, as seen in a rainbow, produced by separation of the components of light by their different degrees of refraction according to wavelength. (2) The entire range of wavelengths of electromagnetic radiation. (3) An image showing types of electromagnetic radiation arranged by wavelength. *See also* electromagnetic spectrum.

specular highlight. A bright reflection caused by light reflecting off a shiny surface. Also called a specular reflection.

specular light. *See* hard light.

specular reflection. *See* specular highlight.

speculation. Shooting photographs in the hope that someone will buy or license them. Commonly called shooting "on spec."

speed. (1) The sensitivity of a photographic emulsion or digital image sensor to light. This is denoted by an ISO number. (2) The maximum aperture of a lens. (3) The duration a camera's shutter remains open.

speed filter. A special-effect filter that creates streaked, blurry lines that can make a stationary subject appear to be moving.

Speed Graphic. A press camera manufactured by Graflex and popular from the 1930s to 1950s.

speedlight. A flash unit that uses xenon-filled gas bulbs. The name derives from their very brief light-output duration. *See also* Speedlight *and* Speedlite.

Speedlight. Nikon's trademark for their line of dedicated electronic flash units.

Speedlite. Canon's trademark for their line of dedicated electronic flash units.

speed ring. A rigid plastic or metal device used to provide a quick connection between a photographic light source and a light modifier (such as a softbox).

spherical aberration. A zonal lens fault that causes loss of image definition at peripheral areas. Its effects are reduced by stopping down the lens.

spherical micro-integrated lens. A small lens used to collect light for CCD elements.

SPI. *See* samples per inch.

spike. Sudden, short rise in the voltage of an electrical supply.

spike filter. Optical device designed to allow the passage of only a very narrow band of wavelengths.

spike oil. *See* lavender oil.

spill. Uncontrolled light that illuminates part of a scene or subject in unwanted ways.

spill kill. An attachment on a studio strobe that prevents light from falling on areas where it is not wanted.

spill rings. Concentric metal bands that prevent spill from a light source.

spindle. (1) The rod or cylinder that forms the main axis of a rotating device. (2) A lens polishing machine.

spindle speed. The rotation rate of the platters in a hard disk.

spiral reel. A spool used for developing roll film. These contain rails on the end flanges to keep the film surfaces a fixed distance apart, allowing the chemicals to reach the inner surfaces of the film.

spirit level. A level consisting of a small tube partially filled with liquid and a bubble of air inside. Lining the bubble up with markings on the outside of the tube ensures that the camera is level.

spirit photography. In the early 19th century, a type of photography in which images were double exposed to create the impression of a ghostlike figure in the frame.

split-diopter lens. A supplementary half-lens used in front of the prime lens to enable two subjects at different distances to be rendered in sharp focus. Also called a split-field filter or split lens.

split-field filter. *See* split-diopter lens.

split-field focus. *See* split-image focus.

split-image focus. A manual focusing aid that appears as a circle in the viewfinder. When the two halves of the image are aligned, the image is properly focused. Synonymous with split-field focus.

split lens. *See* split-diopter lens.

split tone. In the darkroom, a process in which a print is first processed in a color toner (such as sepia), then in an archival toner (such as selenium). This creates better tonal separation and an enhanced sense of depth. In digital photography, the same effect can be achieved in postproduction using an image-editing program. Also called a bicolor print.

sponge tool. In image-editing programs, a tool used to saturate or desaturate areas of an image.

spool. A rod with flanges on each end around which film is wound.

SPOOL USED TO WIND 120 FILM IN A TLR CAMERA.

sports finder. (1) A simple, open viewfinder (used principally on film cameras) that extends up from the camera body so the photographer can focus on the subject with one eye and keep the other eye open to monitor the whole scene. Useful in sports photography and photojournalism. (2) On some digital cameras, a viewfinder that allows the photographer to see areas outside the image-sensor coverage range. The peripheral range is typically marked to distinguish it from the active picture-taking area.

sports mode. A camera setting that employs faster shutter speeds to help freeze action when photographing moving subjects. Called the action or kids-and-pets mode on some cameras.

SPORTS MODE ICON FOUND ON MANY CAMERAS.

sports photography. A type of photography devoted to capturing images of athletes and athletic competition. These images may include action shots, portraits of individual athletes (or other related subjects, such as coaches), and team photographs.

spot color. A specific color in a design, usually printed with a specific matching ink rather than through process CMYK color. *See also* Pantone colors.

spot color channel. Component grayscale image in a digital file that specifies additional plates for printing with spot color inks.

spot healing brush tool. In Photoshop, a tool that allows you to eliminate small blemishes by clicking on them. The tool then automatically samples pixels from adjacent areas and blends them to cover the flaw. *See also* healing brush tool.

spotlight. An artificial light source that employs a Fresnel lens, reflector, and focusing system to produce a strong beam of light with a controllable width.

spot meter. A narrow-angle light meter used to take accurate reflected-light readings of a small part of a subject.

spotting. A method of removing blemishes from negatives and prints using a brush and dye or pencil. This term is carried over into digital imaging, where the same procedures are accomplished using an image-editing program.

SPOT METERING MODE ICON FOUND ON MANY CAMERAS.

spotting scope. A small telescope, often used for birdwatching and amateur astronomy. With the appropriate adapter rings, these can frequently be converted for use on camera bodies as telephoto lenses.

spray adhesive. An aerosol glue often used to mount prints.

spreader. *See* surfactant.

spread function. The amount to which light spreads out past a theoretical point, such as its point of impact upon a photographic emulsion.

sprocket. A projecting tooth on a cogwheel, such as those used in many cameras to advance film.

sprocket holes. The perforations on the edges of roll film that engage with the teeth of the film transport mechanism. Also called perforations.

SPROCKET HOLES.

sprocket hole counter. A device used to count sprocket holes in film, allowing the camera to position the film correctly.

sputtering. *See* vacuum deposition.

spy camera. A tiny camera, usually with a film format smaller than 35mm, designed for taking covert photographs. Minox cameras are the most famous of this category. Also called a subminiature camera.

SQF. *See* subjective quality factor.

square pixels. Pixels with a square aspect ratio. Desirable for imaging applications and a feature of most digital cameras. *Contrast with* rectangular pixels.

squeegee. A tool with rubber blades or rollers that is used to squeeze water out of wet prints. Also called a brayer or roller squeegee.

S-RAM. *See* static RAM.

SRF. A proprietary raw file format used by Sony digital cameras.

sRGB. A color space developed by Microsoft and Hewlett-Packard. Commonly used by image-editing programs and digital cameras. It has a much smaller color gamut than many other color spaces.

SSFDC. *See* Smart Media.

stability. (1) The ability of a photographic medium (or other recording medium, such as CDs) to maintain a recorded image over time. (2) The ability of a medium to avoid changes in shape over time. For example, if a film base shrinks more rapidly than the emulsion layer, the two are likely to separate. This is also called dimensional stability.

stabilization. (1) A process that reduces degradation in a material. (2) Reducing or counteracting camera movement to minimize image degradation.

stabilizer. A solution used in color processing to make the dyes more stable and fade resistant.

stacking filters. Attaching more than one filter to the end of a lens. This increases the risk of vignetting and can degrade the image quality.

stain. A discolored area of a print, usually caused by contaminated solutions or insufficient fixing, washing, or agitation.

staining developer. A developer in which the oxidation products give extra image density by staining the gelatin.

staircasing. *See* aliasing.

stair-stepping. *See* aliasing.

stamp tool. *See* clone stamp tool *or* rubber stamp tool.

stand. A general term for a device used to support a light or camera.

standard illuminant. *See* CIE standard illuminants, illuminant A (CIE), illuminant C (CIE), *and* illuminants D (CIE).

standard lens. *See* normal lens.

standard observer. *See* CIE standard observer.

standards. The movable front (lens) and back (film) panels of most view and monorail cameras.

stand camera. A large-format camera that is usually mounted on a stand.

stand-in. Someone who temporarily takes the place of the subject, often during the process of setting up the lighting.

star filter. A filter with engraved crosshatch markings that turn bright highlights into starburst shapes. Also called a cross-screen filter.

LEFT—ORIGINAL IMAGE. **RIGHT**—IMAGE TAKEN WITH STAR FILTER.

start bit. A single data bit used to indicate the beginning of a transmission.

start-up disk. A disk containing an operating system used to start the computer. Also called the system disk.

start-up time. The time that elapses between when a device is turned on and when it is ready for use. Also called warm-up time.

static marks. Jagged marks on negatives that result from static electricity generating light sparks that register on the film.

static memory. The retention of data in semiconductor memory without refreshing.

static RAM (S-RAM). A type of RAM found in onboard memory units, some printers, and PCMCIA cards.

steganography. The process of embedding a message in an image file in such a way that it does not alter the function or appearance of the file.

Steichen, Edward Jean. *See* appendix 1.

stepper motor. In scanners, the device used to move the sensor in small increments.

step ring. A ring used that is used to adapt a filter to a lens when the two have different filter thread diameters. Step-up rings allow a larger filter to be used on a smaller lens. Step-down rings allow a smaller filter to be used on a larger lens. Also called a filter adapter.

step wedge. A printed series of density increases in regular steps from transparent to opaque. Used to make exposure tests when enlarging.

steradian. The unit of measurement for solid angles.

stereogram. (1) A pair of images that, when viewed simultaneously using a stereoscope, create a three-dimensional appearance. Also called a stereograph. (2) A computer-generated image with a repeating pattern. By decoupling (slightly crossing) their eyes, viewers can trick their brains into seeing a three-dimensional image that is otherwise invisible. (3) *See* anaglyph.

STEREOGRAM.

stereograph. *See* stereogram.

stereoscope. A viewing device that accepts stereograms.

stereoscopic camera. A camera designed to take a pair of images of the same subject from viewpoints that are separated by the same distance as the distance between the eyes.

stereoscopy. Creating a three-dimensional effect using a pair of images taken from slightly different viewpoints. These are viewed through a stereoscope.

Stieglitz, Alfred. *See* appendix 1.

still life. An image featuring an inanimate subject or subjects. Still-life subjects are typically arranged to showcase their form and shape.

still photography. Photography that yields individual images.

stitching. Assembling a series of separate photographs to produce a single composite image, typically a panorama. An image-editing program is used to smooth the transition between the images.

STILL LIFE. IMAGE BY BARBARA A. LYNCH-JOHNT.

stitch mode. *See* panoramic mode.

stock. (1) Unexposed photographic materials such as film or paper. (2) The type of paper used in printing (such as card stock). (3) A type of camera support. *See also* shoulder stock.

stock photograph. A preexisting photograph that can be purchased for use instead of having a photograph specifically made.

stock photography agency. A company that maintains a large library of stock photographs, which are then licensed out to clients.

stock solution. Processing chemicals stored in a concentrated state and diluted just before use.

stop. (1) The effective diameter of a lens opening. (2) A unit of change relative to aperture or shutter speed (with a one-unit change either halving or doubling the light entering the camera during the course of the exposure). (3) *See* stop bath.

stop bath. An acid rinse used to stop development by neutralizing unwanted developer when processing black & white film or paper. This prevents carryover of one chemical into another during development.

stop bit. A single data bit used to indicate the end of a transmission.

stop down. Reducing the size of the lens aperture to reduce the amount of light passing into the camera and/or increase the depth of field.

stop-down metering. TTL metering in which the light is measured at the picture-taking aperture.

storage card. *See* memory card.

straight line. The linear middle portion of a characteristic curve.

Straight Photography. *See* appendix 2.

Strand, Paul. *See* appendix 1.

streak noise. Vertical noise in a scan that appears as light streaks.

streaming. Delivering audio or visual files in real time over the Internet.

street photography. Candid photography taken in public settings as people go about their everyday business.

stress marks. Black lines on a photographic emulsion caused by friction or pressure.

stringer. Colloquial term for a freelance photographer who gets occasional assignments from a publication or agency but is not a regular member of the staff. Stringers typically specialize in covering certain geographical regions or subject matters.

strip bank. *See* strip light.

strip blocker. Rectangular strips of light-blocking material that can be attached to the front of a softbox (in various combinations) to adjust the size or shape of the light output.

strip box. *See* strip light.

strip light. A long, narrow softbox. Also called a strip bank or strip box.

strobe. A general term for electronic flash. Commonly used to describe the type of flash units used in studio photography. The term can also be applied to a device that produces regular bursts of flashing light.

STROBE. PHOTO COURTESY OF ELINCHROM.

strobe duration. *See* flash duration.

stroboscopic flash. A repeating flash mode available on some flashguns. Under certain lighting conditions, this can produce multiple exposures in a single frame. This can be used to capture motion as a progressive series of superimposed still images.

stroke. In graphics applications, a line applied to the periphery of a selection or object.

strong. (1) A photographic image that elicits a positive reaction from viewers due to the choice of subject matter, creative approach, and/or technical superiority. (2) A composition that is particularly effective.

strontium halides. Chemicals used in the creation of collodion emulsions.

Stryker, Roy Emerson. *See* appendix 1.

studio. A facility equipped for the purposes of taking photographs. Also used to describe the images created in such a facility or the equipment used therein (e.g., studio lights).

studio camera. A large-format (12x15-inch) camera on a wheeled stand.

studio flash. Large electronic flash units for use in controlled studio situations. These are of two basic types: monolights and power-pack units.

studio light. Artificial light source for use in a studio.

studio pedestal. *See* studio stand.

studio stand. A large, sturdy device used to support and stabilize a camera. The size and weight of these devices limits their use to studio settings. Also called a studio pedestal.

style. *See* personal style.

stylus. A tool that is used on a graphics tablet as a drawing instrument or in lieu of a mouse.

sub-band compression. *See* wavelet compression.

subbing layer. In film, an intermediate adhesive layer designed to assist in adhering the emulsion to the plastic support. Also called the isolation layer.

subframe sensor. *See* small format sensor.

subject. A person or thing that is the primary point of interest in a photograph.

subject distance. The distance between the front of the lens and the subject. Also called object distance.

subjective photography. An interpretive image in which the photographer attempts to communicate his or her feelings about the subject.

subjective quality factor (SQF). A lens rating system.

subject luminance range. The ratio in a subject of the highest luminance to the lowest. If it is too great for the exposure latitude of the film or sensor used to record the image, some parts of the image will be over- or underexposed.

subminiature camera. Camera using a film format smaller than 35mm. *See also* spy camera.

subpixel. One of the three components (red, green, or blue) that make up each pixel in a color LCD screen.

subsampling. Also called nearest neighbor resampling, this is a type of interpolation in which the value of the new pixel is an average of the neighboring pixels. This significantly reduces the conversion time compared with downsampling but results in image tones that are less smooth and continuous.

substantive film. A film in which the color couplers are contained within the emulsion.

substrate. The support for a film emulsion, printed image, or Polaroid transfer. Refers to the material beneath the image layer.

subtractive colors. *See* primary colors.

subtractive lighting. Technique used to produce a desired lighting effect on a subject by withholding unwanted light using blockers, gobos, scrims, and other devices.

subtractive primary colors. *See* primary colors.

subtractive synthesis. A combination color system used in color photography materials. The complementary colors of yellow, magenta, and cyan are formed to produce a color image.

successive color contrast. A trick of the human eye by which the impression of a color is influenced by an immediately preceding color.

sulfide toning. Conversion of a black metallic silver image into a brown dye image. More commonly called sepia toning.

sulfuric acid. A corrosive chemical used in reducers.

sunlight. Light from the sun.

sunny 16 rule. A simple exposure guideline stating that, in bright daylight and with the aperture set at f/16, a correct exposure can be made by setting the shutter speed to the nearest inverse of the ISO (for example, at ISO 100 the shutter would be set to $\frac{1}{125}$ second).

Sunpak. Manufacturer of electronic flash units, photographic filters, and other photographic equipment.

sunset filter. A pink-, orange-, or yellow-tinted filter that warms the colors in an image, making it look as though it was taken at sunset.

LEFT—ORIGINAL IMAGE. **RIGHT**—IMAGE TAKEN WITH SUNSET FILTER.

sun shade. *See* lens shade.

SuperCCD. A proprietary CCD from Fujifilm that employs octagonal, rather than rectangular, pixels. This yields a higher vertical and horizontal resolution than that achieved by traditional sensors with equivalent pixel counts. *See also* charge-coupled device.

supercoat. *See* overcoat.

superimpose. To place one element over another, typically so that both are at least partially evident.

super multicoated (SMC). A seven-layer lens and filter coating process developed by Pentax.

Superrealism. *See* appendix 2.

super video graphics array (SVGA). Term for a computer display of 800x600 pixels. Most display systems made between the late 1990s and early 2000s are classified as SVGA. *See also* video graphics array (VGA).

supplementary lens. An additional lens element used in front of the standard camera lens to provide a new focal length. Most commonly used to allow for close focusing.

support. A glass, paper, plastic, or other base on which the image layers of photographic film or prints are coated. Also called the base.

surface. The upper layer of photographic paper, specifically when considering its texture and reflective characteristics. *See also* matte, pearl, *and* glossy.

surface development. A development process in which the image forms primarily on the surface of the emulsion and then penetrates deeper.

surfactant. An agent used to lower the surface tension of a liquid. Also called a spreader.

surge. A sudden, large rise in the voltage of an electrical supply.

surge marks. Streaks on the image from each of the sprocket holes of 35mm film caused by excessive agitation.

surreal. Derived from the Surrealist movement, a term generically applied to images that seem to defy reason.

Surrealism. *See* appendix 2.

surveillance photography. A type of photography in which the objective is to document the precise activities of a person or group, or the activities occurring in a specific area.

suspension. A mixture in which particles are dispersed throughout a fluid (such as silver halide grains in gelatin).

Sutton, Thomas. *See* appendix 1.

Svema. Manufacturer of films and printing paper.

SVG. *See* scalable vector graphics.

SVGA. *See* super video graphics array.

swatch. In digital imaging, a small sample showing a color or texture.

sweep. A background created using seamless paper.

sweet oil. *See* olive oil.

sweet spot. Colloquial term for a setting or area of a lens (or other optical device) that offers the best performance in terms of image quality.

swimming pool. A large photographic light often used in automobile photography, where it is suspended overhead by attaching it to the studio ceiling or a large boom stand. Also called a fish fryer or an egg crate.

swing. The movable lens and back panels of view and monorail cameras. These allow the photographer to manipulate perspective and depth of field.

swing lens. A rotating lens typically for use on panoramic cameras.

SWOP (Specifications Web Offset Publications). Color specifications designed for everyone in a graphic arts workflow to ensure that all art received by an offset printer can be reproduced as intended.

SX-70. *See* Polaroid SX-70.

symmetry. A balanced arrangement of visual information on either side of a vertical or horizontal central division.

SYMMETRY.

sync cord. An electrical cord used to connect a flash unit to a camera. *See also* Prontor/Compur cable.

sync delay. With flashbulbs, the delay required between firing the flash and opening the shutter. This is indicated by the code letters F (fast); M (medium); MF (medium fast); and S (slow).

synchronization, flash. Opening the shutter and firing a flash at the correct moment for optimum efficiency. Also called flash sync. *See also* sync delay *and* x-sync.

synchronous dynamic random access memory (SDRAM). A type of memory that runs at higher clock speeds than traditional memory. Often used in digital cameras and other computing devices.

synchronous transmission. The process by which bits are transmitted at a fixed rate with the transmitter and receiver synchronized, eliminating the need for start/stop elements, thus providing greater efficiency.

synchro-sunlight. A slightly archaic term for combining daylight and flash to achieve a controlled lighting ratio. Now more commonly called fill flash.

sync socket. *See* PC terminal.

sync speed. The shutter speed at which the entire film frame is exposed when the flash is fired.

sync terminal. A PC terminal or connector.

synthetic primaries. In color management, primary colors that are actually mathematical constructs that describe the response of human eyes to different wavelengths of light. Color

models (like CIE LAB) that employ these primaries allow color to be specified without ambiguity—unlike color models like RGB and CMYK, which define amounts of colorants, rather than actual colors.

synthetic profile. An ICC profile created in Photoshop to assist in correcting images with severe exposure problems.

system. A collection of hardware and/or software devices designed specifically to work together.

system disk. *See* start-up disk.

system requirements. The operating system, RAM, and other characteristics that must be present on a computer in order to install a given piece of software.

T. *See* time setting.

T*. A lens coating process developed by Zeiss and renowned for its high quality. Used on Zeiss and Contax/Yashica lenses.

tablet. *See* graphics tablet.

tabletop photography. Term for photography of small objects. So called because these are usually placed on a table to elevate them for shooting.

tacking iron. A heated tool used to stick dry-mounting tissue to a print and its mounting board.

tack sharp. *See* sharp.

tag. (1) In HTML, a code denoting the position, formatting, etc., of a graphic or text element. (2) Ancillary information with a digital file that is kept separate from the main data.

tagged. A digital image containing an embedded ICC color profile. *See also* embedding.

tagged-image file format. *See* TIF or TIFF.

tagging. Synonymous with embedding.

tailboard. On field and studio cameras, a rigid or folding bed extending from the back of the camera.

take-up spool. On some cameras, a spool onto which film is wound as it is exposed. When the roll is fully exposed, the take-up spool is removed for processing and the empty spool (the spool on which the film was originally wound) becomes the take-up spool for the next loading.

taking lens. The lens on a camera that sends light to the surface of the film or to the image sensor.

Talbot. A unit of light equal to 1 lumen per second.

Talbot, William Fox. *See* appendix 1.

talbotype. *See* calotype.

Tamrac. Manufacturer best known for their camera bags.

Tamron. Manufacturer of digital camera lenses.

tank. Container that holds chemicals for processing films.

tannic acid. A powder used in the preparation of dry collodion plates.

tanning. A process in which gelatin emulsion is hardened. Used in the gum bichromate process.

Targa (TGA). An image file format, using the extension *.tga, that supports the RLE compression method.

target. In color management, an arrangement of color swatches that are compared against known values/readings in order to analyze how a device captures, displays, or prints colors.

Taupenot's process. A dry collodion-albumen process developed by Dr. J. M. Taupenot in 1855.

TC. *See* teleconverter.

TCP/IP. *See* transmission control protocol/Internet protocol.

tear sheet. A page removed from a publication either for inclusion in the photographer's portfolio or to be filed for future reference.

technical camera. Similar to a field camera, but typically constructed of metal. *See also* field camera.

telecentric. Device designed to ensure that only parallel rays of light reach a sensor, increasing the depth of field and reducing parallax.

teleconverter (TC). An accessory that fits between the lens and the camera body to extend the focal length of the lens.

tele lens. *See* telephoto lens.

telephoto effect. Visual compression that occurs when using a telephoto lens to photograph a scene in which all the elements are at a significant distance from the camera. This makes the elements in the scene appear closer together than they actually are.

telephoto lens. A lens with a focal length longer than the diagonal of the film fame or image sensor. Telephoto lenses make a subject appear larger on film than a normal lens at the same camera-to-subject distance. They also have a shallower depth of field than wide-angle lenses. Also referred to as a long lens or a tele lens.

TELEPHOTO LENS.

temperature. (1) A measure of the energy or heat present in a substance. (2) *See* color temperature.

tempered glass. Glass that is rapidly cooled to give it higher-than-normal tensile strength.

tempering bath. A tank filled with water maintained at the correct temperature for processing. Used to house tanks, drums, trays, and processing solutions.

template. A dummy that acts as a model for the layout of another design, such as a wedding-album page or promotional brochure.

tent. *See* light tent.

terabyte. One trillion bytes.

terminator. A resistor that tells the computer where the end of a SCSI chain is. Terminators filter out electrical noise caused by multiple cables and devices.

tertiary color. A color created by mixing two other colors.

Tessar lens. Created by Dr. Paul Rudolph of Carl Zeiss in 1902, a four-element lens design known for its excellent optical qualities and lightweight design.

test chart. A chart containing fine lines, color blocks, shades of gray, etc., used to test lenses and other optical equipment. *See also* USAF 1951 resolution test chart.

test roll. A roll of film from a shoot that is processed to determine the optimal development time for the remaining rolls. *Contrast with* snip test.

test strip. In the traditional darkroom, a piece of printing paper on which a series of test exposures are made at varying durations in order to determine the ideal base exposure time.

text file. A file containing only letters, digits, and symbols.

text tool. In image-editing programs, a tool used to apply type to an image.

texture. The surface characteristics of an object.

texture screen. In the darkroom, a transparent medium printed with a fine background pattern that is exposed onto printing paper, along with an image, to produce a textured effect.

TFT. *See* thin film transistor.

TGA. *See* Targa.

thermal dye-sublimation printer. *See* dye-sublimation printer.

thermal imaging. Cameras capable of detecting and imaging the infrared radiation associated with heat. Note that infrared photography using infrared-sensitive film is not the same thing as thermal imaging.

thermal wax transfer printer. A printer in which wax sheets are melted onto the paper surface to produce an image.

thermo autochrome printer. Printer that uses paper with three heat-sensitive pigment layers (cyan, magenta, and yellow). Using ultraviolet light, the printer activates and fixes the pigments.

thermometer. In the darkroom, a device used to ensure the correct temperature of the solutions used for developing film and prints.

thick negative. A high-density negative. These are usually either overexposed or overdeveloped and can be difficult to print because of their high contrast.

thin film transistor (TFT). A type of LCD panel that yields fast and bright images. TFT panels are frequently used for digital camera viewfinder/camera back display systems.

TEST STRIP.

thin negative. A low-density negative. These are usually either underexposed or underdeveloped and can be difficult to print because of their low contrast.

third party. A manufacturer of devices designed for use with another manufacturer's camera system. For example, Tamron, Tokina, and Sigma all manufacture third-party lenses designed to work with cameras by Nikon, Canon, Minolta, and Pentax.

thirty-five millimeter. *See* 35mm.

thousands of colors. *See* 16-bit.

thread. A helical ridge on the outside of a screw or inside of a cylinder that allows two parts to be screwed together. *See also* thread pitch.

threaded lens. An accessory lens, usually used to alter the focal length of a lens or add close-focusing abilities, that attaches to the camera by means of the filter threads on the lens.

thread pitch. The distance in millimeters between one thread and another. This affects the compatibility of screw-on filters and screw-mount lenses.

three-chip camera. A camera that employs a beam splitter to separate the image into red, green, and blue components, which are directed to corresponding image sensors.

three-dimensional. Having or appearing to have length, breadth, and depth.

three-pass camera. *See* scanning back.

three-quarter-length. In portrait photography, an image that shows the subject from their head down to somewhere below the waist—usually midthigh or midcalf.

three-quarter tones. Tones between the shadow and midtones in an image.

three-quarter view. In portrait photography, a view of the face where the head is turned so that the far ear disappears from the view of the camera but the tip of the nose does not break the line of the cheek.

three-way head. A mounting head used on tripods and monopods that permits the camera's orientation to be adjusted on any of three axes.

THREE-WAY HEAD. PHOTO COURTESY OF MANFROTTO.

threshold. The point at which an action begins or changes. In scanning line art, the threshold setting determines which pixels are converted to black and which will become white. In applying the unsharp mask filter in Photoshop, the threshold determines how large a tonal contrast must be before sharpening will be applied.

threshold exposure. The exposure level at which a recorded image is visible on a piece of photosensitive material.

throughput. The rate at which a device can process material.

through the lens. *See* TTL flash *and* TTL metering.

thumb drive. *See* jump drive.

thumbnail. A small, low-resolution version of a larger image file that is used for quick identification.

thumbnail index. (1) Another term for a contact sheet, usually one that is produced digitally. (2) On digital cameras, a playback option used to quickly review the images on a storage card.

thyristor. An electronic component used to control electronic flash tubes.

TIF or **TIFF (tagged-image file format).** A widely used raster image file format using an extension of *.tif or *.tiff. The TIFF format supports LZW compression, but images can also be saved without compression, making this a popular format for archiving images.

Tiffen. Manufacturer of filters, accessory lenses, software, and other products for photography.

tight. An image that is either composed or cropped so that very little is included in the frame other than the subject of the image.

tiles. *See* tiling.

tiling. Reproducing a large image by breaking it into smaller parts, called tiles.

tilt. On large-format cameras, a feature that allows you to tilt the lens or film standard to adjust the depth of field.

tilt/shift lens (TS). A lens capable of both tilt and shift movements.

time exposure. An exposure in which the shutter stays open for longer than can be set using the camera's fixed shutter speeds. This is accomplished using the T (time) or B (bulb) setting.

time lag. The time between when an action is initiated and when it actually occurs.

time-lapse photography. Capturing a series of images at preset intervals.

timer. A clock used to control the duration of exposure or processing in the darkroom.

time-scale sensitometer. *See* sensitometer.

time (T) setting. A shutter speed setting used for time exposures. The shutter opens when the release is pressed and closes when it is pressed again. Now largely superceded by the B (bulb) setting.

TIMER.

time–temperature development. A type of development in which a precise time and temperature are used because they are known to produce the desired contrast or density.

time value. *See* Tv.

tint. (1) Various even tones of a solid color, usually expressed in percentages. Most commonly used when referring to pale colors. (2) A slight coloration, usually blue or cream, in the base of some black & white printing papers. (3) The application of colored dyes or paints to an image to create or enhance color. *See also* handcoloring.

tin-type process. A darkroom process used to create direct positive images with dark enameled metal plates as a base. Also known as the ferrotype or melainotype process.

TLR. *See* twin-lens reflex.

T mount. A screw-mount lens system developed by Tamron for use with older manual-focus lenses and still commonly seen today on telescope-to-camera adapters.

t-number. *See* t-stop.

toe. The area of the characteristic curve that corresponds to the low density portion of the image.

token ring. A method of linking computers in which data is sent from one computer to the next in a fixed sequence.

tolerance. The acceptable level of error/inaccuracy. With some tools in Photoshop, the tolerance setting determines how similar two pixels must be to be affected by the tool. At a high tolerance setting, many pixels will be affected; at a low setting, few pixels will be affected.

tomography. Radiographic technique used in medical photography to show cross sections of a solid object.

tonal compression. A reduction in the tonal range of a photographic image to match the available tonal range of the printing process used to reproduce it.

tonal curve. An adjustment function available in Photoshop and on certain scanners. By changing the bend of a line representing the tones in the image, you can control the color and contrast of the photo.

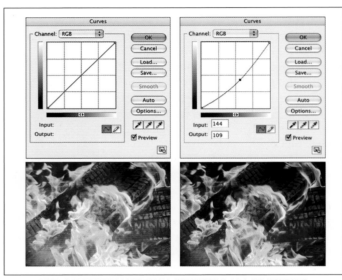

LEFT—IN PHOTOSHOP, THE TONAL CURVE BEGINS AS A STRAIGHT LINE. **RIGHT**—BENDING IT CHANGES THE TONES IN THE IMAGE.

tonal merge. Details that record as shadows and become indistinguishable.

tonal range. *See* dynamic range.

tonal reproduction. A measure of the tones in a print or scan in comparison to those in the source image.

tonal scale. Term used to describe the range of tones in a black & white image.

tone. (1) The lightness or darkness of a color. Also called the tone value. (2) To apply toner to a print.

tone line process. A technique used to produce a photographic image that looks like a pen-and-ink drawing.

toner. (1) In the darkroom, a chemical used to alter the color or archival permanence of a print. This may be sold in a ready-to-use liquid form or supplied as a dry chemical that needs to be mixed with water prior to use. (2) Plastic powder, either black or colored, that is fused onto the paper by heat in order to create the prints produced by photocopiers or laser printers.

tone separation. Reducing the tonal range of a photograph to a small number of tones. Also referred to as posterization.

tone value. *See* tone.

tongs. An instrument with two moveable arms that are joined at one end. Often used to manipulate prints or sheet film being processed in a tray.

tongue. The leader on a roll of film that is shaped to facilitate loading the film.

toning. Soaking a print in chemical liquids to alter its color or increase its archival permanence.

tool. In image-editing programs, a virtual device used to accomplish a given task. This is usually activated by clicking on an icon, then implemented by the use of cursor movements.

tool bar. *See* tool box.

tool box. In Photoshop, a floating palette that contains the tools needed to select, edit, paint, and view areas of an image. Also called the tool bar.

tooth. (1) Term used to describe the slightly rough texture of a surface that is prepared to hold an emulsion or traditional retouching materials that will not adhere to an overly smooth or glossy surface. (2) A projection from a gear that allows it to engage with another gear.

top deck. The flat top section on an SLR camera that commonly houses camera controls, readouts, etc.

top-deck LCD. *See* control panel.

top lighting. Lighting that originates from directly above the subject.

toric lens. *See* cylindrical lens.

Toshiba. Manufacturer of digital cameras and other consumer electronics.

total darkness. The absolute absence of light. This is the condition required for handling unexposed or undeveloped film.

total ink limit. Establishing the maximum amount of ink (per channel) that a printer will apply. This helps avoid puddling, sticky prints, or prints that are too dense.

toy camera. A cheap camera, usually made almost entirely of plastic. Their low-quality lenses tend to produce vignetting, and frequent light leaks often result in interesting effects. As a result, many fine-art photographers enjoy using them. The Diana and Holga cameras are probably the best-known toy cameras.

THE HOLGA. A WELL-KNOWN EXAMPLE OF THE TOY CAMERA.

TOYO. A color system used mostly in Japan.

track. (1) To move a camera with its support in order to follow a subject in motion (as opposed to panning, in which the camera is rotated around a central point). (2) Row of cogs or teeth on a rack-focusing system. (3) Control of alignment (as when film moves through a camera).

trackball. An alternative to a mouse for controlling the cursor on a computer screen.

trademark. (1) A symbol, word, or words legally registered (or established by use) as representing a company or product. (2) A distinctive characteristic.

TRACKBALL.

traditionally licensed images. Exclusive or nonexclusive permission to use an image for a specific purpose.

tranny or **trannie.** Colloquialism for a transparency.

transfer function. The capability of a device to transmit frequencies. *See also* modulation transfer function.

transfer processes. Methods of transplanting a photographic image from one surface to another. *See also* Polaroid transfer *and* ceramic process.

transfer rate. The rate at which data can be moved from one device to another, usually expressed as kilobits per second (Kbps) or bytes per second (Bps).

translucent. A substance that partially blocks the passage of light or scatters light heavily.

transmission. The passage of light through a transparent or translucent material.

transmission factor. *See* transmittance.

transmission control protocol/Internet protocol (TCP/IP). The primary wide-area network (WAN) used on the Internet. This includes standards for how computers connect and communicate.

transmissive artwork. Transparent artwork that is viewed by light shining through it (rather than reflected off it). *Contrast with* reflective artwork.

transmittance. The amount of light that passes through a lens without being either absorbed by the glass or being reflected by glass/air surfaces. Also called transmission factor.

transmitted light. Light that passes through a medium (such as a slide). *Contrast with* reflected light.

transparency. A positive image on a transparent base, such as film or glass, viewed by transmitted rather than reflected light. When mounted in a metal, plastic, or cardboard mount, a transparency is called a slide.

transparency adapter. An add-on device used with a scanner to digitize transparent media.

transparency scanner. An optical input system for digitizing images from positive or negative transparency film.

transparent. A substance through which some or all wavelengths of light pass directly without scattering. Optical material, such as the glass that makes up camera lenses, must be extremely transparent.

transparent magnetic layer. An information storage layer built into APS film.

transport sprocket. Either of two wheels used to guide roll film as it is wound through the camera.

transpose. To exchange the position of two images.

transposing frame. A frame used for printing pairs of stereoscopic negatives from a two-lens camera.

travel photography. Photography devoted to capturing attractive images of unique or exotic locations, leisure activities, and cultures outside of the photographer's own.

tray. A low-sided rectangular pan used to hold the chemicals for processing photographic prints, large pieces of sheet film, etc.

tray development. Any process carried out in open trays rather than tanks or similar containers.

triangulation. A trigonometric operation for finding a position or location by means of bearings from two fixed points a known distance apart.

trichloroethane. An organic solvent once common in film cleaners but now banned in most parts of the world due to concerns about its toxicity.

trichromatic. Consisting of three colors, either the additive or subtractive primary colors.

trichrome carbro process. A method of making color prints from separation negatives.

tricolor filters. Filters in deep primary colors used to expose color prints by the additive method.

trigger. To start an operation, particularly a rapid one. Shutters and flash units, for example, are often described as being triggered.

trilinear. A device that uses three linear CCDs with red, green, and blue filters to capture color scans in a single pass.

tripack. A color photography material used to obtain three separation negatives with a single exposure.

triple extension. A camera system in which the lens-to-image distance can be extended by up to three times its focal length.

triplet lens. A lens consisting of three elements, a diverging lens sandwiched between two converging lenses.

tripod. A stand consisting of three legs, usually telescoping, and a mounting head for a camera. This is used to support and stabilize the camera. *Compare with* monopod.

tripod bush. *See* tripod mount.

tripod collar. *See* tripod mount.

tripod head. An adjustable device used to rotate and tilt the camera while it remains attached to the tripod. There are various types. *See also* ball head, pan and tilt head, *and* quick release plate.

tripod mount. (1) A threaded socket in the base of most cameras to which a screw can be attached. Also called a tripod bush. (2) On very long lenses, a device that allows the lens to be attached to a tripod for additional support that reduces vibration and relieves stress on the lens mount. Also called a tripod collar.

tripoli. *See* rottenstone.

tristimulus. The practice of specifying color based on three values, such as in the RGB, CMY, or LCH color models. *See also* CIE tristimulus value.

tristimulus data. The three values used to create a color, such as: red 100, green 50, blue 24.

TRIPOD WITH CAMERA MOUNTED.
PHOTO COURTESY OF MANFROTTO.

tritone. A printing process for books, magazines, etc., in which three identical copies of an image are printed on a page using three different colors of ink—typically black and two other colors. Photoshop and other image-editing programs allow you to set up digital image files for this type of output.

tropical chemicals. Chemicals for developing and printing black & white images in hot climates where the usual working temperatures are difficult to maintain.

trough. The hollow between two wave crests.

true color. *See* 24-bit.

true watt-seconds. *See* effective watt-seconds.

TTL flash. Through-the-lens automatic flash output control that uses a light sensor to measure the flash intensity through the lens, then shuts off the flash when the measurement indicates a correct exposure.

TTL metering. Through-the-lens metering system that uses sensors built into the camera body to measure exposure.

T setting. *See* time setting.

TS lens. *See* tilt/shift lens.

t-stop. Some lenses, primarily those used in cinematography, have apertures rated in t-stops. These indicate the actual or absolute amount of light being transmitted through the aperture diaphragm. This differs from f-stops, which indicate the aperture size relative to the focal length. *See also* f-stop.

tube. *See* extension tube.

tungsten-balanced film. Film that is designed to record color correctly under tungsten (3200K) lighting. Also called type B film or indoor film.

tungsten-halogen lamp. A version of the normal tungsten lamp that is smaller and more consistent in color temperature. Also called a quartz lamp.

tungsten lamp. Incandescent lightbulb that uses tungsten as a filament. Tungsten lamps produce light with a lower color temperature (roughly 3200K) than daylight, so cooling filters or a tungsten white-balance setting must be used to ensure correct color rendition.

TUNGSTEN STUDIO LAMP. PHOTO COURTESY OF PHOTOFLEX.

tungsten white balance. A white-balance setting that slightly cools images to compensate for the yellowish light typically produced by tungsten bulbs.

turbidity. Lack of clarity in a medium, such as a photographic emulsion or in lens glass.

Tv. On some cameras, the designation for the shutter-priority mode. Short for time value.

TWAIN. A cross-platform protocol for the exchange of information between applications and devices such as scanners and digital cameras.

twin-lens reflex (TLR). A type of camera in which the viewfinder lens and the taking lens are separate optical systems.

two-bath development. Developing negatives in two stages for better control of contrast expansion or contraction. This is

TUNGSTEN WHITE-BALANCE ICON ON MANY CAMERAS.

A TWIN-LENS REFLEX CAMERA.

particularly useful with high-contrast images, since other means of contrast contraction (N–1 or N–2 development) lead to a loss of film speed. *See* N development.

two-color photography. A simple method of color photography that analyzes the spectrum in two parts instead of three.

two-dimensional. Having or appearing to have length and breadth but not depth.

two-level image. *See* binary image.

two touch. A zoom lens with two rotating rings, one to adjust the focus and one to adjust the focal length.

type. Letters and words added to a digital image. *See also* text tool.

type A film. Color film balanced to produce accurate color renditions when the light source that illuminates the scene has a color temperature of about 3400K.

type B film. *See* tungsten-balanced film.

type C print. *See* C-type print.

type D film. An obsolete term for daylight-balanced film.

type R print. *See* R-type print.

UCS (uniform chromaticity scale). *See* chromaticity diagram.

UD. *See* ultralow-dispersion glass.

ultra-extended graphics array (UXGA). A standard monitor resolution of 1600x1200 pixels.

ultrahigh-speed camera. A camera designed to shoot over a million frames per second.

ultrahigh-speed film. An emulsion with an ISO over 1600.

ultralow-dispersion glass (UD). Lens elements made from UD glass have a lower index of refraction than regular glass and are commonly used to correct chromatic aberration.

ultrasonic image. Image formed by recording ultrasound echoes and translating them electronically into a visual image. Also known as sonography.

ultraviolet (UV) filter. A clear filter that blocks many wavelengths of ultraviolet energy without affecting light in the visible spectrum. This can reduce atmospheric haze, especially when photographing faraway subjects.

ultraviolet (UV) light. Part of the electromagnetic spectrum from about 400nm down to 1nm. UV light is invisible to the human eye but strongly affects photographic materials. *See also* ultraviolet filter.

ultrawide-angle lens. A lens with an extremely short focal length, giving an angle of coverage greater than 90 degrees.

umbra. From the Latin word for shadow, an area where light

is completely blocked from hitting the subject (i.e., the darkest part of the shadow area). *Contrast with* penumbra.

umbrella. A simple, concave light modifier used to enlarge the surface area from which the light from a flash (or other bulb

UMBRELLAS. IMAGE COURTESY OF PHOTOFLEX.

source) appears to originate. This softens the light. Photographic umbrellas are usually lined with white or silver fabric. White fabric provides the softest light; silver provides slightly more specular highlights on the subject. *See also* zebra.

uncorrected. (1) Having the aberrations that are characteristic of a simple lens. (2) An image that has not undergone any needed postproduction to adjust color imbalances, remedy tonal problems, and/or address other flaws.

uncoupled rangefinder. A rangefinder that is not interconnected with the taking lens, so the focus must be read from a scale on the rangefinder and transferred to the taking lens.

undercorrected. A lens aberration that is not fully corrected.

underdevelopment. A reduction in the degree of development, usually caused by a shortened development time or a decrease in the temperature of the solution. This results in a loss of density and a reduction in image contrast. Synonymous with underprinting.

underexposure. Allowing less than the normal amount of light to strike the image sensor, film, or printing paper. This produces a thin negative or a dark image file, print, or slide.

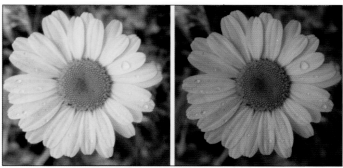

LEFT—NORMAL EXPOSURE. **LEFT**—UNDEREXPOSURE.

underprinting. *See* underdevelopment.

underwater housing. A rigid casing that encloses and protects a camera from damage during underwater photography.

UNDERWATER HOUSING. PHOTO COURTESY OF FUJIFILM.

underwater photography. Creating images of aquatic creatures and environments. *See also* underwater housing.

undo. A common software command used to cancel the most recent action.

uneven. Unwanted variations in tone, color, lighting, or other qualities.

unfocused. *See* out of focus.

uniform chromaticity scale (UCS). *See* chromaticity diagram.

uniform resource locator. *See* URL.

uniform standard (US) system. A system of stop numbers devised in 1881 by The Royal Photographic Society.

unipod. A single-legged camera support that functions in a manner similar to a tripod. Also called a monopod.

United States Air Force 1951 resolution test chart. *See* USAF 1951 resolution test chart.

universal developer. The name given to developing solutions that can be used for processing films and papers.

universal serial bus. *See* USB.

UNIX. A widely used multiuser computer platform.

unsharp mask (USM). A process by which the apparent sharpness of an image is increased by boosting edge contrast. The term comes from a conventional darkroom technique but is today more commonly applied with digital-imaging software.

LEFT—ORIGINAL IMAGE. **RIGHT**— IMAGE SHARPENED USING THE UNSHARP MASK FILTER IN PHOTOSHOP.

untagged. An image file that does not contain an embedded color profile.

upgrade. (1) To improve some aspect of a computer system. (2) The newest version of a software application, usually denoted by a version number.

upload. To send a file from your computer to another device.

uprating. *See* pushing film.

upsampling. Increasing the number of pixels in a digital image. Also called upscaling and upsizing. *See also* interpolation.

upscale. *See* upsampling *and* interpolation.

upsize. *See* upsampling *and* interpolation.

useful life. The length of time during which something can be used and expected to perform as intended.

user interface. The method by which a person gives instructions to a computer.

uranium nitrate. A chemical used in toners and developers.

uranyl chloride. A chemical added to chloride emulsions to increase contrast.

uranyl nitrate. A chemical used in toning, intensifying negatives, and producing uranium/silver gaslight papers.

URL (uniform resource locator). A standard addressing scheme used to locate or reference files on the Internet.

USAF 1951 resolution test chart. Developed by the United States Air Force, a printed chart containing a series of increasingly narrow horizontal and vertical lines. Photographing this and examining the results provides a measure of the resolving power of an optical system. This chart is poorly suited to computer analysis, and has therefore been largely supplanted by improved layouts.

USB (universal serial bus). A hot-pluggable serial communications standard used to attach peripherals to a computer.

USB CABLES. **LEFT**—A-TYPE. **RIGHT**—MINI B-TYPE.

There are two standards: USB 1.1 and USB 2.0 (which offers faster transfer rates). There are also numerous connector styles. The A-type USB connector is the most common. B-type connectors are often used to connect to larger peripheral devices. Additional smaller connectors are commonly seen in USB cables for cameras, card readers, and other portable electronic devices.

USB key. *See* jump drive.

USM. *See* unsharp mask.

US system. *See* uniform standard system.

UV. *See* ultraviolet.

UXGA. *See* ultra-extended graphics array.

vacuum back. A camera back in which a vacuum pump is used to hold the sheet film firmly against a plate during exposure. This is used primarily in special large-format cameras, such as copying devices where dimensional accuracy is critical.

vacuum board. Similar in concept to the vacuum back, an accessory used to hold printing paper flat.

vacuum deposition. Lens coating process in which the coating material is evaporated and allowed to condense onto the glass surface in near-vacuum conditions. Also known as sputtering.

vacuum easel. (1) A contact-printing frame that ensures firm contact between the film and paper by excluding air between the surfaces. (2) A device used to hold paper flat on the enlarger baseboard when enlarging.

value. (1) Level of brightness assigned to a pixel in the HSV color space. (2) Subjective visual evaluation of the brightness or tone of a color. (3) The Zone system step that corresponds to a given subject brightness. (4) *See* exposure value.

Van Der Zee, James. *See* appendix 1.

Van Dyke print. *See* brown print.

vanishing point. (1) The point at which parallel lines, viewed at an oblique angle, appear to converge in the distance. (2) In

PARALLEL LINES OF THE ROAD CONVERGE TO A VANISHING POINT.

Photoshop, a feature that lets you preserve correct perspective when editing images containing perspective planes.

vapor discharge lamp. A lamp in which illumination is produced by electrical current passing through a vapor or gas rather than through a wire filament.

vaporware. A product that is extensively promoted but never actually seems to hit the market and go on sale.

variable aperture zoom lens. A zoom lens that has different maximum apertures at different focal lengths. *Contrast with* constant aperture zoom lens.

variable contrast developer. A print developer that incorporates two separate solutions (usually one high-contrast developer and one low-contrast developer) mixed in different proportions to obtain the desired print contrast.

variable contrast filter. Filters, usually blue or yellow, used to control contrast when printing on variable contrast paper.

variable contrast (VC) paper. A photosensitive printing paper in which the contrast can be varied depending on the color of the printing light. This can be controlled using color filters. Synonymous with multigrade paper and selective contrast paper.

variable focal-length lens. *See* zoom lens.

variable focus zoom lens. Lens that requires the user to refocus after zooming. More common in older lenses than modern designs. Also called a varifocal lens.

variations. In Photoshop, a command that allows you to adjust the color, contrast, and saturation of an image by clicking on thumbnails showing alternative image renditions.

varifocal lens. *See* variable focus zoom lens.

varnish. A protective coating applied to images—particularly collodion-plate photographs, which are otherwise prone to abrasions, peeling, and tarnishing over time.

VC paper. *See* variable contrast paper.

vector image. A type of graphic in which shapes, lines, and colors are described mathematically rather than with pixel values. As a result, they are considered resolution independent. *Contrast with* raster image *and* bitmap image.

LEFT—VECTOR IMAGE. **RIGHT**—RASTER IMAGE.

veil. (1) A uniformly distributed silver deposit in a photographic image that does not form part of the image itself. Also known as fog. (2) Lens flare that causes loss of contrast over part or all of the image.

ventilation. In darkrooms, a system for circulating air to minimize the amount of dangerous or noxious vapors inhaled while processing images.

Vernacular Photography. *See* appendix 2.

vertex. Point where the optical axis enters the lens. Also known as the pole.

vertical orientation. *See* portrait orientation.

vertical shutter. A focal plane shutter that moves vertically (i.e., across the short dimension of the frame). Because the travel distance is short, the top shutter speed is high.

VESA (Video Electronics Standards Association). Organization devoted to coordinating video and multimedia standards.

VGA. *See* video graphics array.

vibration reduction (VR) lens. Synonymous with image stabilization lens.

Victoria card. A small 19th-century print format.

video adapter. *See* video card.

video board. *See* video card.

video card. A printed circuit board controlling output to a display screen. Also known as a video adapter or video board.

video driver. The software used by a computer to control the monitor display.

Video Electronics Standards Association. *See* VESA.

video graphics array (VGA). Term for a computer display of 640x480 pixels. This was the maximum resolution offered by the original IBM computer monitors and became a de facto industry standard. *See also* quarter video graphics array.

videography. Recording moving images of a performance or event by means of video camera.

video in/out. A jack used to connect a camera or other device to a television, monitor, VCR, etc.

video RAM (V-RAM). A specialized type of RAM that can simultaneously receive data from the CPU and write it to the monitor for quick image display.

view. (1) Appearance of a scene to be photographed. (2) To look at a photograph, often with the implication of careful or critical observation.

view camera. A large-format camera with a ground-glass viewfinder at the image plane for viewing and focusing. The photographer must stick his head under a cloth hood in order to see the image projected on the ground glass. Because of their 4x5-inch (or larger) negatives, these cameras can produce extremely high-quality results. View cameras also usually support movements. *See also* field camera *and* technical camera.

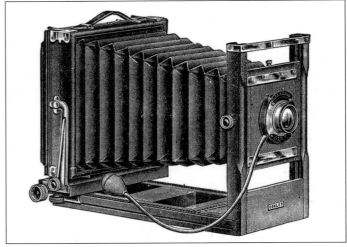

VIEW CAMERA.

viewfinder. An optical or electrical device used to compose and frame a scene. Because you must hold the camera against your face to look through the viewfinder, the camera is steadier and less prone to shaking (as opposed to when using the large LCD screen on the back of the camera to compose images). Also called a finder or viewing screen. *See also* direct vision viewfinder, electronic viewfinder, eye-level viewfinder, ground glass view-finder, interchangeable viewfinders, LCD viewfinder, magnifying viewfinder, optical viewfinder, reflex viewfinder, right-angle viewfinder, *and* waist-level viewfinder.

VIEWFINDER.

viewfinder camera. Camera with a viewfinder that is separate from the lens used in taking the picture.

viewfinder frame coverage. The percentage of the total image area that can be viewed through the viewfinder. Normally this is only a concern for SLR cameras. Only professional SLR cameras have 100 percent coverage.

viewing booth. A tabletop device, typically an open-front cube, equipped with a controlled color-temperature light source. This allows the color and/or quality of prints (or other objects) placed within it to be evaluated under precise conditions. Also called a light booth.

viewing distance. The distance at which the viewer of a print obtains an accurate perspective. This is calculated by multiplying the focal length of the lens by the magnification of the enlargement.

viewing filter. A transparent piece of glass or plastic designed to simulate the look of a particular film or lighting or to assist in focusing an enlarging lens. Largely obsolete in both functions.

viewing lens. The lens on a camera through which the photographer sees the subject.

viewing screen. *See* focusing screen.

viewpoint. The position of the camera relative to the subject being photographed.

vignette. Darkening of an image around the edges and corners. This includes deliberate darkening for dramatic effect and inadvertent darkening caused by a physical barrier (such as a filter or lens shade) that prevents some light from entering the lens. A darkening around the edge of the image can also be produced when using wide-angle lenses, due to light hitting the image-recording surface at an oblique angle. In flash photography, a similar effect can be caused by the coverage of the flash being insufficient to illuminate the field of view. In digital photography, the effect is most commonly added in postproduction using image-editing programs.

LEFT—ORIGINAL IMAGE. **RIGHT**—IMAGE WITH VIGNETTE.

vignetter. A filtering device used in front of the camera lens to produce a vignette effect.

vinegar syndrome. Slow chemical deterioration of cellulose film caused by poor storage conditions. The name derives from the acetic acid generated in this process, which has a sharp smell.

vintage image. A photograph from a past era or displaying visual qualities that are considered to be characteristic of past eras.

virtual image. (1) A representation of an actual object formed by diverging rays of light. This term is used in op-

VINTAGE IMAGE.

tics and physics. (2) An image that is viewed on a focusing screen.

virtually lossless compression. A compression strategy that reduces image size by discarding color information rather than image detail.

virtual memory. Technique of using hard drive space to simulate RAM and increase the operating speed of an application. Hard drive space is cheaper than RAM (per megabyte) but also much slower.

virtual reality (VR). A computer-based simulation of reality. This can involve shooting a series of photographs of a three-dimensional subject from different angles, then combining them using software to "reconstruct" the subject as what appears to be a three-dimensional object.

virus. A computer program designed to damage or destroy other software and/or data. *See also* worm *and* antivirus.

viscose sponge. A synthetic sponge used to wipe water off film before it is hung up to dry.

viscous processing. In instant picture processing, using chemicals carried in sticky, semifluid substances instead of normal liquids.

Vishniac, Roman. *See* appendix 1.

visible light. The portion of the electromagnetic spectrum that the unassisted human eye can see. Synonymous with visible spectrum.

visible spectrum. *See* visible light.

visiting-card image. *See* carte-de-visite.

visual. (1) Relating to human vision. (2) An illustration used to educate or advise. (3) Preliminary design used as a guide for the creation of final artwork.

Vivitar. Manufacturer of cameras and lenses.

V-number. *See* Abbe number.

volatile. (1) A substance, such as many photographic cleaners, that is easily converted to a gaseous state at normal temperatures. (2) Liable to change rapidly and unpredictably—usually for the worse. (3) *See* volatile memory.

volatile memory. Computer memory that retains data only as long as power is applied.

volt. Basic unit of electrical potential. One volt is the force required to send 1 ampere of electrical current through a resistance of 1 ohm. Named in honor of the Italian physicist Alessandro Volta (1745–1827), who invented the first modern chemical battery.

voltage stabilizer. An electronic device able to deliver relatively constant output voltage when input voltage and load current changes over time. The output voltage is usually regulated using a transistor.

Vorticism. *See* appendix 2.

vortograph. An abstract photograph made with a simple kaleidoscopic apparatus, first used by Alvin Langdon Coburn in 1917.

V-RAM. *See* video RAM.

VR lens. *See* vibration reduction lens *or* image stabilization lens.

VR. *See* virtual reality.

waist-level viewfinder. A device on a reflex camera that lets you hold the camera at waist level and compose an image while looking down into the viewfinder. Some SLRs have optional waist-level finders. *Contrast with* eye-level viewfinder.

WAIST-LEVEL FINDER.

WAN (wide area network). A series of connected LAN networks, such as at the separate sites of an organization. *See also* LAN.

wand tool. *See* magic wand tool.

Warhol, Andy. *See* appendix 1.

war photography. Images that document the events and experiences of military conflicts.

warm colors. Colors in the red and yellow area of the color spectrum, which are thought to impart a feeling of vibrancy and visually advance. *Contrast with* cool colors.

warming filter. A yellow- or pink-tinted filter that makes the colors in a photograph more warm by blocking the passage of some blue wavelengths of light.

LEFT—ORIGINAL IMAGE. **RIGHT**—IMAGE WITH WARMING FILTER.

warm-tone developer. A developer producing image colors ranging from warm black to reddish brown.

warm-toned paper. A photosensitive printing paper that produces warm, brownish blacks rather than neutral or cool blacks. *Contrast with* cold-toned paper.

warm-up time. The time taken by a device between when it's turned on and when it's ready for use. Also called start-up time.

warp. Imaging technique that intentionally distorts the shape of an object.

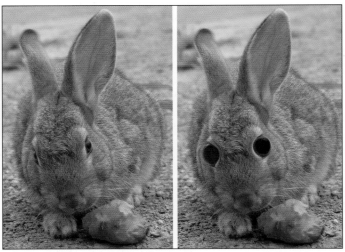

LEFT—ORIGINAL IMAGE. **RIGHT**—IMAGE WARPED WITH PHOTOSHOP'S LIQUIFY FILTER.

wash. Running clean water over photographic film or paper to remove any residual chemicals.

washer. A large tank used for washing processed prints.

washing aid. A chemical solution used to shorten the washing time by converting residues from the fixer into forms more easily dissolved by water. Also called hypoclear, hypoclearing agent, and hypo eliminator.

water bag. *See* weight bag.

water bath. (1) Process in which exposed negatives are rinsed in water after the first development step. (2) Tank of water into which other containers of various solutions are placed in order to maintain their temperature.

watercolor paper. A type of paper designed for use with an inkjet printer and intended to simulate the look and feel of a traditional watercolor painting.

waterfastness. The ability of a printed image to resist the application of water. *See* waterproof paper.

Waterhouse stop. A system of interchangeable fixed-size aperture plates used in camera lenses of the mid- to late 1800s (before the introduction of the adjustable iris-type aperture diaphragms found in lenses today).

watermark. (1) A logo or symbol superimposed over part of a picture to establish ownership. *See also* digital watermark. (2) A negative or print defect caused by the deposition of solutes as water evaporates.

waterproof. Something that is impervious to the effects of water, including being submerged in water at some depth. Cameras designed for use in underwater photography are waterproof. Waterproof housings are also available for some conventional cameras.

waterproof paper. Another term for resin-coated paper.

water resistant. Something designed to be tolerant of being splashed with water but not to being submerged in it. Some consumer-level cameras are equipped in this way, and most professional SLRs have water-resistant seals around their operating controls.

water softener. Substance used to reduce the minerals and salts found in hard water.

Watkins factor. An old system of development control based on observation of the developing image under safelights.

watt (W). A measurement of electrical power equal to 1 joule of energy per second. It is important to note that the watt rating of a light source measures how much power it consumes, not how much light it produces.

watt-second (Ws). A measurement of power equal to 1 joule per second. Used to describe strobe power requirements and brightness levels. *See also* effective watt-seconds.

wave form. Pictorial representation of the shape of a wave.

wavelength. The distance from crest to crest between two corresponding waves of light in the electromagnetic spectrum. Measured in nanometers (nm) and Angstrom units (Å).

WAVELENGTH.

wavelet compression. A mathematical technique used in the JPEG2000 file format to reduce file size. Also known as subband compression.

wax. Substance applied to early photographic prints to improve depth of tone and reduce fading. *See also* waxed paper process.

waxed paper negative. *See* paper negative *and* waxed paper process.

waxed paper process. A variation on the calotype process designed to increase image quality by waxing the paper base of the negative to seal it and create a smoother surface.

wax thermal printer. *See* thermal wax transfer printer.

WB. *See* white balance.

weak. (1) A negative or print that is low in contrast or density. (2) A low-concentration chemical solution. (3) A low-powered optical system. (4) An image that elicits an overall neutral or negative reaction from viewers due to the choice of subject matter, unimaginative approach, and/or technical flaws. (5) An ineffective composition.

web cam. A camera that sends images to a computer connected to the Internet so that its images can be viewed by Internet users.

Weber's law. States that the amount of change required to produce a perceptible variation in a stimulus is directly proportional to the strength of the original stimulus.

web optimization. Adjusting an image file for optimal Internet viewing by reducing its resolution, limiting the number of colors in the file, or converting to the GIF or JPEG format.

WEB OPTIMIZATION INTERFACE IN PHOTOSHOP.

web page. A document connected to the World Wide Web. Sometimes used synonymously with web site.

web presence provider (WPP). A company that provides World Wide Web hosting services.

web press. Type of printing press in which the paper is fed from rolls rather than as sheets.

web-safe color. A color that will display accurately and consistently on every Internet browser and computer platform. There are 216 web-safe colors.

web site. A location connected to the Internet that maintains one or more web pages on the World Wide Web.

wedding photography. Photography designed to tell the story of the wedding day, including images of the bride and groom, guests, locations, clothing, and decorations.

wedge. (1) An optical device with a smooth or stepped gradient of densities. (2) Thin prism used to angularly displace light.

Weegee. *See* appendix 1.

weight. (1) Measure of thickness of a paper stock. (2) In graphics, the thickness of a line or stroke. (3) The relative mass of an object. (4) An object of known mass used in a scale to determine how heavy another object is. (5) In composition, the visual impact of an image element. (6) An object of significant relative mass used hold something down. *See also* weight bag.

weight bag. A sack, normally with two hinged rectangular compartments and a handle, that can be filled with sand, buckshot, and in some cases water. This is used to temporarily secure light stands, backdrops, and other gear.

Weston, Edward. *See* appendix 1.

wet collodion. *See* wet plate process.

wet darkroom. Processing photographs by the application of chemicals in fluid form. This is the traditional method of photographic processing.

wet plate camera. A camera designed to be used in wet plate process photography. Usually features a trough to collect chemical runoff from the wet plates.

wet plate process. A process in which the photographer coats a glass plate with a collodion mixture immediately before expo-

sure. The plates must then be developed in a silver nitrate solution within twenty minutes from the time of exposure. Also called the collodion process.

wet proof. A color proof used by offset printers as a definitive color match.

wetting agent. A chemical that reduces water surface tension, thereby reducing the risk of drying marks forming on the surface of the film. Applied at the end of the washing process.

whey process. A non-halide silver-based process introduced in the 1850s and designed to increase image permanence.

whirler. A device used to apply albumen to glass plates.

white. (1) Light consisting of wavelengths from across the entire visible spectrum. (2) Description of the color of a surface that reflects all wavelengths of light. (3) The result of combining the additive primary colors (red, green, and blue) in equal amounts. (4) *See* paper white.

white balance. On digital cameras, a setting designed to allow photographers to quickly neutralize the color casts that are produced by different lighting conditions. It can also be used to adjust color results. For example, selecting the shade white balance when shooting in daylight will render colors that are slightly warmer than those in the actual scene. White balance is sometimes referred to as neutral balance or gray balance. *See also* automatic white balance, cloudy day white balance, color temperature white balance, custom white balance, daylight white balance, flash white balance, shade white balance, *and* tungsten white balance.

LEFT—DAYLIGHT WHITE BALANCE. **RIGHT**—SHADE WHITE BALANCE.

White, Clarence Hudson. *See* appendix 1.

white light. Light containing equal proportions of red, green, and blue.

white light control. Switch on a color enlarger that removes all color filtration and returns it when required.

white light spectrum. Synonymous with visible spectrum.

White, Minor. *See* appendix 1.

whitened camera. In early photography, a camera with a white interior designed to reduce contrast for more flattering portraits.

whitener. A substance, usually a fluorescent compound, used to increase the apparent whiteness of paper or improve highlights in a black & white print. Also known as an optical brightener.

white paper. A short treatise, often prepared by a manufacturer, designed to educate industry customers.

white point. The intensity and color of the brightest white that is reproducible by a device.

white-point compensation. In color management, a software setting that maps the white point of the source profile to the white point of the destination profile. This will determine the amount of highlight detail in an image.

white reflector. A reflective device used to redirect light onto a scene or subject. The matte white surface yields softer light than that from a silver reflector and does not affect the color of the light as a gold reflector would.

whole plate. A plate measuring 6.5x8.5 inches, based on the largest plate made by Daguerre.

wide-angle distortion. When using a wide-angle lens, an effect that causes elements close to the lens to look larger than they actually are.

WIDE-ANGLE DISTORTION.

wide-angle lens. A lens with a focal length shorter than the diagonal of the film frame or image sensor. Wide-angle lenses provide a broader angle of view than a normal lens. These lenses can be rectilinear (straight lines are preserved) or fisheye (showing extreme barrel distortion). Also called a short lens.

WIDE-ANGLE LENS.

wide-angle rack. An additional focusing rack used on large-format cameras.

wide-area autofocus. Denotes an autofocus detection area that is wider than normal. This makes it easier to photograph moving subjects.

wide area network. *See* WAN.

wide array. A gridlike pattern of photosensors. Used in most digital cameras.

wideband. (1) Measuring or affecting a large range of colors or wavelengths. (2) Transmitting large amounts of data in a short time. Also known as broadband.

wide gamut RGB. A very large gamut color space that exceeds the capabilities of current monitors and printers.

wide open. Colloquial expression for shooting with the lens set to its largest aperture.

widescreen. A viewing device or mode in which the aspect ratio is significantly wider than normal.

Wiener filter. A filter used to reduce the noise present in a signal. In photography, used to improve image sharpness.

Wi-Fi (wireless fidelity). A trade name for 802.11b wireless networking. Such systems allow for the transmission of signals or data between two devices that are not physically connected.

wildlife photography. Type of photography devoted to documenting the appearance and behavior of animals in their natural environment.

WILDLIFE PHOTOGRAPHY.

winder. A camera mechanism for advancing film and recocking the shutter. *See also* motor drive.

wind machine. A device used to direct a stream of moving air onto a subject, causing movement in the hair and clothing.

window. In image-editing programs, an on-screen frame containing the image being edited or giving the user access to tools for changing the image.

window glass. Ordinary glass used for making household windows, mirrors, etc. Compared to optical glass, window glass contains many impurities.

window lighting. Use of the directional ambient light through a wall opening to illuminate the subject of a photograph. This is commonly used in portrait photography.

WINDOW LIGHTING.

window mat. A two-piece housing, often made of matboard, with a hole (window) through which the framed art is visible. Also called a passé-partout.

Windows. A Microsoft operating system used on many personal computers.

Wing camera. An camera introduced in 1862 that featured a system for making successive multiple exposures on a single plate.

Winogrand, Garry. *See* appendix 1.

wipe. (1) Type of transition in a slide or multimedia image presentation in which a line moves across the screen as the old image is replaced by the new one. (2) To remove data from a hard drive or other data-storage device.

wired remote. A remote controller attached by a wire. The most common example is an electronic cable release.

wireless. A system of transmitting information that does not rely on a physical connection between devices.

Wolcott, Alexander. *See* appendix 1.

wood alcohol. *See* methyl alcohol.

woodburytype. A continuous-tone print created by exposing unpigmented bichromated gelatin in contact with a negative. Invented in 1864 by Walter Woodbury. Also occasionally referred to by the French term photoglyptie.

Wood effect. The bright glow seen from sun-illuminated deciduous trees and other types of plants when photographed using infrared film. Named after its 1910 discoverer, R. W. Wood.

Wood lens. *See* radial gradient lens.

wood print. Print made on a wooden surface that has been photochemically prepared.

Woods glass. Visibly opaque glass designed to transmit only near-ultraviolet radiation. Also called cobalt glass.

workflow. A collective term for the steps involved in handling images from the time they are shot to the time they are delivered to clients or otherwise deemed finalized. This includes (but is not limited to) backing up files, color management, postproduction image enhancements, proofing, printing, framing, and album design.

work for hire. A work produced by an employee as part of the terms of his or her employment (or under similar contractual terms, such as a commission). Copyright and all other rights of such work are held by the employer and not the artist. Also called work made for hire.

working aperture. The widest aperture at which an acceptable image can be achieved.

working distance. The distance from the front of the lens surface to the subject.

working file. A copy of a digital image on which edits are made, leaving the original image file unaltered.

working solution. A liquid chemical that has been mixed and diluted for use.

working space. An intermediate color space used to define and edit color in image-editing programs. Each color model has a default or user-defined working space profile that is associated with it.

work made for hire. *See* work for hire.

workstation. A computer, monitor, and its peripherals.

World Wide Web (WWW). An interconnected network of electronic documents that are written in hypertext markup language (HTML). Cross references between documents are recorded in the form of uniform resource locators (URLs).

worm. (1) Acronym for "write once, read many." Used to describe a type of computer memory device, such as CDs and other optical discs, that cannot be changed once written but may be read as many times as desired. (2) A computer program, normally with negative or destructive effects, that is able to propagate itself across a network. *See also* virus *and* antivirus.

wothlytype. A collodion emulsion printing-out process invented by Jacob Wothly in 1864.

WPP. *See* web presence provider.

wraparound lighting. Produced by large, soft sources, light that has an extremely gradual transition from highlight to shadow and, therefore, seems to envelop the subject.

Wratten, Frederick Charles Luther. *See* appendix 1.

Wratten numbers. Numbers used by some manufacturers to describe filters. Named for Frederick Wratten, a British inventor who developed a series of color filters. Individual filter numbers and letter grades are inconsistent but follow a general structure:

2–15yellow
16–32orange, red, magenta
34–61violet, blue, green
80A–80D . . .cooling (blue)
85N3–85C . .warming (amber)
81–81Dwarming (pale yellow)
82–82Ccooling (pale blue)
87–106miscellaneous *(87, 87C, and 89B are infrared filters; the 96 range are neutral-density filters)*

write. To store digital data to a hard drive, CD, DVD, or other digital storage device.

write once, read many. *See* worm.

write-protected. A digital storage device that prohibits the user from writing data to it, usually to prevent the loss of data already stored on the device.

wrong reading. The orientation of a negative or transparency in which the image appears backward relative to the subject (i.e., a mirror image). *Contrast with* right reading.

Ws. *See* watt-second.

WWW. *See* World Wide Web.

WYSIWYG. An acronym for What You See Is What You Get (pronounced "wizzy-wig"). Refers to the ability to output data from the computer exactly as it appears on the screen.

x axis. (1) The horizontal line at the bottom of a graph, usually indicating the input values. (2) In graphics, the width of an image or layout. (3) In aerial photography, the flight line of the aircraft.

xD card. A small flash memory card used by some cameras for storing digital photos.

x direction. In a scanner, the direction in which the sensors are arranged in the array. *See also* y direction.

xenon. A rare gas employed in some electronic flash tubes and enclosed arc light sources.

XD CARD.

xerography. A copying process using electrostatic technology to reproduce images. Used in most photocopying machines and in laser and LED printers.

XGA (extended graphics array). A proprietary video card developed by IBM that produces a resolution of 1024x768 pixels and can display 256 colors.

XMP (Extensible Metadata Platform). A labeling technology from Adobe that allows metadata to be embedded in a file.

Xpan. A film camera designed specifically for shooting panoramic images. Created in partnership by Fujifilm and Hasselblad.

X-ray. A form of high-energy electromagnetic radiation that can fog undeveloped photosensitive material.

X-ray film. Sheet film for radiography.

x-sync. A camera setting that causes the flash to burst in synchronization with the shutter. For some manual cameras, the x-sync speed refers to the maximum speed at which the camera can synchronize with the flash.

x,y chromaticity diagram. *See* chromaticity diagram.

xy scanner. A scanner in which the head can be moved to any position within the scanning area.

xyY chromaticity diagram. *See* chromaticity diagram.

XYZ. *See* CIE XYZ color space.

Y. *See* yellow.

Yashica. Manufacturer of cameras and other video/audio consumer electronics.

yaw. Lateral rotation of a tripod head. *Contrast with* pitch.

y axis. (1) The vertical line at the left of a graph, usually indicating the output values. (2) In graphics, the height of an image or layout.

YCC. The color model used in Kodak's PhotoCD system.

y direction. The direction in which the stepper motor in a scanner moves the sensor array. *See also* x direction.

yearbook photography. Creating a wide variety of images to document, in book form, the people who attended (or worked at) a school during a given year, as well as the academic, social, and sporting events that occurred during the same period.

yellow (Y). A subtractive primary, and one of the four process ink colors. Yellow is the complementary color to blue. *See also* CMY, CMYK, *and* primary colors.

yellow glass. In darkrooms, glass used to filter light for the blue-sensitive processes popular in the 19th century.

yellowing. Discoloration that affects image color and, in earlier processes, the white borders of prints.

yellow prussiate of potash. *See* potassium ferrocyanide.

Young-Helmholtz theory. Devised in the 1800s by Thomas Young and extended by Hermann Ludwig Ferdinand von Helmholtz, a theory stating that the image receptors in human eyes contain three separate color-sensing cells that detect red, green, and blue light. This theory was proved correct in the later part of the 20th century.

Z

zebra. Available on some umbrellas, an interior surface of alternating white and silver panels. This is designed to produce light that is slightly harder than that created by an umbrella with a solid white interior.

Zeiss. Founded in 1846 by Carl Zeiss, a German company that remains a world leader in optics and lens manufacturing.

Zeiss, Carl. *See* appendix 1.

zenith. The highest point in a spherical virtual-reality photographic image. *Contrast with* nadir.

zero. (1) A point on a scale from which a positive or negative value is measured or calculated. (2) To adjust an instrument to zero.

Ziatype. A variation on the traditional platinum-palladium printing process that provides a greater range of color options, less grain, and easier contrast control.

zip. (1) To compress multiple files into one file, typically for transmission via the Internet. (2) A lossless compression method supported by PDF and TIFF file formats. ZIP compression is most effective for images that contain large areas of a single color.

Zip disc. An advanced type of floppy disc from Iomega that can hold up to 250MB of data.

zirconium lamp. An arc lamp used in powerful enlargers and projectors.

ZLR. *See* zoom lens reflex.

zoetrope. An early form of motion-image creation produced by viewing a series of still photographs through a rotating drum with slits cut in it.

zone. In the Zone system, a description of subject luminance.

zone focusing. Focusing the lens so that the depth of field extends over a selected range of distances.

zone plate. A glass plate marked with alternating opaque and transparent concentric rings. Used like a lens to focus light.

Zone system. A method of planning film exposure and development to achieve precise control over tones in a print. It is based on analyzing subject luminosities in terms of gray tones, labeled zones 0 through 10 (often noted using Roman numerals), and previsualizing them as print densities. By measuring each subject luminance, you can determine how much the range of values must be contracted or expanded by negative development to produce the required values in the print. Pioneered by American photographer Ansel Adams. *See also* minus development,

ZIP DISC.

| 0 | I | II | III | IV | V | VI | VII | VIII | IX | X |

ZONE SYSTEM SCALE OF TONES.

normal development, normal–1 (N–1) development, normal–2 (N–2) development, normal+1 (N+1) development, normal+2 (N+2) development, *and* plus development.

zoom creep. A problem with push–pull zoom lenses in which the lens slowly slides (changing focal length) when it is pointing up or down. Some lenses have locking friction rings to help prevent the problem.

zoom effect. Deliberately altering the focal length of the lens during an exposure to create blurred radial lines.

zoom flash. A flash with an adjustable-width light beam that allows it to be set to suit the angle of view of the lens.

zoom in. (1) With a zoom lens, adjusting to a longer focal length for a tighter view of the subject. *See also* digital zoom *and* optical zoom. (2) On digital cameras, or on-screen in image-editing software, enlarging a portion of an image in order to see it more clearly or make it easier to alter.

ZOOMING IN WITH A LENS ALLOWS YOU TO ISOLATE A SMALLER AREA OF THE SCENE.

zoom lens. A lens with a variable focal length. *See also* variable aperture zoom lens *and* variable focus zoom lens.

zoom lens reflex (ZLR). An SLR camera with a zoom lens that cannot be removed. Most famous were the Olympus IS-series cameras.

zoom out. (1) With a zoom lens, adjusting to a shorter focal length for a wider view of the scene. *See also* digital zoom *and* optical zoom. (2) On digital cameras, or on-screen in image-editing software, switching from an enlarged view of one small area of the image to a view of the entire image (or a larger area of the image).

ZOOMING OUT WITH A LENS ALLOWS YOU TO INCLUDE A LARGER AREA OF THE SCENE.

zoom tool. In image-editing programs, a tool that allows you to increase or decrease the on-screen view of an image.

INFLUENTIAL INDIVIDUALS

Throughout the history of the medium, both artists and scientists have worked toward the advancement of photography. The following list includes some of the most notable contributors. These entries are not intended to be exhaustive, but only to provide a basic overview of the many people who have played a role in the creation of photography as we know it today.

Slim Aarons (1916–2006). An American photographer known for his exclusive use of natural light to produce his celebrity photos.

Berenice Abbott (1898–1991). An American photographer who got her start as an assistant to Man Ray. Abbott was part of the Straight Photography movement (*see* appendix 2).

Ansel Adams (1902–1984). American photographer known for his landscape images. Along with Fred Archer he developed the Zone system, a systematic method for translating the tonalities of a scene into specific densities on negatives and paper.

Edward T. (Eddie) Adams (1933–2004). An American photographer well noted for his photojournalistic documentation of thirteen wars, as well as for his portraits of celebrities and politicians.

Manuel Alvarez Bravo (1902–2002). Mexican Surrealist photographer (*see* appendix 2) and cinematographer whose work explored psychology, religion, sexuality, and dreams.

Nicolai Andreev (1982–1947). Russian photographer known for his use of soft focus lenses, alternative processes, and handcoloring to produce a romantic mood in his images.

Diane Arbus (1923–1971). An American photographer known for her stark, documentary style, and especially her images of people outside the boundaries of "proper" society.

Frederick Scott Archer (1813–1857). Born in England, Archer used photography as an aid in his work as a sculptor and is known as the inventor of the first practical photographic process to be both sharp and easily reproducible.

Jean-Eugène-Auguste Atget (1857–1927). French documentary photographer known for photographing Paris and Parisian life.

Richard Avedon (1923–2004). An American photographer who, as a staff photographer at *Vogue* and *The New Yorker,* led fashion photography into the realm of fine art.

Oskar Barnack (1879–1936). Head of the development department of the German optical company Leica, credited with the release of the very first 35mm camera, originally considered a "miniature" camera.

E. J. Bellocq (1873–1949). Commercial photographer from New Orleans remembered for his documentary work on the lives of prostitutes.

Ruth Bernhard (1905–2006). Born in Germany, Bernhard moved to New York City and became well known as a commercial photographer. She is most noted, however, for her abstract female nudes.

Louis-Désiré Blanquart-Evrard (1802–1872). The inventor of albumen paper and an important pioneer in the field of archival processing.

Karl Blossfeldt (1865–1932). German photographer known for his black & white close-up photography of plants, which often focused on capturing textures, details, and patterns that would otherwise go unnoticed. His work became a landmark of New Objectivity (*see* appendix 2).

Margaret Bourke-White (1904–1971). An American photographer known as a pioneer of industrial photography. The first staff photographer at *Fortune* and one of the original four staff photographers for *Life.*

Mathew B. Brady (1823–1896). An accomplished studio photographer who became renowned for his documentation of the American Civil War.

Bill Brandt (1904–1983). Known as a photographic explorer, Brandt's work spanned numerous genres, including social documentation, war photography, fashion and portrait photography, and landscape photography—to name just a few.

Brassaï (1899–1984). Gyula Halàsz, now known as Brassaï, was born in Transylvania and is remembered for his emotional and provocative photographs of life in Paris.

Alice Broughton (1865–1943). Portrait photographer well known for her romantic imagery, often of young women. Member of the Photo-Secession movement (*see* appendix 2).

Wynn Bullock (1902–1975). An American photographer most famous for his photographs of nudes and West Coast landscapes and notable for his psychological approach.

Harry Callahan (1912–1999). An American photographer known for his innovative use of the abstract and as a great innovator of modern American photography.

Julia Margaret Cameron (1815–1879). A portrait photographer well known for her expressive portraiture and pioneering use of soft focus to create emotion.

Robert Capa (1913–1954). Born André Friedmann, Capa is remembered as one of the world's greatest war photographers and as a founding member of Magnum (serving as its president from 1948 to 1954).

Henri Cartier-Bresson (1908–2004). Legendary French photographer whose concept of "the decisive moment" is a

cornerstone of contemporary photojournalism. A founding member of Magnum Photos.

Imogen Cunningham (1883–1976). American photographer known for her portraits and pictorial works. While her early work was romantic and soft focus, she later adopted Modernism (*see* appendix 2) and became a member of Group f/64 (*see* appendix 2).

Louis Jacques Mandé Daguerre (1787–1851). French painter and physicist who invented the first practical process of photography, known as the daguerreotype.

Robert Demachy (1859–1936). French Pictorialist (*see* appendix 2) who championed the manipulated image.

Andre Adolphe-Eugene Disderi (1819–1890). French photographer credited with the first mass production of photographs. His cartes de visite (visiting cards) were shot using a multi-lens camera that produced several images on one photographic plate.

Robert Doisneau (1912–1994). A French photographer noted for his frank and often humorous depictions of Parisian street life.

George Eastman (1854–1932). Founder of Kodak and early pioneer of numerous products and processes designed to make photography more convenient for nonprofessionals.

Harold Edgerton (1903–1990). American photographer and inventor of the electronic stroboscope, which revolutionized stop-motion photography. His discoveries formed the basis for electronic flash photography.

Alfred Eisenstaedt (1898–1995). A photographer and photojournalist best remembered for his "kiss" photograph documenting the celebration of V-J Day.

Peter Henry Emerson (1856–1936). American photographer known as an important figure in pictorial photography.

Frederick Henry Evans (1852–1943). Photographer known for his exacting use of light, color, and texture in architectural and landscape images.

Walker Evans (1903–1975). American photographer known for his direct documentary style—capturing reality, no matter how harsh.

Hercules Florence. In 1832, the first person to coin the term "photography." This is often misattributed to Sir John Frederick William Herschel.

Ernst Haas (1921–1986). German photographer whose work for *Life* helped introduce the artistic possibilities of color photography.

Phillipe Halsman (1906–1979). Photographer whose work included magazine stories, advertising pictures, and private portraits of men and children. He is credited with over a hundred *Life* magazine covers and was the first president of the American Society of Magazine Photographers.

George Harris (1872–1964). A pioneering photojournalist who later became the official White House photographer, serving administrations from Roosevelt through Eisenhower.

Victor Hasselblad (1906–1978). Swedish inventor and photographer best known for inventing the Hasselblad 6x6cm SLR camera.

Sir John Frederick William Herschel (1792–1871). Widely but incorrectly credited with the first use of the term "photography" (*see* Hercules Florence), an English astronomer and chemist who made numerous early and far-reaching advances in the chemistry of photography. Herschel actually did coin the terms "negative," "positive," "emulsion," and "snapshot."

Lewis Wickes Hine (1874–1940). Photographer who sought to incite social reform through his images. Best known for his photography of immigrants at Ellis Island and child laborers. He is also remembered for documenting the construction of the Empire State Building.

George Hurrell (1904–1992). An American photographer known for his glamorous images of Hollywood celebrities in the 1930s and 1940s.

William Henry Jackson (1843–1942). One of the most respected landscape photographers of the American West.

Yousuf Karsh (1908–2002). A Canadian photographer of Armenian birth, Karsh is known for his evocative portraits of famous and powerful people. His 1941 image of a scowling and defiant Winston Churchill is one of the most famous photographic portraits in the world.

André Kertész (1894–1987). A Hungarian photographer who was one of the founders of photojournalism. He later worked as a freelance fashion and interiors photographer for such magazines as *Look, Harper's Bazaar, Vogue, Colliers,* and *Town and Country.*

Dr. Edwin Land (1909–1991). American physicist and inventor credited with introducing the Polaroid Land camera. *See also* Polaroid camera.

Dorothea Lange (1895–1965). An American documentary photographer and photojournalist who is best known for her revealing Depression-era work for the Farm Security Administration (FSA).

Gabriel Lippmann (1845–1921). Winner of the 1908 Nobel Prize in physics for his invention of the first process for creating fixable color photographs.

Auguste Lumière (1862–1954) and **Louis Lumière** (1864–1954). French scientists who, in 1904, invented the first widely used color photography process. Their 35mm motion picture camera, first introduced in 1895, continues to be widely used today.

Robert Mapplethorpe (1946–1989). Photographer recognized for his elegant still lifes, portraits, and nudes. In the late 1980s, his homoerotic images (funded in part by grants from the National Endowment for the Arts) were the source of great cultural controversy.

Paul Martin (1864–1944). Photographer who is remembered for his candid images of London and its residents. A member of the Linked Ring Brotherhood (*see* appendix 2).

Dr. C. E. Kenneth Mees (1882–1960). A British scientist credited with numerous advancements in the field of photography—and particularly for innovations in color photography.

Lee Miller (1907–1977). Model and photographer whose amazing life story took her from assisting Man Ray, to shooting for *Vogue,* to being the first photographer to document the German concentration camps of Buchenwald and Dachau.

Laszlo Moholy-Nagy (1895–1946). A photographer and theoretician who served as a professor at the Bauhaus (the influential German school of art and design) from 1923 to 1928.

Barbara Morgan (1900–1992). An American photographer known for her photographs of modern dancers such as Martha Graham, Merce Cunningham, and José Limón.

William Mortensen (1897–1965). A leader of the Pictorialist movement (*see* appendix 2), Mortensen is best known for his Hollywood film stills and heavily manipulated portraits.

Eadweard Muybridge (1830–1904). An English-born photographer, known primarily for his early use of multiple cameras to capture motion.

Nadar (1820–1910). Born Gaspard Felix Tournachon, Nadar was a French photographer known for his images of the artists, writers, and musicians of Paris. He was also the first photographer to implement electric lighting in his studio. *See also* Impressionism (appendix 2).

Arnold Newman (1918–2006). Photographer renowned for his environmental portraits of artists, presidents, authors, and leaders of industry.

Helmut Newton (1920–2004). A German photographer noted for his daring fashion photography (often of domineering models) and nude studies of women.

Joseph Nicéphore Niépce (1765–1833). A French inventor credited with taking the first fixed photographic image using a process he called heliography.

Wilhelm Ostwald (1853–1932). German professor of chemistry known for his theories on the ripening and growth of the grains in an emulsion.

Gordon Parks (1912–2006). A groundbreaking African American photographer, activist, and film director. He is best remembered for his photo essays for *Life* magazine and as the director of the 1971 film *Shaft*.

Joseph Petzval (1807–1891). Hungarian mathematician who invented the first specialized lens for photography. This reduced exposure times by 90 percent.

Man Ray (1890–1976). An American artist, born Emmanuel Rudnitsky, best known for his avant-garde photography. He was also a renowned fashion and portrait photographer.

Frank Foster Renwick (1877–1943). Photographic scientist who, while working for Ilford, developed the first variable contrast paper.

Herb Ritts (1952–2002). An American fashion photographer who concentrated on black & white photography and portraits in the style of classical Greek sculpture.

Henry Peach Robinson (1830–1901). British art photographer who was a follower of the Pre-Raphaelites (*see* appendix 2) and founder of the Linked Ring Brotherhood (*see* appendix 2). Known for his Pictorialist images (*see* appendix 2).

Alexander Mikhailovich Rodchenko (1891–1956). A founder of the Constructivist movement (*see* appendix 2), Rodchenko is remembered for his photomontage work and experimental compositions.

Arthur Rothstein (1915–1985). The first photographer chosen for the Farm Security Administration's (FSA) documentary project, Rothstein created iconic images of the Great Depression in America.

Galen Rowell (1940–2002). A noted American wilderness photographer and climber whose images appeared in *Life* and *National Geographic*.

Aramand Sabattier (1834–1910). French scientist who first described "pseudo-solarization reversal," which later became known as the Sabattier effect.

Erich Salomon (1886–1944). A pioneer of photojournalism, Salomon used small cameras (like the Leica model A) and fast lenses to capture candid images of politicians and royalty. With his wife and son, Salomon was killed at the concentration camp at Auschwitz.

Johann Heinrich Schulze (1687–1744). German scientist who first discovered that light (not heat) darkens silver nitrate. This was a landmark discovery upon which photography was built.

Aaron Siskind (1903–1991). American documentary photographer well known for his black & white images of city life and, later, urban decay.

W. Eugene Smith (1918–1978). An American photojournalist known for his refusal to compromise his professional standards and his brutally vivid World War II photographs.

Edward Jean Steichen (1879–1973). An American photographer known for his pictorialist images. During World War II he served as the director of the Naval Photographic Institute. He was later named director of photography at New York's Museum of Modern Art. A founder of the Photo-Secession movement.

Alfred Stieglitz (1864–1946). An American modernist photographer who was instrumental in making photography an accepted art form alongside painting and sculpture. He is also remembered for his marriage to painter Georgia O'Keeffe.

Paul Strand (1890–1976). An acclaimed American photographer and filmmaker who, along with Alfred Stieglitz and Edward Weston, helped establish photography as an accepted art form. His work covers numerous genres and subjects from around the world.

Roy Emerson Stryker (1893–1975). Director of the extensive documentary photography program undertaken by the Farm Security Administration (FSA) from 1935 to 1943. This project produced over 200,000 images of rural America during the Great Depression, and included work by photographers such as Dorothea Lange and Walker Evans.

Thomas Sutton (1819–1875). English photographer and inventor who patented the first reflex camera in 1861.

William Henry Fox Talbot (1800–1877). A British photographer known as the father of the negative-positive photographic process, enabling the production of multiple prints from a single negative.

James Van Der Zee (1886–1993). Photographer who chronicled the Harlem Renaissance with elaborate, storytelling portraits of the neighborhood's emerging middle class.

Roman Vishniac (1897–1990). Russian photographer who documented pre-Holocaust Jewish life in Lithuania, Poland, and Hungary. After emigrating to the United States, he became a pioneer in photomicrography.

Andy Warhol (1928–1987). Born Andrew Warhola, America's most famous practitioner of Pop Art (*see* appendix 2). Known for appropriating images from mass-produced products and popular culture.

Weegee (1899–1968). The pseudonym of Arthur Fellig, an American photojournalist known for his stark black & white

street photography, including images ranging from bloody crime scenes to raucous dance halls.

Edward Weston (1886–1958). An American photographer known for his nude, still-life, and landscape images. With Ansel Adams, he was a founder of Group f/64 (*see* appendix 2).

Clarence Hudson White (1871–1925). An American photographer and a founding member of the Photo-Secession movement (*see* appendix 2). Widely recognized for his pictorial portraits and his excellence as a teacher of photography.

Minor White (1908–1976). American photographer known for his images of things usually considered mundane but made special by the quality of the light in which they were photographed. With Ansel Adams, Dorothea Lange, and Barbara

Morgan, White was a founder of the highly influential magazine *Aperture.*

Garry Winogrand (1928–1984). Photographer known for his raw, high-energy documentary images.

Alexander Wolcott (1834–1885). Photographer who opened the world's first portrait studio in 1840.

Frederick Charles Luther Wratten (1840–1926). The founder of one of the earliest photographic supply companies, Wratten is best known as a manufacturer of photographic filters.

Carl Zeiss (1816–1888). A German optics manufacturer responsible for many important technical breakthroughs in optical design, such as the Tessar lens design and multicoated lenses.

APPENDIX 2
INFLUENTIAL MOVEMENTS AND STYLES

Throughout the history of the medium, photographic styles have interplayed with movements in the world of painting. The following list describes principle stylistic changes. Where possible, the direct impact of these movements on photography is noted. In select instances, the influence is notable but largely indirect; in these cases, the description refers principally to painting (or in some cases other visual arts). In other cases, the movement refers only to photography. These descriptions are not intended to be exhaustive, but only to provide a basic overview of the evolving approaches.

Abstract Expressionism. An art movement that originated in the United States in the 1940s and remained strong through the 1950s. Abstract Expressionism emphasized spontaneous personal expression in nonrepresentational images.

Art Deco. A popular design movement from 1920 until 1939, seen as elegant, functional, and ultramodern. Its impact was seen in the decorative arts, such as architecture and interior design, as well as in the visual arts. It represents an amalgamation of early 20th-century styles, including Constructivism, Cubism, Modernism, and Futurism.

Barbizon School. A mid-19th-century association of French landscape painters who painted directly from nature. Their style appealed to early art photographers with their need for long exposures, bright light, and immobile subjects.

Conceptual Art. Developed in the 1960s, Conceptual artists emphasized the idea over the art object. Somewhat counterintuitively, this type of art is frequently tied to photography as a source of documentation for a performance that otherwise leaves no object.

Constructivism. An artistic and architectural movement in Russia from 1913 onward, Constructivism dismissed "pure" art in favor of art as an instrument for social purposes (and particularly the construction of the socialist system). In modern art, the term is often used to describe works characterized by the use of everyday or industrial materials in abstract, often geometric, compositions.

Cubism. An artistic style that arose just before World War I and is characterized by a reduction of the image to geometrical forms and multiple viewpoints. One of many factors credited in photography's shift from a pictorial aesthetic toward a more modernist viewpoint.

Dadaism. A movement that followed World War 1 and spoke out against the contemporary academic and cultured values of art, rejecting logic and embracing anarchy and the irrational. Photomontage techniques were developed during this period, creating challenging and absurd non-images. In New York City, much of the Dadaist activity centered in Alfred Stieglitz's gallery, called 291.

Expressionism. Expressionism arose in Germany in the early 20th century and used emphasis and distortion to create an emotional response. Expressionists argue for a separation of photography as a fine-art medium from its functional tradition.

Futurism. A 20th-century art movement espousing a love of technology and passionate loathing of ideas from the past—especially political and artistic traditions. The car, the plane, and the industrial landscape were favorite subjects because they represented the technological triumph of man over nature. Futurists embraced the camera as a technological advance but were troubled by the static nature of the images it produced. This led to the development of Photodynamism.

Group f/64. A loose band of photographers (including Edward Weston and Ansel Adams) who promoted Straight Pho-

tography, asserting that the "greatest aesthetic beauty, the fullest power of expression, the real worth of the medium lies in its pure form rather than in its superficial modifications."

Impressionism. A movement developed from naturalistic painting, a central feature of 19th-century art. Impressionism is characterized by the representation of a scene, object, or figure through the application of paint in dabs of color in order to produce an impression rather than an accurate, detailed depiction. Impressionists in the art world included Monet, Degas, Renoir, and Pissarro. Photography also had its impressionists. In May 1874, a group of them in Paris began to exhibit photographs at the studio belonging to Nadar. The group continued to exist for the next twelve years, and work was exhibited by, among others, Cezanne and Gaugin.

The Linked Ring Brotherhood. A British group formed in 1892 by the Pictorialist photographer Henry Peach Robinson who, along with other members, resigned from the Royal Photographic Society because of their objections to its technical emphasis. Members included Frederick Evans, Paul Martin, and Alfred Stieglitz. Membership required the belief that photography was an art form.

Magnum Photos. An international photographic cooperative formed in 1947 by Robert Capa, David Seymour, and Henri Cartier-Bresson. Membership in the group is extremely selective.

Minimalism. A 20th-century style of abstract art in which an extreme simplification of forms, shapes, colors, or lines reduces a concept or idea to its simplest form.

Modernism. Modernists believed that by rejecting tradition they could discover radically new ways of making art. The use of photography, which had rendered much of the representational function of visual art obsolete, strongly affected this aspect of Modernism.

Naturalism. In 1889, P. H. Emerson produced a book entitled *Naturalistic Photography for Students of Art,* asserting that photography should be treated as a legitimate art form in its own right, rather than a pale imitation of other art forms. This was a reaction against Pictorialism, which he felt was becoming bogged down with sentimentalism and artificiality. Naturalism is also occasionally referred to as Straight Photography.

Neo-Impressionism. A term applied to an avant-garde art movement that flourished principally in France from 1886 to 1906. Led by the example of Georges Seurat, artists of this circle renounced the random spontaneity of Impressionism in favor of a painting technique grounded in science and the study of optics.

Neo-Romanticism. While Naturalism stresses external observation, the late 19th- and early 20th-century Neo-Romantic movement emphasizes feeling and internal observation. These artists tend to react against the modern world of machines, cities, and profit, focusing instead on themes like longing for love, utopian landscapes, nature reclaiming ruins, and romantic death. This is a strong current in post-1945 British photography.

New Objectivity. An approach to the subject matter of photography originating in Germany in the 1920s. The photographer remains an impartial observer, intensifying the appreciation of forms and structures in ordinary things but depersonalizing his/her approach. Also called New Realism.

New Realism. *See* New Objectivity.

New Topographics. A photographic movement in which the landscape is depicted unsentimentally and without excluding evidence of human impact. The 1975 exhibition *New Topographics: Photographs of a Man-Altered Landscape,* organized by William Jenkins for the George Eastman House International Museum of Photography and Film, defines this movement.

Op Art. Originating in the mid-1950s and peaking in the 1970s, a short-lived movement using geometric pattern and design to produce an optical effect. The most well-known artist is Vasarely.

Photodynamism. Developed by Giulio Bragaglia, a photographer who participated in the Futurist movement, Photodynamism involves the capture of movement by slow exposure time photography. This was designed to overcome the static quality of traditional photography by depicting motion and sensation in the form of objects and figures merging with space.

Photojournalism. (1) A style of photography with a narrative theme designed to inform the viewer, especially when published in the context of a chronological record of events. Pure photojournalists take an objective stance designed to yield images that are a fair and accurate representation of the events they depict. A similar and related term is reportage. (2) In the 1990s and later, an approach to candid photography. For example, weddings may be shot in a photojournalistic style, resulting in candid images that chronicle the events and emotions of the day.

Photorealism. Originating in the late 1960s, a movement that aims to produce photograph-like paintings and sculpture. Evidences the influence of photography on painting (rather than vice versa, as has historically been more common).

Photo-Secession. An early 20th-century attempt to break away from the orthodox approach to photography and from what Photo-Secessionists considered the stale work of fellow photographers. Characteristic of this movement was the employment of special printing processes and artwork that lessened the detail on the finished print.

Photovoice. A methodology, used mostly in education, that combines photography with grassroots social action. Subjects (often from marginalized groups) are asked to document their community by taking photographs that provide viewers with insight into their circumstances.

Pictorialism. A photographic movement that reached its height in the early 20th century, then declined rapidly after 1914 with the widespread emergence of Modernism. Pictorialists subscribed to the idea that art photography needed to emulate the painting and etching of the time. Among the methods used were soft focus, darkroom manipulation, and rough-surface printing papers that broke up a picture's sharpness. Pictorialist photographers whose work is characterized by soft focus and atmospheric effects have also been called Impressionists.

Pointillism. A style of painting in which small distinct points of primary colors create the impression of a wide selection of secondary colors. This style is frequently emulated in photography using both traditional media and digital enhancements.

Pop Art. Originating in the 1960s, particularly in Britain and the United States, Pop Art consciously tore down the barriers between fine art and commercial art (especially advertising and

pop-culture images). The placement of fashion photography in fine-art museums is evidence of the impact of this movement. Andy Warhol, Ray Lichtenstein, and Robert Rauchenberg were key figures in this movement. Pop Art is said to be a reaction to the Abstract Art movement.

Postmodernism. Any of several artistic movements since about the 1960s that have challenged the philosophy and practices of modern art or literature. Postmodernism reacts against an ordered view of the world and fixed ideas about form and meaning. It emphasizes devices such as parody and breaking down the distinction between high and low culture.

Pre-Raphaelites. A brotherhood founded in 1848 and consisting mainly of British artists who rejected the neoclassical style and looked instead to "purer" early-Renaissance art for their inspiration. This approach influenced a number of later photographers, including Henry Peach Robinson and Julia Margaret Cameron.

Red Shirt School. A trend in photography pioneered by *National Geographic* photographers in the 1950s who tended to (or chose to) photograph subjects in extremely colorful clothes because it rendered best on Kodachrome film. This method was especially popular for brightening up drab photographs or focusing attention on the subject. Today, the term is sometimes used critically, to suggest that a journalistic image lacks authenticity or objectivity.

Reportage. *See* Photojournalism.

Romanticism. An artistic movement originating in 18th-century Western Europe that stressed strong emotion as a source of aesthetic experience, placing emphasis on emotions like trepidation, horror, and the awe experienced in confronting the sublimity of nature. Romanticism also elevated the achievements of what it perceived as misunderstood heroic individuals and artists, permitting freedom from classical notions of form in art. *Contrast with* Neo-Romanticism.

Social Documentary. Photography that seeks to document aspects of society in an organized way, usually through long-term projects. The most famous example of such work is the Farm Security Administration (FSA) photography program, which employed numerous photographers (including Dorothea Lange and Walker Evans) to document the historical, sociological, and economic aspects of Depression-era government relief programs in the United States.

Straight Photography. Photography that attempts to depict a scene as realistically and objectively as permitted by the medium, forsaking the use of manipulation at the time of exposure or in postproduction. A circle of famous photographers who espoused straight photography, Group f/64, was founded in 1932. *See also* Naturalism.

Superrealism. *See* Photorealism.

Surrealism. An early- to mid-20th-century artistic movement, growing out of Dadaism, that attempted to express the workings of the subconscious by fantastic imagery and incongruous juxtaposition of subject matter. Man Ray was a significant contributor to this movement.

Vernacular Photography. A type of "accidental art," these are photographs by amateur or unknown photographers that have uncommon qualities to them. This may include vacation photos, family snapshots, class portraits, and photobooth images.

Vorticism. A short-lived movement of the early 20th century with its roots in Futurism and Cubism. Vorticism ridiculed traditional values and exalted modern technology. This movement was championed by the poet Ezra Pound and made popular by Alvin Langdon Coburn, who was one of its leading exponents, as was London celebrity photographer Malcolm Arbuthnot.

APPENDIX 3

PROFESSIONAL ORGANIZATIONS

The following is a list of leading professional organizations that may be consulted by those seeking additional training, professional accreditation, and/or industry contacts.

Advertising Photographers of America
P.O. Box 250, White Plains, NY 10605
www.apanational.com

African American Photographers Association, Inc.
The Exposure Group, P.O. Box 76447, Washington, DC 20013-6447; www.exposuregroup.org

American Society of Media Photographers, Inc.
150 N. 2nd St., Philadelphia, PA 19106; www.asmp.org

American Society of Picture Professionals, Inc.
117 South Saint Asaph St., Alexandria, VA 22314
www.aspp.com

Antique & Amusement Photographers International
www.oldtimephotos.org

Association of Photographers UK
81 Leonard St., London EC2A 4QS, United Kingdom
www.the-aop.org

British Institute of Professional Photography
Fox Talbot House, Amwell End, Ware, SG12 9HN, Hertfordshire, United Kingdom; www.bipp.com

British Society of Underwater Photographers
www.bsoup.org

Canadian Association of Photographers and Illustrators in Communications
 55 Mill St., Case Goods Bldg. 74, Ste. 302, Toronto, ON, Canada, M5A 3C4; www.capic.org
The Daguerreian Society
 3126 Millers Run Rd., Ste. 4, P.O. Box #306, Cecil, PA 15321-0306; www.daguerre.org
Editorial Photographers
 P.O. Box 591811, San Francisco, CA 94159-1811 www.editorialphoto.com
Evidence Photographers International Council, Inc.
 229 Peachtree St. NE, #2200, Atlanta, GA 30303 www.epic-photo.org
International Association of Panoramic Photographers
 Church Street Station, P.O. Box 3371, New York, NY 10008-3371; www.panphoto.com
International Combat Camera Association
 www.combatcamera.org
International Freelance Photographers Organization
 P.O. Box 777, Lewisville, NC 27023-0777 www.aipress.com
National Association of Photoshop Professionals
 333 Douglas Rd. E., Oldsmar, FL 34677 www.photoshopuser.com
National Press Photographers Association
 3200 Croasdaile Dr., Ste. 306; Durham, NC 27705 www.nppa.org
North American Nature Photography Association
 10200 West 44th Ave., Ste. 304; Wheat Ridge, CO 80033-2840; www.nanpa.org
Photographic Society of America
 3000 United Founders Blvd., Ste. 103, Oklahoma City, OK 73112; www.psa-photo.org
Photo Marketing Association International
 3000 Picture Place; Jackson, MI 49201; www.pmai.org
Pictorial Photographers of America
 147-10 41st Ave., Flushing, NY 11355-1266 www.ppa-photoclub.org

Professional Photographers of America, Inc.
 229 Peachtree St. NE, Ste. 2200, Atlanta, GA 30303 www.ppa.com
Professional Photographers of Canada
 www.ppoc.ca
Professional School Photographers Association International
 3000 Picture Place, Jackson, MI 49201 www.pmai.org/index.cfm/ci_id/24455
Professional Women Photographers
 511 Avenue of the Americas #138, New York, NY 10011; www.pwponline.org
The Royal Photographic Society
 Fenton House, 122 Wells Rd., Bath BA2 3AH, United Kingdom; www.rps.org
Society of Sport and Event Photographers
 229 Peachtree St. NE, Ste. 2200, Atlanta, GA 30303 www.sepsociety.com
Sports Photography Association of America
 3000 Picture Place; Jackson, MI 49201 www.pmai.org/index.cfm/ci_id/33512.htm
Student Photographic Society
 229 Peachtree St. NE, Suite 2200, Atlanta, GA 30303 www.studentphoto.com
Travel and Outdoor Photographers Alliance
 www.t-o-p-a.com
University Photographers' Association of America
 www.upaa.org
Wedding and Portrait Photographers International
 P.O. Box 2003, 1312 Lincoln Blvd., Santa Monica, CA 90406-2003; www.wppionline.com
Wedding Photojournalists Association
 www.wpja.com
Women in Photography International
 www.womeninphotography.com

MASTER GUIDE FOR TEAM SPORTS PHOTOGRAPHY

James Williams

Learn how adding team sports photography to your studio's repertoire can help you meet your professional and financial goals. Includes technical, artistic, organizational, and business strategies. $34.95 list, 8.5x11, 128p, 120 color photos, index, order no. 1850.

JEFF SMITH'S POSING TECHNIQUES FOR LOCATION PORTRAIT PHOTOGRAPHY

Learn how to design poses that take advantage of architectural and natural background elements, how to maximize the flow of the session, and how to create refined, artful poses for individual subjects and groups—whether indoors or out. $34.95 list, 8.5x11, 128p, 150 color photos, index, order no. 1851.

MASTER LIGHTING GUIDE
FOR WEDDING PHOTOGRAPHERS

Bill Hurter

Master the techniques you need to capture perfect lighting quickly and easily at the ceremony and reception—indoors and out. Includes tips from the pros for lighting individuals, couples, and groups. $34.95 list, 8.5x11, 128p, 200 color photos, index, order no. 1852.

ROLANDO GOMEZ'S
GLAMOUR PHOTOGRAPHY
PROFESSIONAL TECHNIQUES AND IMAGES

Learn the techniques you need to create classy glamour portraits your clients will adore. Rolando Gomez takes you behind the scenes, offering invaluable technical and professional insights. $34.95 list, 8.5x11, 128p, 150 color images, index, order no. 1842.

CHILDREN'S PORTRAIT PHOTOGRAPHY
A PHOTOJOURNALISTIC APPROACH

Kevin Newsome

Learn how to capture spirited images that reflect your young subject's unique personality and developmental stage. $34.95 list, 8.5x11, 128p, 150 color images, index, order no. 1843.

PROFESSIONAL PORTRAIT POSING
TECHNIQUES AND IMAGES FROM MASTER PHOTOGRAPHERS

Michelle Perkins

Learn how master photographers pose subjects to create unforgettable images. $34.95 list, 8.5x11, 128p, 175 color images, index, order no. 2002.

STUDIO PORTRAIT PHOTOGRAPHY OF CHILDREN AND BABIES, 3rd Ed.

Marilyn Sholin

Work with the youngest portrait clients to create cherished images. Includes techniques for working with kids at every developmental stage, from infant to preschooler. $34.95 list, 8.5x11, 128p, 140 color photos, order no. 1845.

THE PHOTOGRAPHER'S GUIDE TO
COLOR MANAGEMENT
PROFESSIONAL TECHNIQUES FOR CONSISTENT RESULTS

Phil Nelson

Learn how to keep color consistent from device to device, ensuring greater efficiency and more accurate results. $34.95 list, 8.5x11, 128p, 175 color photos, index, order no. 1838.

SOFTBOX LIGHTING TECHNIQUES
FOR PROFESSIONAL PHOTOGRAPHERS

Stephen A. Dantzig

Learn to use one of photography's most popular lighting devices to produce soft and flawless effects for portraits, product shots, and more. $34.95 list, 8.5x11, 128p, 260 color images, index, order no. 1839.

CHILDREN'S PORTRAIT PHOTOGRAPHY HANDBOOK

Bill Hurter

Packed with inside tips from industry leaders, this book shows you the ins and outs of working with some of photography's most challenging subjects. $34.95 list, 8.5x11, 128p, 175 color images, index, order no. 1840.

JEFF SMITH's LIGHTING FOR OUTDOOR AND LOCATION PORTRAIT PHOTOGRAPHY

Learn the techniques you need to produce elegant, flattering portrait light throughout the day—whether indoors or out—and make location portraits a highly profitable venture for your studio. $34.95 list, 8.5x11, 128p, 170 color images, index, order no. 1841.

DIGITAL CAPTURE AND WORKFLOW
FOR PROFESSIONAL PHOTOGRAPHERS

Tom Lee

Cut your image-processing time by fine-tuning your workflow. Includes tips for working with Photoshop and Adobe Bridge, plus framing, matting, and more. $34.95 list, 8.5x11, 128p, 150 color images, index, order no. 1835.

PROFESSIONAL FILTER TECHNIQUES
FOR DIGITAL PHOTOGRAPHERS

Stan Sholik

Select the best filter options for your photographic style and discover how their use will affect your images. $34.95 list, 8.5x11, 128p, 150 color images, index, order no. 1831.

DIGITAL PHOTOGRAPHY FOR CHILDREN'S AND FAMILY PORTRAITURE, 2nd Ed.

Kathleen Hawkins

Learn how staying on top of advances in digital photography can boost your sales and improve your artistry and workflow. $34.95 list, 8.5x11, 128p, 195 color images, index, order no. 1847.

MASTER LIGHTING GUIDE
FOR COMMERCIAL PHOTOGRAPHERS

Robert Morrissey

Use the tools and techniques pros rely on to land corporate clients. Includes diagrams, images, and techniques for a failsafe approach for shots that sell. $34.95 list, 8.5x11, 128p, 110 color photos, 125 diagrams, index, order no. 1833.

RANGEFINDER'S PROFESSIONAL PHOTOGRAPHY

edited by Bill Hurter

Editor Bill Hurter shares over one hundred "recipes" from *Rangefinder's* popular cookbook series, showing you how to shoot, pose, light, and edit fabulous images. $34.95 list, 8.5x11, 128p, 150 color photos, index, order no. 1828.

PROFESSIONAL PORTRAIT LIGHTING
TECHNIQUES AND IMAGES FROM MASTER PHOTOGRAPHERS

Michelle Perkins

Get a behind-the-scenes look at the lighting techniques employed by the world's top portrait photographers. $34.95 list, 8.5x11, 128p, 200 color photos, index, order no. 2000.

MASTER LIGHTING TECHNIQUES
FOR OUTDOOR AND LOCATION DIGITAL PORTRAIT PHOTOGRAPHY

Stephen A. Dantzig

Use natural light alone or with flash fill, barebulb, and strobes to shoot perfect portraits all day long. $34.95 list, 8.5x11, 128p, 175 color photos, diagrams, index, order no. 1821.

BLACK & WHITE PHOTOGRAPHY
TECHNIQUES WITH ADOBE® PHOTOSHOP®

Maurice Hamilton

Become a master of the black & white digital darkroom! Covers all the skills required to perfect your black & white images and produce dazzling fine-art prints. $34.95 list, 8.5x11, 128p, 150 color/b&w images, index, order no. 1813.

NIGHT AND LOW-LIGHT
TECHNIQUES FOR DIGITAL PHOTOGRAPHY

Peter Cope

With even simple point-and-shoot digital cameras, you can create dazzling nighttime photos. Get started quickly with this step-by-step guide. $34.95 list, 8.5x11, 128p, 100 color photos, index, order no. 1814.

ARTISTIC TECHNIQUES WITH ADOBE® PHOTOSHOP® AND COREL® PAINTER®

Deborah Lynn Ferro

Flex your creativity and learn how to transform photographs into fine-art masterpieces. Step-by-step techniques make it easy! $34.95 list, 8.5x11, 128p, 200 color images, index, order no. 1806.

MASTER GUIDE FOR UNDERWATER DIGITAL PHOTOGRAPHY

Jack and Sue Drafahl

Make the most of digital! Jack and Sue Drafahl take you from equipment selection to underwater shooting techniques. $34.95 list, 8.5x11, 128p, 250 color images, index, order no. 1807.

DIGITAL PHOTOGRAPHY BOOT CAMP

Kevin Kubota

Kevin Kubota's popular workshop is now a book! A down-and-dirty, step-by-step course in building a professional photography workflow and creating digital images that sell! $34.95 list, 8.5x11, 128p, 250 color images, index, order no. 1809.

LIGHTING TECHNIQUES FOR **FASHION AND GLAMOUR PHOTOGRAPHY**

Stephen A. Dantzig, PsyD.

In fashion and glamour photography, light is the key to producing images with impact. With these techniques, you'll be primed for success! $29.95 list, 8.5x11, 128p, over 200 color images, index, order no. 1795.

POSING FOR PORTRAIT PHOTOGRAPHY
A HEAD-TO-TOE GUIDE

Jeff Smith

Author and photographer Jeff Smith teaches you surefire techniques for fine-tuning every aspect of each pose to achieve the most flattering results. $34.95 list, 8.5x11, 128p, 150 color photos, index, order no. 1786.

WEDDING AND PORTRAIT PHOTOGRAPHERS' LEGAL HANDBOOK

N. Phillips and C. Nudo, Esq.

Don't leave yourself or your business exposed to costly legal actions! Sample forms and practical discussions help you protect yourself and your business. $29.95 list, 8.5x11, 128p, 25 sample forms, index, order no. 1796.

PROFITABLE PORTRAITS
THE PHOTOGRAPHER'S GUIDE TO CREATING PORTRAITS THAT SELL

Jeff Smith

Learn how to design images that are precisely tailored to your clients' tastes—portraits that will practically sell themselves! $29.95 list, 8.5x11, 128p, 100 color photos, index, order no. 1797.

THE PORTRAIT PHOTOGRAPHER'S GUIDE TO POSING

Bill Hurter

Posing can make or break an image. Now you can get the posing tips and techniques that have propelled the finest portrait photographers in the industry to the top. $34.95 list, 8.5x11, 128p, 200 color photos, index, order no. 1779.

THE PRACTICAL GUIDE TO DIGITAL IMAGING

Michelle Perkins

This book takes the mystery (and intimidation!) out of digital imaging. Short, simple lessons make it easy to master all the terms and techniques. $29.95 list, 8.5x11, 128p, 150 color images, index, order no. 1799.

DIGITAL LANDSCAPE PHOTOGRAPHY STEP BY STEP

Michelle Perkins

Using a digital camera makes it fun to learn landscape photography. Short, easy lessons ensure rapid learning and success! $17.95 list, 9x9, 112p, 120 color images, index, order no. 1800.

BEGINNER'S GUIDE TO PHOTOGRAPHIC LIGHTING

Don Marr

Create high-impact photographs of any subject with Marr's simple techniques. From edgy and dynamic to subdued and natural, this book will show you how to get the myriad effects you're after. $34.95 list, 8.5x11, 128p, 150 color photos, index, order no. 1785.